MW00754131

GATEWAYS TO DRAWING

Stephen C. P. Gardner

GATEWAYS
TO DRAWING

A Complete Guide

With 529 illustrations, 494 in color

Thames & Hudson

To my students, both past and future,
who continue to inspire me.

Front cover
Carl Randall, *Shibuya*, 2008. © The artist. www.carlrandall.com

Frontispiece
Alain Kirili, *Opulence XIV*, 2016. Courtesy the artist

Gateways to Drawing © 2018 Thames & Hudson Ltd, London

Text © 2018 Stephen Gardner

All Rights Reserved. No part of this publication may be reproduced or transmitted in any form or by any means, electronic or mechanical, including photocopy, recording or any other information storage and retrieval system, without prior permission in writing from the publisher.

First published in 2018 in the United States of America by Thames & Hudson Inc., 500 Fifth Avenue, New York, New York 10110

www.thamesandhudsonusa.com

Library of Congress Control Number 2018952387

ISBN 978-0-500-29448-2

Printed and bound in China

Contents

Preface

As a professor and an administrator, I have had the pleasure of observing many drawing teachers, some new to teaching and others seasoned professors, as they instructed their students. The inventive ways in which different teachers describe and explain the act of drawing continue to fascinate me. Over time, I have noticed that the most successful and engaging teachers possess three characteristics: they are inspirational, informative, and hands-on. I frequently ask my students what they value most in their teachers, and they agree. To ensure that *Gateways to Drawing* is the same type of "teacher," I have embedded the book with those characteristics.

Gateways to Drawing is an introduction to drawing, providing students with all the tools they need to understand, practice, and delight in the discipline. To offer students **inspiration**, the book has been beautifully designed, with over 500 examples of drawings. The works are both historical and contemporary, from professionals and students, and highlight diverse artists. They reflect today's college classrooms, which are often made up of students from around the world, studying not only fine arts, but also fields in design and the applied arts.

The **informative text** illuminates key drawing concepts and the elements of art. Extended captions provide quick reminders of how each drawing relates to the text. The "Gateway to Drawing" features allow students to discover many ways to analyze a single work of art. "Drawing at Work" boxes investigate how drawing can communicate the ideas of practitioners from a range of fields, and "The Work of Art" features provide insight into artists' processes, told through analyses of their work. To provide a **hands-on** approach, *Gateways to Drawing* includes practical step-by-step demonstrations, and Tips are strategically placed to assist and guide students in techniques for making drawings. At the end of each chapter, "In the Studio Projects" challenge students to apply what they have learned.

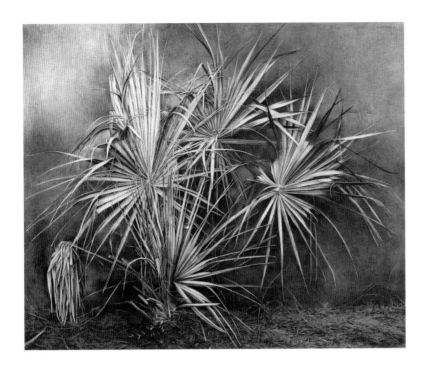

0.1 Stephen Gardner, *Fan Palm,* 2014. Charcoal, 40 × 48" (101.6 × 121.9 cm). Collection of the artist

Organization

Gateways to Drawing is organized in a very practical way. It clarifies the subject of drawing for students and organizes a drawing course for the instructor. The book is structured in five parts, for ease of navigation. Part 1, "Why Draw?" (Chapters 1–3), considers the importance of drawing. It answers the questions that students often ask, such as "Why is drawing important?" and "How could drawing be applied in my career?" These chapters include a discussion about different approaches to drawing, as well as a presentation of materials. Part 2, "How to Draw" (Chapters 4–6), covers composition and the sketchbook, and provides an easy-to-follow, step-by-step technique for observational drawing. Part 3, "Drawing Elements" (Chapters 7–13), isolates the elements of art as they apply to drawing, with chapters on line, shape, value, form, space, texture, and color. With the knowledge gained in these chapters, students can progress to Part 4, "What to Draw" (Chapters 14–17), which focuses on different genres of drawing, from the history and exciting possibilities of still life, to those of figure drawing, portraiture, and landscape. Finally, Part 5, "Looking at Drawing: Critical Thinking and Critique" (Chapter 18), presents specific approaches to evaluating and critiquing drawings.

Gateways to Drawing is a comprehensive and flexible text that is ideal for individual drawing

classes on the quarter or semester system, and can be used for a series of courses, whether for beginners or advanced students. It covers such fundamental techniques as setting up to draw, and delves into more complex and conceptual considerations within each genre. "In the Studio Projects" offer three activities at the end of each chapter, which vary in degrees of difficulty and provide motivating choices for students.

See p. 14 for more information on how to use *Gateways to Drawing: A Complete Guide.*

Resources for Students

The **Gateways to Drawing Sketchbook** is an ideal companion to the textbook. The prompts and examples throughout the sketchbook parallel the topics covered in each chapter of the textbook and will prepare students to accomplish better the "In the Studio Projects" in the textbook. With plenty of blank pages, the sketchbook can also be used to complete the additional prompts and projects found throughout the textbook, while providing space to make sketching a daily routine.

Videos feature the author as he demonstrates each stage of the process of observational drawing, including: deciding what to draw, thumbnail sketches, composition, gesture, sighting and measuring, drawing an ellipse, value, and one-, two-, and three-point perspective.

Resources for Instructors

- **Art Slides in PowerPoint**, featuring **ALL** the images and captions from the book, support classroom discussions and provide content for missed lectures or online use.
- **Quizzes** for each chapter facilitate testing of key concepts.
- **Coursepack** provides PowerPoints, videos, and quizzes all in one place.

Ebook: *Gateways to Drawing* is available as a PDF ebook.

To find out more about resources for students and instructors, go to:
digital.wwnorton.com/drawing

Features

Each chapter in *Gateways to Drawing* contains several features that not only serve to emphasize the chapter topic, but also instill the importance of doing, looking, and analyzing.

The text provides many pathways for developing skills. "In the Studio Projects," sketchbook prompts (in both the textbook and the accompanying *Gateways to Drawing Sketchbook*), guiding Tips, and the sketchbook itself offer students many ways to master skills by doing. Visual step-by-step demonstrations help students to develop skills that range from fundamental to complex. Supporting author-created videos demonstrate each step of the observational drawing process, including use of linear perspective—one of the more difficult techniques to master.

Step-by-step demonstrations show students the process of and techniques for making drawings. Each demonstration varies in approach and media. Photos and text guide students in an easy-to-follow process.

Tips can be found throughout the text to provide practical suggestions to guide students in their work.

"In the Studio Projects" end each chapter, providing activities for several different levels of practice, including fundamental, observational, and non-observational drawing.

Key drawing terms are defined in the margins, as well as an end-of-book glossary, for clarification and reinforcement of the vocabulary of drawing. These terms have been set in bold at first mention in the text to help students to identify them with ease.

Definitions of the artistic movements, styles, and periods mentioned in the book can be found in the additional **"Glossary of Artistic Movements, Styles, and Periods"** on p. 356.

"The Work of Art" boxes in each chapter provide a critical review of an artist and his or her process of drawing. They highlight the practitioner's artistic aims, challenges, methods, and results.

Sketchbook Prompts throughout the book challenge students to practice concepts as they learn.

The Work of Art Kara Walker

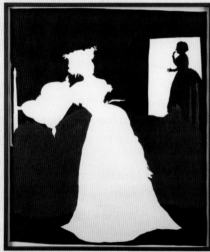

8.2 Kara Walker, *Untitled*, 1996. Ink, paper, and graphite on paper, 7' 1¼" × 6' ¼" (2.17 × 1.84 m). Virginia Museum of Fine Arts, Richmond, VA
This ink-and-graphite drawing is a grouping of silhouettes, creating a strong two-dimensional appearance. Simplifying figures and objects into general shapes in this way is a type of abstraction. In this case, the image has not been reduced so far as to lose its depictive quality. Instead, the use of general shapes becomes a storytelling language for the artist.

Who: Kara Walker
Where: United States of America
When: 1996
Materials: Ink, graphite, and collaged paper

Artistic Aims
The American contemporary artist Kara Walker confronts social issues surrounding black history. As in the traditions of storytelling, her narrative scenes blend fact and fiction. Her

Artistic Challenges
How does one visually address the history of American slavery in relation to racism today? How can one address modern and historical social concerns

about hatred, race, gender, and sexuality in a drawing? These are the themes that Walker addresses in her works. She invents tales, beautiful and unsettling, that simultaneously fascinate and accuse her viewers.

Artistic Method
Walker's work takes the form of drawings, life-sized installations, collages, prints, and shadow-puppet film animations. Whether in large scenes composed of freehand cut-paper silhouettes or in her carefully drawn notebook-size ink drawings or other media, Walker simplifies figures and environments into traditional Victorian-style silhouette shapes, recalling a popular art craft from the 1700s and 1800s. Using this old-fashioned technique lends her work an appearance of sentimental prettiness that contrasts with her themes. The characters in her narratives, usually stark black figures with exaggerated features, caricature racial stereotypes. Her flattened tableaus appear historically accurate, yet are invented.

The Results
There is a striking balance between realism and abstraction in Walker's work. She is able to communicate the essence of complex social issues using simple shapes. Her work has been both celebrated and savagely criticized for its challenging messages.

use of silhouettes creates blunt and powerful visual images that also serve as metaphors for our stereotypes and our oversimplified views of one another. Walker aims to confront us with statements that question and challenge.

Sketchbook Prompt

Choose an object that has many negative shapes. In a sketchbook, draw only the negative shapes, taking care to locate them correctly in relationship to each other.

Orozco, *Man Struggling with Centaur*
Mark-Making and Media

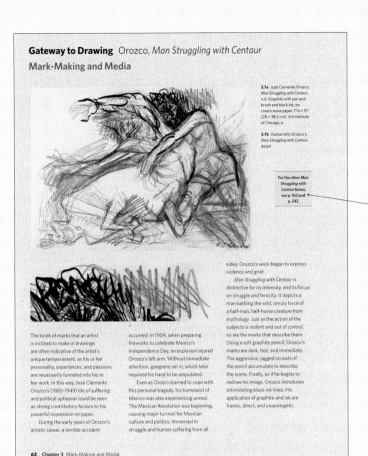

3.7a José Clemente Orozco, *Man Struggling with Centaur*, n.d. Graphite with pen and brush and black ink, on cream wove paper, 7½ × 15" (28 × 38.2 cm). Art Institute of Chicago, IL

3.7b (below left) Orozco's *Man Struggling with Centaur*, detail

For the other *Man Struggling with Centaur* boxes, see p. 163 and p. 242

The kinds of marks that an artist is inclined to make in drawings are often indicative of the artist's unique temperament, as his or her personality, experiences, and passions are necessarily funneled into his or her work. In this way, José Clemente Orozco's (1883–1949) life of suffering and political upheaval could be seen as strong contributory factors to his powerful expression on paper.

During the early years of Orozco's artistic career, a terrible accident occurred. In 1904, when preparing fireworks to celebrate Mexico's Independence Day, an explosion injured Orozco's left arm. Without immediate attention, gangrene set in, which later required his hand to be amputated.

Even as Orozco learned to cope with this personal tragedy, his homeland of Mexico was also experiencing unrest. The Mexican Revolution was beginning, causing major turmoil for Mexican culture and politics. Immersed in struggle and human suffering from all sides, Orozco's work began to express violence and grief.

Man Struggling with Centaur is distinctive for its intensity, and its focus on struggle and ferocity. It depicts a man battling the wild, unruly force of a half-man, half-horse creature from mythology. Just as the action of the subjects is violent and out of control, so are the marks that describe them. Using a soft graphite pencil, Orozco's marks are dark, fast, and immediate. The aggressive, jagged scrawls of the pencil accumulate to describe the scene. Finally, as if he begins to redraw his image, Orozco introduces intimidating black ink lines. His application of graphite and ink are frantic, direct, and unapologetic.

62 Chapter 3 Mark-Making and Media

"Gateway to Drawing" features present three exemplary drawings, which are revisited throughout the text, teaching students to consider art from different perspectives. These works span time and place, and reinforce the common course goal of learning to analyze drawings in multiple ways. Overlays direct students to important details.

Cross-references
Use this feature to find the page references for the other "Gateway to Drawing" boxes discussing this artwork. This will allow you to locate them quickly, and to compare and contrast the different ways in which you can appreciate the drawing.

Featured Gateway Drawings

- José Clemente Orozco, *Man Struggling with Centaur* (pp. 62, 163, and 242)
- Nora Heysen, *Gum Trees, Hahndorf* (pp. 102–3, 192, and 339)
- Edward Burne-Jones, *The Tomb of Tristram and Isoude* (pp. 28, 176, and 299)

Drawing at Work Le Corbusier

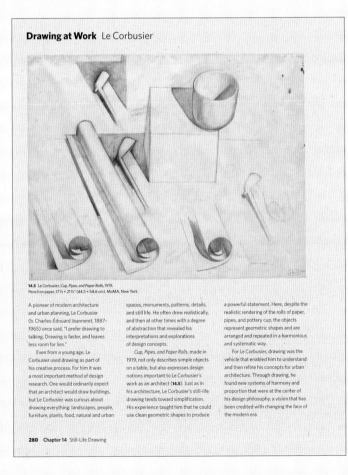

14.5 Le Corbusier, *Cup, Pipes, and Paper Rolls*, 1919. Pencil on paper, 17½ × 21½" (44.5 × 54.6 cm). MoMA, New York

A pioneer of modern architecture and urban planning, Le Corbusier (b. Charles-Édouard Jeanneret, 1887–1965) once said, "I prefer drawing to talking. Drawing is faster, and leaves less room for lies."

Even from a young age, Le Corbusier used drawing as part of his creative process. For him it was a most important method of design research. One would ordinarily expect that an architect would draw buildings, but Le Corbusier was curious about drawing everything: landscapes, people, furniture, plants, food, natural and urban spaces, monuments, patterns, details, and still life. He often drew realistically, and then at other times with a degree of abstraction that revealed his interpretations and explorations of design concepts.

Cup, Pipes, and Paper Rolls, made in 1919, not only describes simple objects on a table, but also expresses design notions important to Le Corbusier's work as an architect (**14.5**). Just as in his architecture, Le Corbusier's still-life drawing tends toward simplification. His experience taught him that he could use clean geometric shapes to produce a powerful statement. Here, despite the realistic rendering of the rolls of paper, pipes, and pottery cup, the objects represent geometric shapes and are arranged and repeated in a harmonious and systematic way.

For Le Corbusier, drawing was the vehicle that enabled him to understand and then refine his concepts for urban architecture. Through drawing, he found new systems of harmony and proportion that were at the center of his design philosophy, a vision that has been credited with changing the face of the modern era.

280 Chapter 14 Still-Life Drawing

"Drawing at Work" boxes in each chapter feature drawings from a variety of fields, such as fashion, architecture, and illustration. These show the practical applications of drawing, not only as a form of fine art, but also as a means for communicating ideas.

How to Use *Gateways to Drawing: A Complete Guide*

Every course is unique and involves distinctive goals and outcomes, which is why *Gateways to Drawing* is designed to facilitate flexibility.

Instructors wishing to offer a fully comprehensive course may utilize the entire book, as well as the *Gateways to Drawing Sketchbook*. Alternatively, depending on the length of the course and preference of the instructor, a selection of specific projects may be taught. For example, for beginning-level students, instructors may choose to assign only the fundamental projects from each chapter. For a different type of class, the instructor may have students read the chapters on still life, drawing the human figure, portraiture, and landscape drawing, and then ask them to select which genre they wish to pursue. This offers the creative freedom that many students desire and also provides a solution for courses with time constraints. Alternatively, an instructor who would like to focus on sketchbook drawing could recommend that students only complete the sketchbook prompts within each chapter in combination with the additional prompts found in the *Gateways to Drawing Sketchbook*. By utilizing the text inventively, *Gateways to Drawing* can fit almost any academic schedule, and lets instructors make their class their own.

This text has been designed to be flexible for any syllabus. Instructors can choose combinations of chapters that will best support their students. Below are just a few examples of how the textbook could be applied to different courses:

Beginning Drawing: Chapters 1–13. Instructors to assign only the fundamental projects at the end of each chapter.

Comprehensive Drawing: Chapters 1–18. Instructors to assign a mixture of activities from "In the Studio Projects" at the end of each chapter, underscoring both observational drawing and non-observational drawing.

Observational Drawing: Chapter 1 for background, followed by Chapters 2–18. Instructors to assign only the observational drawing activities from "In the Studio Projects" in these chapters.

Non-Observational Drawing: Chapter 1 for background, followed by Chapters 2–5 and 7–18. Instructors to assign only the non-observational drawing activities from "In the Studio Projects" in these chapters.

Short Course: Chapters 1–4 and 14–17. Students may decide which genre to pursue.

Life Drawing: Chapters 1–4, 15, and 16.

Sketchbook Focus: Chapters 1–18, with a special focus on Chapter 5, and *Gateways to Drawing Sketchbook*. Instructors to assign sketchbook prompts from each chapter, in addition to those in the accompanying *Gateways to Drawing Sketchbook*.

Landscape Drawing: Chapters 1–13 and 17.

Acknowledgments

Writing such a book as this is a collaborative, group project. This book could not have been created without the following people. Special recognition goes to all the reviewers whose opinions and suggestions I value very much. They include: Kelly L. Adams, East Carolina University; Sarah Atkinson, University of the Arts London; William Burgard, University of Michigan; Joomi Chung, Miami University; Jan Crooker, Northampton Community College; Alison Denyer, University of Utah; Tracy Featherstone, Miami University; Frank Hockett, Ivy Tech Community College; Wendy Kveck, College of Southern Nevada; Gingher Leyendecker, Mesa Community College; David Lindsay, Texas Tech University; Cheryl Lorance, Ivy Tech Community

College; Sondra Martin, Fayetteville State University; Agnes Murray, Bronx Community College; Anna Pagnucci, Coastal Carolina Community College; Elaine Pawlowicz, University of North Texas; Cynthia Peterson, Mesa Community College; Gabrielle Roach, Miami University; Kent Rush, University of Texas at San Antonio; Seymour Simmons III, Winthrop University; Biddy Tran, Cerritos College and California State University—Long Beach; and Scott J. Wakefield, Rocky Mountain College of Art and Design.

I was pleased to be able to exhibit some works by truly talented students, including: Atakan Basol, Savannah College of Art and Design; Madilyn Bedsole, Savannah College of Art and Design; Christina Budres, Cape Fear Community College; K. Christian, Cape Fear Community College; Dana Demsky, University of Michigan; Isabella Gardner, Savannah College of Art and Design; Dawna E. Guzman, Glendale Community College; Kirstyn Harris, Augusta University; Alexander Hicks, Cape Fear Community College; Radha Howard, Savannah College of Art and Design; Alexandra N. Ibarra, San Antonio College; Addison Jones, Cape Fear Community College; Hannah Lawson, University of Cincinnati; Gabriela McDonald, Glendale Community College; Dan Muangprasert, Savannah College of Art and Design; Melisha Polk, Tennessee State University; Paul Rodriguez, San Antonio College; Stephanie Tarascio, Cape Fear Community College; Amber Turner, Ball State University; Fermin Uriz, Savannah College of Art and Design; Yang Wang, Savannah College of Art and Design; and Ellie Ward, University of Michigan. Thank you for sharing your drawings.

I am also very appreciative to faculty from across the country who shared their students' work: William Burgard, University of Michigan; Adriana Burgos, Savannah College of Art and Design; Alfonso Cantu, San Antonio College; Brandon Donahue, Tennessee State University; Barbara Giorgio-Booher, Ball State University; Jeff Markowsky, Savannah College of Art and Design; Terry Moeller, Savannah College of Art and Design; Deborah Mosch, Savannah College of Art and Design; Victoria Paige, Cape Fear Community College; Steven Schetski, Savannah Arts Academy; Gaylen Stewart, Glendale Community College; Kim Taylor, University of Cincinnati; Scott Thorp, Augusta University, and Jason Zimmer, Savannah College of Art and Design.

It has been a pleasure to work with Thames & Hudson. They have made me feel welcome and supported throughout the writing process. For their most important contributions I would like to recognize Priscilla McGeehon, Lucy Smith, Sharon Adams Poore, Izzie Hewitt, Poppy David, Giovanni Forti, Aman Phull, Chandler Gum, and Margaret Manos. And, although they have since left the team, I would also like to include Ian Jacobs (to whom I still owe lunch at *The Ship*), Nicole Albas, and Alex Goodwin.

I am especially grateful to my family: my loving and understanding wife, Sabrina, sons Max and Peter who patiently allowed me to include them in this book, and to Isabella whose diagrams, drawings, and creative advice I have valued throughout this project. Finally, to my dad, who would have been very proud to buy the first copy of *Gateways to Drawing* by Stephen C. P. Gardner.

About the Author

Stephen Gardner is an ardent draftsman. His realistic representations reveal a unique blend of traditional influences and modern sensibilities reflective of his own life in the southern United States. He makes large-scale charcoal drawings, and works extensively on-site in his sketchbooks. He finds satisfaction in the way that each of these approaches to drawing enriches the other. His detailed garden illustrations can be found in magazines including *Better Homes and Gardens* and *Garden Deck & Landscape*, and books such as *Small Gardens of Savannah and Thereabouts* (Gretna, LA: Pelican Press, 2003).

Professor Gardner has taught at Savannah College of Art and Design (SCAD) since 1993. He currently serves as Associate Chair for the Foundation Studies Department. He received a B.F.A. from Rhode Island School of Design and a M.F.A. from Parsons School of Design.

Part 1
Why Draw?

Throughout history, artists and designers have made drawings for many different reasons—as part of a creative process, to communicate ideas, and to create independent works of art. How might drawing be important to you, or enhance what you do? What approach to drawing would be most useful to you? The type of drawing you choose and how you create it will depend on your goals. The materials that artists select are often carefully considered, as each medium has its own distinctive strengths. What materials would best support your desired results? The chapters in this part will help you answer these important questions and get you started on your own work.

Chapter 1

Drawing as a Way of Life

The word "**drawing**" is both verb and noun, process and product. As a verb, drawing refers to the action of making marks on a surface. As a noun, drawing refers to the composition resulting from this process of mark-making.

Drawing is a response to outer and inner stimuli. Often a drawing is a pictorial representation of something that exists in the world, such as an object or place, although sometimes a drawing depicts something that does not yet exist, or perhaps can never exist.

The act of drawing, however, is also an intrinsic way of making thoughts and feelings visible, because the process of drawing consists of continual decision-making. Whether consciously or not, each new mark analyzes the marks that came before in a cyclical process of evaluation and response. The resulting composition is a way of communicating ideas and emotions to others. In fact, it might be said that drawing's essential purpose is communication.

In this chapter, we will explore the role of drawing as a way of life. We will see how drawings make connections to history, why artists and designers choose to draw, how studying drawings can be inspirational, and how drawing is an integral part of the work and creative process of artists and designers.

Drawing As a verb, drawing refers to the action of making marks on a surface. As a noun, drawing refers to the composition resulting from this process of mark-making.

Everyone Can Draw

Can anyone draw? Yes. In fact, almost everybody does draw in one form or another. Given that drawing can be defined simply as a collection of marks on a page, most people, whether they consider themselves artists or not, draw throughout their lives—all the time actually, according to the British painter David Hockney (b. 1937).

While most people's drawings may not be made to exhibit in galleries, consider how often we sketch a map, doodle on scrap paper, or draw a diagram to share ideas. All of these are kinds of drawing. This drawing by a child is typical of how almost everyone experiments with drawing at a young age (**1.1**).

Drawings can be inspiring to study. By studying a drawing, we can connect with its creator's thoughts and feelings through his or her specific marks. These marks are the distinctive "signature" of the artist; they describe a personality and give evidence of that artist's life and energy.

Drawings often record a creative process that seeks to turn inspiration into a visual representation. The American inventor Thomas Edison (1847–1931) may not have been a fine

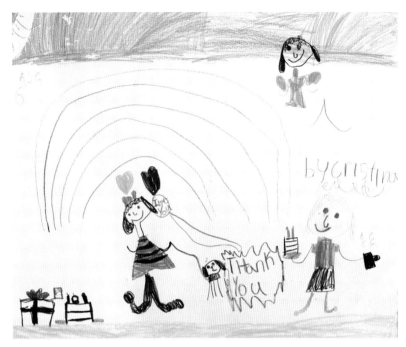

1.1 A child's drawing
Most children experiment with drawing. This drawing was made by a four-year-old girl as she imagined her sixth birthday party. We can see her creative approach to portraying a scene, not so different from the way that most people first play with drawing.

TIP

No matter your major field of study, continual drawing will enhance the way you think about the world around you.

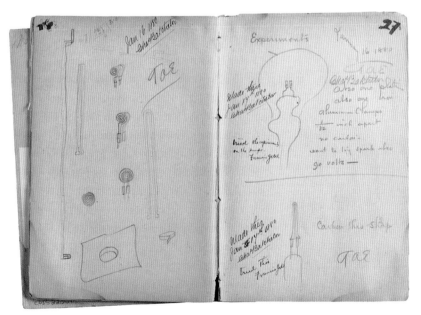

1.2 Thomas Edison, lightbulb drawing in journal, 1880.
Thomas Edison National Historical Park, West Orange, NJ
This drawing was made to record a thought: the design of a lightbulb. It was not made with a particular concern for style or aesthetics, but was focused simply on the details of an idea. Edison's journal is a record of an inventor's thought process.

artist, but he was a remarkably inspired thinker. He filled his journals with drawings that helped him to envision and record his new ideas, and these drawings in turn offer insight into his creative process. In this example of a sketch of a lightbulb, the drawing was not intended to be a finished work of art, but instead was simply a practical way to develop, record, and communicate his thoughts (**1.2**).

Just as with sports, creative writing, or playing a musical instrument, drawing demands practice in order to improve. As with an athlete, continual practice will gradually achieve better coordination between an artist's eye, mind, and hand. As with any focused creative activity, practice leads to an increasing desire to expand technique, concept, and approach. Practice inevitably develops vision and strength, and as we will see, the practice of drawing has been invaluable to creative people again and again throughout history.

Drawing throughout History

Drawing has always been an integral part of human life, as human beings have continuously had a desire to make marks on surfaces. We can find examples of drawings from any period in history, some dating back thousands of years. Drawings, however, were often combined with another art form instead of being prized as an independent genre of art. For example, during the early ancient Greek civilization, drawing was very often used as a way to adorn pottery and architecture in order to enhance their designs (**1.3**). These drawings share characteristics of the culture and period in which they were made, but over time artists became increasingly self-directed and drawing slowly found its place as an independent art form. It can be hard to pinpoint exactly when drawing was first considered a separate and distinct artistic activity. In the East, for example in China, drawing with ink and brush has been practiced for millennia, and a distinction was not historically made between drawing and painting since most artistic work was essentially graphic. In the West, drawing appears to have become independent of other artistic endeavors quite naturally in artists' studios, especially around the fourteenth century in northern Italy.

Today, such contemporary artists as Dawn Clements (b. 1958) use drawing as their primary method of expression as they respond to their personal experiences (**1.4**) and are influenced by the world around them. The unique circumstances of their lives—the times in which they live, their families, their artistic influences, economics, war, politics, and religion—all affect their work. In one way or another, every modern drawing reflects an artist's personal history.

This personal connection is at the heart of drawing's power as an independent art form. The act of drawing can become contemplative as the artist finds him- or herself lost in thought. It can also encourage the artist to make more drawings to explore new areas, while the successes and mistakes that the artist encounters in the practice of drawing can enlighten future works. For an engaged artist, drawing can become a lifelong pursuit.

Why Draw?

Drawing is a core component of a creative person's development and visual perception: the practice of drawing helps establish a habit of intensive looking, which increases our awareness of the world around us and stimulates creative ideas. By recording your experiences, thoughts, and expressions through drawing, you can expand your creative repertoire and nourish your visual memory. Drawings kept in this way may supply you with inspiration for a long time to come.

Drawing has always been a fundamental part of an artist's or a designer's education, as it offers an investigative path and economical way to examine visual relationships and solve visual problems. For some artists, the primary reason for

1.3 Proto-Attic Terra-cotta neck-amphora, early 7th century BCE. Terra-cotta, height 11⅝" (29.8 cm). Metropolitan Museum of Art, New York
The drawings made on Greek vases are examples of how drawings can be used as decorative ornament to add interest to an object. The chariot scene and the geometric style are distinctive features of the time period and culture.

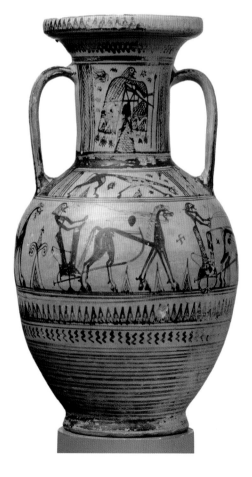

The Work of Art Dawn Clements

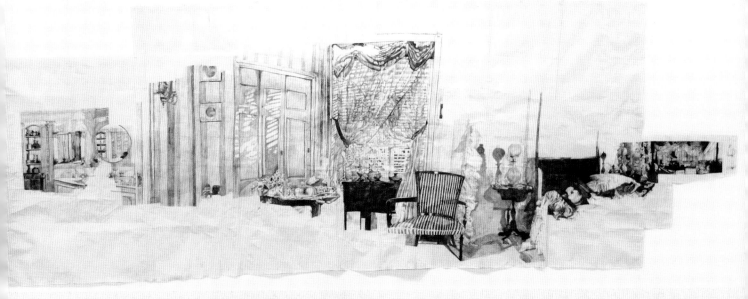

1.4 Dawn Clements, *Mrs. Jessica Drummond's (My Reputation, 1946)*, 2010.
Ballpoint pen on paper, 7' 3½" × 20' (2.22 × 6.1 m). Pierogi Gallery, New York
Clements uses drawing to express and respond to spaces that she is familiar with:
both personal spaces and fictional spaces found in movies. This large-scale ink drawing
depicts an expansive space from Curtis Bernhardt's film *My Reputation* (1946).

Who: Dawn Clements
Where: United States of America
When: 2010
Materials: Ballpoint pen on paper

Artistic Aims

Dawn Clements uses drawing to
capture the experience of moving
through interior spaces. Her scenes—
sometimes her own apartment and
sometimes taken from classic 1940s
and 1950s Hollywood movies—are filled
with narrative. In her drawing based on
the movie *My Reputation*, she aims to
capture the narrative arc of the movie by
combining several of the camera shots
into a single composition.

Artistic Challenges

In the movie *My Reputation*, the actress
Barbara Stanwyck plays a recent widow
who falls in love with a new man,
much to the dismay of her gossiping
friends and family. Clements draws
Stanwyck's character in her bedroom

the morning after her husband's funeral,
replicating the way in which the camera
zooms in and pans out by shifting from
one viewpoint to the next. By doing
this, Clements gives herself the task of
compiling multiple images that parallel
the cinematography of a movie to create
a unified composition.

Artistic Method

To create her drawing, Clements plays
the movie, pausing it at strategic scenes
that capture her imagination. Working
with ballpoint pen, and occasionally
Sumi ink, she begins by observing and
drawing details of one camera angle.
She starts in the center of her paper and
works outward, drawing other camera
shots and adding paper as she goes. Her
finished drawings often become wrinkled
and creased, reminding the viewer of
her improvisational working methods.
Her works—constructions that blend
images and pages—sometimes result
in panoramas that fill large walls.

The Results

In her drawing from *My Reputation*,
Clements captures fleeting moments
of the movie. Echoing it, she tells the
story through a sweeping pan over the
environment. Her adjoined images
blend in a way that results in a smooth,
yet somewhat distorted, panoramic
format. The drawing successfully
portrays both the visual and emotional
sense of the movie.

Sketchbook Prompt

Watch a movie on a computer or
television. Pause the movie at a
scene that you find interesting
visually. Draw the scene in your
sketchbook. Pay special attention
to the position of people and
objects within the scene.

Sumi ink A pressed
block made from a
mixture of carbon and
glue that creates ink
when water is added.

making drawings is to create saleable works of art, but many drawings are not made for this purpose. The value of these works can be found not only in their aesthetics, but also—perhaps more importantly—in their personal significance to the artist's own progress.

Familiarizing yourself with the visual history that drawings provide can initiate and instruct your creativity, just as these drawings have recorded key moments of discovery for their originators. Make no mistake, drawings often take on special meanings for artists, because artists understand that as long as they take part in their own development they will grow as creative people.

Fundamentally, drawing provides a unique outlet for the visual expression of inspiration. The act of drawing offers a free and direct platform for experimentation: flexibility and immediacy are two attractive qualities that drawing possesses as an art form. As you study and practice the artistic language of drawing, you will develop an increasingly articulate and even poetic approach to your own personal expression.

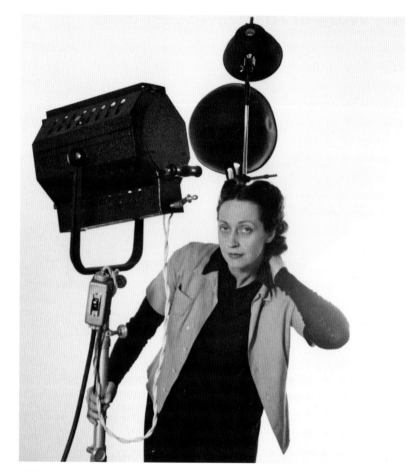

1.5 Barbara Morgan in her studio, 1942

Drawing in the Creative Arts

Drawing occupies a unique place in the arts. While it is considered to be its own form of art, it also blends seamlessly into almost every other creative endeavor. Professionals of all types—including artists, designers, illustrators, animators, and architects—utilize drawing in their work to communicate with others. When drawing is combined with other creative efforts, the possibilities are endless.

The photographs of the American artist Barbara Morgan (1900–1992) display a strong interest in drawing, as well as a belief that gestures can express profound emotions (**1.5**).

As if with a bold white marker, Morgan used light to create **gesture drawings** with her camera in a dark studio. The expressive light drawing *Pure Energy and Neurotic Man* was created in a carefully controlled photography studio, and sought to capture the energy that, according to the artist, is of primary importance in a photograph (**1.6**).

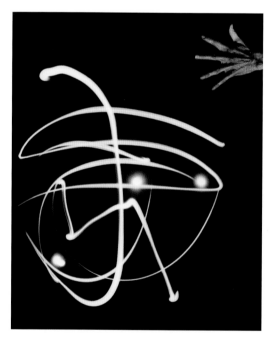

1.6 Barbara Morgan, *Pure Energy and Neurotic Man*, 1940–41. Gelatin silver print, 19⅝ × 15" (49.8 × 38.1 cm). Charles E. Young Research Library, UCLA, Los Angeles, CA
Noted for her photographs of modern dance, Morgan is also remembered for her abstract images. In this artwork, she used the language of drawing to depict rhythmic movement.

TIP

It is important to draw using an approach that works best for you. An architect may draw differently from a fashion designer, who may draw differently from a film-maker.

Gesture drawing Often quickly made, these drawings intend to express a sense of movement, action, or energy.

Storyboard Panels of sketches made to suggest a sequence of actions, such as a movie or animation.

Alfred Hitchcock (1899–1980), an English film director and producer of psychological thrillers, understood the importance of drawing as a tool for communication (**1.7**). During his career, he made hundreds of pencil drawings for **storyboards**, including this page for his thriller *Stage Fright* (1950) (**1.8**). It was his way of sharing his vision with his cast and crew, including, in this case, camera directions, such as close-up shots.

One of the most significant figures in the history of jazz and twentieth-century music, Miles Davis (1926–1991) worked obsessively on visual art and drawings when he was not performing (**1.9**). As with his music, Davis's drawings exemplify a focus on individual expression (**1.10**).

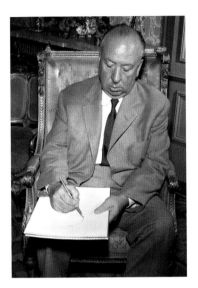

1.7 Alfred Hitchcock sketching, 1957

1.8 (below) Alfred Hitchcock, storyboard drawing for *Stage Fright*, c. 1949. Pencil on paper, 10½ × 7½" (26.6 × 19 cm)
This storyboard exemplifies the economical value of drawing. Hand-drawn storyboards are a quick and effective way to organize the sequences of a film clearly by visualizing the framing of each shot.

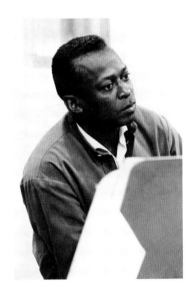

1.9 Miles Davis, 1962

1.10 (below) Miles Davis, *Josephine Baker*, n.d.
Miles Davis approached drawing with the same vigor as he did music. What started out as a hobby quickly turned into a serious endeavor. As in his jazz music, he worked diligently to create such fluid and bold compositions as this study of the celebrated entertainer and activist Josephine Baker.

The Creative Process: Ideation and Practical Development

Creative people produce ideas that solve problems. Creativity, however, is not merely the capacity to have lots of ideas. Rather, creativity depends on the ability and willingness to transform ideas into reality.

Creative activities rely on a foundation of know-how and flourish through focused practice. Learning to be more creative is comparable to learning a sport: we excel when we combine an understanding of fundamentals with extensive exercise and practice. Creativity requires a determined approach, but one that can also accommodate flexibility and openness to change, which makes room for new possibilities. (An open mind is characteristic of creative people, although this is also often combined with an intense level of commitment that enables them to bring their ideas to fruition.) In drawing, creativity might show itself through a uniqueness of subject matter, the employment of an imaginative concept, or the original application of materials.

Creativity can be applied to almost every endeavor. Whatever the field, the conditions for creativity are the same. Knowledge and practice support two key phases of the creative process: ideation and practical development.

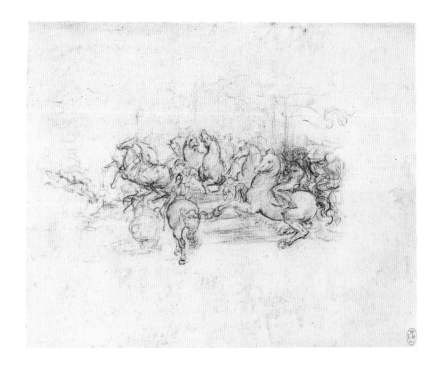

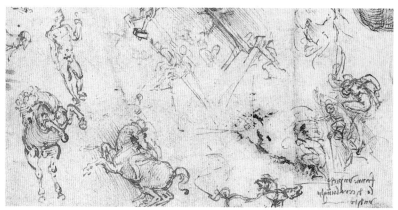

1.11 (top) Leonardo da Vinci, *A Body of Cavalry*, 1503–4. Black chalk, 6¼ × 7¾" (15.9 × 19.7 cm). Royal Library, Windsor, England

1.12 (above) Leonardo da Vinci, detail of *Sketches of Horses, the Angel of the Annunciation*, 1503–4. Black chalk, pen, and ink, 8¼ × 11⅛" (21 × 28.3 cm). Royal Library, Windsor, England

Ideation

Ideation is the development of ideas or concepts. This intuitive, open-ended phase of creativity is about generating something new, perhaps something that has not been done before. Within this phase there is a lot of room for thinking in terms of extremes, perhaps even exploring crazy, impractical notions. Some choose to approach ideation with a sense of playfulness. At this stage the creative person asks the question, "What if…?"

While drawing, ideation questions could be "*What if* I used an alternative medium?," "*What if* I used the same technique, but changed the subject matter?," "*What if* I applied the media with my hands instead of a brush?," "What is the best part of my drawing, and *what if* I could bring that quality to the rest?" Almost always, innovative ideas result from asking questions.

The same energy that produces good ideas will sometimes result in bad ideas. While the tendency for most people is to avoid "failure," bad ideas are a natural and essential part of the creative process. You should cherish your mistakes, because even bad ideas have potential. Failures can be seen as by-products of creative exploration that point the way to better ideas. If nothing else, trial and error and the process of elimination will indicate what does not work and bring you that much closer to an excellent result. Indeed, during the process of

TIP

Thoughtfully studying great drawings will enhance your own works.

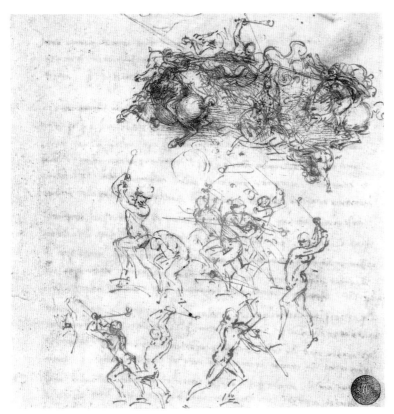

1.13 Leonardo da Vinci, *Study of Horsemen in Combat and Foot Soldiers*, 1503. Pen and ink, 6½ × 6" (16.4 × 15.2 cm). Gallerie dell'Accademia, Venice, Italy

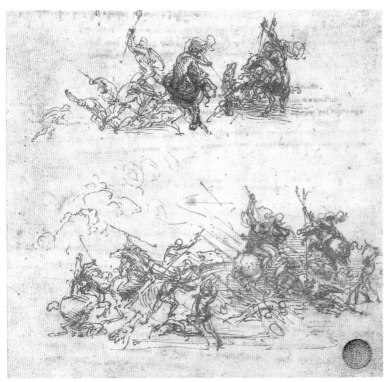

1.14 Leonardo da Vinci, *Study of Horsemen in Combat and Foot Soldiers* (2), 1503. Pen and ink, 5¾ × 6⅛" (14.7 × 15.4 cm). Gallerie dell'Accademia, Venice, Italy
This group of drawings from Leonardo da Vinci's sketchbook shows how the master thought, rethought, revised, and revisited themes of interest, such as (in this case) a battle scene. Considering that one of his goals was to express the passions of war, which of these drawings is most compelling to you? Why?

ideation, you should hope to uncover as many failed ideas as you can, as fast as you can, in order to discover the idea that will really work!

For Leonardo da Vinci (1452–1519)—arguably one of the greatest creative geniuses of all time—drawing was fundamental to his creative journey and closely linked to his thinking process. By examining his notebooks, we can see how he conducted thought experiments to generate new ideas through drawing, often cultivating his thoughts over long periods of time (**1.11** and **1.12**).

Around 1503, Leonardo was commissioned to paint a mural of the Battle of Anghiari for the Great Council Hall of the Palazzo della Signoria in Florence. Only a portion of his mural was ever completed. Nevertheless, some of his preliminary studies for this project still exist, and illustrate the ingenuity of his working methods.

In these drawings, we can see Leonardo grappling with various arrangements of horses and soldiers (**1.13** and **1.14**). It is a familiar motif in his work: a similar grouping can be found in the background of his earlier work, *Adoration of the Magi* (a preliminary drawing for which can be seen in **11.21**, p. 230). In *The Battle of Anghiari* sketches, he sought to communicate the violence and passions of war through gestural drawings of men and their horses.

We can observe how Leonardo tried and retried different compositions. He initially conceived an expansive composition consisting of separate skirmishes surrounding a central battle, and the pages reveal his ideas for the figure groupings (he inserts a written note on one page to remind himself to make a wax model to help visualize the work). In some drawings, he depicts rearing and racing horses, while on other pages, armed men fight in hand-to-hand combat. Curiously, he experiments with an idea of men pole-vaulting over a river, presumably the Tiber River, which was the strategic location of the battle. Many of his thoughts were ultimately abandoned, however, in favor of a focus on an isolated central grouping of four horsemen battling for possession of a war flag.

In his notebooks, Leonardo wrote about ways to stimulate the imagination and expand upon compositional ideas. He recommended studying stained or cracked walls, while allowing one's

mind to find likenesses freely. The variety of scenes found in Leonardo's drawings seems to validate this exercise, and exemplify his remarkably fertile imagination and flexibility of mind.

Practical Development

Practical development is the application of new ideas toward a usable solution. It includes the evaluation of ideas as well as the decisions made to carry them out. This phase of creativity is logical and relies on realistic approaches to arrive at connections between questions, ideas, and solutions.

For those of us who draw, practical development may have to do with deciding on a subject matter, the utilization of a technique, or even determining the best way to set up a workspace. A fundamental behavior during this phase of the creative process is experimentation. Exploring new solutions by finessing various possibilities associated with a chosen idea often leads to truly creative drawings.

The work of the American artist April Coppini (b. 1972) appears to be the result of a continuous search for a "right" answer (**1.16**). Her charcoal drawings are built from multiple layers of changes and erasures, trials and errors. All of these experiments, made in the framework of a single drawing, eventually lead to a collection of marks that capture something intrinsic about the form of her subject. Every decision she makes is a step in the development of the drawing. Her openness to experiment on the page leads her on a creative journey that ends in a beautiful drawn solution.

1.15 Student work. Alexandra N. Ibarra, *Skeleton.* (Instructor: Alfonso Cantu)
This student drawing demonstrates a willingness to use drawing as an exploration of the subject matter. The build-up of lines, some erased and others just worked over, exhibits a readiness to revise work as it progresses. While producing this drawing the artist made hundreds of mark-making decisions, evaluating each as assessments were made as to what to do next.

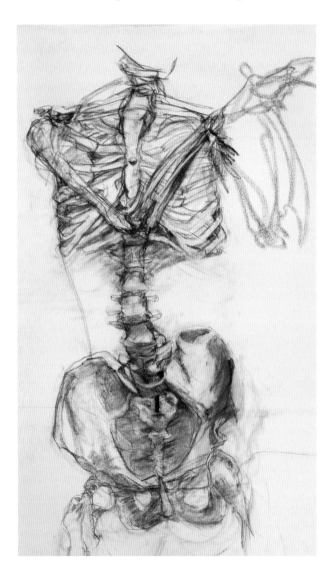

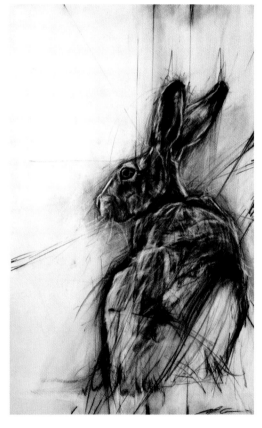

1.16 (above) April Coppini, *European Brown Hare, Watching Out*, 2014. Charcoal on BFK Rives paper, 29 × 21" (73.7 × 53.3cm). Private collection
Here, the implementation of a creative process is made evident. Every mark appears to have been attempted multiple times. Coppini tests ideas, then decides whether they should remain or be erased. The end result is not only a picture of a hare, but also a thought-provoking collection of personal solutions.

Drawing at Work Yves Saint Laurent

1.17 Yves Saint Laurent drawing, 1976
Yves Saint Laurent made drawings as a way to develop his fashion designs. He would typically redraw garments many times, changing each version in order to refine his ideas.

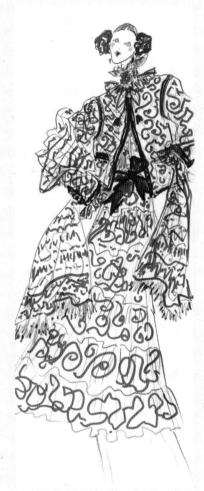

1.18 (above) Yves Saint Laurent, original sketch of a Spanish-inspired formal ensemble, *Spring–Summer 1977 Haute Couture Collection*

Designers of all types often begin the creative process by drawing. Renowned fashion designer Yves Saint Laurent (1936–2008) was no exception (**1.17**). Born in Algeria, Saint Laurent was head designer of Christian Dior at the remarkably young age of twenty-one. He was concerned with designing clothing that reflected the changing times in which he lived. He dressed women in pants, tuxedo suits, and prints and rich fabrics, and is often credited with changing the way women dress to complement modern culture.

Drawing was always a starting point for Yves Saint Laurent's fashion designs. At the drawing stage of his design process, he ignored the limitations that fabric or construction technique might impose, and worked freely. His focus was on invention.

In order to conceive a three-dimensional garment by way of a two-dimensional drawing, Saint Laurent rooted his work in gesture in an attempt to envision how the figure would move in the garment. All decisions, such as color or fabric, were based on the movements of the body; it was of utmost importance that a woman could move gracefully with ease. Yves Saint Laurent's decorative sketch of a Spanish-inspired formal ensemble shows a design for a muslin blouse, quilted jacket, and skirt (**1.18**). This drawing suggests the natural movement of the garments as they follow the "S"-shaped curve of the model. In an energetic and gestural specification sheet with a sketch for a formal dress, Saint Laurent puts onto paper his ideas for a black wool design where accessories play an important part (**1.19**). Written notes and a fabric swatch conclude the statement of his initial inspiration.

Saint Laurent often made hundreds of drawings before editing them down to the ones that would be further developed. As his designs went on into production, it was important to Saint Laurent to try to retain the initial inspiration recorded in the original sketch. During his lifetime, Yves Saint Laurent utilized thousands of sketches for the creation of his elegant and beautiful fashion designs.

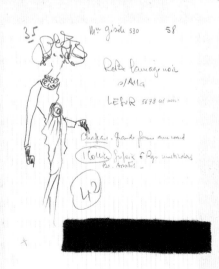

1.19 Yves Saint Laurent, specification sheet from the "Bible" of the collection, for a formal dress, *Fall–Winter 1962 Haute Couture Collection*

Gateway to Drawing Burne-Jones, *The Tomb of Tristram and Isoude*

The Creative Process

Edward Burne-Jones (1833–1898) was an active member of the Aesthetic Movement, an art movement in Britain and throughout Europe during the nineteenth century that advocated "art for art's sake." The Aesthetic Movement sought to displace the repetitive designs of industrialized mass production with designs reflecting the traditional skills of the craftsperson. It exalted artisanship, emphasizing the sensuous pursuit of beauty. The decorative arts company Morris, Marshall, Faulkner & Co., helped champion this movement, and Burne-Jones was one of their designers.

Burne-Jones had an extraordinary talent for design in a variety of media. Whatever the intended final object—ceramic tiles, jewelry, woodcuts, or his most celebrated stained-glass windows—he always made careful preparatory drawings during the planning stages. Burne-Jones's design for *The Tomb of Tristram and Isoude* exemplifies how he employed drawing in the development of his stained-glass window designs (**1.20**).

Burne-Jones's drawings had to be sensitive to the techniques used by craftspeople. Traditionally, stained-glass windows were composed of colored glass pieces cut to desired shapes (**1.21**). To create a scene, the glass was painted with staining agents and then fired in a kiln to fix the color permanently. In a mosaic-like fashion the individual pieces were held together with lead tracks, called **calmes**, and then installed as a window. This entire process was guided by drawings, one of which is seen here. Burne-Jones's drawings, beautiful in themselves, were the basis of many of the finest stained-glass works made during the period, such as his *The Tomb of Tristram and Isoude* (**1.22**).

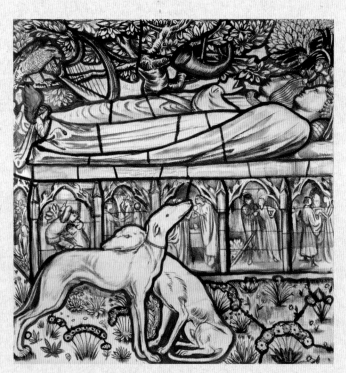

1.20 Edward Burne-Jones, design for *The Tomb of Tristram and Isoude*, 1862. Black ink and brown wash over pencil, 25¼ × 25¼" (64.1 × 64.1 cm). Birmingham Museum and Art Gallery, England

1.21 Outline of shapes used for Burne-Jones's *The Tomb of Tristram and Isoude*

1.22 (below) Edward Burne-Jones, *The Tomb of Tristram and Isoude*, c. 1862. Stained glass, 26¾ × 23⅞" (68 × 60.5 cm). Bradford Museums & Galleries, England

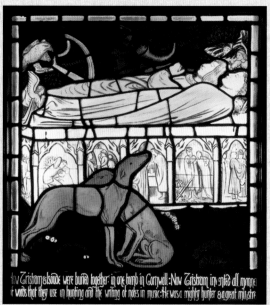

Calmes In a stained-glass window, the lead tracks that hold together individual pieces of glass in a mosaic-like fashion.

For the other *The Tomb of Tristram and Isoude* boxes, see p. 176 and p. 299

In the Studio Projects

Fundamental Project

Look online, in books, or through this text to find a drawing that you appreciate. Answer the following questions: Why did you choose the drawing? From the appearance of the drawing can you tell why the artist might have made it? What do you suspect was most important to the artist? Share your answers with others.

Criteria:

1. Give clear answers to each question listed above.
2. Provide accurate support for your answers.
3. Communicate effectively, including speaking in a clear, confident, and assertive voice.

Materials: Oral presentation

Writing Project

After reading Chapter 1, take some time to reflect on whether drawing is important to you. How does drawing concern you? Is drawing valuable to you in your personal and professional life? How do your views compare or contrast with those of others? Write an essay answering these questions.

Criteria:

1. You should follow a logical essay structure, including an introduction, body, and summary.
2. Describe clearly how drawing relates to your life.
3. Evaluate specific examples of attitudes and approaches to drawing, and explain how these examples resemble or differ from your outlook.

Materials: Typed essay

Research Project

Conduct visual research by studying the drawings and sketches of an artist, designer, or other person of interest. Collect your findings in a sketchbook or as a PowerPoint presentation.

Criteria:

1. Gather material from a variety of sources. Include examples of drawings, sketches, and finished works. For example, if you choose an architect, then you might collect sketchbook images, presentation drawings, and photographs of completed buildings.
2. Organize your research—neatly and coherently—in a sketchbook or PowerPoint presentation.
3. Note ways in which the drawings relate to or inspire the finished works. Describe as many of these connections as possible.

Materials: Sketchbook, photocopies and/or printouts, glue or tape. Or, create a PowerPoint presentation.

Chapter 2
Modes, Sources, and Expressions

There are many different types (**modes**) of drawings, and drawings are often made for diverse purposes. This chapter examines a variety of these modes, with examples from the past and the present, including process drawings and independent works. We will also discuss gesture drawings, which can be examples of both of these. It is interesting to compare and contrast the different modes of drawings, noticing the differences (and sometimes similarities) between those that appear to have been made as part of a creative process versus those that stand alone as autonomous works of art.

In this chapter we will also review the different kinds of sources that artists use to create drawings. These include working from direct observation and photographs, as well as from memory or the imagination. Master studies are also highlighted. The concepts of style and expression are introduced along with definitions of representational drawing, abstract drawing, and non-objective drawing.

Mode The type of drawing and the manner of its creation.

Considering the Modes of Drawing

Some drawings are made as part of a creative process. These are called **process drawings**, and are made in order to work out ideas, explore concepts, rearrange compositions, or visualize the development of a product. In short, process drawings are intended as means to an end.

Some drawings, on the other hand, are ends in themselves. These drawings—known as independent works—are intended as complete works of art, encapsulating all that the artist wanted to produce or express.

A third kind of drawing—gesture drawing—combines characteristics of both process drawings and independent drawings. Often quickly made, these drawings intend to express a sense of movement or energy.

The type of drawing and the manner of its creation is called the mode of the drawing. While one drawing mode is not inherently better than another, it is a useful distinction to keep in mind when embarking on your own drawing practice or appreciating the drawings of others.

While it is important to recognize the original intent of a drawing, the time and culture in which a work is made also affect its significance in unintended ways. In the same manner, the premises of our time and culture affect our appreciation of a drawing's meaning. For example, drawings made during the Renaissance often dealt with religious or mythological imagery because those themes were very important during that time. Drawings from the period often seem to be a manner of making those narratives visible. In the twenty-first century, however, these themes are not as strongly foregrounded by the culture and so are less often the subject of artists' work. Drawing allows for a more far-ranging scope of themes and personal expression.

By comparing and contrasting drawings of all modes from diverse times and cultures, you will enlarge your range of understanding and self-expression.

Process Drawings

Process drawings are indispensable parts of the working methods of many artists and designers. These drawings are made to explore ideas. They are also used toward the planning of larger and more complex projects.

A beautiful example of a process drawing can be seen in the work of American illustrator and muralist Violet Oakley (1874–1961). This preparatory chalk drawing for a mural, although loose and quickly drawn without details, contains and develops important features of the theme and composition (**2.1**).

While process drawings are not usually considered finished works, they are often shared with patrons or colleagues in order to communicate ideas to gain feedback.

A drawing by the French painter Charles de La Fosse (1636–1716) was most likely used by the artist as a proposal to a client seeking a decorative ceiling (**2.2**, p. 32). Even in its unfinished state, it clearly represents Fosse's plans.

Russian-born theatrical designer Sophie Fedorovitch (1893–1953) utilized drawings as part of her creative design process and as

TIP

Before making a drawing, always acknowledge your intent. Are you making the drawing as part of a process or is it an independent work of art?

Process drawings
Drawings made for the development of a finished work of art or product.

2.1 Violet Oakley, study for *Unity*, Panel 9, Pennsylvania Senate Chamber Mural, c. 1916. Red chalk, 4¾ × 19⅝" (12.1 × 49.8 cm). The State Museum of Pennsylvania, Harrisburg, PA
Muralist Violet Oakley conducted extensive research when beginning a project. Such drawings as this were part of her visual research. This process drawing exhibits the themes and the Renaissance style for which she was known.

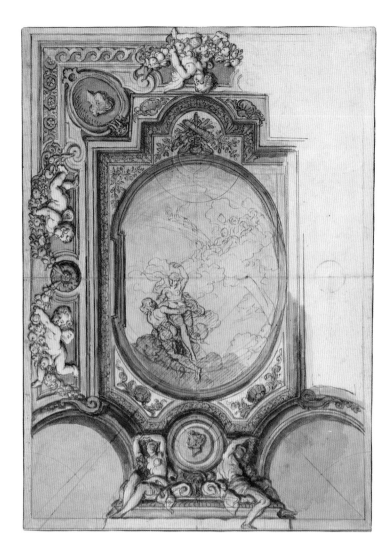

2.2 Charles de La Fosse, *Studies for a Ceiling Decoration* (recto), 1680. Pen, red chalk, watercolor, and gouache, 14¼ × 10¼" (36.2 × 26 cm). J. Paul Getty Museum, Los Angeles, CA
Such a drawing as this is an essential part of a design proposal or presentation to a client. Such drawings communicate and make design concepts clear. Although this drawing was made in the seventeenth century, presentation drawings are still commonly used today.

a way to propose new works. This pencil-and-watercolor work was made as a set design for the ballet *Symphonic Variations,* created for the Sadler's Wells Ballet at the Royal Opera House, London, in 1946 (**2.3**). In an abstract and minimal way, the colors and stripes are meant to suggest an open, airy landscape.

Process drawings usually fall into one of four categories: sketches, studies, thumbnail studies, and design drawings.

Sketches

A **sketch** is typically an informal, quick drawing that is sometimes, but not always, intended to serve as fodder for future works. While a sketch may lack detail or an overall resolution, a good sketch is a "thinking" drawing made with careful consideration toward its purpose. It suggests the artist's primary thought.

Sketches may be descriptive, capturing the essential quality that an artist wishes to record. They may be exploratory, probing visual scenarios. They may be variously anecdotal, documentary, or analytical. Generally, sketches are notations that seek to grasp the meaning of a concept, or enable the artist to come to know something, rather than to state a conclusion. They often create strong fundamental statements by including only the most essential parts of a subject, encapsulating the artist's approach to editing and simplifying.

The French painter and printmaker Jean-Baptiste-Camille Corot (1796–1875) used sketching as a means to nourish his visual memory. On this page of a pocket sketchbook he devised a shorthand formula of descending squares and circles to indicate colors and **values**

2.3 Sophie Fedorovitch, *Symphonic Variations*, 1946. Pencil and watercolor on card, 13¾ × 20" (34.9 × 50.8 cm). Victoria and Albert Museum, London, England
This set-design drawing represents a collaboration between a choreographer and a set designer. Like the pared-down one-act ballet for which the drawing was made, it evokes a flowing landscape with minimal lines and colors. Such presentation drawings as this are important milestones in the design process.

When Making a Sketch

1. Choose something that you would like to draw.
2. Decide what quality of your subject you would like to capture in your sketch. (For example, you might like the graceful curve of a tree, or maybe the deep space of a hallway.)
3. If you are using a pencil, hold it toward the end rather than gripping it as you would write. (This will help you to draw quickly and loosely, two good qualities in a sketch.)
4. Focus on describing the quality of your subject that inspired you to make the sketch.

2.4 Example of a sketch
The overriding goal for the sketcher should be to make a drawing that focuses on its purpose; other details are unnecessary. Here the artist works quickly to capture the essence of the sweeping curves of the spray bottle.

Sketch A quickly made drawing that suggests the artist's thought.
Value The relative lightness or darkness of an area or object.

that he observed in the landscape (**2.5**). Records of such observations contributed greatly to his studio work.

Today, artists and designers continue to value sketching for its immediacy. Because of its informal nature, sketching provides the artist with a sense of freedom. Sketching enables you to be at ease and spontaneous in your work. Modern and contemporary artists have furthered their critical awareness of the sketch to include—among many other concepts—appreciation of the sketch as a tool for self-expression, for its ability to convey the subconscious, and as an art form that, because of its tendency to disclose the layers of the drawing process, seems to suggest time.

2.5 Jean-Baptiste-Camille Corot, page from a pocket sketchbook, n.d. Graphite, 2³⁄₄ × 4" (7 × 10.3 cm). Musée du Louvre, Paris, France
Although such sketches as this may not seem impressive at first glance, they were extremely important to Corot. They were his way of quickly gathering information to use later. Notice the squares and circles throughout the sketch that Corot sometimes used as a key for noting values and colors (for more on which see Chapter 9, p. 182, and Chapter 13, p. 256).

The Work of Art Beatrix Potter

Who: Beatrix Potter
Where: England
When: Date unknown
Materials: Pencil, black ink, and wash

Beatrix Potter's *The Tale of Peter Rabbit* begins:

> Once upon a time there were four little Rabbits, and their names were —Flopsey, Mopsy, Cotton-tail, and Peter. They lived with their Mother in a sand-bank, underneath the root of a very big fir-tree. "Now, my dear," said old Mrs. Rabbit one morning, "you may go into the fields or down the lane, but don't go into Mr. McGregor's garden."

Artistic Aims

As we know, despite his mother's rules, Peter couldn't resist sneaking into Mr. McGregor's garden. Maybe Peter is not far from the illustrator and author's own personality. Beatrix Potter (1866–1943) was born into a wealthy family during Victorian times. As was customary in privileged households, children were raised and educated at home by a governess who was expected to instill manners and values. Commonly during this era, women were to keep their opinions to themselves, and children were to be "seen and not heard."

Potter, however, was uncommon: she had rare courage and the resourcefulness to follow her passions for nature, drawing, writing, and eventually, for publishing. Luckily, her father supported her interests, taking her to nearby museums of art and natural history.

Beatrix Potter wanted her drawings "to make reality and wonder akin."

To mix realism and fantasy, she personified the animals in her works by outfitting them with such things as coats and eyeglasses.

Artistic Challenges

The young artist's earliest friendships were with a wide host of unusual pets, such as lizards, guinea pigs, bats, and rabbits. The third floor of the Potter house was dedicated to a collection of natural specimens and a menagerie of live animals, including Beatrix's favorite pet rabbits. Getting her pets to sit still for a long study was almost an impossible task, so she had to sketch quickly and complement her live studies with those taken from her specimen collection. This collection grew quite large over time, for she was not given to squeamish sentimentality (an undesirable trait in Victorian England). When one of her pets became ill she quickly and humanely put it to death. Then, after she had boiled the carcass, extracted the skeleton, and stuffed the skin, she added the animal to her growing specimen collection.

Artistic Method

Potter spent hours on the third floor, educating herself as she filled sketchbooks with drawings of the animals and plants, both large and small, that so fascinated her. In fact, she often sketched with one eye to a microscope! The numerous sketchbooks she left behind evince

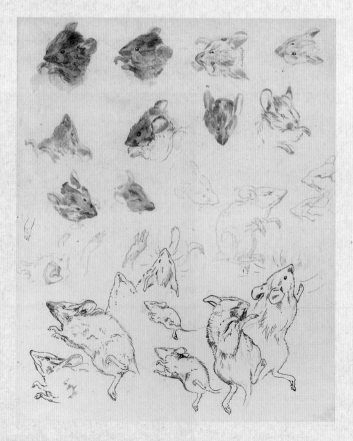

2.6 Beatrix Potter, *Study of Field Mice*, n.d. Pencil, black ink, and wash, 7¾ × 6¼" (19.7 × 15.9 cm). Private collection
Looking at this page of studies, we can sense the artist's dedicated exploration of her subject. She draws the full body of the mouse and its individual parts with attention to value and focus on line (for more on which see Chapter 9, p. 182, and Chapter 7, p. 150). Making such studies as these inevitably leads to greater understanding, whatever our subject.

her love for drawing and her appreciation for the details of the natural world.

Potter was a master at making studies from direct observation. This page is a thoughtful investigation of a mouse. Through repetition, she analyzes her subject and we can see an evolution in her studies, from details of heads and feet to depictions of the entire subject from different angles. Some of the drawings on this page are line drawings and others are fully rendered; over and over again she explores with pencil, inked lines, and wash.

The Results

From Potter's sketchbook pages emerged her illustrated stories. One such story, originally written in a letter to the children of a former governess, became the book *The Tale of Peter Rabbit*. Initially turned down by several publishers, in 1902 the firm of Frederick Warne & Co. agreed to publish a color version. Potter took part in all of the publishing negotiations and decision-making.

Eventually, Potter wrote and illustrated twenty-four children's tales. Her story of a courageous and rebellious rabbit named Peter remains one of the most beloved children's books of all time.

Sketchbook Prompt

Following Beatrix Potter, choose a natural object and draw it multiple times in your sketchbook.

Study A drawn investigation made of a subject, often in preparation for future works. Usually more detailed than a sketch.

Studies

Drawing **studies** are investigations or practice runs made in preparation for future works. Studies can be made quickly as a sketch, or they can be labored explorations. This sheet of mouse studies by Beatrix Potter is an example of exploration, where she not only investigates a mouse from different angles, but also experiments with different media (**2.6**). The English illustrator and author frequently drew nature and wildlife studies as source work for her well-known illustrated children's books, including *The Tale of Peter Rabbit*.

When Drawing a Study

1. Imagine a finished work of art or design that you would like to make. What details would you have to understand in order to produce this work successfully?
2. Carefully examine these details through a series of drawings.
3. Continue exploring alternatives through sketching until you are satisfied with the results.

2.7 How to make a study This collection of studies exhibits the fundamental approach that all good studies should share: exploration. The artist isolates parts of the spray bottle in order to examine them, and different views are investigated.

Eliza Ivanova (b. 1988), originally from Bulgaria and now an animator for Pixar Animation Studios, uses drawn studies to understand her subjects better and to work through and realize ideas. In this collection of drawings we can see her bold investigations of hand poses (**2.8**).

The sixteenth-century Italian artist Paolo Veronese (1528–1588) created several studies for a performance of Sophocles' classic tragedy *Oedipus Tyrannus*. These quickly drawn ink studies show the artist's focus on the costume design (**2.9**). From these drawings stage costumes were eventually created.

2.8 (left) Eliza Ivanova, *Studies of a Hand Holding an Apple*, 2014. Pencil and markers, 12 × 8½" (30.5 × 21.6 cm). Collection of the artist
These drawings demonstrate an animator's desire to understand better the postures of the hand. While her drawing technique is quick and loose, it does not diminish the detail that she captures. Drawing your own hand is an excellent exercise to practice making studies.

2.9 Paolo Veronese, *Costume Studies for Sophocles' "Oedipus Tyrannus,"* 1585. Pen and brown ink, with brown wash, 8³⁄₈ × 12" (21.3 × 30.5 cm). J. Paul Getty Museum, Los Angeles, CA
These studies were made to explore theatrical costume design. Through the repetition of similar garments, Veronese is able to modify his ideas. The clarity of his line work makes the drape and structure of the garments convincing. Shadows added to the figure at the upper right suggest illumination, as if the figure were onstage.

Thumbnail studies Small
preliminary drawings
with a primary focus on
composition.
Figurative Art that is
recognizably derived from
the visible world, especially
human or animal forms.

Thumbnail Studies

Another type of preliminary drawing is the
thumbnail study. Called "thumbnails" because
of their often very small size, they are made
with a primary focus on composition, or the
arrangement of objects within a picture. Artists
often make multiple thumbnail studies as a way
to try out a variety of configurations before
embarking on the final project. Vertical format,
horizontal format, close-up, or distant view are
just four of the possibilities for alternate ways to
frame a scene using a thumbnail.

Some artists use thumbnails to experiment
with different picture proportions, while others
may already have a specific size and shape
of finished piece in mind. If you are making
thumbnails in preparation for an 18 × 24"
drawing, make the studies proportionate,
perhaps 1½ × 2". As a first step, thumbnail
studies help to direct you toward success from
the beginning of the project.

There are many different ways to approach
making thumbnail studies, as evidenced in
these two examples by Umberto Boccioni
(1882–1916) and Narcisse-Virgile Diaz de
la Peña (1808–1876) (**2.10** and **2.11**). These
artists used thumbnails in the early stages
of making complex **figurative** paintings.
From these studies we can readily deduce
that their motivation was to try out different
arrangements and formats for future paintings.

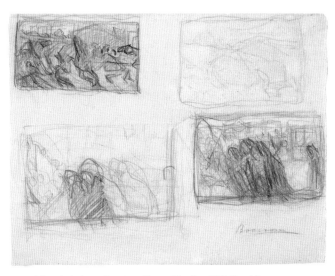

2.10 (above) Umberto Boccioni, *Sheet of Studies*, 1910. Graphite on paper,
5½ × 7⅛" (14 × 18.1 cm). Metropolitan Museum of Art, New York

2.12 Student work. Isabella Gardner, sketchbook page.
(Instructor: Deborah Mosch)

Collected in this student's sketchbook are inspirational images printed
from the Internet. These images motivated the thumbnail studies on the
same page. Each thumbnail represents a different abstract idea. Notice
that the focus of these small drawings is on compositional arrangement.
Different formats are explored in order to develop exciting compositions.

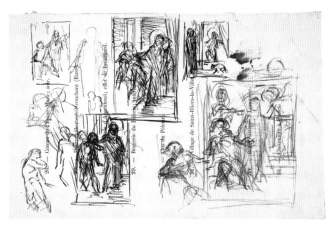

2.11 Narcisse-Virgile Diaz de la Peña, *Studies for a Figure Composition*,
n.d. Black chalk and pen and brown ink on wove paper, 5⅜ × 8⅜"
(13.5 × 21.1cm). Metropolitan Museum of Art, New York

These thumbnail studies were made by two different figurative artists. **2.10**,
by Boccioni, shows four compositions of figures within a space. It may be
hard for us to recognize the subject matter, but for the artist these drawings
are important tests in search of a composition with dynamic movement. **2.11**,
made by Diaz on a piece of scrap paper, shows different arrangements of figures,
as he tries zooming in, panning out, and various alternative positions.

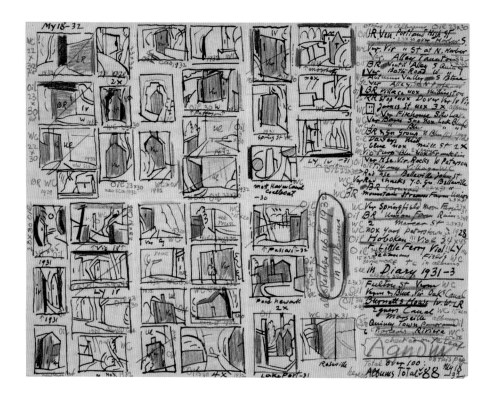

2.13 Oscar Bluemner, illustrated list of works of art, 1932. Mixed media, 8⅝ × 11" (22 × 28 cm). Archives of American Art, Smithsonian Institution, Washington, D.C. Without much space for detail, the thumbnail studies crowded on these pages become simplified versions of the larger paintings. This simplification—a type of abstraction—is typical of thumbnail studies. On the right, the artist has included written notations to accompany the drawings.

Thumbnail studies can also be utilized for other reasons. The German-born American Modernist painter and color theorist Oscar Bluemner (1867–1938) used compositional thumbnail studies in a very different role. They were, for him, a way to make a visual inventory of his completed paintings (**2.13**).

When Making a Thumbnail Study

1. Begin by drawing a small rectangle on your page. Artists frequently use pencil and sketchbook for this purpose.
2. Draw objects and the background as simple shapes. (Remember that the primary goal is to consider the arrangement of objects within the rectangle. Avoid drawing details.)
3. Repeat this process many times in order to experiment and test a variety of arrangements.

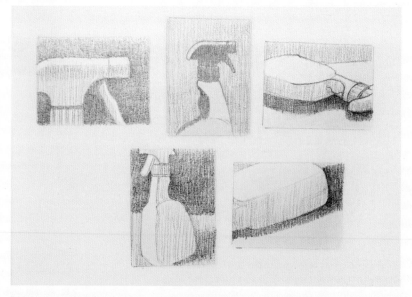

2.14 How to make a thumbnail
These thumbnail studies focus on composition. While the size stays the same, the artist tries different placements of the subject and considers vertical and horizontal configurations. The artist attempts zooming in and panning out. From such thumbnails an artist can choose to use the one he or she likes best for a finished drawing.

Drawing at Work Edward Hopper

Often artists use a variety of process drawings to explore ideas and alternatives before beginning a final work. They might include sketches, studies, thumbnails, or design drawings.

Although never meant for public viewing, Edward Hopper's (1882–1967) process drawings—a selection of them featured here—give insight to the development of one of his most famous paintings, *Nighthawks*.

Edward Hopper was an American realist. After going to art school he worked as an illustrator and then moved to fine art painting. His works depict common places in American life. Empty rooms and lonely cityscapes are typical subjects—drab and routine scenes painted in a poetic and disquieting way.

In *Nighthawks*, Hopper depicts a waiter and four figures who sit alone in a New York City café. Somber in thought, it is hard to know the relationship between the characters. This painting was created in 1942, during the Second World War, just at the time of the bombing of Pearl Harbor. The prevailing feelings among Americans at the time were of distress and disbelief. In its own quiet way, *Nighthawks* reflects these sentiments.

Hopper's preliminary drawings give us insight to the planning of *Nighthawks*. We witness his examinations of details. Some of these drawings were redrawn several times, indicative of the artist's aim to perfect his craft. These rough drafts are evidence of personal development and the search for understanding.

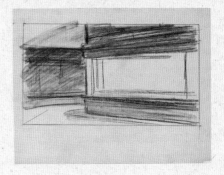

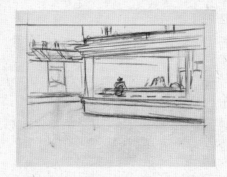

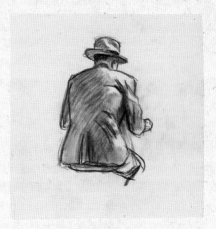

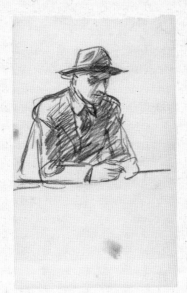

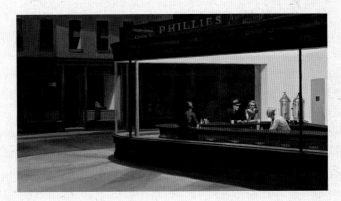

2.15–2.21
Edward Hopper, *Nighthawks*: (above) six studies, 1942. Whitney Museum of American Art, New York; (left) finished painting, 1942. Oil on canvas, 33⅛ × 60" (84.1 × 152.4 cm). Art Institute of Chicago, IL

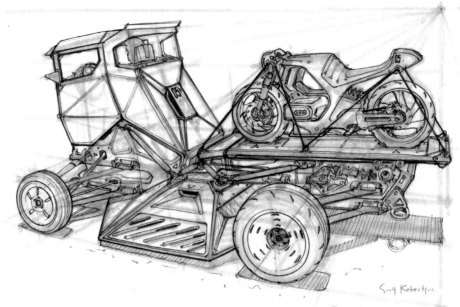

2.22 Scott Robertson, "Sci-Fi Bike Hauler," 2017, originally drawn for *Scott Robertson Design, Sketch Collection, Vol. 02.* Copic marker and ballpoint pen, 4 × 6½" (10.2 × 16.5 cm)
Notice how these vehicles were constructed on a transparent framework. This framework enhances the three-dimensionality of the drawing. When developing designs for objects, large or small, the consideration of all sides of a form is essential. This drawing is of an imagined subject, but the same "drawing through" technique can be used when developing designs for real transportation vehicles.

Design Drawings

Architects, engineers, product and industrial designers, jewelry designers, and furniture designers—to name only a few—all use drawing in the pursuit of creating functional objects. To do this effectively, designers develop drawing methods that enable them to think fluently and quickly, providing them with a visual language in which they can represent three-dimensional objects. Drawing also allows designers to explore and develop their ideas, work out solutions to problems, and communicate these ideas to others.

Scott Robertson (b. 1966) is a contemporary American concept artist who is an expert in transportation design work. His **design drawings** represent objects with clarity of form and space. This clarity is enhanced as he "**draws through**" his subjects, a technique often utilized in drawings for design. In this technique objects are drawn as if they are transparent (**2.22**).

The industrial designer and architect Greta Magnusson Grossman (1906–1999) uses a simplified drawing in order to represent accurately the complex engineering of a lamp design. As with all drawings made for design, clarity of concept is of utmost importance. This type of minimalist design made Grossman an influential figure in the Southern California design movement of the 1950s and 1960s (**2.24**).

Design drawings
Drawings made by designers to explore and develop ideas and products.
Drawing through
A technique in which objects are drawn as if they are transparent.

When Making a Drawing for Design

1. Envision a new product or an adaptation of an already existing item. Think about how that object would look in-the-round, or from all sides.
2. Consider your object as a simple geometric form. First draw that form as a guide. This will act as an underlying structure for your drawing. For example, if you are designing a table, you may wish to draw a simple cube as your guide.
3. Superimpose your object onto your form. You may wish to use a different color for clarity. Make the drawing of your object as if you could see through the item, drawing the front side as well as the back portion of your item in the single drawing. Study **2.23** as an example.

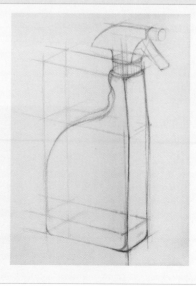

2.23 Example of a design drawing
To create this drawing, the designer first conceived of the spray bottle as a simple three-dimensional form. After drawing the cubic form, he worked in the manner of a sculptor, adding and subtracting the parts of the spray bottle. The advantage to working in this way is that the designer remains mindful of all sides of the object.

2.24 Greta Magnusson Grossman, *Design for a Table Lamp, made for Ralph O. Smith, Burbank, c.* 1947. Graphite on paper, 8½ × 12½" (21 × 31.1 cm). R & Company Library & Archives, New York
This presentation drawing benefits from its simple and restrained approach. Most important in a presentation is that the audience has a clear understanding of the design: design concepts must be communicated. In such situations, excessive shading and mark-making can be distractions.

Independent Works

In the early Renaissance, ***disegno*** was considered to be only a means to an end. Sculptors, painters, printmakers, and designers utilized drawing as a step in a process of developing something further. Over time, however, drawings became valued as independent art objects. Artists increasingly began to make drawings not only as research for other works, but also for their own sake. Today, many artists choose drawing as their chief or sole means of expression, and find the act of drawing to be a pleasurable activity in its own right. Collectors, galleries, and museums also appreciate finished drawing as its own art form.

Antonio López García (b. 1936) created the drawing of his uncle's home in **2.25** as a stand-alone work of art. It has a sense of completeness within itself. It is not merely a part of something else; it is the entire work of art. This is a quality that finished drawings exhibit.

Lenore Tawney (1907–2007) was an innovative fiber artist whose drawings became, as independent works of art, an important part of her artistic output. Her ink drawings on graph paper, conceived from her knowledge of the Jacquard loom (a textile manufacturing device), are singular works of art that possess a mesmerizing, pensive quality (**2.26**).

2.25 Antonio López García, *Home of Antonio López Torrez*, 1972–1980. Pencil on paper, 32¼ × 26¾" (82 × 68 cm). Fundación Sorigué, Lérida, Spain
This artwork is an example of drawing as an independent art form. It can be appreciated purely for its aesthetic values, and as such is capable of being judged as art, independently of any utilitarian concerns.

Disegno A Renaissance term that describes the process of having creative ideas and making them visible through drawing.

2.26 Lenore Tawney, *The Great Breath*, 1964. India ink on graph paper, 11 × 17" (27.9 × 43.2 cm). Whitney Museum of American Art, New York
As an independent abstract artwork, this drawing has value in and of itself. Derived from the artist's knowledge of textiles, the drawing finds a balance between real life and an imaginary image. Abstract drawings provide us an opportunity—perhaps even more than realistic works—to interpret things in our own way.

2.27 Susan Rothenberg, *Untitled*, 1987. Charcoal and pencil on paper, 22⅜ × 31" (56.8 × 78.7 cm). Private collection
Gesture drawing pays special attention to movement. This drawing captures and suggests movement in many ways: the repetition of the figure, the fast and directional marks, the aggressive erasing. Every part of the drawing appears to be changing and in motion.

Gesture Drawings: Both Process and Independent

Gesture drawings combine aspects of both process and finished drawings, and can be considered to be their own drawing mode.

Gesture drawings are often utilized as a type of "warm-up" for more sustained works, or can be made as part of a process, but a gesture drawing can also be made to stand alone as a finished piece. Gesture drawings suggest movement. They are an intuitive exploration in which the lines are drawn in response to the middle of the form, often intentionally avoiding edges. Gestures are driven by the spontaneous movement of the artist's eye as it scans the subject. They do not necessarily describe what something looks like, but instead capture rhythms, directions, changes, flows, and shifts. Thus, gesture drawings impart suggestions of life.

The capacity that a still and unchanging drawing has to imply a sense of motion is a remarkable quality of gesture drawings. In the drawing *Untitled* by Susan Rothenberg (b. 1945) we see the way the artist depicts an animated figure moving through space (**2.27**).

The gesture-drawing approach is not confined to living or moving subject matter. Alberto Giacometti's (1901–1966) drawing of an unmoving interior with a chandelier and a table resonates with a feeling of flux, change, and unrest (**2.28**). The lines Giacometti makes are always on the brink of disappearing. They are

2.28 Alberto Giacometti, *The Chandelier at Stampa*, n.d. Pencil drawing, 18 × 10¼" (45.5 × 26 cm). Private collection
To refer to a drawing as a "gesture drawing" speaks less about the subject matter and more about the impression of movement, especially the movement of the eye and mind. This gesture drawing is of a still room. It was drawn with layers of fast marks, and the speed at which it was drawn triggers the viewer's eye to move with equal speed throughout the composition.

2.29 (above) Eugène Delacroix, *Crouching Lion, a Hare between His Paws*, 1851. Red chalk, 7¾ × 10¼" (19.8 × 30.7 cm). Kunsthalle, Bremen, Germany
The quality of the lines that make up this drawing suggests movement. Some are bolder than others, but every line is rapid, sweeping, and curving; there are no straight, vertical, or timid lines in this work. The types of marks used to describe this lion are the sorts that imply gesture.

not confining lines, but instead are strokes that impart their own movement to the objects.

An effective gesture drawing is not dependent on the amount of time that is spent in its creation. A quickly drawn work, such as *Crouching Lion, a Hare between His Paws* by Eugène Delacroix (1798–1863), conveys energy, intensity, and life (**2.29**). These qualities can also be seen in *Head of Catherine Lampert VI* by Frank Auerbach (b. 1931), which demonstrates a continuous and unrelenting search to describe the subject (**2.30**).

Many of the marks that suggest movement in a gesture drawing are made quickly, with boldness and an emphasis of direction. The work of Nordic artist Olav Christopher Jenssen (b. 1954) employs these types of marks (**2.31**). This drawing demonstrates how, even without representing an object, mark-making by

2.30 Frank Auerbach, *Head of Catherine Lampert VI*, 1979–80. Charcoal and chalk on paper, 30⅜ × 23" (77.2 × 58.4 cm). MoMA, New York
Auerbach's drawings are accumulations of marks. Because of his dissatisfaction with what he has drawn, he reworks his images over and over again, continuing this process until he arrives at a point at which he thinks order has been achieved. His completed drawings have an undeniably gestural quality.

2.31 Olav Christopher Jenssen, *Untitled*, 1996–2002. Charcoal on paper, 9¾ × 7⅛" (24.8 × 18.1 cm). MoMA, New York
This non-objective drawing (i.e. one that is not meant to represent items in the physical world), relies on the language of mark-making to suggest gesture. Alone, the individual hatch marks suggest direction. Together, the marks form a moving progressive rhythm.

2.32 Şule Yiğit, *Figure Drawing*, 2007. Charcoal on paper, 12 × 9" (30.4 × 22.9 cm). Collection of the artist
Many of the lines in this drawing could not have been seen when studying the model. For example, the diagonal line that extends from the model's right arm to her left knee seems to have been invented. The sweeping curves on the upper right portion of the drawing appear independent of the figure. While not directly describing the edges of the model, these lines suggest the powerful directional movements of the pose.

2.33 Nathan Oliveira, *Untitled Figure*, 2003. Watercolor on paper, 14½ × 10½" (36.8 × 31.8 cm). The Estate of Nathan Oliveira, Palo Alto, CA
Observe the movement of the wash as it was applied to this drawing. It changes angles as it travels down the page. The movement of the mass—the mass gesture—not only leads the viewer throughout the page, but it also indicates the unrest within the figure.

itself can suggest the illusion of motion. The drawing's fast-moving staccato marks work together to form larger crescent shapes. As these shapes lighten and become smaller, they suggest a progressive movement into space.

Some artists use line as the primary element in creating a gesture drawing, while others create bold volumes and forms in the pursuit of movement: "mass gesture." The Turkish artist Şule Yiğit (b. 1979) uses linear gesture to show broad directions, or movements, of the figure's pose. Her drawing does not concern itself with details, but instead is focused on capturing large observed shapes and the figure's recession into space (**2.32**). The fast, vigorous lines that Yiğit uses seem to imply energy and life.

In contrast, the American artist Nathan Oliveira's (1928–2010) *Untitled Figure* creates a mass gesture by utilizing a fluid wash to suggest a predominant direction and the mass of the standing figure (**2.33**). As seen in these

two examples, both linear gesture and mass gesture can create strong visual movement. It is the gesture of these drawings that produces an impression of life.

Sources for Drawings

Depending on their intent, artists are free to utilize numerous different references and sources. The origin of the information that inspires a drawing can range from the visual world, such as working from direct observation or from photographs, to invented imagery from the artist's imagination.

TIP

Captivating drawings are sometimes a result of working from multiple sources, perhaps combining images drawn from direct observation, photographs, memory, and imagination.

Direct Observation

Perhaps the most valuable activity that artists and designers can practice is to study the world around them. Drawing from direct observation—often referred to as **observational drawing**—helps increase visual awareness and sharpen perceptual skill. More than any other practice, observational drawing nurtures the understanding of essential artistic fundamentals, such as line, value, form, color, and space (see Part 3, "Drawing Elements," p. 148). For these reasons, since the Renaissance, art and design instructional programs have encouraged their students to draw from direct observation.

Observational drawing is not about capturing an image as a camera would, nor is it merely recording a subject. It is about establishing a conscious relationship between what is seen and what is drawn. An observational drawing will appear truthful and convincing because of the accurate correlations between what is observed and the marks that are made on the page.

To translate accurately what you see into a clear pictorial statement is not an easy undertaking. When you draw directly from the world around you, you are obliged to slow down and carefully observe. You must develop a strategy for expressing what you see, which often may involve complex objects or spaces. This takes a type of analysis and interpretation that can be developed only from practiced and persistent, focused looking.

The work of Michael Grimaldi (b. 1971) results from direct observation. His realistic interpretations show a keen understanding of naturalistic light, form, and space (**2.34**). A different approach toward observational drawing can be seen in the studies of the Australian artist Jenny Sages (b. 1933). Sages made this drawing of her ageing friend Emily Kngwarreye, an accomplished contemporary indigenous Australian artist (**2.35**).

Observational drawing
Also called drawing from direct observation. Drawings made by viewing the subject directly.

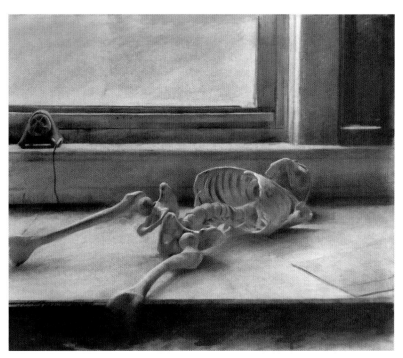

2.34 Michael Grimaldi, *Skeleton Drawing (Still Life with Half-Scale Skeleton on Windowsill)*, 2012. Graphite and gouache on paper, 14 × 17" (35.6 × 43.2 cm). Private collection
Grimaldi's study is an elegant result of drawing from direct observation. The subtleties of the natural light and shadows would have been hard to invent without having the subject before him. The diagonal objects that oppose the horizontal and vertical features were most likely arranged before beginning to draw.

2.35 Jenny Sages, study for *Emily Kame Kngwarreye with Lily*, 1993. Charcoal on paper, 12 × 9" (30.4 × 22.8 cm). National Portrait Gallery, Canberra, Australia
This drawing elicits character from the sitter as a result of direct observation. The drawing captures the natural form of ageing hands. There is a sense of a private and personal connection between artist and subject. Such shared connections are impossible unless the artist is together with a subject in reality.

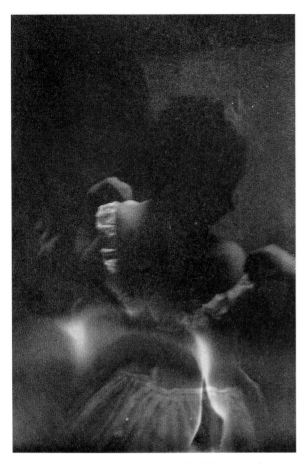

2.36 Edgar Degas, "Dancer Adjusting Her Shoulder Straps," photograph for *Blue Dancers*, 1895–96. Modern print from gelatin dry plate negative, 7⅛ × 5⅛" (18 × 13 cm). Bibliothèque Nationale de France, Paris

Photographs

Our word "photography" comes from the Greek words *photos* (meaning "light") and *graphein* (meaning "to draw"). Surprisingly, the optical principle of photography was employed long before the modern invention of film photography (now being replaced by digital photography). In the fifteenth century, artists found that they could use a *camera obscura* (a darkened room or box with a pinhole projecting light onto the opposite surface) to trace projected images onto paper or canvas. In the late nineteenth century, the introduction of photochemical technology made photography convenient and inexpensive. The film camera became a new and exciting tool for artists. The French painter and sculptor Edgar Degas (1834–1917) took his own photographs to use in his work (**2.36**). A comparison of this photograph with a drawing from his series of ballet dancers shows that Degas did not copy the photograph exactly, but instead used it as a reference to develop an idea (**2.37**).

Drawing from photographs has advantages. Photographs provide a reference that is static: subjects do not move and scenarios do not change. Photographs offer the freedom of being able to work when you are ready, without relying on having the right lighting, or waiting for the model to arrive. American illustrator Norman Rockwell (1894–1978) often worked from direct observation, but he also used photographs to realize fully his storytelling vision. He found that photographs could capture the spontaneous expressions of his

2.37 Edgar Degas, *Blue Dancers*, c. 1899. Pastel, 25⅝ × 25⅝" (65 × 65 cm). Pushkin Museum, Moscow, Russia
Compare and contrast Degas's photograph in **2.36** with the drawing that he made using it as a reference in **2.37**. Elements have changed significantly: the use of color is an obvious addition in the drawing. As a result of much experience drawing from direct observation, Degas breathes life into a pastel drawn from a photograph.

2.38 Photographic reference for *Family in Auto*, 1950. Photograph, 4 × 5" (10.2 × 12.7 cm). Norman Rockwell Museum, Stockbridge, MA

models (often family and friends) for him to incorporate into his work. Notice the liberties that Rockwell takes with his source photograph in order to create a more fully realized drawing, *Family in Auto* (**2.38** and **2.39**). It is interesting to note that Rockwell always used black-and-white film even though his finished work was often in full color. Working only from black-and-white photographs gave Rockwell the freedom to apply his own colors, unrestrained by the photo images. He found transposing from photography liberating, a part of his working process he enjoyed.

Other artists have approached drawing from photographs in different ways. Iranian-born artist Raha Raissnia (b. 1968) uses her personal films to create intense charcoal works.

2.39 Norman Rockwell, *Family in Auto*, 1954. Pencil on paper, 7½ × 11½" (19.1 × 29.2). Norman Rockwell Museum, Stockbridge, MA

Norman Rockwell used photographs out of practicality, as his models would not have been able to sit for the long hours he required in his work. Also, by using photographs, he could readily adapt details, transpose compositions, and adjust expressions as he went along.

2.40 Raha Raissnia, *Untitled*, 2016. Mixed media, 12⅝ × 19¾" (32.1 × 50.2 cm). The Drawing Center, New York
This drawing uses a video belonging to the artist as a point of departure. By inventively making changes to the video images, the layering of scenes generates a final product that wanders in and out of abstraction.

As she draws, reworks, and layers images that she finds in her films, forms sometimes become unrecognizable, yet nevertheless they tend to speak of her private life (**2.40**). The Latvian-American artist Vija Clemins (b. 1938) also uses photographs to help her render natural scenes, enabling her to work for long periods of time to capture extraordinary amounts of detail (**2.41**).

Even though many artists draw from photographs successfully, there are some clear disadvantages. Most of these shortcomings are related to the fact that photographs often limit rather than expand one's creative vision. For example, it is common when drawing from photos to become overly invested in details and fail to represent or understand the object or space as it actually exists. Inexperienced artists working from photographs often create drawings that appear flat while trying to create an illusion of space. The results can appear artificial even though the artist is trying to draw realistically. After all, viewing a two-dimensional photograph is not the same as experiencing the three-dimensional world. It must be remembered that although photographs might seem convincingly "real," they are only mechanical impressions of reality, mere slices of all that an experience of the world has to offer.

2.41 Vija Clemins, *Untitled (Irregular Desert)*, 1973. Graphite on synthetic polymer ground on paper, 12 × 15" (30.5 × 38.1 cm). MoMA, New York
The use of photography as a reference allowed the artist to develop a hyper-realistic image of the desert, which might not have been possible to develop outside of the studio. The slow, time-consuming process of rendering textures makes the use of photography particularly effective in this artist's work.

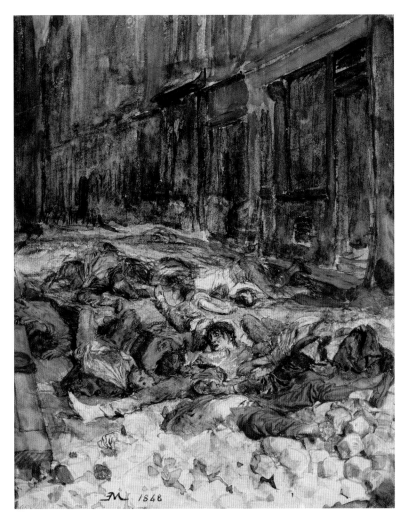

Memory

Everybody has a story and a unique vision. Our stories and visions fill our memories, and the practice of drawing can help externalize these for us. Making a drawing based on one's past can result in a work that is both personal and deeply significant. Not restricted to perception, artists are free to recall memories embracing past experiences and the emotions associated with them. As memories of experiences tend to be selective and change over time, there is an obvious difference between works made from memory and those derived from photographs. In *The Barricade*, the French artist Ernest Meissonier (1815–1891) taps into his memory of a tragic event he witnessed, a massacre in 1848 that affected him profoundly. This horrific experience resonated with him for many years (**2.42**).

Despite the high degree of complexity and detail in his representational drawings, the South Korean artist Kim Jung Gi actually draws from memory. He avidly studies the world around him when he is not drawing so that he can recall images later when he works (**2.43**).

2.42 (above) Ernest Meissonier, *The Barricade*, 1848. Watercolor with traces of pencil on paper, 10¼ × 8¼" (26 × 21 cm). Musée d'Orsay, Paris, France
This drawing is representational, although it was not made from observation. Instead, it was made by recalling memories. Recollections of disturbing events can haunt and traumatize people. Meissonier dealt with his experiences through his art, immersing himself in the details of memory. The drawing projects the emotional tenor associated with the event.

2.43 Kim Jung Gi, *Untitled*, 2013. Ballpoint pen, 8¼ × 11¾" (21 × 29.7 cm). Private collection
Kim Jung Gi has a remarkable ability to gather visual information in his mind. He is able to tap into this mental library of images as he draws. This drawing is the result of his ability to work from memory. With a ballpoint pen and a strong understanding of perceptual space and form, he draws layers of astonishing detail, all from his head.

2.44 (above) Edmund Monsiel, *Untitled*, n.d. Lead pencil on paper,
7 × 5¼" (17.7 × 13.2 cm). Collection de l'Art Brut, Lausanne, Switzerland
Imagination provides all of us with the ability to create new things. Sometimes, paradoxically
due to limitations in some areas, a mind can be extraordinary, having unique strengths and
differences. This drawing is a unique visualization from the imagination of an autistic person.

Drawing from Imagination

All things imaginable are possible subjects
for drawing. Imagination partly arises from
past experience; consequently, drawing from
imagination is closely related to drawing
from memory. When you draw from your
imagination, you create something that did
not already exist. This is an inventive and
exploratory process.

Everyone's imagination is different.
Edmund Monsiel (1897–1962) was affected
by autism, a general term for a complex range
of disorders in brain development. He also
was challenged with auditory and visual
hallucinations. While hiding away from human
contact for nearly twenty years, Monsiel created
about five hundred drawings, such as the
pencil-on-paper drawing pictured here (**2.44**).
Characteristic of his work, this drawing reflects
his repetitive, obsessive behavior.

When drawing from imagination, an artist
will frequently combine concepts or elements
from disparate sources to find new forms and
new possibilities. In this imaginary scene,
English poet and artist William Blake (1757–
1827) illustrates God descending from heaven
on the last day (**2.45**). Blake's image combines
things that he had read, seen, and imagined.

By tapping into the imagination as a means
of inspiration you can find your own unique
voice, whether it be representational, abstract,
or non-objective (see p. 53). The American
artist Keith Haring (1958–1990) was committed
to drawing from his imagination throughout
his life and invented his own abstract
vocabulary of images and symbols. This large
drawing about world conflict is representative
of Haring's compelling interest in graffiti as a
form of social message (**2.46**).

2.45 William Blake, *The Last Trumpet*, c. 1780–85.
Pen and gummed carbon black ink and layered gray
ink washes with graphite underdrawing, 8⅛ × 8⅜"
(20.5 × 21.2 cm). Metropolitan Museum of Art, New York
This drawing represents an imaginary scene of God
descending to earth. With line and washes Blake portrays
a believable image of light and emotion, but not one from
an existing reality. Such scenes as this can arise when
working from imagination.

2.46 Keith Haring, *Untitled,* 1982. Ink on two sheets of paper, 6' × 55' 11½" (1.83 × 17.06 m). MoMA, New York
From his imagination, the artist has concocted an abstract collection of images and symbols. This graffiti-like work sends cryptic messages about matters that the artist feels directly affect us all.

Stream-of-consciousness drawing A spontaneous approach to drawing from imagination in which the artist quickly records images and ideas as they come to mind.

One type of drawing made from the imagination is the **stream-of-consciousness** drawing, recording spontaneous images and ideas on paper immediately as they come to the mind. This approach might be considered a type of mental wandering. In practice, it can help one develop intuitive, unrestrained thinking. The stream-of-consciousness drawings of Hila Laiser Beja (b. 1966), an artist working in Tel Aviv, Israel, combine seemingly random marks and ideas that together describe a relation between the artist's hand and brain (**2.47**).

Master Studies

Artists have always sought to learn from other artists, and master studies have long been a common part of an artist's training. In the past copying a master was meant to teach technique

2.47 Hila Laiser Beja, *Stream of Consciousness,* 2016. Ink on fine paper, 19⅝ × 27½" (50 × 70 cm). Collection of the artist
A stream-of-consciousness approach attempts to connect the mind to the hand in a direct way. Created without preparation or a previously conceived notion of their appearance, the artist's marks are spontaneous, comparable to an actor improvising without a script.

2.48 Giotto, detail of *Ascension of St. John the Evangelist*, c. 1320. Fresco, 9' 2¼" × 14' 9⅛" (2.8 × 4.5 m). Peruzzi Chapel, Santa Croce, Florence, Italy

as well as to provide an example of what the master considered to be good taste. Copies might analyze portions of architecture, sculpture, drawings, or paintings. It is easy to understand why the habit of copying master works was ingrained in the art world and continues to this day. Through the exercise of copying, even of fragments, the valuable lessons of previous masters are passed on to new generations.

When drawing from masterworks it is important to understand that there is a difference between outright copying and actually *studying*. Avoid copying just for the sake of duplicating a work. Instead, seek to discover and incorporate new knowledge. In this example, Italian artist Michelangelo (b. Michelangelo Buonarroti, 1475–1564) uses his own drawing techniques to study a portion

of a fresco by his Florentine predecessor Giotto (**2.48** and **2.49**). Michelangelo's study concentrates on the interaction between two of the figures in Giotto's composition.

Through copying a masterwork, an artist can capture the essential quality that makes that masterwork inspiring. French sculptor and painter Jean-Baptiste Carpeaux (1827–1875) made this drawing from the pedimental frieze sculptures of the Parthenon, the so-called Elgin Marbles currently displayed in London's British Museum (**2.50** and **2.51**). From his dramatic and emotional study of these rearing horses, we can imagine Carpeaux's desire to learn from these Classical Greek sculptures and incorporate these qualities into his own work.

2.49 Michelangelo, *Study after Two Figures in Giotto's Ascension of St. John the Evangelist*, c. 1490–92. Pen and gray and brown ink over traces of drawing in stylus, 12⅜ × 9" (31.5 × 23 cm). Musée du Louvre, Paris, France

We can learn a lot by studying the works of earlier artists. Often referred to as a "master copy," this phrase can be misleading. The focus should be to seek and discover. Here an artist of genius, Michelangelo, studies a work by a genius of the previous generation, Giotto (**2.48**).

2.50 (above) *Horse of Selene* from the East pediment of the Parthenon, 438–432 BCE. Marble, 24⅝ × 32¾ × 13⅛" (62.6 × 83.3 × 33.3 cm). British Museum, London, England

TIP

When working on a drawing, consider the general feeling that you wish your drawing to convey to the viewer. As inspiration, find drawings in this book that convey a similar expression.

Representational drawing
Drawings that record the appearance of a subject so that we recognize what is represented.
Non-objective drawing
Drawings that are neither derived from, nor do they depict, a subject from reality.

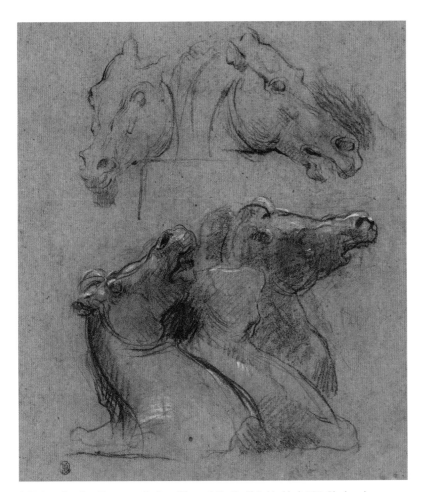

2.51 Jean-Baptiste Carpeaux, *Studies of Horses (after the Elgin Marbles)*, 1871. Black and white chalk on brown paper, 13 × 10¼" (33 × 26 cm). J. Paul Getty Museum, Los Angeles, CA
Drawing studies of the Elgin Marbles helped the sculptor Carpeaux to observe and learn from the dynamic poses of the ancient Greeks. Drawn with vigor, these drawings exemplify the free and naturalistic style for which Carpeaux is known.

Style and Expression

Modes of drawing can be carried out in a variety of ways, depending on an artist's approach and sensibility to style and expression. Artists may work representationally, abstractly, or non-objectively. **Representational drawing** depicts the appearance of a subject, often as an illusion of reality. While originally derived from reality, abstract drawing departs from the external appearance of the subject, often simplifying, distorting, or exaggerating its appearance. **Non-objective drawings** are neither derived from, nor do they depict, a subject from reality.

There are numerous examples of representational, abstract, and non-objective drawings throughout this book. Take a moment to browse through the book to find examples of each. As you browse, try to compare and contrast them, examining how they are either representational, abstract, or non-objective. How do these drawings deal with the elements of line, shape, value, texture, and color? How are these elements used, and for what purposes? In each example, what do *you* find most compelling?

2.52 Camille Pissarro, *Boulevard de Rochechouart*, 1880. Pastel on beige wove paper, 23½ × 29" (59.9 × 73.5 cm). Sterling and Francine Clark Art Institute, Williamstown, MA

General style A way to define works that have similar characteristics.
Personal style The individual and personal influence an artist has on his or her work.

Style

There are at least as many styles of drawing as there are creative people in the world. For example, if ten artists were asked to draw a landscape from exactly the same spot, and to draw exactly what they see as realistically as possible, every drawing would be different. This is because we each have our own particular way of conceiving the world and our own way of doing things. In this example we can distinguish two different types of style: a **general style** (in the case of the landscape example, this would be realism), and a **personal style**, whereby each drawing shows its maker's individuality.

Identifying a general style is a way of connecting works that have similar characteristics. Often, works that were made during a similar period, culture, or movement are seen to share a general style. For example, French Impressionism was a movement centered on a group of artists who lived in Paris during the nineteenth century. In these three French Impressionist drawings, Camille Pissarro (1830–1903), Berthe Morisot (1841–1895), and

2.53 Berthe Morisot, *Boats (Entry of the Midina to the Isle of Wight)*, 1875. Watercolor over graphite on off-white paper, 7½ × 6⅞" (19 × 17.4 cm). Harvard Art Museums—Fogg Museum, Cambridge, MA

2.54 Alfred Sisley, *Early Snow at Louveciennes, c.*1871–72. Pastel, 7¼ × 11¾" (18.3 × 30 cm). Museum of Fine Arts, Budapest, Hungary
Comparing these three works (**2.52**, **2.53**, and **2.54**) suggests the difference between general style and personal style. These drawings share the same general character of Impressionism, but they are surely different in terms of the artist's personal method of drawing. For instance, note the particular marks with which each artist describes the landscape.

Expression The individual spirit that results when an artist conveys ideas, feelings, and vision.

Alfred Sisley (1839–1899) could be said to share the same general style (**2.52**, **2.53**, and **2.54**). Their distinctive general style—French Impressionism—includes atmospheric composition, obvious mark-making, and an emphasis on the depiction of light. While sharing a general style, however, each artist also has his or her own individual style. Individual style is the artist's personal influence on the general style. It is closely linked to the manner, or technique, in which a drawing is made.

Expression

Expression is the indescribable characteristic that separates one artist's work from another's. Some consider it the most important characteristic of drawing, comprising the fundamental and individual quality of spirit, personality, and soul. Expression results from the artist's will to convey ideas, feelings, and vision. Drawings can communicate emotions of sadness, excitement, anger, joy, empathy, spirituality, tension, and of course the list goes on. Such expression can be deliberate or unconscious. While viewer reactions can never be fully anticipated, the poetic nature of a drawing is, first and foremost, the product of the artist's expression.

Expression takes myriad forms. One type of expression is that of the entire piece, the expressive whole. This is the general feeling that is established by the combination of all elements of a drawing. Just as in music, where the individual notes and the way in which the musician plays the notes can stir one's emotions, so too the combination of image and technique can create powerful expressiveness in a drawing. For example, take the pairing of a melancholy theme with shadowy and somber tones. The German artist Käthe Kollwitz (1867–1945) produced such drawings with expressive power. In *Battlefield* there is an emotion of heavy sadness (**2.55**). Her portrayal of suffering and death, the dark atmosphere, and the

2.55 (below) Käthe Kollwitz, "Battlefield," plate six from *The Peasants War,* 1907. Etching, mechanical grain, aquatint, and engraving on paper, 25 × 28¾" (65.5 × 73 cm). Smith College Museum of Art, Northampton, MA
This dark, haunting image is an expression of mourning. The subject matter and the use of media work collectively to express grief and sorrow. Drawings have remarkable capacities to communicate feelings and stimulate the moods of their audiences.

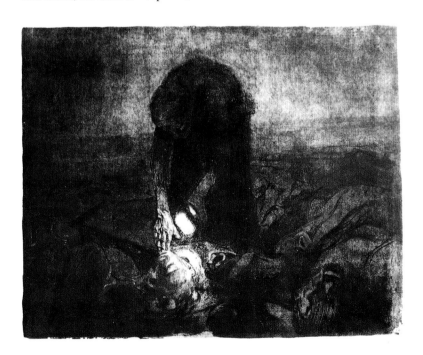

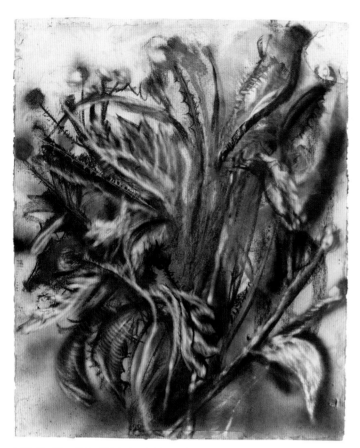

2.56 Jim Dine, *Dying Thistle*, 2014. Charcoal, pastel, and watercolor on paper, 49 × 40½" (124.5 × 102.9 cm). Private collection

Rather than depicting the subject exactly as it appears, this drawing conveys emotion. Reacting to his observation of a plant, the artist employs a variety of emotional effects: aggressive application of media, exaggerated marks, and an aggravated twisting and turning of the subject.

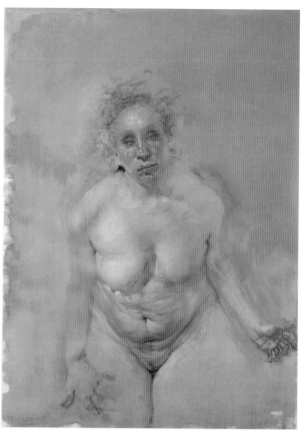

2.57 Anne Harris, *Bending Over Study (Orange)*, 2006. Watercolor, oil, and graphite on mylar, 41 × 30" (104.1 × 76.2 cm). Collection of the artist

This self-portrait is an emphatically personal statement. Not only does it depict the artist in a vulnerable naked state, the manner in which it is drawn also heightens the anxiety. The pose is bent and uncomfortable, while the artist's choice of colors is strategically unnatural, making the figure glow with intensity.

2.58 Odd Nerdrum, *Sketch for the Arrest*, 1975

We can share the feelings of the person in this drawing. As human beings, most of us have the innate instinct of empathy—we can understand and relate to the feelings of others. This drawing taps into the viewer's ability to identify with another. Our feelings arise from the representation of the subject's emotions.

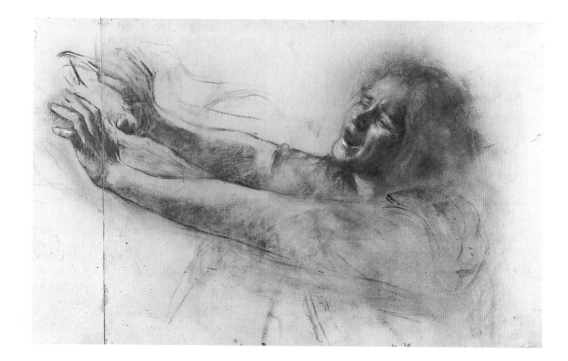

strong marks that she used all contribute to a wholeness of expression.

A mixed-media botanical drawing by the American artist Jim Dine (b. 1935) displays a variety of expressive mark-making techniques, including bold and soft marks, erasure, smudging, and an unexpected use of color (**2.56**). When drawing plants (something he did throughout his life), Dine expresses his feelings at the moment of creation, imbuing the entire event with a chord of expressive wholeness.

Another type of expression comes from an ability to endow the subject with feelings and emotions that set an overall tone. This can readily be seen in figure drawings. Anne Harris's (b. 1961) nude self-portrait uses body language to emit non-verbal thoughts and feelings, and the vulnerable, frank nakedness of the body is both challenging and discomfiting (**2.57**). By contrast, Odd Nerdrum (b. 1944) uses convincing facial expression in *Sketch for the Arrest* to communicate a strong sensation of fear and distress (**2.58**).

In the Studio Projects

Fundamental Project

Choose a subject to draw, such as a landscape, still life, or interior. In your sketchbook, create five small thumbnail studies that consider different compositional arrangements of your subject. Use the suggestions from "When Making a Thumbnail Study," p. 38.

Observational Drawing

In a sketchbook, create a series of ten process drawings to explore ideas and alternatives for a potential finished drawing. You may choose to work from direct observation or photographs. Refer to Edward Hopper's preliminary studies featured in this chapter (p. 39).

Non-Observational Drawing

In a sketchbook, create a series of drawings that explore different modes (process, gesture, independent). Utilize a variety of different sources, including memory and imagination. For each mode, refer to the suggestions in this chapter.

Criteria:

1. An engaging subject matter should be chosen for this project.
2. Five thumbnail studies should be made following the suggestions listed on p. 38.
3. The thumbnail studies should explore a range of compositional possibilities, such as vertical format, horizontal format, close-up, or distant view. For this exercise, compositional arrangement is more important than the accurate representation of the subject.

Criteria:

1. The collection of drawings should include sketches, studies, and thumbnails.
2. The process drawings should be a thorough exploration of the subject.
3. The collection of drawings should result in a thoroughly considered concept for a potential finished drawing.

Criteria:

1. The collection of drawings should include three process drawings.
2. The collection of drawings should include three gesture drawings.
3. The collection of drawings should include one finished independent work.

Materials: Sketchbook, graphite pencil

Materials: Sketchbook, graphite pencil

Materials: Sketchbook, graphite pencil

Chapter 3
Mark-Making and Media

At the most elementary level, a drawn image is the result of applying media to a surface. The media that one chooses and the surface on which a drawing is made are vital to the overall impression of that drawing. Professional artists try to learn as much as they can about their materials so they can be fully aware of all aspects of their work. Every medium has its own characteristics: media can be very light or dark; easy to erase or permanent; good for tight **rendering** or better for large, loose mark-making; easily portable or not. Artists tend to gravitate toward certain media depending on their needs and the material's limitations, as well as the artist's own temperament.

The best way to become well acquainted with the qualities of a medium is by hands-on experimentation. Refining the techniques that are needed in order to control the application of materials takes time and practice. Dedicated artists work continuously to perfect their material techniques throughout their careers. By having a working knowledge of a variety of media—and today's artists enjoy a huge selection of both wet and dry media, prepared papers, and non-traditional working surfaces—you can comfortably rely on your media skills to move in any creative direction that you wish.

Rendering The execution of a drawing, especially when adding color, shading, and/or texture.

Mark-Making

For some mysterious reason, human beings have a keen appreciation for marks that are visible on a surface. **Mark-making** encompasses the world of spots, smears, lines, erasures, dots, stains, blotches, smudges, scratches, sprays, and effusions in their infinite variety (**3.1**). Mark-making relates to any media applied to any surface to make drawings in any mode. The type and variation of mark registers the artist's touch, and connects the viewer with the tactile experience of drawing. This immediacy of touch is an important aspect of every drawing.

Marks can be made randomly without thought, or intentionally with controlled effect. Marks may be made in relationship to something seen, or in response to a feeling or thought. Every person's marks are essentially unique, and can form the basis of a personal visual language. By exploring your mark-making vocabulary through your drawing practice, you can expand your communicative and expressive possibilities.

Kunizo Matsumoto (b. 1962), a mentally disabled dishwasher living in Japan, was intrigued by notebooks and writings that he had seen. Unable to write, he created his own "written works" by inventing marks that act in the manner of text on the page (**3.2**). His obsessive layers of mark-making offer insight into a unique world view.

Marks have strong formalist qualities of which drawing takes special advantage. In drawing, the formal elements of line, shape, value, texture, and color combine to emphasize

Mark-making The marks made upon a surface.

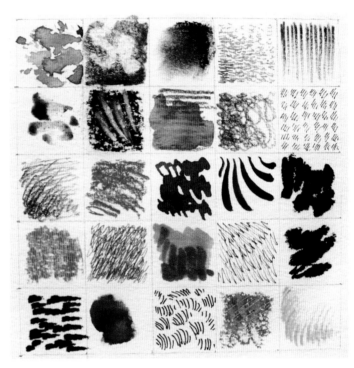

3.1 (above) Grid of twenty-five different marks using different media
On this page, the artist made twenty-five squares. Within each square he made very different marks. Using different media, he explored marks that are bold, delicate, smears, colorful, gradated, soft, severe, *etc*. These are the kinds of marks that could become a part of an expressive drawing. Experiment with mark-making for yourself.

3.2 Kunizo Matsumoto, *Untitled,* from artist's notebook with 110 leaves, 2002. Pencil and ink on paper, 6¼ × 4¾ × ⅝" (16 × 12 × 1.5 cm). Collection Daniel Klein
Mark-making is personal and individual to the maker, so it is no wonder that people who study drawings consider the marks that an artist makes to be so important. Marks, such as those in Matsumoto's notebook, are inherently unique, and reflective of the life of a particular person.

TIP

An excellent way to become familiar with the diverse marks that different media can make is to create a page of samples, such as the one in **3.1**. You may wish to label each sample for future reference.

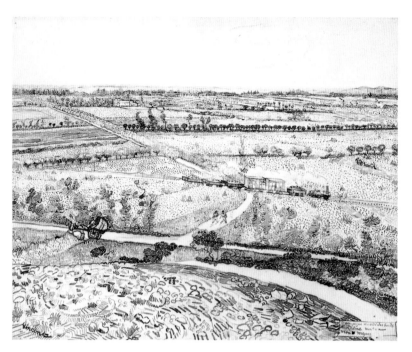

3.3 Vincent van Gogh, *Landscape near Montmajour with Train*, 1888. Pencil, reed pen, and quill pen in brown ink, 19¼ × 24" (49 × 61 cm). British Museum, London, England
This drawing shows a variety of marks—stipples, hatching, twists, and swirls—that create an energized visual texture. Moreover, by controlling the direction, size, and spacing of the marks, the illusion of a deep landscape is made. Van Gogh's mark-making, for which his paintings are well known, began with his drawings.

In *Male Nude*, by the American painter Paul Cadmus (1904–1999), the colors and textures of marks are instrumental in developing the illusion of form. The curved hatching convinces the viewer of volume and light (**3.4**).

Expressive mark-making can be the catalyst to create non-objective art (artwork that does not necessarily refer to any external visual stimulus). In such instances, artists focus on how marks visually interact; this interaction becomes the subject of the drawing. The American artist Sonia Gechtoff (1926–2018) uses characteristic tangles of marks that appear to float above the surface of the paper, resulting in a distinctive and spontaneous work (**3.5**).

A different approach to seemingly non-objective mark-making can be seen in the subway drawings of the American painter William Anastasi (b. 1933). While riding on subways—and not looking at his drawings—Anastasi lets the motion of the subway dictate the marks that he makes on paper. The marks record the physicality of his subway ride (**3.6**).

composition and create space. (These are addressed in detail in Part 3, "Drawing Elements," p. 148.)

In this drawing by the Dutch painter Vincent van Gogh (1853–1890), the variety of marks coalesce to compose a landscape (**3.3**). The way the artist's marks progressively diminish in size helps create the illusion of receding space within the drawing.

3.4 (below) Paul Cadmus, *Male Nude*, 1979.
Crayon on toned paper, 9¼ × 18¾" (23.5 × 47.6 cm)
The marks of this figurative drawing are crafted with deliberate subtlety. The fine lines blend to describe surface, form, and light. Straight lines are used to shade flat surfaces, and curved marks wrap over the surfaces of round forms. Every mark is made with direction, giving the viewer a suggestion of solidity.

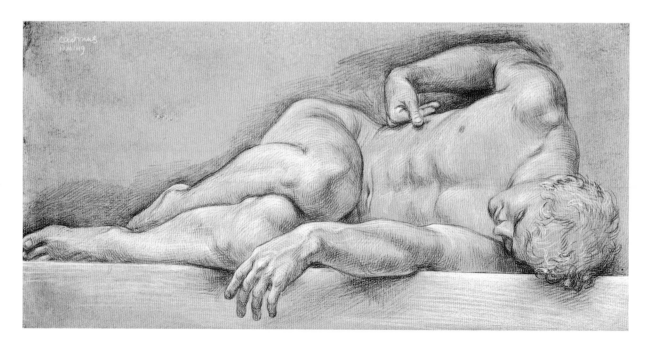

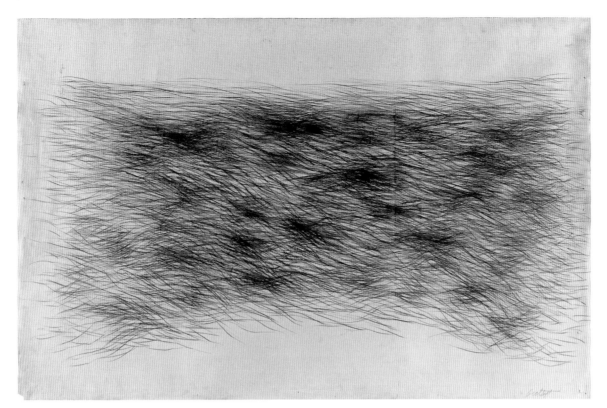

3.5 (above) Sonia Gechtoff, *Untitled*, 1959. Graphite, 40½ × 60½" (102.9 × 153.7 cm). Private collection

Non-objective art often focuses on mark-making rather than depicting an object. In this drawing, whips of wavy lines gather and spread, creating a rectangle within the page. The result is an invented topography, unlike any we have seen before. We want to search the nooks and crannies, explore the soft edges and investigate the darkest hollows.

3.6 William Anastasi, *Untitled (Subway Drawing)*, 2009. Pencil on paper, 8 × 11½" (20.3 × 29.2 cm). Brooklyn Museum, New York

The motion of a subway dictated the marks of this drawing. This type of non-objective work can be referred to as generative art, because it was created with the use of a non-human process or technique that was responsible for the result. In this case, the process of how the drawing was made also represents Anastasi's artistic creativity.

Gateway to Drawing Orozco, *Man Struggling with Centaur*

Mark-Making and Media

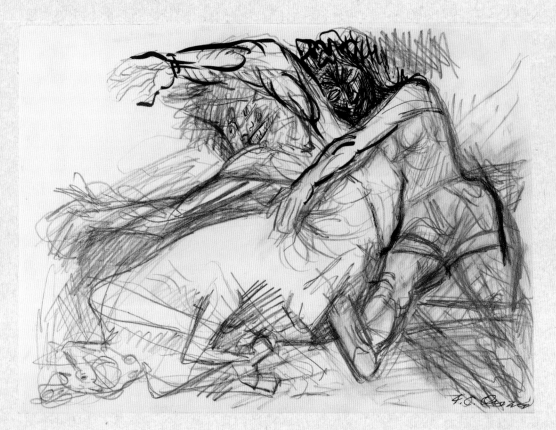

3.7a José Clemente Orozco, *Man Struggling with Centaur*, n.d. Graphite with pen and brush and black ink, on cream wove paper, 7⅞ × 15" (28 × 38.2 cm). Art Institute of Chicago, IL

3.7b (below left) Orozco's *Man Struggling with Centaur*, detail

For the other *Man Struggling with Centaur* boxes, see p. 163 and p. 242

The kinds of marks that an artist is inclined to make in drawings are often indicative of the artist's unique temperament, as his or her personality, experiences, and passions are necessarily funneled into his or her work. In this way, José Clemente Orozco's (1883–1949) life of suffering and political upheaval could be seen as strong contributory factors to his powerful expression on paper.

During the early years of Orozco's artistic career, a terrible accident occurred. In 1904, when preparing fireworks to celebrate Mexico's Independence Day, an explosion injured Orozco's left arm. Without immediate attention, gangrene set in, which later required his hand to be amputated.

Even as Orozco learned to cope with this personal tragedy, his homeland of Mexico was also experiencing unrest. The Mexican Revolution was beginning, causing major turmoil for Mexican culture and politics. Immersed in struggle and human suffering from all sides, Orozco's work began to express violence and grief.

Man Struggling with Centaur is distinctive for its intensity, and its focus on struggle and ferocity. It depicts a man battling the wild, unruly force of a half-man, half-horse creature from mythology. Just as the action of the subjects is violent and out of control, so are the marks that describe them. Using a soft graphite pencil, Orozco's marks are dark, fast, and immediate. The aggressive, jagged scrawls of the pencil accumulate to describe the scene. Finally, as if he begins to redraw his image, Orozco introduces intimidating black ink lines. His application of graphite and ink are frantic, direct, and unapologetic.

Media: Past and Present

Among the earliest media used to create drawings were natural pigments dug from the earth, along with charcoal obtained from fire. In Indonesia, handprints (apparently female) made on rock walls using ocher pigments have been found that date back to more than 39,000 years ago (**3.8**). Charcoal drawings of animals on rock faces, such as those found in the Apollo 11 Cave in southwestern Namibia, date back 27,000 years (**3.9**). These early examples of media and surfaces for drawing can still inspire us today.

Every medium has inherent associations with its history. Silverpoint, for example, is a drawing medium that uses a fine silver wire on a prepared surface. It is an unforgiving medium that cannot be erased, which was first employed during medieval times and favored throughout the Renaissance. *Smaze* by Michael Nichols (b. 1973) is a contemporary example of a work done in this medium (**3.10**). For those familiar with the medium's history, it is hard not to relate the modern drawing to the work of artists who used it long before, such as the Dutch painter Jan van Eyck (1390–1441) (**3.11**). Living centuries apart, both Van Eyck and Nichols

3.9 Drawing at Apollo 11 Cave in southwestern Namibia
Part of a larger group of drawings, the animal figure on this stone was made approximately 27,000 years ago. Typical of early drawings, it is made with charcoal, ocher, and other natural materials so durable that they have lasted the test of time.

3.8 (right) Handprint, Sulawesi Caves of Indonesia
The earliest materials human-kind used to produce art were those that could be readily found in nature. This work was probably created by placing someone's hand against a wall as a stencil, and then spraying ocher pigments from the mouth. Today we can appreciate these prehistoric works not only for their historical significance, but also for their resourceful and inventive use of artistic media.

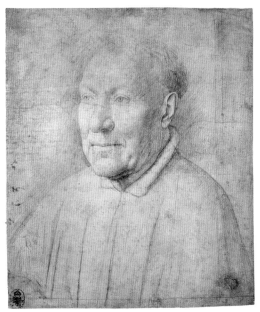

3.11 Jan van Eyck, *Portrait of Cardinal Albergati, c.* 1435. Silverpoint, 8¾ × 7⅛" (21.4 × 18 cm). Staatliche Kunstsammlungen, Dresden, Germany
For Van Eyck's exacting and refined lines, silverpoint was the ideal medium. Compare and contrast this Renaissance drawing with Michael Nichols's contemporary work in the same medium (**3.10**).

3.10 Michael Nichols, *Smaze*, 2013. Silverpoint on paper, 9 × 12" (22.9 × 30.5 cm). Collection of the artist
Here, layers of fine hatchings produce a hazy portrait that appears modern, despite the fact that the artist's materials are not.

Student-grade
A designation for less expensive art supplies.
Ground The drawing surface, paper or otherwise.
Acid-free Contains nothing acidic, preventing the possibility of yellowing and ageing.

share the same painstaking, time-consuming technique. The differences in their drawings reflect the individual cultures in which each artist worked. Artists frequently meditate on their similarities and differences with the artists who came before them.

Throughout time, people have refined preexisting drawing materials and invented others to meet new needs. The choice of drawing materials is important, but so is the quality of the materials chosen. Materials made from higher-quality ingredients generally cost more. "**Student-grade**" materials are often purchased with the notion that they are more economical, but this is not always the case: the ingredients of a high-quality watercolor, for example, will contain more pigment than a less-expensive brand, will last the artist longer, and will probably be more permanent. Poor-quality materials, in contrast, often end up causing technical difficulties, not a problem that most people want to face. High-quality materials are also likely to be more durable, allowing a work to remain the way it was intended to be seen without fading or falling apart. Knowing the difference between higher-quality and lower-quality materials will help you to make good decisions about how to spend your money.

Drawing Surfaces

The drawing surface, often referred to as the **ground**, is responsible for the adhesion and absorption of the drawn mark. The characteristics of different grounds are determined by how they are made. The most customary surface for a drawing is paper, but there are many other, non-traditional surfaces on which artists can draw. The choice of a drawing surface is an important decision for the artist as it has a major influence on the final appearance of a work.

Paper

The Egyptians and the Chinese made the earliest types of papers almost two thousand years ago. By the thirteenth century, paper mills, such as Fabriano, which supplied paper to Michelangelo, were beginning production in Europe. Since then, manufacturers have developed extensive lines of papers for every level of artist and for almost every medium.

Papers range in price and quality. If the paper is for a quick throw-away exercise, perhaps you do not need to use high-quality paper. You may choose to spend more money on high-quality paper, however, if you are planning to create a finished work of art. When selecting paper, important variables to consider are content, weight, and surface.

Content

The content of the paper is the ingredients with which the paper is made. The quality of those ingredients will give each kind of paper its unique characteristics and have a strong bearing on that paper's permanence. Paper is composed primarily of cellulose fibers, usually either fibers from wood or fibers from cotton. Paper that contains high amounts of low-quality wood fiber generally will become acidic, and will turn yellow and become brittle over time (**3.12**). This disadvantage should be considered when selecting this type of paper.

Paper made from cotton fiber is often referred to as rag paper. It is typically stronger than wood-fiber paper and is naturally free of acid. **Acid-free** paper, as the name suggests, contains nothing acidic, preventing the possibility of yellowing and ageing. Some papers are marked as having "neutral pH." This means that the paper has a low acid-alkaline

3.12 Yellowed paper
The top piece of wood-pulp paper in this image was covered on one side and then left in strong sun for just a few hours. Notice how the uncovered side turned yellow. The bottom piece of paper, made from cotton fiber and acid-free, did not turn yellow even though it was exposed to the sun in the same way.

3.13 Rough, cold-press, and hot-press papers
From left to right, the papers photographed here are rough, cold-press, and hot-press. Note the different surfaces of each.

Archival Having durable qualities that prevent deterioration.

Weight of paper An indication of the thickness of a type of paper.

Hot-press paper Paper that generally has a smooth surface.

Cold-press paper Paper that generally has a slightly textured surface.

Rough paper Paper that generally has a considerably textured surface.

Tooth The feel, or texture, of the surface of a paper.

range. The best-quality papers available are sometimes called "**archival**," meaning they can be expected to last for a long time if stored carefully under controlled normal conditions.

To summarize, when selecting drawing paper, consider its content, including such factors as:

- Wood pulp
- Cotton fiber (rag)
- Acid-free
- Neutral pH
- Archival

Weight

The **weight of paper** is determined by how much a ream (500 sheets) of paper weighs. For example, a ream of standard office copy paper typically weighs 20 pounds. In contrast, a drawing paper that is classified as 140 pounds will be a paper in which 500 sheets of 22 × 30" paper weigh 140 pounds. The weight is a reflection of the thickness of that type of paper. As in this example, sometimes the pound denominations can be misleading and difficult to compare as they are dependent on the size of the sheet.

While the weight of the paper is not necessarily a reflection of quality, it is useful in figuring out if the paper is appropriate for a desired medium. Lightweight papers are ideal for delicate drawing techniques. Heavyweight papers are desirable when repeated reworking is required, or when

washes or watercolor are to be applied to the surface.

Surface and Sizing

The type of paper surface you choose can be a matter of personal preference, but the paper surface ought to be compatible with the intended drawing technique or desired visual effect. The surface of paper significantly affects its performance characteristics. Paper surfaces come finished in three principal ways: **hot-press**, **cold-press**, and **rough** (**3.13**).

Hot-press papers, as the name suggests, have been pressed with heat and high pressure to create a smooth paper. These types of paper are generally good for fine work, including pencil and pen drawings.

The manufacture of cold-press papers does not use heat or as much pressure, resulting in a paper with more texture. Cold-press papers are desirable for drawing techniques that need a surface with more "**tooth**" to capture the media, such as charcoal or pastel.

For an even coarser texture, some papers are made with a rough surface. Rough papers may hamper some techniques, but in other cases they can enhance the creation of beautiful textured effects. Rough papers tend to be thick and stiff, serving usefully in brushwork with wet media (see pp. 78–85). Experimenting with a variety of paper surfaces while searching for a certain look will often disclose unexpected effects.

Paper manufacturers sometimes treat the surface of paper to control its absorbency. When an artist works with wet media, such as ink or watercolor, absorbency is an important consideration. The absorption rate of liquids into the paper can be controlled by the addition of "sizing," usually made from natural glues. If paper is not treated with sizing, any wet media will soak into the paper very quickly and randomly, often bleeding more than anticipated. Sizing slows the paper's rate of absorbency and allows wet media to distribute in a more predictable manner. Sizing paper also adds strength to the paper (**3.14**, p. 66).

Which side of the paper should you use? As there are two sides to every paper, this is a common question. It may seem obvious, but it

3.14 Sized and unsized papers
On the left, ink was applied to an unsized piece of paper. Notice the bleeding edges of the mark. On the right, the same ink was applied to a piece of sized paper. The edges of the mark did not bleed. Generally, when working with most media, it is best to buy paper that has been sized by the manufacturer.

needs to be considered. Which side to draw on is entirely up to you. The top is called the *felt side* and the bottom of the paper is called the *wire side*. The two sides have different characteristics.

The felt side is face-up during production. When you buy a single sheet of quality paper you can tell the felt side by the watermark (a faint design that identifies the paper's maker), as the watermark is only legible on this side. The grain of the paper is less noticeable on the felt side, and so is typically smoother and

generally brighter. The bottom side of the paper is called the wire side because it faces down on a wire mesh screen during production. This side tends to have a more obvious texture.

There is also a type of paper called two-ply paper. The manufacturer glues two sheets of paper together so that the paper has two felt sides. This paper, of course, has the same texture on both sides.

In addition to the above characteristics there are other variables to consider when selecting paper, such as color, the dimensions available in different papers, cost, and so on. By trying out different types of paper and different paper manufacturers, you can discover their advantages and disadvantages. Many artists eventually settle on one type of paper that works best for them. Others enjoy a career of paper experimentation and discovery.

Non-Traditional Surfaces
Nearly every type of surface that exists has, at one point or another, been adorned with drawing. Knowing that there are countless possibilities for surfaces to draw on should give you a great sense of freedom. Some choices include materials found in art stores, such

3.15 Student work. Amber Turner, *Double Self-Portrait*. (Instructor: Barbara Giorgio-Booher)
This work is a diptych (a work made up of two parts that together form the complete piece). Here the student juxtaposes two self-portraits made with colored pencils. The left drawing was made on cream paper. It is rendered with dark and light values. The drawing on the right was made on black paper. Here the student restricted herself to linear mark-making.

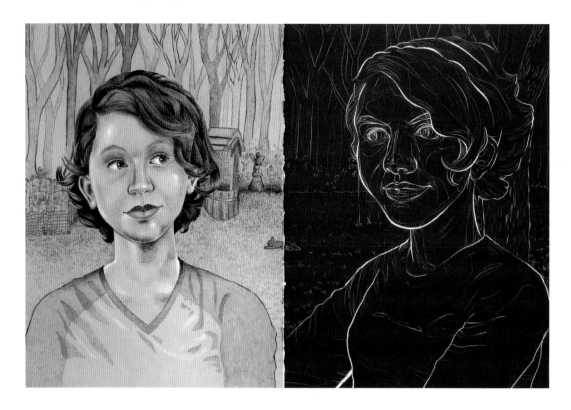

as Mylar, acetate, parchment, or fabric. They could also include surfaces not normally used for drawing, such as found objects, metal, plastics, or surfaces found in the wild. As you seek to create new expressions and techniques, try experimenting with alternative and non-traditional surfaces.

Drawing on walls as well as other materials, Israeli-born Nava Waxman (b. 1974) works in an improvisational way, interlacing performance and drawing. Her works stem from her physical, spiritual, and emotional body (**3.16**). Drawing on a wall can provide a practical solution for a performance, and can result in an art installation rather than a portable object.

In 1997, the Belgian artist Wim Delvoye (b. 1965) began to use live pigs as a surface for his tattooed drawings (**3.17**). The animals are not harmed; however, when the pigs die of old age, the skins are sold to collectors. The drawings themselves are based on images from Western culture, but the unconventional choice of surface has provoked strong controversy from animal rights organizations.

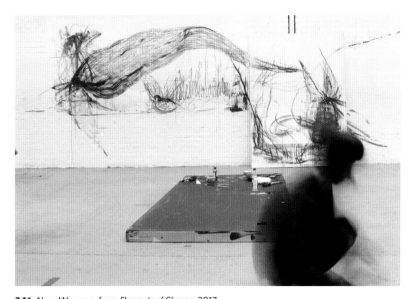

3.16 Nava Waxman, from *Elements of Chance*, 2017. Durational performance incorporating drawing, sound, body presence, and mixed media
Nava Waxman does not limit herself to drawing on paper, nor does she limit herself to drawing on only one surface at a time. Her spontaneous non-objective works are an example of how the surface on which we draw need not be restricted by tradition.

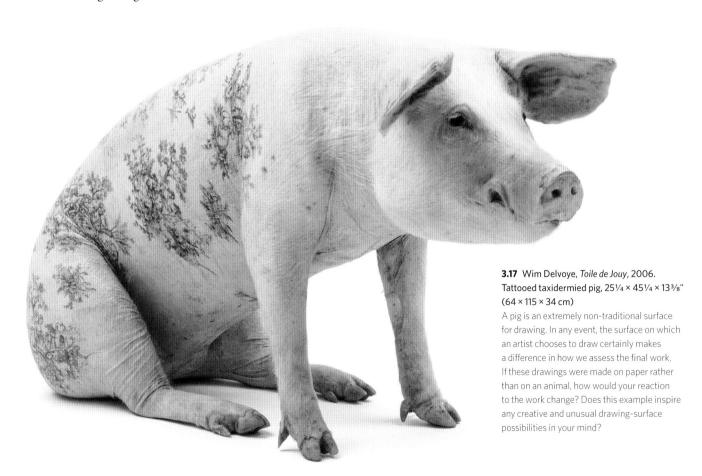

3.17 Wim Delvoye, *Toile de Jouy*, 2006. Tattooed taxidermied pig, 25¼ × 45¼ × 13⅜" (64 × 115 × 34 cm)
A pig is an extremely non-traditional surface for drawing. In any event, the surface on which an artist chooses to draw certainly makes a difference in how we assess the final work. If these drawings were made on paper rather than on an animal, how would your reaction to the work change? Does this example inspire any creative and unusual drawing-surface possibilities in your mind?

3.18 Pencils from "H" to "B"

Often when you buy pencils, they will be arranged from softest to hardest, like these. 5B is the softest shown here, and 5H the hardest. The pencil labeled as "F" can be sharpened to a fine point.

Drawing Media

There is an assortment of different media that can be used to create drawings. Each medium has its own appearance and is often associated with different techniques. Media contribute to the character of a drawing. Drawing media typically fall into one of four groups: dry, wet, digital, and mixed media.

Dry Media

Dry media for drawing typically include graphite, charcoal, pastels, conté crayons, and colored pencils, but there are many others as well. Dry media provide a very tactile drawing experience. In most cases dry media give the options of being tightly controlled, boldly used, erased, smudged, and smeared. In dry media you can create very thin, soft lines, or large areas of tone and color. You can easily manipulate dry media as they come in a variety of forms, such as powder, sticks, and pencils. Dry media offer the possibilities of working **additively** or **subtractively**, tonally or with full color.

Some dry media are classified according to hardness from "H," referring to hard, to "B," denoting black. "HB" is situated in the center of the scale with 9H being the hardest material and 9B being the softest (**3.18**). The letter "F" indicates that pencils can be sharpened to a fine point. Artists often use hard and soft materials in combination. Hard materials can create light marks and softer materials can be used to make darker ones. Manufacturers achieve the full range of material hardness by adjusting the ratio of ingredients, such as pigment to clay.

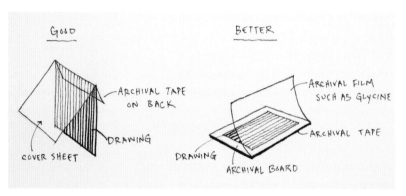

3.19 Coversheet

Coversheets are important for protecting finished drawings. The diagrams above show two different constructions: the one on the left works well, but the construction on the right gives added support and protection to the back of the drawing. The use of archival materials is especially recommended for long-term storage.

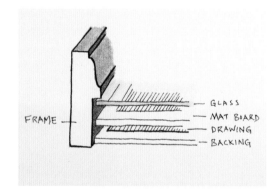

3.20 Cross-section of a frame with glass

This image diagrams a suitable construction of a frame made for a drawing. Most important is that the surface of the drawing does not touch the glass. In the diagram, insertion of the mat board provides this space.

While most dry media are archival, a finished work can easily be smeared or altered if it is touched or if friction is applied. To protect a finished drawing, **fixative** can be applied. Most fixatives are a combination of non-yellowing resins and alcohol. Fixative can be lightly sprayed on the surface of a drawing to reduce the possibility of smudging. In addition to fixative, a well-made coversheet can go a long way toward preserving a drawing in dry media (**3.19**). To protect and preserve a dry media work best, it should be properly framed behind glass (**3.20**).

Additive An artistic process in which the work is created by adding or layering material.
Subtractive An artistic process in which the work is created by removing or erasing material.
Fixative A spray used to protect the surface of delicate drawings made with such media as pencil, charcoal, or pastels.

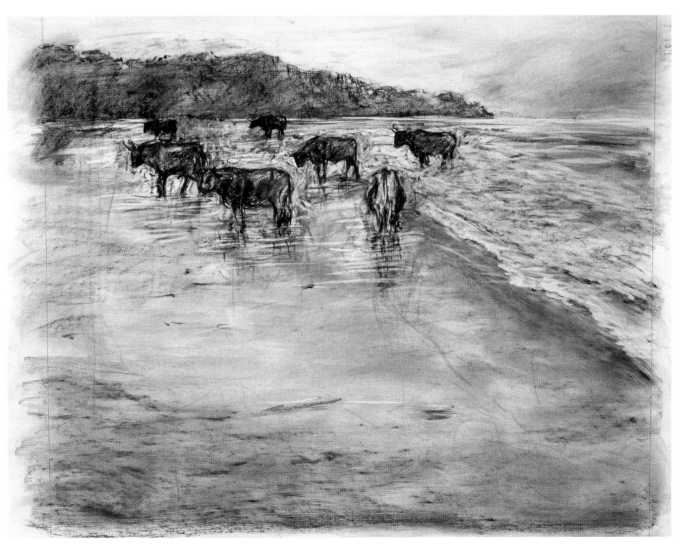

3.21 William Kentridge, "Cattle in Ocean" drawing from *Tide Table*, 2003. Charcoal on paper, 48 × 63" (121.9 × 160 cm)
This drawing was made as one part of an animation. The artist uses charcoal as it can be easily changed and manipulated. Other advantages of charcoal include: its ability to create a large range of values, from rich darks to very light; its erasability; and its capacity for fast application.

Charcoal

Considered the oldest medium, charcoal has withstood the test of time, both in terms of its durability and popularity. Today, as in the past, charcoal is universally used. It has the flexibility to be used both additively and subtractively, and is an ideal medium when working and reworking. The South African artist William Kentridge (b. 1955) takes advantage of charcoal's distinctive qualities to create animated films. Kentridge uses a 35mm movie camera to record the stages of a charcoal drawing as he erases, redraws, and changes the drawing from one image to the next (**3.21**).

With charcoal, previous marks can be worked over, or they can be left visible, revealing the history of the drawing process. The shadows of previous marks are called **pentimenti**, and are often desired by artists.

Pentimento
(pl. **pentimenti**) Italian for "repentance," the appearance of previous marks made by the artist, often revealing the drawing process.

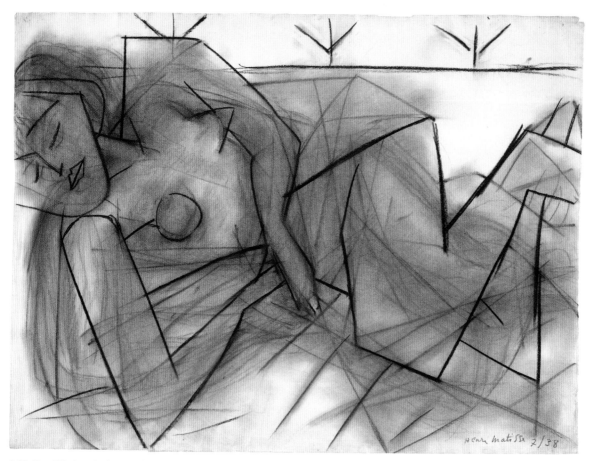

3.22 Henri Matisse, *Reclining Nude*, 1938. Charcoal on paper, 23⅝ × 31⅞" (60.5 × 81.3 cm). MoMA, New York
Charcoal has long been prized as a medium that allows the artist to revisit and revise. The lines of this drawing have been changed multiple times. Matisse often started with a more representational figure, and through a lengthy process of abstraction, finally arrived at his desired result.

In his very angular *Reclining Nude*, the French artist Henri Matisse (1869–1954) allows the viewer to see his struggle in finding the lines that he wanted to keep. The charcoal ghost marks reveal the artist's process and decision-making during the time of the creation of the work (**3.22**).

Artist charcoal differs from cooking charcoal or the kind of burnt wood you might find left over from a campfire. To produce good-quality artist charcoal, specialty woods are burned in oxygen-deprived kilns until the wood turns to carbon. Removing the oxygen from the burning process prevents the production of soot. Charcoal can be purchased in the form of vine or willow sticks, compressed charcoal, charcoal pencils, and charcoal powder (**3.23**). Vine and willow charcoal,

made from grape vine and willow trees as the names suggest, are very soft, gray drawing media. Because these charcoals have no binder added, they are easy to erase and rework, but they cannot produce strong and lasting dark values. In compressed, pencil, or powdered form, charcoal can be used to create a full range of values, from very light to rich black. Softer charcoals and powder charcoal are well suited for covering large areas with value.

3.23 (below)
Types of charcoal
Powdered charcoal, vine charcoal, compressed charcoal, and charcoal pencils are pictured here. Each type of charcoal has its own characteristics and affords different possibilities.

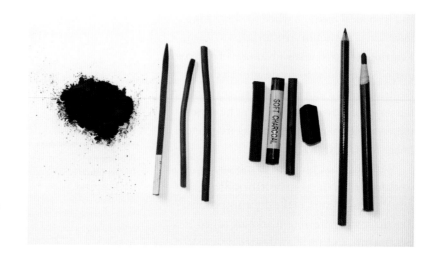

3.24 Types of graphite
Graphite can be purchased in powder form, sticks, and pencils. Producing a silvery range of values, it can be used with extraordinary control or spontaneous freedom.

Graphite

Graphite is a tonal medium preferred by many artists. It is portable and has great mark-making flexibility, enabling an artist to create beautiful values ranging from light to dark silver-gray. In stick form, graphite can be sharpened to a fine point, meaning that it is capable of rendering fine detail as well as spontaneous, expressive marks (**3.24**).

Ashley Oubré (b. 1984) uses a brush to apply powdered graphite, often in combination with other media, in the creation of detailed, photorealistic drawings (**3.25**).

3.25 Ashley Oubré, *Untitled Jelly*, 2014. Graphite and India ink on paper, 11 × 14" (27.9 × 35.6 cm). Collection of Robert Fontaine Gallery, Miami, FL
This artist used powdered graphite to create this highly representational photorealist drawing. This is a particularly good choice of medium because graphite allows the development of details and subtle variations of darks and lights necessary to establish a convincing effect.

3.26 Jasper Johns, *Flag*, 1955. Graphite and graphite wash on prepared paper, 8⅝ × 10⅛" (21.9 × 25.7 cm). MoMA, New York
Combining different types of graphite application, Jasper Johns created an expressive depiction of the American flag. Within this richly worked drawing we can see a wide range of graphite marks, demonstrating the range of possibilities that graphite offers as a medium.

Georgia-born artist Jasper Johns (b. 1930) draws with a combination of graphite wash and solid graphite to create familiar and iconic imagery (**3.26**).

Graphite can be purchased as powder and sticks, but the form of graphite most often utilized is the graphite pencil. Crude versions of the graphite pencil were used in the seventeenth century. The modern-day version is encased in wood (typically cedar).

This drawing by the French painter Jean-Auguste-Dominique Ingres (1780–1867) exemplifies how delicate and articulate a graphite pencil can be (**3.27**). The four figure studies shown here, each at different stages of completion, are all characterized by clarity and precision of detail. With an extraordinary use of the medium, Ingres combined crisp linear contours with sculptural mass, bringing forth a suggestion of both soft flesh and bony, three-dimensional anatomical structures.

Handled in a different way, *Max* is also made with graphite (**3.28**). For this portrait, powdered graphite was smeared onto the paper, the side of the pencil was used for expressive hatching, the tip of the pencil added sharpness and details, and an eraser was used to subtract graphite in the lightest areas.

3.27 (above) Jean-Auguste-Dominique Ingres, *Study for the Cadaver of Acron*, *c.* 1810–12. Graphite on paper, 7³⁄₄ × 14³⁄₄" (19.6 × 37.4 cm). Metropolitan Museum of Art, New York

For many, the graphite pencil is unmatched in terms of the control that it offers the artist. Analyze the subtle character of the lines in this drawing. Notice the meticulous and delicate soft shading. There is a sense of precision and accuracy throughout.

3.28 Stephen Gardner, *Max*, 2011. Graphite on paper, 24 × 20" (61 × 50.8 cm). Collection of the artist

Graphite can produce immediate, dramatic marks and it can also make slow, carefully drawn details. In this portrait of a young boy, graphite pencils and powder have been used additively and erasers have been used to draw subtractively.

3.29 Rosalba Carriera, *A Muse*, c. 1725. Pastel on laid blue paper, 12¼ × 10¼" (31 × 26 cm). J. Paul Getty Museum, Los Angeles, CA

Pastels give us the freedom to draw directly with color, and the powdery pigment can be built up to create rich and vibrant images. Pastels are ideal for colorful mark-making, but can also easily be blended and feathered, as seen in Carriera's drawing.

Scumble To lay a color on top of an already colored surface to create uniformity and/or visual texture.

3.30 Paula Rego, *Dancing Ostriches from Disney's "Fantasia"* triptych, 1995. Pastel on paper mounted on aluminum, each panel 59 × 59" (150 × 150 cm)

These large drawings are made with impasto layers of pastel, illustrative of how commanding the medium can be. Rego is known for her dramatic narrative works rich with mystery. These drawings are an interpretation of Walt Disney's *Fantasia* (1940).

Chalk Pastels

Chalk pastels are made by binding powdered pigment into stick-like cylinders, square sticks, or a pan format. Traditionally, such binders as gum arabic have been used, while methylcellulose has been commonly used by modern manufacturers. Chalk pastels provide the possibility of drawing directly with color, leaving visible strokes or creating smooth blends and gradations. In drawings where pastels are applied loosely, the ground will often remain partially exposed, meaning that

the color of the ground will have a great impact on the pastel colors that are used.

The Venetian painter Rosalba Carriera (1675–1757) was one of the first artists to use pastels for formal portrait commissions, which had the effect of popularizing the medium. In her work *A Muse*, the laid blue paper has a cooling effect on the entire drawing. In some areas of the drawing, such as the drapery over the shoulder, Carriera uses pastel to **scumble** over the surface, revealing other pastel colors underneath (**3.29**).

Pastels can also be applied in a solid manner so that they completely cover the drawing surface; in this case the color of the ground is not as important. Portuguese-born British painter and printmaker Paula Rego (b. 1935) builds thick layers of pastel media, known as impasto, in her triptych Dancing Ostriches. Her strong and direct marks complement the power of the monumental figures in the drawing (**3.30**).

Chalk pastels come in two varieties: soft pastels and hard pastels (**3.31**). Soft pastels are available in hundreds of colors. They are usually thicker than hard pastels. They are fragile, so they are often wrapped in paper. Soft pastels contain more pigment and less binder than hard pastels, so their colors are richer but typically more powdery. Soft pastels are easily smeared and are water soluble.

3.31 Types of chalk pastels
Different types of chalk pastels are readily available to the artist: soft pastels, hard pastels, pastel pencils, and pan pastels. Experimenting with each is the best way to learn their inherent pros and cons.

Hard pastels have more binder and less pigment than their soft counterpart, which results in the less brilliant colors of hard pastels. They are, however, also less fragile than soft pastels and can be sharpened to a point. They are often used to create detail, sharp edges, and can be applied as an underlying layer to be worked on top with soft pastels. Pastel pencils are essentially hard pastels made into pencils. All pastels work best when used on textured surfaces with a bit of tooth.

Pan pastels are a fairly new invention. They are soft, dry pastel dust packed in a pan, or dish. Like makeup, the dust can be applied with a sponge, brush, rag, stylus, or finger. Colors are easily blended, and they are fairly easy to remove or erase.

3.32 Georges Seurat, *Embroidery; The Artist's Mother*, 1882–83. Conté crayon on paper, 12¼ × 9½" (31.2 × 24.1 cm). Metropolitan Museum of Art, New York
Conté crayon used on a textured paper can produce a grainy surface appearance. This drawing of the artist's mother was made by applying the Conté in a rubbing-type of motion. As the artist made layers, darker values emerged. Notice the rich black areas that the medium allows.

Conté Crayons

Conté crayons were invented in the eighteenth century by the Frenchman Nicolas-Jacques Conté (1755–1805), who was also the creator of the clay-and-graphite recipe still used today for making graphite pencils. Conté expanded his original graphite formula by using other natural pigments to extend the color palette. Conté crayons have been a popular choice ever since.

In his drawings, the French Impressionist painter Georges Seurat (1859–1891) used a type of Conté crayon, a combination of carbon black and clay. By rubbing the media over rough paper he created a rich atmospheric and granular effect (**3.32**).

3.33 Types of Conté
Conté crayons come in a variety of forms to suit the artist and different applications. Traditional Conté crayons came in earth tones, but today many other colors are available as well.

3.34 (below) George Dawnay, *Testarossa*, 2018. Conté, 24 × 19" (61.1 × 48.3 cm). Private collection
This representational figurative drawing, made with Conté crayons, is a good illustration of the way in which the medium can be used dynamically. Examining the drawing we can find scratched lines that must have been made from the sharp edges of the Conté crayon. Other areas are covered broadly using the large, flat side of the stick.

Conté crayons are most commonly found in earth tones such as black, brown, and sanguine (red-brown), as well as in white, which is often used to create highlights. Today, larger color sets can be purchased. They perform in a similar way to hard pastels, but are less powdery. The small square sticks can jot down sharp marks or be turned on their sides to cover larger areas. Conté crayons are also sold in pencil format (**3.33**).

The English artist George Dawnay (b. 1970) creates a variety of marks by using the edges and sides of Conté crayons in his figure drawing. This drawing exemplifies the versatility that Conté crayons offer. The range of marks enlivens the surface of the drawing, enticing the viewer's eye to move throughout the work (**3.34**).

Oil Pastels

Oil pastels are a distinctively modern medium, first used during the twentieth century. Oil pastels are crayons made by cooking raw pigment with non-aggressive oil and wax binder. Unlike chalk pastels, they are oil soluble, water resistant, and free of dust.

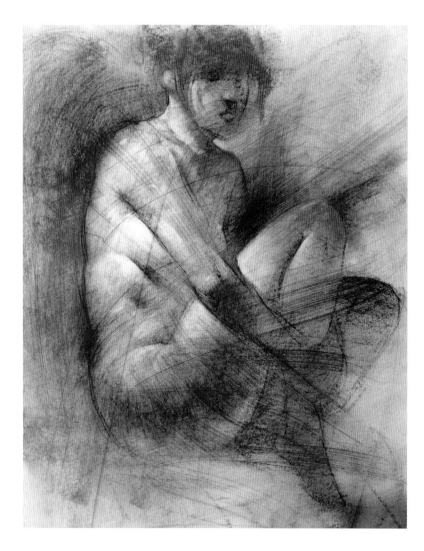

3.35 (above) Types of oil pastels
The slow-drying, buttery qualities of oil pastels can create colorful and dramatic effects. They are particularly apt for creating pronounced surface textures. They are a good choice for larger works, as small details can be hard to create with the medium.

3.36 David Hockney, "Study for *A Closer Grand Canyon* VII, Cheops Pyramid," 1998. Oil pastel on paper, 19¾ × 25½" (50.2 × 64.8 cm). Private collection

This oil-pastel drawing exhibits the vibrant layers of color that are such an appealing quality of the medium. The pastel is applied with big, bold marks. Notice how every color has another color underneath.

The dust-free characteristic, in particular, is an attractive quality to some artists. Oil pastels create a very strong bond with paper, as well as many other surfaces; they go on as a paste rather than as small chalk particles (**3.35**). They can be worked directly or diluted with turpentine, linseed oil, or other solvents. Oil pastels can be manipulated to create interesting surface textures by scratching and scraping

with razor blades, pallet knives, or other tools. Oil pastels harden very slowly, and never dry completely.

David Hockney (b. 1937) highlights the brilliant color potential that oil pastels offer in "Study for *A Closer Grand Canyon* VII" (**3.36**).

Colored Pencil

Colored pencils can be purchased in different compositions, such as wax-based, clay-based, oil-based, and water-soluble. Each contains a different mixture of pigments, waxes, binders, and additives, and has its own unique performance characteristics.

Colored pencil leads tend to be soft, and the extensive color palette available makes them an outstanding tool for blending and shading color drawings. The pencil form offers the artist much control and the ability to create fine detail. Colored pencils have a semi-opaque quality. They can be lightly layered to show the color of the previous layer, or to expose the paper color. With more pressure they can create solid and brilliant color effects. The American artist Wayne Thiebaud (b. 1920) uses colored pencil in his drawing *Rabbit* (**3.37**). As is often the case in his work, Thiebaud focuses on light

3.37 Wayne Thiebaud, *Rabbit*, 1970–71. Colored pencil on paper, 18½ × 23⅝" (47 × 59.9 cm). Private collection

This representational drawing of a rabbit was made with colored pencils. With skilled pencil technique the artist renders sharp edges and describes delicate texture. The variety of colors enables the creation of a truthful likeness.

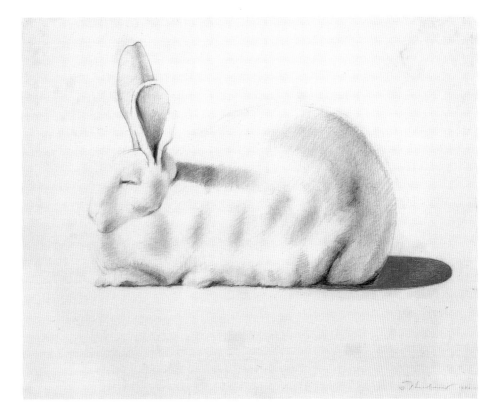

3.38 Types of colored pencils
Colored pencils can be purchased in traditional style, top, or water soluble, bottom. Useful for making simple sketches as well as complex color works, they are erasable, easily blended, and come in a huge range of colors.

3.39 (below) James Gurney, *Bartlett Burial Vault*, 2012. Watercolor and water-soluble colored pencils, 5 × 8" (12.7 × 20.3 cm). Collection of the artist
This drawing was made using both traditional colored pencils and water-soluble colored pencils. Combining the types of pencils in one drawing allows outcomes that are otherwise unachievable. This drawing's use of color enhances the beautiful sense of light.

and the perception of color when viewing ordinary objects.

Water-soluble colored pencils are a very popular choice, as they bridge the gap between dry and wet media. They can be used wet or dry, and can be layered to create brilliant effects (**3.38**). Contemporary artist and illustrator James Gurney (b. 1958) uses them skillfully to create a strong sense of light in his drawing of a burial vault (**3.39**).

Wet Media

Because of their fluid nature, wet media blur the line between drawing and painting. This can make you wonder: If I use a brush am I drawing or painting? Can I draw with paint, or is that painting? Some people characterize wet media as "drawing media" when they are used in a drawing manner, used on paper, or used to embellish line drawings. But it might be best to consider drawings on a continuum (a sliding scale) ranging from pure linear marks on one side of the scale to painterly puddles of color on the other side. Drawings can be located anywhere on such a scale, some created with mostly drawing characteristics (such as lines), others possessing very painterly qualities (such as brushstrokes), and still others being an intermingling of the two. Perhaps more important than determining whether a medium is meant for drawing or painting is to remember that most works, despite the media that were used to create them, can be appreciated in terms of their drawing qualities.

3.40 John Robert Cozens, *The Lake of Geneva*, c.1776. Ink and watercolor on paper, 9 × 14⅛" (22.9 × 35.9 cm). Tate, London, England

This drawing is made from a series of washes. Working from light to dark, the artist started with thin, transparent veils, adding more pigment to the wash with each successive layer. In the foreground of the landscape we can see the darkest washes. It is likely that these were added as finishing touches.

Wet media for drawing typically include watercolor and inks, but also extend to include any water-soluble drawing media, such as graphite, colored pencils, pastels, markers, and even water-soluble paints.

Wet media allow artists to create a *wash*. Washes are pigments that have been diluted with water or solvent to create transparent or semi-transparent glazes of color or value. Drawing with washes has long been considered especially suitable for landscape drawing, as it can create impressive atmospheric qualities in a work. The monochromatic landscape drawings of the British artist John Robert Cozens (1752–1797) influenced generations of artists to follow a similar technique (**3.40**). Modern artists continue to value washes as an effective and immediate way to develop drawings. Grace Hartigan (1922–2008) uses washes to establish values and lines in a bold, abstract style (**3.41**).

3.41 Grace Hartigan, preparatory drawing for *In Memory of My Feelings,* by Frank O'Hara, 1967. Ink on acetate, 13⅞ × 11" (35.3 × 28 cm). MoMA, New York
Washes offer the opportunity to draw with a brush. This ink drawing on acetate shows experimental line and wash work. Hartigan's abstract drawings often incorporate or derive from recognizable objects that are eventually lost to the viewer.

3.42 Ink marks (pour, blot, spray, sponge)
Ink, in common with other wet media, can be applied in many ways. Here the artist experimented (from left to right) by pouring, blotting, spraying, and sponging ink onto the paper. While these are only samples, the possibilities for practical uses in a drawing are endless.

Inks

For millennia, ink has been a staple medium for those who draw. It is a flexible medium that can be applied in a variety of ways, using a range of tools that result in different effects. Inks can be applied with brushes and dip pens to create characteristically varying lines. Reservoir pens and technical pens dispense inks in a consistent and precise way. Artists can experiment with ink techniques that result from such applications as pouring, blotting, spraying, and sponging (**3.42**).

Dox Thrash (1893–1965), known for his realistic depictions of African American life during the twentieth century, applies ink to his drawings boldly. This drawing illustrates the former slave cabin where he and his wife raised their four children, and captures the process of gathering, washing, and hanging laundry (**3.43**).

The Chinese artist Xia Gui (1195–1224) uses ink with a variety of application techniques, making lines, dots, and calligraphic marks as well as soft washes and modeling to create a mystical landscape (**3.44**).

3.43 Dox Thrash, *Monday Morning Wash*, 1938–39. Graphite, ink, and gouache on paper, 11¾ × 15" (29.8 × 38.1 cm). Georgia Museum of Art, University of Georgia, Athens, GA
This drawing employs bold forceful lines and robust ink washes. By using such strong darks, light areas appear even brighter. Ink is an excellent medium for artists who wish to make such bold and confident drawings as this one.

TIP

When it comes to exploring media, experiment, experiment, experiment!

The Work of Art Xia Gui

Who: Xia Gui
Where: China
When: Early thirteenth century
Materials: Ink on silk

Imagine walking down the streets of Hangzhou, China, during the Southern Song Dynasty (1127–1279). You would be in the capital city of the era's largest and most advanced civilization. Commercial, technological, and cultural advances abounded; in beautiful restaurants, teahouses, and Buddhist temples, people gathered for festivals, games, and theater. This period in Chinese history became known as "the Chinese Renaissance."

The Southern Song Dynasty is famous for its many innovations. China during the Southern Song era was the first nation to see widespread printing processes and the resulting rapid growth of literacy. The earliest paper currency appeared during these times, leading to commercial expansion and economic wealth. Despite the widespread custom of foot-binding, which ensured that women would retain child-sized feet, in some respects women enjoyed progressive rights for the time: they were allowed to own property and petition for divorce.

Artistic Aims

The Southern Song culture appreciated an aesthetic way of life, one that conveyed both a sense of fleeting beauty and worked in sync with the Tao, the Chinese principle that loosely translates as "the Way." A holistic conception of the essence that creates the natural world, the Tao is usually described in terms of elements of nature, water being prime among them. Hence Hangzhou's West Lake, visible at the bottom of the drawing, was a great source of inspiration; even today it is considered one of China's most beautiful places.

Artistic Challenges

Because much of this work was created with an ink wash, Xia Gui had to carefully consider each movement he made and each stroke of his paintbrush: once made, many of his artistic choices became irrevocable. Furthermore, the radical simplicity of his figures, trees, and buildings presented another challenge: how far could he refine or streamline these elements while keeping the subject matter immediately apparent?

Artistic Method

Artists of the period mastered the combination of high technical standards and expressive images of nature. Intimate foreground scenes made from calligraphic marks were placed into direct contrast with vast and seemingly infinite background spaces. In Xia Gui's *Mountain Market*, for example, the foreground rocks, trees, and small buildings are connected by a meandering road. People on their way to the market provide a human scale to the expansive landscape. The artist used ink wash techniques to make the mountains in the background appear to vanish into the misty air. Most importantly, Xia Gui has captured the peaceful and tranquil spirit of the mountain market.

The Results

Xia Gui, who was likely to have been born in Hangzhou and who served in the Imperial Painting Academy, is considered by many to be the highest master of this style.

3.44 Xia Gui, *Mountain Market, Clearing Mist*, early thirteenth century. Album leaf, ink on silk, 9¾ × 8⅜" (24.8 × 21.3 cm). Metropolitan Museum of Art, New York
For centuries, Chinese artists have used ink to create striking works of art. As modern artists, we can study their techniques to improve our drawings. This thirteenth-century masterwork is an example of how contrast—soft and hard, light and dark—can enrich the impression of atmosphere in a drawing.

> ## Sketchbook Prompt
>
> Using ink and a brush in a sketchbook, draw a landscape. Try to capture the mood and atmosphere of the space by replicating the dark and light areas that you see. Can you capture both detail and vastness?

3.45a and **b** (above) Inks: non-waterproof and waterproof; (above right) ink tools
The diagram on the left shows two lines, the first made with non-waterproof ink and the second drawn with waterproof ink. It is predictable what happens when water is brushed over them. The diagram on the right displays an assortment of tools that can be used to apply ink: (from left to right) brush, bamboo dip pen, quill pen, and mechanical pens.

3.46 Salvator Rosa, *Two Men Seen Three-Quarter Length*, n.d. Pen and brown ink, brown wash, 3½ × 3¼" (8.8 × 8.2 cm). Metropolitan Museum of Art, New York
While many people try to avoid getting water onto drawings made with non-waterproof ink, this artist utilizes bleeding ink to his benefit. After sketching the figures, the water was brushed over the lines to melt the ink, creating subtle shadows.

Inks are available in both waterproof and non-waterproof varieties. Waterproof inks provide permanence, while lines made with non-waterproof inks will bleed when wet (**3.45**). The Italian painter, poet, and printmaker Salvator Rosa (1615–1673) takes advantage of the non-permanent quality of his medium to soften lines and blend the ink into washes in *Two Men Seen Three-Quarter Length* (**3.46**).

Historically, inks were made only in variations of black and brown. Often, these inks were not completely archival, because they faded or did not remain fast to the page. Today, manufacturers have developed diverse inks that offer not only a wide range of colors, but also improved permanence and archival qualities. Other advances in artist inks include enhanced flow characteristics, improved opacities, and environmentally conscious products.

Watercolor

Watercolor, a water-based paint, is traditionally made from pigment and gum arabic, or another type of water-soluble binder. The transparency of watercolors allows color to pass through them, either from the drawing surface or from the previous layer of color. Watercolors can be reconstituted by adding water, which allows the artist to continue work even once his or her palette has dried.

Watercolors come in tubes and pans (**3.47**). Many artists find tube paints ideal for in-studio use, as they are particularly good for mixing large quantities of paint that may be needed for large drawings. Tube paints dissolve easily in water and it is possible to mix highly concentrated colors. One disadvantage of

3.47 Types of watercolors
This image shows two types of watercolors that can be purchased: pans and tubes. While both have advantages and disadvantages, it is the artist's prerogative to choose which works best.

tube paints is the possibility of wasting paint when it is hard to judge how much paint is needed. Pan colors have different advantages and disadvantages. They are compact and easy to transport, and so are ideal for traveling and on-site work. Properly protected, they will store indefinitely, and so there is little waste. The disadvantages of pan colors are that they tend to yield smaller quantities of color and can be hard on brushes, as pans need agitating with a wet brush to reconstitute the color. Also, watercolors sold in pans tend to be more expensive than the same amount of tube colors.

Watercolor techniques have arisen in many cultures around the world. The first prominent styles of watercolor emerged in the Far and Middle East. Perhaps the oldest continuous tradition has its origins around 4000 BCE in China, and techniques have been developed ever since. While still retaining precise linear work from the influence of ancient Chinese artists, early Japanese painters added watercolor to their works in a very delicate manner. This flower painting by Tani Buncho (1763–1840) is an example of Japanese watercolor (**3.48**). Notice the limited palette of colors. Here the goal of adding watercolor was to reinforce the natural characteristics of the subject, not necessarily to depict light or atmosphere. Those ideas emerged later in the Western tradition of watercolor.

Such British artists as J. M. W. Turner (1775–1851) refined the expressive and illusionistic possibilities of watercolors. Based on a Swiss landscape, Turner's *Goldau, with*

3.48 Tani Buncho, hanging scroll, n.d. Ink and watercolor on silk, 32⅜ × 13½" (82.2 × 34.3 cm). British Museum, London, England
This floral work shows a delicate use of watercolor. The limited colors used in the work help to clarify the illustration. The soft gradation found on each leaf and every petal adds to the picturesque quality of the image.

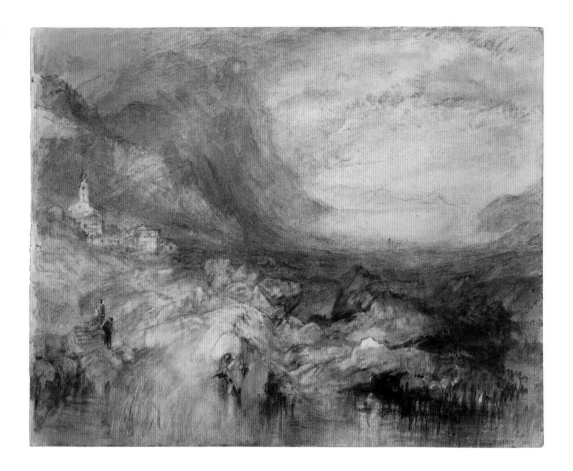

3.49 J. M. W. Turner, *Goldau, with the Lake of Zug in the Distance: Sample Study*, c. 1842–43. Graphite, watercolor, and pen on paper, 9 × 11⅜" (22.8 × 29 cm). Tate, London, England
Often starting his watercolors with sketchy pencil line work, Turner would then aggressively add washes. The brilliant layering of luminous colors creates depth and light. Parts of this work are clearly representational while others become abstracted as they are obliterated with atmosphere.

3.51 (below) Martin Longmore, *Car Design (Alien Car)*, 1984. Marker pen, silhouetted on card, 16½ × 23⅜" (42 × 59.4 cm). Victoria and Albert Museum, London, England
Markers can quickly add clarity to design drawings. They come in solvent-based or water-based ink varieties. Professional quality markers are characterized by higher pigment content and lightfastness. This car design is enhanced by the use of color.

the Lake of Zug in the Distance displays how the transparency of watercolors can create a stirring and luminous atmosphere (**3.49**).

Markers

A mid-twentieth-century invention, the classic marker is a type of container filled with wadding that wicks ink to a soft tip. Markers provide consistent, permanent, and quick-drying colors. They are available in archival-grade brilliant colors, as well as in gray scales (**3.50**). Markers are highly useful in design fields, but they are also important to many fine artists.

The automotive and motorcycle designer Martin Longmore draws with markers when designing cars. In this marker drawing, we can see his excellent skills, used here to imply the shine and reflections that we would expect from such a modern vehicle (**3.51**). The German

3.50 (above) Markers
A wide variety of markers can be purchased from many different manufacturers. They are very commonly used in design fields as they provide fast, convenient, consistent, and brilliant color.

3.52 Oliver Zwink, *Blocks #1*, 2000. Marker pen on tracing paper, 11¾ × 16½"
(29.7 × 42 cm). Plancius Art Collection, Amsterdam, The Netherlands
Although markers are primarily used in the design world, fine artists have found
uses for them as well because they come in so many different colors and are so
easily workable. This marker drawing utilizes a range of colors, each applied by
either directional marks or cross-hatching.

artist Oliver Zwink (b. 1967) uses markers in
the creation of his colorful imagined structure
in *Blocks #1* (**3.52**). While markers can be used
on nearly any surface, there are papers that
have been designed specifically for markers
in order to resist bleeding.

Digital Media

Frieder Nake (b. 1938), one of the pioneers of
digital art, produced his first digital drawings
in 1963. His digital drawings are often generated
by a computer, using algorithms based on
paintings or other imagery (**3.53**).

As digital technology has expanded, so
has the potential for using it as a drawing tool.
As with other media, digital drawing can be
used by itself or in conjunction with other
media. Although digital media provide some
shortcuts, to be skilled still requires much
dedication and hard work. With a tablet and
software an artist has an infinite choice of

3.53 Frieder Nake, *7.4.65 Nr. 1 + 6*, 1965. Ink on paper, plotter drawing,
using Zuse Graphomat, 9 × 13⅜" (23 × 34 cm). Private collection
Digital technology is yet another medium creative people can use. It offers
powerful versatile platforms for drawing. Computers can generate drawings,
and offer myriad new means to visualize ideas and explore imagery.

TIP

There are an infinite number of ways that digital technology can be used to help in the creation of a drawing. Consider how you could manipulate one of your own drawings with a computer.

3.54 (above) Nathalie Savoie, *Figure 5*, 2015. Acrylic on canvas, pencil on paper, and Photoshop, 8 × 8" (20.3 × 20.3 cm). Private collection
This work demonstrates the possibilities of mixing traditional art supplies with digital media. Drawings can be layered, scanned, and digitally altered, while computer images can be printed and enhanced by hand. Some artists move back and forth between digital and traditional media.

digital drawing tools. Currently, software can digitally replicate the look of brushes, markers, pencils, textures, and just about any other mark-making tool that one can conceive of. Pens and tablets have become increasingly tactile and sensitive to the artist's touch. Drawings can be enhanced through animation and 3-D software. Drawings made by hand can be photographed and imported to digital platforms, where they can be manipulated further. By the same token, digital art can be printed on paper, canvas, or other surfaces, and then drawn over further in other media by hand. The Canadian animator and graphic designer Nathalie Savoie uses traditional materials in combination with digital media. In **3.54**, Savoie combines hand-drawn pencil line-work with acrylic paint and digital effects.

A great advantage to digital drawing is that digital drawings can be saved, both during the creative process and finally as finished works. This risk-free environment encourages experimentation, allowing for trials of a variety of possibilities before committing to one approach. With experience some artists find rendering in a digital environment to be faster, more forgiving, and more efficient than traditional methods.

Mixed Media

Most drawing media can readily be combined and mixed as an artist wishes. Mixed media, meaning the use of more than one medium in a work, can produce effects—unexpected textures, vibrant color mixtures, interactive combinations— that cannot be produced in any

3.55 Robert Rauschenberg, *Religious Fluke*, 1962. Transfer drawing, graphite, washed colored pencil, watercolor, and acrylic on paper, 23 × 29" (58.5 × 73.6 cm). Solomon R. Guggenheim Museum, New York
This non-objective work was made with many different materials. It exploits the natural qualities of each medium to enhance the overall piece. For example, when lines are desired the artist uses graphite, but when large areas of color are needed, watercolor is used.

other way. Throughout his career, the American painter Robert Rauschenberg (1925–2008) found exciting ways to combine materials. In *Religious Fluke*, he combines transfer drawing, graphite, washed colored pencil, watercolor, and acrylic on paper (**3.55**).

Some artists incorporate found objects into their drawings. In his work, Whitfield Lovell (b. 1959) often juxtaposes portraits of anonymous African Americans with found objects. This is Lovell's way of making connections with America's history between the Emancipation Proclamation and the Civil Rights Movement. The pairings also seem to suggest the personalities or life experiences of the persons depicted (**3.56**).

3.56 Whitfield Lovell, *Kin XLVI (Follie)*, 2011. Conté on paper and shooting gallery target, 30 × 22¾ × 2" (76.2 × 57.8 × 5.1 cm). DC Moore Gallery, New York
This mixed-media work combines drawing with the addition of a found object. Placing these together encourages us to question what they have in common, or how they might clash. What is your opinion?

Drawing at Work Kiki Smith

Imagine having an idea that inspires you to make a drawing. What kind of paper would you use? What medium would you use? Which materials would enhance the message that you are trying to express? Kiki Smith (b. 1954) asks herself these kinds of questions when she makes a drawing.

Smith never restricts herself to one medium. Always exploring new possibilities, she has become well known for her sensitive use of media and also drawing surfaces. Her work *We See Each Other* confirms that the right choice of media can enhance a drawing's message (**3.57**).

Smith utilizes mixed media in her work. *We See Each Other* is drawn with black and colored ink. The surfaces are embellished with glitter, and with silver and gold leaf. Two colors of birds—blue and pale brown—populate the tree branches. The surrounding sky is decorated with stars. A lightbulb hanging from a low branch radiates glitter and sparkles. The choices of materials flash throughout the work, transforming an everyday natural scene into a mystical and symbolic representation.

Smith is an artist uniquely attuned to drawing surfaces and their possibilities. The paper for *We See Each Other*, as with many of her other drawings, is handmade in the Himalayas of Nepal. These papers, made from the long fibers from the lokta plant using traditional Nepalese techniques, are available in large sizes. Although fragile in appearance, Nepalese paper is actually very durable and resistant to tearing, and is also prized for its semi-transparent quality and attractive texture. For Smith, Nepalese paper serves as a powerful medium of expression. Her linear drawing style works in tandem with the trembling surface of the paper that offers an atmospheric world, imbued with life.

In *We See Each Other* we witness the celebration of nature and a love for living things. In combination with her choice of materials, Smith's motifs of birds, stars, and lightbulbs (which appear elsewhere in her work) explore ideas about physical existence as well as the spiritual world.

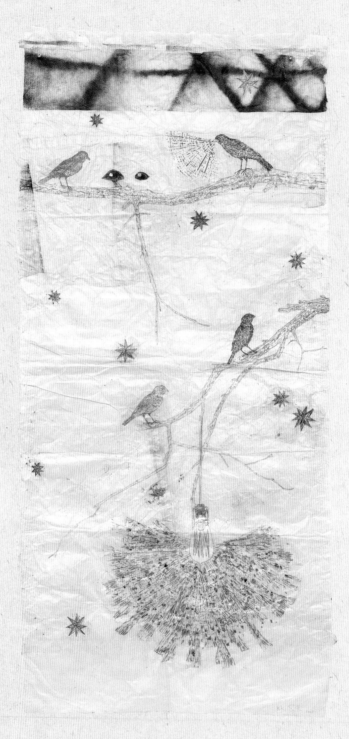

3.57 Kiki Smith, *We See Each Other*, 2010. Ink on Nepalese paper with glitter and silver and gold leaf, 59⅜ × 28¼" (150.8 × 71.8 cm). Private collection

Tools

Artists have always been inventive with their tools in order to obtain the effects they wish to produce. There are countless drawing tools (in addition to the ones listed here), but some have been used again and again and have proven to be indispensable. Every instrument has its strengths and limitations. With practice and experimentation, you can learn how each tool can enhance your own work.

Erasers: Erasers range from soft to abrasive (**3.58**). A wide range are available, including gum erasers, kneaded erasers, vinyl erasers, and electric erasers.

3.58 Erasers
Selection of erasers, from left to right: vinyl eraser; kneaded eraser; pen eraser; rubber eraser; black eraser. Each has been manufactured to provide the best possible solution when erasing various different media from diverse surfaces.

Blending tools: Typically, it is not recommended to blend a drawing with bare fingers, as oils from the skin can affect the media and paper. Tools for blending include chamois cloth, blending stump, and tortillion (**3.59**).

Sharpeners: It is important to keep a proper point on a pencil or drawing stick. A point can be sharpened by hand with a knife or sandpaper, or by using a manual or electric sharpener (**3.60**).

Brushes: Generally, artists consider two primary characteristics when choosing a brush: (1) size and shape, and (2) types of hair, natural and synthetic.

The size and shape will dictate the types of marks that can be made. Generally, larger brushes are used for large areas and small brushes are for small areas and details. The number found on the side of the paint brush refers to the thickness, length, and width of the bristles, but (to make matters confusing) this numerical size varies among manufacturers. A brush labeled with an "8" may be smaller or larger than an "8" brush by a different company.

The shape of the brush will yield different marks and can help to produce different effects.

3.59 (below) Blending tools
This diagram displays a variety of blending tools. Chamois cloth, blending stumps, and tortillions are all tools designed for blending dry media.

3.60 (above) Sharpeners
For sharpening pencils and drawing sticks, artists and designers use one-hole manual sharpeners, sharp knives and blades, as well as many other tools. The choice usually depends on the point that is desired.

3.61 Brushes
Here, many different brushes are displayed. They range in size, shape, and bristle. The design of any individual brush offers particular advantages suitable for various different techniques and choices of media.

Finding the best-shaped brush for the job sometimes takes some experimentation. Below is a list of commonly used brush shapes, and some advantages of using them (**3.61**).

- Flat: The bristle length is twice as long as the width. Flat brushes are good for covering large areas.
- Bright: The width is equal to the length, allowing for more control.
- Filbert: Similar to a flat brush, but with round edges making it a multi-purpose brush.
- Round brushes: Bristles are arranged in a round metal ferrule. This type of brush is often used for details.
- Mop: This shape of brush has a large amount of absorbent bristles, making it suitable for applying large amounts of media. This type of brush is favored by watercolorists.
- Angled: The bristles are cut at an angle, making it an excellent brush for creating flat planes or sharp edges.

The type of hair that a brush is made of determines its purpose and quality. Stiff bristles will often leave brushstrokes. Such visible marks are often desired by artists for expressive and textural reasons. Softer bristle brushes are often preferred for smooth blending or for delicate applications of media. Generally, the bristles of a brush are made from one of three materials:

- Natural hair: These brushes are made from the hair of sable (a mammal of the weasel family), hog, squirrel, and others. While expensive, these brushes are some of the best quality brushes available as they perform well and are long-lasting.
- Synthetic: Typically made from nylon or polyester fibers, synthetic brushes are very versatile. They can be used with many different media, and are usually less expensive than brushes made of natural hair.
- Combination: These brushes combine natural hair and synthetic fibers, giving the artist qualities provided by both types of bristles.

Safety Issues

Whether considering the use of dry media or wet media, artists must keep in mind the inherent safety issues of any media. It is good practice to assume that all materials could be potentially harmful. To begin to understand the risks associated with particular materials,

carefully read the information on the packaging. For more in-depth information, consult the Material Safety and Data Sheet (MSDS). The MSDS is a document that all manufacturers are required to provide to describe the hazards of their products; typically, it reports risks, safety issues, and effects on the environment. It also describes how to work with the product in a safe manner. MSDS documents are often available online, or from retailers.

Following elementary precautions will help diminish risks and improve safety. Key precautions include working in well-ventilated spaces, keeping a clean working area, avoiding the consumption of food, beverage, or tobacco products while working, and regularly washing hands. Important for any working artist is the use of appropriate protective equipment, such as eye protection, respirators, and gloves. Detailed information about safety procedures and equipment can be found through the Occupational Safety and Health Administration (OSHA) in the United States, or from the Health and Safety Executive (HSE) in Great Britain.

In the Studio Projects

Fundamental Project

Explore drawings made from different media. Collect images in a digital slide show.

Observational Drawing

Draw the same object four times using four different papers or surfaces and four different (or different combinations of) media. Choose media from those listed in this chapter or experiment with others. When complete, analyze the drawings as a group. What materials did you enjoy working with the most? How is the image affected by the change in medium?

Non-Observational Drawing

This assignment explores material interactions. On 4 × 5" samples of different types of drawing paper, experiment with different combinations of media. Mix two to five materials in each sample. Try to make interesting color, value, and mark-making effects with each. Label each sample with the media and paper used. Make a total of between ten and twenty samples.

Criteria:

1. You should collect five examples of drawings made with dry media, and label each with the artist's name and media used.
2. You should collect five examples of drawings made with wet media, and label each with the artist's name and media used.
3. You should collect five examples of drawings made with digital media, and label each with the artist's name and media used.

Criteria:

1. The drawings should take advantage of the qualities that each medium offers. Each drawing should demonstrate an in-depth experimentation with the chosen medium or media.
2. The overall appearance of each drawing should contrast from the others because of the use of media.
3. You should be able to articulate your experience verbally or in written form.

Criteria:

1. The samples should take advantage of the qualities that each medium offers.
2. Each sample should demonstrate an in-depth experimentation with mark-making.
3. Each of the ten to twenty samples should be appropriately labeled demonstrating a variety of experiments.

Materials: Digital slide show

Materials: Mixed media and four assorted papers (size optional)

Materials: Mixed media and ten to twenty 4 × 5" assorted papers

Part 2

How to Draw

In these chapters, you will learn a practical method for producing a drawing. By employing the specific compositional strategies and by practicing the step-by-step drawing process, you will find that your drawings improve immeasurably. These chapters offer many useful strategies and tips for starting and refining your work. In addition to drawings made on a single sheet of paper, we will examine examples of drawings made in sketchbooks, offering inspiration for your own practice. You will be encouraged to draw in your sketchbook every day, starting with the prompts and projects in this book. These chapters will guide you and provide an excellent foundation from which you can develop your individual creative direction.

Chapter 4
Composing a Compelling Drawing

Composition The overall design or organization of a drawing.

A primary goal for any artist is to create a work the parts of which all contribute to a coherent whole. Strong drawings take into consideration how the various parts of a drawing interact visually. The organization or arrangement of the different parts in a drawing is referred to as the **composition**.

When composed well, a drawing possesses completeness or wholeness, where every component stands in its correct relation to everything else, and nothing appears extraneous or redundant. On the other hand, a drawing done with little consideration of composition tends to leave a viewer feeling that it is lacking and incomplete. Compositional choices are some of the first and most important decisions to make when starting a drawing, beginning with the size and shape of the paper. What size paper should be used? Should the paper be oriented vertically or horizontally? Where should an object be placed on the paper? How big or small should the object be in relationship to the paper? With so many decisions to make, it is good to know that there are proven strategies to assist in composing a compelling drawing. This chapter discusses many of these strategies.

Format

The **format** of a drawing refers to the size and the shape of the drawing surface. The format should be considered in the early stages of the drawing process, as all subsequent decisions are made in relationship to this. Whether you choose to draw within a square, horizontal, or vertical area, your decision significantly affects the way your work will be perceived. There are certain intrinsic qualities to the orientation you choose. For many people, horizontal shapes tend to read as more passive, and vertical ones appear more dominant. The horizontal format also echoes the horizon line and suggests a panoramic view, and so is often chosen for landscape work (see Chapter 17, p. 330). The

vertical format implies upward and downward movement and has traditionally been used for portrait drawing (see Chapter 6, p. 312).

Many artists regularly experiment with a variety of formats to explore the full range of their artistic expression. Some artists, such as Elizabeth Murray (1940–2007), abandon the traditional rectangular format altogether. Irregular formats seem appropriate for her angular abstractions. Her works are not focused on convincing the viewer of an illusionistic three-dimensional space. Instead, Murray's unusual shapes disrupt our expectations, and remind us that the drawn object, a lithograph in the case of *Up Dog*, is two-dimensional (**4.1**).

Format The size and shape of a work of art.

> **TIP**
>
> A drawing can be considered in terms of its flat surface and/or the imaginary space that it suggests.

4.1 Elizabeth Murray, *Up Dog*, 1987–88. Lithograph on 14 sheets of torn and pasted paper, 52 × 36⅜" (132.2 × 92.3 cm). MoMA, New York
The size and shape of a drawing is an important consideration for the artist. The irregular format of this work, which was assembled from fourteen sheets of paper, came about through the process of abstracting an image of a dog. Its unusual shape is a key feature as it highlights the idea of a fragmented image.

4.2 Albrecht Dürer, "Perspective Machine," 1525. Print from *Dürer und Seine Zeit*, by Wilhelm Waetzoldt (Grosse Phaidon Ausgabe, 1936)
Albrecht Dürer's diagram illustrates the relationship between the artist, the picture plane, and the object being drawn. The picture plane is the flat surface onto which an image is drawn.

4.3 Egg carton, closed composition

4.4 Egg carton, open composition (1)

4.5 Egg carton, open composition (2)
Before beginning to draw it is important to consider where your subject will be placed on the picture plane. Here, simply by zooming in or placing the egg cartons to the right or left, we see three distinct options. The configurations shown here are only a start—there are many more possibilities.

The Picture Plane and the Ground Plane

When making and viewing drawings, two opposing notions should be considered: the drawing's flatness and its illusion of space. When composing a drawing on paper it is important to understand that you are working on a flat surface. Similar to the drawing surface, the **picture plane** can be conceived as a flat and vertical window-like surface through which the viewer looks to see a representation of the world. It is as if you are looking through a sheet of glass and tracing the shapes of the objects on the other side. This woodcut by Albrecht Dürer (1471–1528) diagrams this very concept (**4.2**). Clearly, when drawing on paper it is not practical to set up the picture plane—your drawing paper—in your line of sight. It would block your view. It is, however, a very important concept to keep in mind when considering space and illusionistic forms.

Conventionally, the material surface of the drawing is considered equivalent to the picture plane. This flat surface is rich with possible arrangements. Even when viewing the same subject matter, zooming in or shifting one's gaze to the right or left can dramatically affect a composition (**4.3–4.5**). The first image is an example of a **closed composition**, which is a composition that includes the entire subject

Picture plane
An imaginary plane corresponding to the surface of a picture; the extreme foreground of a drawing.

Closed composition
A type of composition in which the entire subject exists within the picture plane.

Open composition A type of composition in which parts of the subject extend beyond the picture plane.

Plane A flat surface. Planes can be the fundamental structural unit of a drawing.

Ground plane
The horizontal "floor" surface of a drawing, extending into its imaginary space.

within the picture plane. The second and third images are **open compositions**. Open compositions, in which the subject is cropped by edges of the picture plane, tend to feel more dynamic as they give the viewer only a portion of an apparently fuller image. We feel closer to the subject and therefore feel as if we are within the illusionary world.

In contrast to the flat picture plane of the drawing is a **plane** that moves into the imaginary space of the drawing, the **ground plane**. This spatial movement is an important concept as it relates to the illusion of space and to linear perspective, both of which we will address further in Chapter 11 (p. 216). The ground plane starts at the bottom of the picture plane and stretches back into the distance. You might consider it the "floor" of the imaginary space. In the egg carton diagrams, notice the relationship between the ground and picture planes. Objects, or parts of objects, at the top of the picture plane tend to correspond with objects in the distance, or toward the back of the ground plane. Objects toward the bottom of the picture plane are seen to be those closest to the viewer.

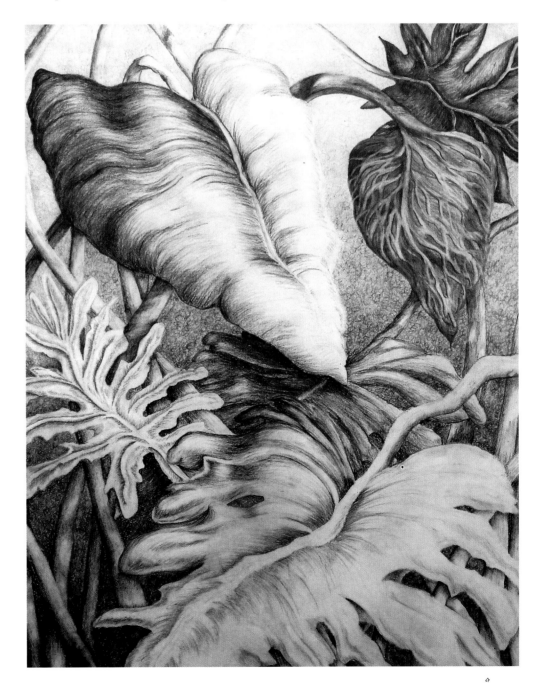

4.6 Student work. Christina Budres, *Organic.* (Instructor: Victoria Paige) The student who made this drawing chooses to focus on a specific part of a larger subject. Similar to using a zoom lens on a camera, she effectually crops the outer edges of the still life to create an open composition, implying that there is more of the still life than has been portrayed. As a result, the viewer feels closer to the subject.

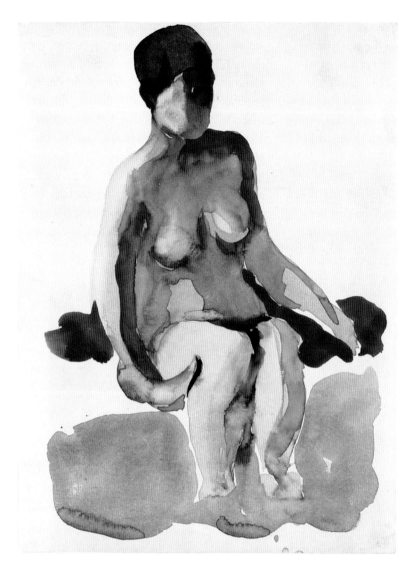

Geometric Divisions of the Picture Plane

We can conceive of objects throughout space as part of a flat compositional arrangement. A common approach to composing a drawing is to divide the picture plane geometrically. Using a geometric framework to guide the placement of items in a drawing, despite their location on the ground plane, provides desirable visual harmony and visual predictability. There are many traditional geometric schemes that can be used. A few are discussed below.

A simple geometric compositional plan is to place the items in a drawing in a manner that follows a simple geometric shape, such as a triangle, circle, or square. In this drawing by Georgia O'Keeffe (1887–1986), the figure is arranged in a triangular shape (**4.7** and **4.8**). The result is a stable and visually pleasing composition.

Another time-tested practical scheme for achieving a satisfying composition is the **Rule of Thirds**. By dividing a page into thirds, both vertically and horizontally, an evenly spaced grid is created. The four intersections of the grid lines are ideal locations to place the main subject of a work, helping avoid a central placement of the subject, which is not always the most interesting compositional choice. By analyzing *Windmills near a Body of Water*, a drawing by Dutch painter and printmaker Jacob van Ruisdael (1628–1682), you can see how the Rule of Thirds guides the effective placement of such important objects as the cliff and the windmill (**4.9** and **4.10**). Even if applied only approximately, the Rule of Thirds still gives reliable suggestions for compositional placement.

4.7 Georgia O'Keeffe, *Seated Nude X*, 1917. Watercolor on paper, 11⅞ × 8⅞" (30.2 × 22.5 cm). Metropolitan Museum of Art, New York

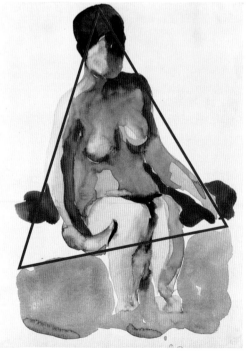

4.8 Superimposed triangle applied to O'Keeffe's *Seated Nude X*
The figure in this drawing loosely corresponds to a triangular shape. This could have been intended by the artist, or it could have happened more intuitively. Either way, by conforming to a simple geometric shape, the parts of the drawing are united.

Rule of Thirds
A compositional scheme whereby objects are placed according to the intersections of one-third divisions of the picture plane.

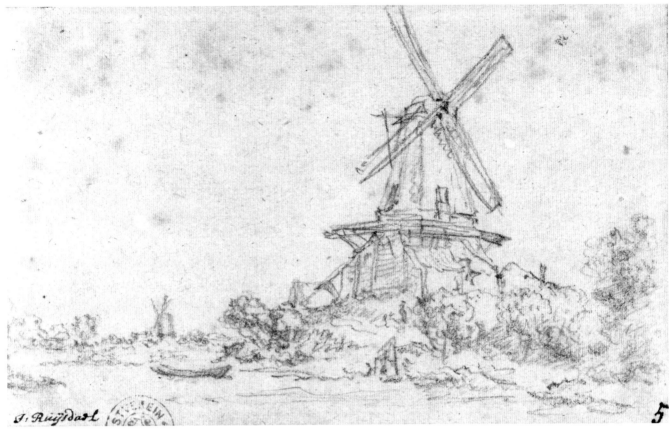

4.9 Jacob van Ruisdael, *Windmills near a Body of Water*, *c*. 1655. Black chalk, 3¾ × 6⅛" (9.4 × 15.7 cm). Kunsthalle, Bremen, Germany

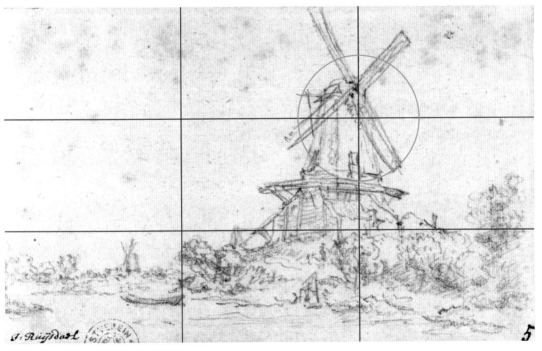

4.10 Rule of Thirds grid applied to Ruisdael's *Windmills near a Body of Water*
Ruisdael's drawing exemplifies how an artist can use the Rule of Thirds. Notice how the placement of objects in the drawing coincides with the division of the picture plane into thirds and the intersections of the grid lines.

4.11 Golden Rectangle
To construct a Golden Rectangle, start with a square. Use the distance from the midpoint of the bottom of the square (M) to an opposite corner (C) as a radius to draw an arc that will define the length of the rectangle (E). A Golden Rectangle (and its divisions) is said to be one of the most aesthetically pleasing rectangular shapes, and ideal for a drawing.

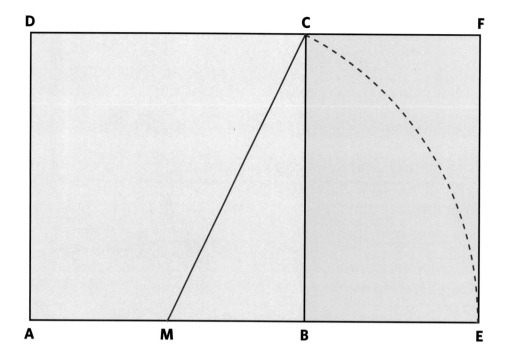

4.12 Golden Spiral
The Golden Rectangle can be progressively subdivided into smaller Golden Rectangles. By doing this a pattern will emerge from which a spiral can be drawn. This spiral, known as the Golden Spiral, follows the Golden Section. This age-old geometry can be used to plan the harmonious placement of objects within a drawing.

Golden Section
A geometric relationship that has been employed by artists since Classical times. Its divisions, such as the Golden Rectangle and the Golden Spiral, can be used to place objects harmoniously in a drawing.

The **Golden Section** is a unique geometric relationship that has been employed by artists since Classical times. It is a ratio of proportion that states that the relationship between two quantities, *a* and *b*, is as follows: when the larger part (*a*) is divided by the smaller part (*b*), the ratio is the same as when the combined total (*a+b*) is divided by the larger part (*a*). Therefore, a/b = (a+b)/a. (This ratio is also designated by the Greek letter *phi (f)*, where a/b = f.) Also referred to as the Golden Proportion, Golden Mean, or Golden Ratio, this geometric relationship can otherwise be expressed approximately in the numerical ratio 1.618 : 1.

The Golden Section abounds in beautiful forms in nature, and it can also be applied to help achieve harmony in artistic compositions. Conforming to the Golden Section, various proportionate divisions can be established, such as the Golden Rectangle (**4.11**) and the Golden Spiral (**4.12**). These proportional relationships are surprisingly fruitful frameworks to use when planning the placement of objects within the configuration of a drawing.

4.13 William Bailey, *Montepulciano*, 1996. Aquatint with hard ground etching, 19³/₄ × 16" (50.2 × 40.6 cm). Edition 25

4.14 (below) Superimposed grid applied to Bailey's *Montepulciano*
Notice how the components of this image have been strategically placed to follow geometries. Particularly calculated is the way that the still-life objects align with the geometry of the background.

As long as they relate to the overall proportions of the drawing, other types of geometric division can also lead to a harmonious composition. For example, the superimposed diagram over *Montepulciano*, a print by William Bailey (b. 1930), reveals the underlying geometric regularities that structure the composition as a whole (**4.13** and **4.14**).

Composing a Drawing with the Organizing Principles of Design

By studying great works of art, you will begin to notice that they have certain underlying qualities in common. They tend to share an organizational agreement among their parts. This holistic harmony seems to be a result of a remarkably short list of principles, referred to as the **organizing principles of design.** Although there has long been debate over the "perfect" set of principles, they commonly

include: unity, balance, emphasis, focal point, pattern, rhythm, variety, contrast, scale, and proportion.

It is important to remember that there is an inherent interrelationship between these principles. This means, as we will see when we examine each individually, that more than one can be used at a time and they often support and enhance one another. To some degree all artworks can be examined by way of the organizing principles of design, but as well as helping to explain why artworks are composed as they are, they also suggest guidelines for us to follow when making our own drawings.

Artists and designers increase their awareness, control, and critical thinking by studying these principles. Some artists strictly align their work with them, and others apply them more intuitively, but by understanding the individual principles one can select, mix, and match them to create compositions.

TIP

Think of your drawing as a design. Use one of the organizing principles of design to plan the composition.

Organizing principles of design Fundamental features that guide the holistic arrangement of parts in a work of art.

Gateway to Drawing Heysen, *Gum Trees, Hahndorf*

Composing a Compelling Drawing

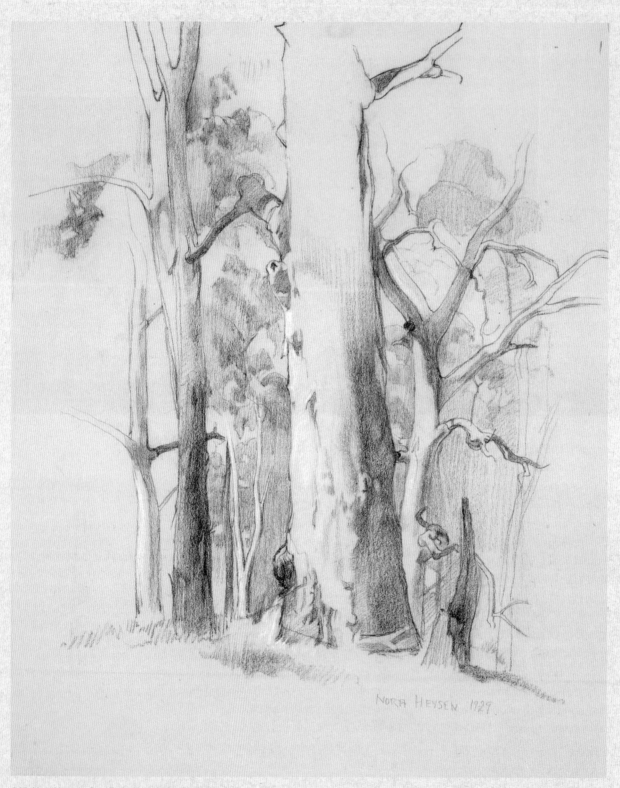

4.15 Nora Heysen, *Gum Trees, Hahndorf*, 1929. Carbon
pencil and white chalk on green-gray paper, 16 × 13⅛"
(40.6 × 33.4 cm). Art Gallery of New South Wales,
Sydney, Australia

The Australian artist Nora Heysen (1911-2003) was born to artistic parents. Their rural home, The Cedars, provided an ideal setting for her to grow as an artist. The strict traditional drawing training she received in school contrasted with the more relaxed lessons her father gave her. She continued to draw throughout her life and achieved high regard as an academic realist.

Nora Heysen's landscape drawing *Gum Trees, Hahndorf* possesses an airy ease, and a sense of unity resulting from the strong verticality of the drawing (**4.15**). To begin, Heysen chooses to orient her paper vertically, unlike the horizontal format traditionally used for landscapes. This gives space for her to expand upon the height of the trees; they seem to push upward. Areas where vertical hatching can be detected further emphasize the verticality of the drawing. The verticals of the trees are spread fairly evenly, creating an alternating rhythm. The consistency of this spacing helps produce the drawing's visual unity.

Paradoxically, the strong verticality of the drawing is accentuated by the addition of horizontals (**4.16**). These opposing angles, implying branches that grow from the tree trunks, provide a significant function in the drawing. They link the powerful vertical movements of the composition. Without the horizontals, the trees would seem disconnected from one another, and would read independently, not as part of a whole. You can read more about the principle of unity on p. 104.

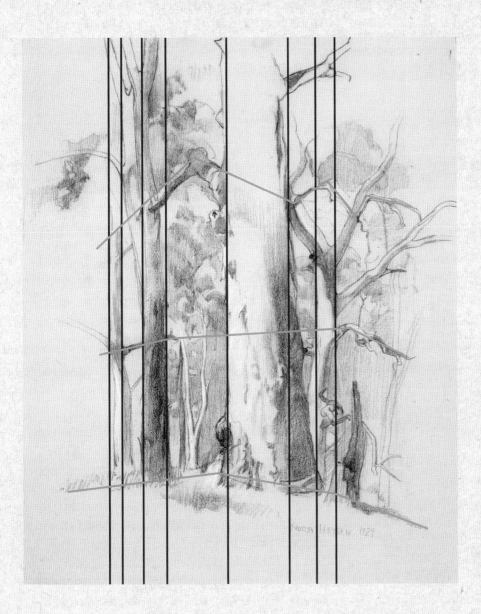

For the other *Gum Trees, Hahndorf* boxes, see p. 192 and p. 339

4.16 Superimposed vertical and horizontal lines applied to Heysen's *Gum Trees, Hahndorf*

4.17 Piet Mondrian, *Ocean 5*, 1914. Charcoal and gouache on wood-pulp wove paper, glued to Homosote panel, 34½ × 47⅜" (87.6 × 120.3 cm). Solomon R. Guggenheim Museum, New York

4.18 Grid applied to Mondrian's *Ocean 5*
Mondrian created unity in his charcoal-and-gouache drawing by conforming the parts to a grid-like structure and by clustering the marks into an oval shape. For Mondrian's simplified abstractions, beauty through unity was paramount.

Gestalt A German psychological term meaning "unified whole." In art, refers to the mind's ability to assemble multiple perceptions into a whole that is more than merely the sum of its parts.

Unity

A unified drawing possesses harmony among all its parts. Nothing seems missing and nothing seems superfluous. Unity is sometimes equated with **gestalt**, a German psychological term meaning "unified whole." Gestalt refers to the mind's ability to assemble multiple perceptions into a whole that is more than merely the sum of its parts. For example, although a drawing is simply a collection of marks on a page, our minds are capable of grouping the marks so that we perceive a unified visual image that has an overarching meaning. In this case we might say we "get the whole gestalt of the thing."

All the organizing principles of design help contribute toward a unified composition. A visual system, such as a grid or one of the geometric divisions discussed above, will also lead to unity. The drawing entitled *Ocean 5* by Piet Mondrian (1872–1944) represents the motion of ocean waters in an abstract way (**4.17**). The scheme of clustering marks into an oval while orienting them in a grid-like structure creates organization and unity (**4.18**).

4.19 Paolo Uccello, *Diamond Pointed Sphere*, c.1460. Ink and brown wash, 10⅝ × 9⅝" (27 × 24.5 cm). Musée du Louvre, Paris, France

Imagine drawing a line through the center of this drawing. It becomes immediately apparent that one side is nearly a mirror reflection of the other. This drawing is an example of symmetrical balance.

Balance

Consciously or unconsciously, when viewing a drawing we compare and contrast both sides of the work, and are inclined to find satisfaction in well-balanced works. A balanced drawing has a visually satisfying distribution of **visual weight**, usually based on a central vertical line. Visual weight is a measure of an object or area's ability to attract attention. There are principal types of balance that can be applied to visual weight: symmetrical, asymmetrical, and radial. Each of these can be used to craft a sense of pictorial equilibrium.

Symmetrical balance arranges identical elements on either side of a central axis in the composition; each side is essentially a mirror reflection of the other. Psychologically, we have a strong affinity for symmetry. In fact, it has been scientifically proven that people around the world have a strong preference for faces and bodies that are symmetrical. Not only has it been found that people perceive more symmetrical faces to be more attractive, but symmetry also appears to have associations with supposed trustworthiness.

Bilateral symmetry tends to produce a formal impression, one of stability and permanence. This drawing by Paolo Uccello (1397–1475) is one such example (**4.19**). In this type of arrangement, the viewer is drawn toward the center of the drawing. Similarly, in his obsessively

Visual weight A measure of an object or area's ability to attract attention.
Symmetrical balance Compositional arrangement whereby identical elements lie on either side of a central axis.

The Work of Art Michelangelo

Who: Michelangelo
Where: Italy
When: 1555–64
Materials: Chalk and white lead

Artistic Aims

Michelangelo was a devout Catholic. During the last years of his life he made a series of crucifixion studies. These drawings were not made as presentation drawings, but were more privately used as a form of religious meditation for the ageing artist. The process of making the drawings gave him the opportunity to contemplate his beliefs and perhaps his own death. In his black-chalk drawing *Christ on the Cross between the Virgin and St. John*, Christ hangs from an archaic Y-shaped cross with two mourners, who historically have been presumed to be the Virgin Mary and St. John.

Artistic Challenges

As Michelangelo became older, he battled failing eyesight as well as lesser control of his hands. As he contemplated his own death, the crucifixion of Christ became a theme that he revisited often. Drawing was a way for him simultaneously to reflect on formal religion and on his personal life.

Artistic Method

Michelangelo's choice of chalk allowed for continuous exploration; other media may not have provided this same artistic freedom. It seems likely that he did not use a model as a reference as this drawing was made as a personal and spiritual exercise. Michelangelo makes little attempt to refine the figures, but instead reworks parts of the drawing until they almost deteriorate.

Christ on the Cross between the Virgin and St. John is an example of a symmetrical composition. The figures are placed on a neutral background devoid of any landscape or scene. The viewer is drawn toward the center of the drawing. The heavily reworked mourners on the right and left are stricken with sorrow.

The Results

Michelangelo's approach to drawing, the subject matter, and formal compositional structure work together powerfully to express the devout character of Michelangelo's personal religious beliefs.

4.20 Michelangelo, *Christ on the Cross between the Virgin and St. John*, c. 1555–64. Chalk and white lead, 16¼ × 11¼" (41.2 × 28.5 cm). British Museum, London, England

4.21 (below) Symmetry diagram applied to Michelangelo's *Christ on the Cross between the Virgin and St. John*
The essential arrangement of forms on one side of this drawing is reflected on the other side. This type of symmetrical balance has a formal appearance, especially appropriate for Michelangelo's drawing of this biblical scene.

Sketchbook Prompt

Choose a subject that can be used to create a symmetrical drawing. Draw it in a sketchbook. Change your point of view and draw the same subject as an asymmetrical composition.

Asymmetrical balance
Compositional arrangement in which visual equilibrium is achieved by elements that contrast and complement one another without being the same on either side of a central axis.

4.22 Pieter Bruegel the Elder, *Hope*, 1559. Pen and dark brown ink, 8⅞ × 11⅝" (22.4 × 29.5 cm). Kupferstichkabinett, Staatliche Museen zu Berlin, Germany

4.23 Asymmetry diagram applied to Bruegel's *Hope*
Looking at the artwork (**4.22**) and diagram (**4.23**) together helps us see how Bruegel's complex drawing finds balance through asymmetry. Notice how the separate groupings on the left are equivalent in size and shape to the large form on the right. The strong diagonal through the middle of the image creates yet another difference between the sides.

reworked crucifixion study, Michelangelo (b. Michelangelo Buonarroti, 1475–1564) chooses the ideal form of balance that focuses the viewer's attention toward the main subject in the center, and endows the image with reverence and an eternal quality (**4.20** and **4.21**).

Asymmetrical balance exists when elements that differ on either side of a central axis still create a look of visual equilibrium. This kind of compositional balance tends to move the viewer's attention actively around the picture plane in search of differences. This preparatory drawing made by Pieter Bruegel the Elder (1525–1569), created to transfer a design for an engraving, demonstrates asymmetrical balance. Bruegel positions the personified Hope on the central axis and then balances the suffering of mankind to the left and right of her (**4.22** and **4.23**). On the left, the foreground, middle ground, and background areas together equal the size and shape of the architecture on the right. They are different objects, but equivalent in terms of their respective visual weights.

4.24 Tal R, *Spiral Bar*, 2002. Ballpoint pen on paper,
9¼ × 12⅝" (23.5 × 32 cm)

4.25 Radial diagram applied to Tal R's *Spiral Bar*
This invented scene establishes balance through
its radial design. Some viewers will follow the lines
and shapes round and round as they converge
inward to a point. Others will view the parts of this
drawing as radiating outward from that point. This
is a natural paradox of radial balance.

Radial balance occurs when elements emanate from a central point. It creates a strong visual pull toward a focal point. Born in Israel, but living and working in Copenhagen, Denmark, Tal R (b. 1967) uses a radial design as a way to organize the details of his drawing, *Spiral Bar* (**4.24**). The viewer's attention spins inward and outward from a central point, creating a drunk and dizzying effect (**4.25**). Considering the subject of the drawing, radial balance was a most appropriate compositional arrangement. The viewer not only views the drawing, but is also drawn into its spiral.

4.26 Ruth Asawa, *Untitled*, c. 1970. Pen and ink and brown marker on paper, 10¾ × 14" (27.3 × 35.6 cm)
This drawing's composition is based on a single area of emphasis. As the viewer's eye scans this drawing, it cannot help but come back to the area of largest and lightest shapes. We are drawn to this focal point because it is significantly different from the rest of the drawing.

Emphasis and Focal Point

To create emphasis in a drawing is to attract attention to particular content. A focal point in a drawing is a specific place that will first attract the viewer. Emphasis and focal point are closely tied to the relationships between parts of a composition: by heightening the differences between them, the parts of a drawing can be organized to create emphasis or a focal point.

Differences in placement, proportions, color, or values can all attract the viewer's attention. This drawing by the sculptor Ruth Asawa (1926–2013) exemplifies how a point of emphasis can be created in a drawing (**4.26**). In this case, the viewer's eye is led to the lightest area made up of the largest shapes.

Radial balance
Compositional arrangement whereby elements emanate from a central point.

4.27 Meg Dutton, *City Patterns*, 2015. Etching and watercolor, 23¼ × 35⅜" (59 × 90 cm). Private collection
Pattern has the capacity to bring organization to the surfaces or structures in a drawing. In this work many different patterns are used, but they impart consistency across the image. Pattern brings an abstract element to this representational scene.

Pattern

The repetition of events within a drawing creates **pattern**. Sometimes patterns are loosely structured, while other times they are systematic and predictable. In *City Patterns* by Meg Dutton (b. 1951), pattern is used throughout the image (**4.27**). Despite the complexity of the image, the strong unifying effect of pattern brings about a coherent organization.

Rhythm

Rhythm refers to the visual flow or movement created by repetition. By repeating objects or motifs in a regular and predictable manner, one can create a **visual movement**. Visual movement is the graphic path taken when

looking at an artwork. The movement could flow smoothly, or could be a type of staccato beat. Just as rhythm in music depends on the types of sounds and their spacing, visual rhythm is determined by the types of marks or objects and how they are arranged.

The Italian Renaissance artist Jacopo Pontormo (1494–1557) creates linear rhythms in many of his drawings. In his study for *The Deluge*, he twists bodies in a turbulent flow, tossing and turning across the page (**4.28** and **4.29**).

The American Expressionist painter David Park (1911–1960) creates an alternating rhythm of values in his sketchbook drawing (**4.30**). Bold areas of ink record a pattern of lights and darks that move the viewer's eye from left to right (**4.31**).

Pattern A repetition of motifs within a drawing.
Rhythm The regular or ordered repetition of elements in a work.
Visual movement The graphic path taken by the eye when looking at an artwork.

4.28 Jacopo Pontormo, study for *The Deluge*, 1550–55. Black chalk, 10½ × 15⅞" (26.6 × 40.2 cm). Uffizi Gallery, Florence, Italy

4.29 (below) Diagram of visual movement applied to Pontormo's study for *The Deluge*
Mirroring the fast-flowing water where these figures are held, the design of this page creates a forceful visual movement. Dark and light lines direct the eye across the interweaving of forms. This rhythm links the individual parts of the drawing into one.

4.30 David Park, drawing from sketchbook (folio 1, verso), *c.* 1960. Mixed media, 11¾ × 9" (30 × 23 cm). Archives of American Art, Smithsonian Institution, Washington, D.C.

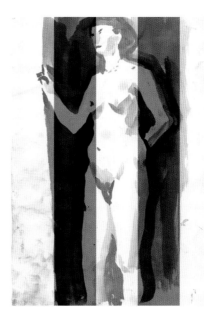

4.31 Diagram of alternating rhythm applied to Park's sketchbook drawing
Echoing a musical piece with a staccato rhythm, this drawing features sharp, rapid beats. Flashing back and forth from dark to light, the values of the drawing propel us across the page. So dominant is this alternating rhythm, it establishes an overall harmony.

Composing a Drawing with the Organizing Principles of Design **111**

Drawing at Work Jacob El Hanani

4.32 Jacob El Hanani, *Gauze*, 2008. Ink on paper, 17⅞ × 22⅜" (45.4 × 56.8 cm). Private collection

Gauze is an ink drawing on paper, 6 × 10" in size, composed of thousands of tiny squares (**4.32**). Its creator, Morocco-born Israeli artist Jacob El Hanani (b. 1947), has made interesting choices of format and organization.

Gauze was created within a relatively small rectangular format. The small scale forces the viewer to engage intimately with the drawing. Upon detailed inspection, the concentrated repetition is obvious, but the effect is different depending on our viewing distance. Up close, we tend to view it as a miniature terrain full of possibilities. From a distance, we perceive the image more as a whole, so that the small individual shapes create a quivering gray fabric that moves in and out of space.

Gauze is an example of a type of composition often referred to as a continuous field. A continuous-field drawing creates a surface that appears to extend beyond the edges of the page, evenly on all sides. In El Hanani's work there is no single direction; instead, shifts of gray and white squares undulate widely across the surface of the paper, creating the impression that the drawing could continue forever. The repetition of shapes enhances this effect as it establishes a pattern that viewers can easily continue in their minds.

The organized field of *Gauze* is a result of repetition and rhythm, two principles of design that give the drawing a pleasing visual harmony. The recurring squares set up a system for darker and lighter areas that work together to create a strong visual flow. Smooth and rolling, the surface is hypnotic.

4.33 Helen Frankenthaler, *Untitled*, 1961. Oil and colored crayons on paper, 14⅛ × 22½" (35.9 × 57.2 cm). UBS Art Collection
Study this non-objective work by Helen Frankenthaler. Consider the visual components of this drawing: line, shape, color, *etc.* Within this work we can see variations of each: thick and thin lines, big and small shapes, bright and restrained colors. These contrasts encourage continued looking.

4.34 (below) Dina Brodsky, *Secret Life of Trees #18*, 2015. Ballpoint pen on paper, 5½ × 3½" (14 × 8.9 cm). Private collection
The importance of the scale of an original drawing should not be undervalued. Small drawings, such as this one, require the viewer to come close in order to examine them. Imagine how the presence of this drawing would be different if its actual size was ten times larger.

Variety and Contrast

Variety is the concept of introducing difference to a theme. When artists utilize repetition in their work, variety can add considerable interest. Otherwise, a recurring element could become tedious to the viewer. Subtle or obvious contrast between elements creates variety, for example, dark/light, big/small, textured/smooth, and dull/bright. In a non-objective work on paper by Helen Frankenthaler (1928–2011), we see the artist's freedom of imagination (**4.33**). She plays with both heavy and light lines and shapes that are big and small, opaque and transparent. Each part of the composition remains interesting because it is unlike the others.

Scale and Proportion

The **scale** of a drawing is its size in relationship to the viewer. The effect of scale on the spectator is one aspect that is often lost when looking at photo images of drawings rather than experiencing original works. Whenever possible it is always preferable to view an actual drawing "in the flesh" as opposed to a reproduction. A very small drawing asks to be viewed up close and often creates an intimate viewing experience. The contemporary

miniaturist Dina Brodsky's (b. 1981) small drawing of a tree (on 5½ × 3½" paper) invites the viewer to inspect the meticulous ballpoint pen detail (**4.34**). Influences on Brodsky's work

Scale The size of an object or shape in relation to the viewer.

TIP

The scale of a drawing and the proportions of elements within it can be controlled by the artist. These are important decisions.

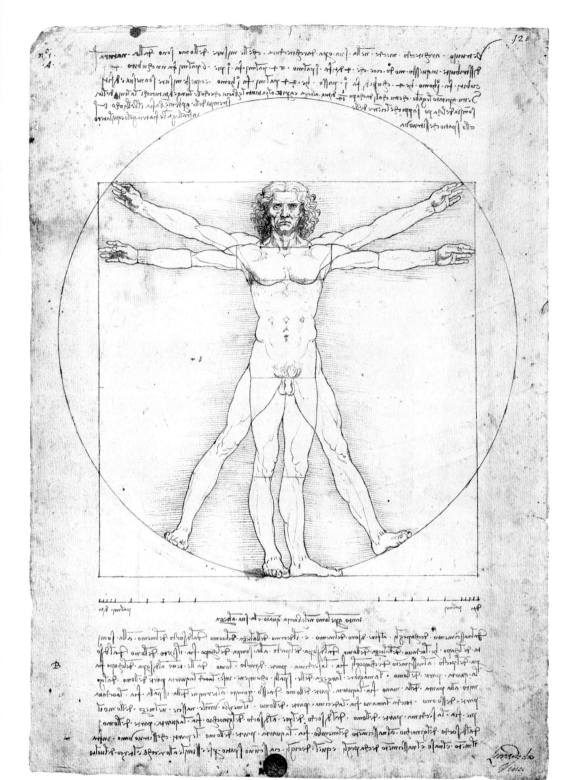

4.35 Leonardo da Vinci, *Vitruvian Man*, *c.* 1490. Pen and ink on paper, 13⅜ × 9½" (34 × 24 cm). Gallerie dell'Accademia, Venice, Italy
Leonardo's drawing of the Vitruvian man represents his profound interest in proportion and its universal applicability. As an organizing principle of design, proportion is used to maintain relationships among all the parts of a drawing, such as the size of the head in relation to the body, or the size of the figure in relation to the page. When all parts of a drawing relate proportionally, it produces a visual agreement.

Proportion
The relationship in size between individual parts and the whole.

range from the miniaturist techniques found in the Italian Renaissance, fifteenth-century Flemish portraits, and Islamic miniature art.

Tiny works of art have sometimes been employed for jewelry and luxury items. By contrast, very large drawings have a powerful presence and can envelop a viewer or a space.

Proportion is the relationship in size between parts and the whole. Accurate depiction of proportions is crucial in such descriptive drawing as a still life from direct observation. We will fully explore techniques for analyzing and drawing accurate proportion in Chapter 6 (p. 130).

Proportions can be manipulated in order to enhance the expressiveness of a work. Consider how Leonardo da Vinci (1452–1519) uses proportions to relate nature to geometry (**4.35**). His drawing *Vitruvian Man* illustrates the ideal proportions of the human body, sometimes known as the Canon of Proportions, as originally defined in the writings of the Roman architect, Vitruvius, who lived during the first century BCE. The drawing presents two poses of the male body within a circle and a square. The text in the lower part of the page outlines the proportional relationships of the body as they are marked with lines on the drawing. For example, the length of the outspread arms is equal to the height of a man, the width of the shoulders is equal to one quarter of the height of a man, and the length of one hand is one-tenth of the height of a man.

In the Studio Projects

Fundamental Project

Draw the same subject twice. In one drawing use a 9 × 18" sheet of paper horizontally, and in the second drawing use a 9 × 18" sheet of paper vertically. In each drawing, carefully consider the placement of objects on the page.

Criteria:

1. The drawing on the horizontally orientated paper should fill the composition in a complete manner.
2. The drawing on the vertically orientated paper should fill the composition in a complete manner.
3. Viewed together, the drawings should demonstrate your ability to compose the same subject within two different formats.

Materials: Two 9 × 18" sheets of paper, optional media

Observational Drawing

Set up a still-life arrangement (see Chapter 14, p. 276) that will lend itself to a well-designed drawing. Consider organizing objects into a vertical or horizontal arrangement. Draw the still life using one method of organization: use geometric divisions or one of the organizing principles of design discussed in this chapter.

Criteria:

1. The drawing should demonstrate an obvious focus on good design. The chosen format (especially size and orientation) should be selected wisely in accordance with the still-life arrangement.
2. The drawing should utilize one method of organizing the page: geometric divisions or one of the organizing principles of design.
3. The composition should display an overall sense of harmony.

Materials: Optional

Non-Observational Drawing

Choose a masterwork. Explore the work through a series of drawings that deconstruct its composition. Use the diagrams in this chapter as examples. You may find it useful to trace a reproduction of a masterwork and then use a ruler to find compositional divisions.

Criteria:

1. The drawings should reveal the method(s) of organization that were utilized in a masterwork: geometric divisions or one of the organizing principles of design.
2. The drawings should accurately deconstruct a masterwork.
3. Each drawing should focus on composition rather than other aspects of the masterwork.

Materials: Optional

Chapter 5
The Sketchbook

On its own, a **sketchbook** is merely a portable supply of drawing paper. In the hands of an artist, however, a sketchbook becomes a repository for drawings, observations, inventions, ideas, and notes to self. By providing free space for thought, reflection, and experimentation, your sketchbook can serve as a private journal where you can work without concern for criticism, beyond critique.

Developments in technology at the time of the Industrial Revolution, which was a period in the early nineteenth century when new and rapid manufacturing processes changed the shape of society, mean there is now a huge range of portable artist materials, including sketchbooks.

Artists' sketchbooks compile messages from the world of the artist, whether used in the studio, while traveling, for process drawings, or to create finished works. Whatever their purposes and whatever their contents, sketchbooks open doors to new creative possibilities. Over time, your old sketchbooks will become invaluable records of your ideas, concerns, solutions, and former selves.

Sketchbook A book or pad used to collect drawings, observations, inventions, ideas, and notes to oneself.

5.1 Elena Prentice, *Landscape*, 1988. Japanese ink stick rubbed on traditional slate, on top of watercolor wash, 4¾ × 7⅛" (12 × 18 cm). Harvard Art Museums—Fogg Museum, Cambridge, MA

This is one page from a sketchbook of landscapes made during the artist's travels. Rather than filling the entire sheet, the image is isolated in the center. This layout gives the drawing a sense of importance. Although representational, the simplified composition and ethereal atmosphere give it an abstract quality.

5.2 (below) Byung Hwa Yoo, *Girl Using Her Phone in the Subway*, 2016. Pen and pencil on paper, 8⅞ × 6⅛" (22.5 × 15.5 cm). Private collection

Keeping a portable sketchbook handy is a great way to collect imagery throughout the day. This drawing was made on a subway. Can you think of opportunities in your daily routine where you could take advantage of your time to work in a sketchbook?

Inside Sketchbooks

Recording a moment at the time of discovery is important to the artist: we see evidence of this time and time again when looking at artists' sketchbooks. Elena Prentice (b. 1946) uses sketchbooks as a personal and creative outlet. She fills them with drawings and luminous watercolors of landscapes made from her journeys around the world; the small size of her sketchbooks is especially convenient when traveling (**5.1**).

When an artist finds his or her inspiration, documenting the occasion takes on urgent meaning. Byung Hwa Yoo (b. 1951) from Seoul, South Korea, often sketches at markets, churches, and parks, and in subways. Drawing on location, she must work quickly. With little time to capture a subway scene, the lines of her sketchbook drawing are fast and hurried (**5.2**). Recording fresh impressions through drawing nourishes visual memory and enlarges creative repertoire, often supplying inspiration for a long time to come. The constant practice of recording visual experiences initiates and instructs creativity in profound ways.

Sketchbooks that incorporate found objects are distinctive. Serving as a type of scrapbook,

Drawing at Work Frida Kahlo

5.3 and **5.4** Pages from the diary of Frida Kahlo, c. 1944–54

The Mexican-born artist Frida Kahlo (1907–1954) led a life of both physical and psychological suffering. She contracted polio at an early age and it left her right leg thin and debilitated. Later in life, as a result of a traumatic and near-fatal bus accident, she was made to endure many surgeries. She suffered a lifetime of pain that left her bedridden for months at a time. Kahlo also struggled in her relationship with her mother, as well as with her volatile and unfaithful husband Diego Rivera (1886–1957), a famous painter and muralist. Her artwork, mostly self-portrait paintings, was her way of dealing with her own existence.

Perhaps one of her most personal works is the sketchbook that she made during the last years of her life. It is an accumulation of private drawings and diary writings, and reflects her life through the recurring themes of love, pain, and death. The pages are obsessive in their stream of consciousness and repetitively drawn elements (**5.3** and **5.4**). Her thoughts about her life were the driving force behind her book entries.

To this day Frida Kahlo is admired as an icon. In spite of the pain that she endured, she was able to live a life of strength, resilience, and creative significance. Throughout her life she seized opportunities to be an outspoken feminist, standing up for the equality of all people. She is an example of what can be accomplished even in the face of constant problems and limitations.

5.5 Derek Jarman, page from untitled sketchbook, 1965. Collage, 10 × 6" (25.4 × 15.2 cm). BFI National Archive, Gaydon, England

This is a page from a film-maker's sketchbook. It is a veritable cornucopia of drawings, writings, and collage. Individual pages are captivating, and the book in its entirety is an intriguing three-dimensional art object.

the pages are transformed by the addition of a physical texture. In this regard, the books themselves can be appreciated as three-dimensional objects as well as places that collect two-dimensional drawings. Each page of a sketchbook—no matter what is drawn, written, or attached—puts the other pages in context. Its importance is provided by the artist's decision to include it in the book.

The film director, stage designer, and author Derek Jarman (1942–1994) often layered found papers, writings, drawings, and images into his sketchbooks. His work has a strong autobiographical, diary-like point of view. Jarman's mixed-media sketchbooks are inspirational (**5.5**).

Sometimes, a page in a sketchbook will present redrawn portions of a preceding drawing. This reflects the artist's interest in resolving a particular passage, or finding an improved or alternate depiction. Frequently, artists select only specific areas of an object to draw. Drawing these details gives an artist the opportunity to scrutinize such elements as line, shape, and form, rather than being concerned with an overall composition. Details frequently appear as separate vignettes in the overall arrangement on the page.

On a page of his sketchbook, Paul Gauguin (1848–1903) does not complete an entire figure, but instead concentrates on portions of four Breton women (**5.7**, p. 121). The lower three

The Work of Art Théodore Géricault

5.6 Théodore Géricault, *Studies of a Cat*, c. 1820–21. Graphite with touches of black chalk on tan wove paper, 12¾ × 15⅞" (32.4 × 40.3 cm). Harvard Art Museums—Fogg Museum, Cambridge, MA Discoveries are made when a single subject is drawn many times. This is noticeable when creative people work through variations of a single problem, or, as seen here, when rendering a subject multiple times. The reiteration of themes and images is commonly found in sketchbooks.

Who: Théodore Géricault
Where: France
When: 1812–14
Materials: Graphite pencil drawing in sketchbook

Théodore Géricault was not a good student. Choosing to leave the classroom, he studied at the Louvre where he copied many paintings by the Old Masters. Géricault competed for the Prix de Rome, an annual government scholarship awarded to artists, but was unsuccessful. Instead, in 1816 he traveled to Florence and Rome at his own expense. He drew, painted, and spent time in museums. With tenacity, he taught himself the skills and knowledge to become a great artist.

Artistic Aims

Géricault was influential in the development of French Romanticism, an art movement that originated in Europe and grew in influence from 1800 to 1850. As a reaction against the restraint fashionable in academic circles, Romanticism emphasized emotion and considered nature to be its primary inspiration.

In his work, Géricault sought to respond to life with bold and expressive realism. Géricault's sketchbook drawings reflect his interest in spontaneous observational drawing.

Artistic Challenges

This sketchbook page seems to exemplify Géricault's determination in

the study of a cat (**5.6**). Drawing animals presents its own special challenges. Animals are complex structures, including pattern and texture. The problem is compounded when working from live animals, which are liable to move. On this page we can see evidence that Géricault drew lightly and quickly at first. It appears that he rejected some beginnings, possibly because his subject moved. We see other studies where he was able to develop the drawings further.

Artistic Method

This page from Géricault's sketchbook shows ten sketches of a cat. The poses and actions reflect the Romantic style of the time, emphasizing intensity of feeling and emotion. The drawings are evidence of Géricault's lifelong interest in the refinement of his artistic skills.

This page was made from direct observation with graphite pencil. Géricault's drawings reflect his impulsive temperament and bold artistic style. With quickly drawn marks, he seems to be very aware of the anatomy of the cat.

The Results

Géricault lived only a short life, dying at thirty-two as a result of a series of horse-riding accidents. Despite the relatively few completed works he created, he has inspired generations of artists with his emotional and empathic realism. Today, he is considered to be a quintessential Romantic artist.

Sketchbook Prompt

Spontaneously draw an animal from observation.

5.7 Paul Gauguin, *Four Studies of Breton Women* (recto), 1884–88. Graphite and crayon on wove paper, 6⅝ × 9" (16.9 × 22.8 cm). National Gallery of Art, Washington, D.C.
Individual studies of details are often found in an artist's sketchbook, where the artist has focused on a specific area of interest. As the artist finds space on the page to work, one study seems to float next to the other. Gauguin, devoted to his art, was an avid sketcher.

sketches on the left page reveal his search for the lines that describe a facial profile.

Sometimes, a sketchbook records pages of possibilities that delineate steps toward creative solutions. The French artist Théodore Géricault (1791–1824) continually worked to refine his artistic skills. The pages of his sketchbooks testify to his personal pursuit. This particular page of drawings contains multiple studies of a cat, some fully rendered and others abandoned before completion (**5.6**).

Types of Sketchbooks

Since the Industrial Revolution, manufacturers have been offering an ever-widening selection of portable artists' materials, including sketchbooks. Today, many types of sketchbooks are available. While the purposes of studio sketchbooks and traveling sketchbooks sometimes overlap, the differences in how the artist plans to use a sketchbook should be considered when selecting one. Typically, both studio and travel sketchbooks contain imagined compositions, preliminary drawings, and artist's notes. But the artist may choose to use different media and formats depending on where he or she anticipates working.

While seemingly endless selections of sketchbooks can be found at any given art store, many artists find it rewarding to make their own personalized sketchbooks according to their preferences and needs. It is a fairly simple matter to fold, bind, and cut to size a favorite kind of paper that is not otherwise available in sketchbook form, using heavier stock for the covers. Drawing papers can be bound using simple techniques, such as stapling, sewing, and ring binding. In addition, more complex bookbinding techniques are possible (**5.8**).

Finally, some people are more comfortable drawing with a stylus or with the swipe of a finger than drawing with a pencil or pen. For these people, technology has the answer. There are a variety of drawing applications available for smartphones and tablets, which can act as digital sketchbooks because of their portability. Drawings can be saved and revisited later. Michaela Bartoňová incorporates her digital sketchbook into theater. As actors perform, her sketches are projected onstage in real time. She responds to the performance, and at the same time the actors interact with the images she creates. Her drawings are often humorous, colorful abstractions (**5.9**).

5.8 Handmade sketchbooks Sketchbooks are easily purchased in an array of styles, but many people prefer to customize their own. This is a selection of handmade sketchbooks. Rings, glue, or string can provide a secure way to bind paper. Formats and types of paper can be selected by the artist. Handmade sketchbooks are unique and distinctive places in which to draw.

The size, paper, and binding are also important criteria when selecting a sketchbook. Portability is dictated primarily by size, but also by the strength and durability of a sketchbook's cover and binding. If a sketchbook is too cumbersome, it will most likely not be used. Sketchbooks can be purchased containing different types of paper, dimensions, colors, and covers. Some sketchbooks cater to specific artistic techniques by supplying paper that lends itself to a particular medium.

5.9 Michaela Bartoňová, "My Little Eye Pet," 2014. iPad drawing from *Drawing in Motion*, Tineola Theater
This iPad drawing is representative of the kind of work that can be made using digital media. Because smartphones and tablets are portable, they can easily be used as traveling sketchbooks. They have the advantage of being often at hand, and they offer a wide range of color and mark-making possibilities.

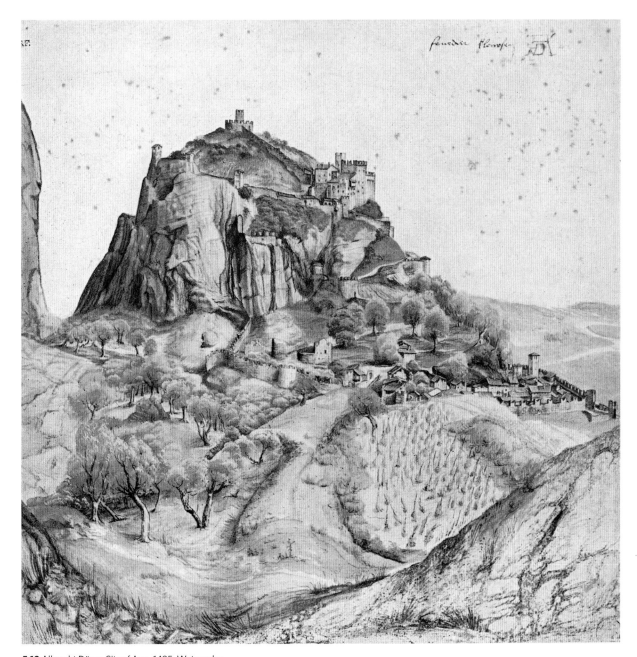

5.10 Albrecht Dürer, *City of Arco*, 1495. Watercolor and gouache on paper, 8¾ × 8¾" (22.1 × 22.1 cm). Musée du Louvre, Paris, France

While people nowadays usually use a camera, travel drawings are an exciting way to record experiences when traveling. New people and places inspire artists. Most of this drawing is thought to have been made on-site, but the foreground may have been added later. Some artists like to touch up their work after arriving home.

Traveling Sketchbooks

In earlier times, instead of using purchased sketchbooks, travel drawings were first made on single sheets of paper and compiled into book-type portfolios later on. One such drawing from a larger set of works is Albrecht Dürer's drawing of the Italian cliffside town of Arco. He made this and other drawings on his return trip home to Nuremberg from Venice in 1495 (**5.10**).

The **traveling sketchbook** can become a portable studio. Whether used for extended travel to foreign lands or just wandering the streets of one's own hometown, an artist's traveling sketchbook provides the opportunity to continue drawing. Nathalie Ramirez from the Dominican Republic took advantage of

TIP

Keep a pocket-size sketchbook with you at all times. Make drawing part of your daily routine.

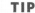

Traveling sketchbook
A sketchbook utilized outside of the studio for short or extended travel.

Studio sketchbook
A sketchbook utilized for creative exploration within the studio.

5.11 Nathalie Ramirez, *Brush Factory in La Romana*, 2011. Ink on paper, 4 × 6" (10.2 × 15.2 cm). Private collection
The lines of this travel drawing appear to be rendered as fast as they can be observed. The artist forms a true impression of the complex factory scene. After making the drawing she added a rectangle on top, as if to consider how she could consolidate the scene into a completed composition.

a tour of a paintbrush factory to record a new experience. Her portable sketchbook helps her to capture life as it occurs (**5.11**).

A traveling sketchbook is a clear illustration of how an artist's life and work necessarily complement each other. It becomes an inventory of the forms and scenes that most interest the artist. In contrast to studio sketchbooks, traveling sketchbooks more often rely on novel experiences and new visual impressions for inspiration. Seen together, the sequences of individual drawings support each other and tell a story of the artist's exploits. Once completed, a traveling sketchbook naturally comprises a conceptual unity derived from the consistency of its overarching theme, the artist's journey. During a trip to Italy in 1804, French artist Élie-Honoré Montagny (1782–1864) made travel drawings of sculpture, decorative arts, and frescoes in Herculaneum, the Roman town that had been destroyed by the eruption of Mount Vesuvius in ancient times and was only then being first excavated. Montagny used the renderings in his

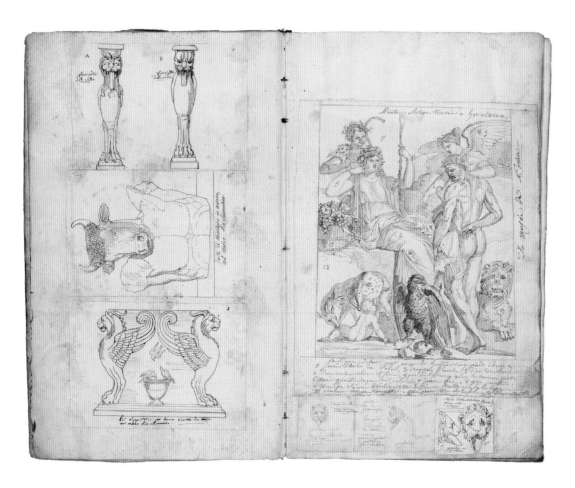

TIP

Study great works of art by drawing them in your sketchbook. Analyze compositions and techniques.

5.12 Élie-Honoré Montagny, spread from *Collection of Antiques Drawn from Paintings Found at Herculaneum, Stabia, and Pompeii*, 1804–5. Pencil, pen, and ink, 17⅛ × 9⅝" (43.5 × 27.6 cm). The Getty Research Institute, Los Angeles, CA
Some artists travel with their sketchbooks to specific locations in order to gather information. These carefully rendered sketchbook drawings were made at the ruins of Herculaneum, and were used as sources for later works.

5.13 Utagawa Hiroshige, *Shaseijo Tokkaido bu (Sketchbook: Tokaido)*, 1838. Ink and color on paper, 4⅞ × 7¼" (12.5 × 18.3 cm). British Museum, London, England
Taking a sketchbook on the road brings new inspiration into an artist's life, relieving the possibly stagnant quality of a closed studio. Travel sketches closely tie artists to their observations, guiding them to new ideas.

sketchbook as a theme-based visual resource for later works (**5.12**).

Of course, artists living throughout the world have been influenced by travel. For instance, Japanese culture has long valued travel. This drawing, thought to have been made by Utagawa Hiroshige (1798–1858), is from the artist's sketchbook used during a trip along the *Tokaido* ("East Sea Road"), the horse and pedestrian highway connecting Kyoto and Edo (present-day Tokyo). Slight color notations were made to these predominantly line sketches (**5.13**).

Today, art schools and colleges around the world offer off-campus programs in response to the desire of students to study abroad. Travel can be an important part of art education. Even more than aspiring artists who preceded them, today's students have opportunities to immerse themselves in the cultures and art of foreign lands, and will benefit from recording their experiences in travel sketchbooks.

Studio Sketchbooks

Sketchbooks are important for creative people who choose to work in a studio, at a business, or at home. **Studio sketchbooks** are a place where visual people can test materials, practice techniques, develop ideas, create preliminary works, and keep written notes. As a safe place for exploration, a sketchbook also becomes a storeroom of ideas.

5.14 Student work. Fermin Uriz, *Texturstad 09*. (Instructor: Stephen Gardner)
A sketchbook is a wonderful place to experiment. This is one of many sketchbook pages where the student investigated approaches to abstraction. This drawing utilizes the elements of line, shape, and space to create a captivating new visual experience.

5.15 Christopher Wilmarth, *Experimentation on Fabric*, 1961. Collage with multiple drawing media on cream wove paper, 12⅜ × 9" (31.3 × 23 cm). Harvard Art Museums—Fogg Museum, Cambridge, MA
Studio sketchbooks make an ideal laboratory journal. They are where idea generation can occur and be recorded. In this sketchbook we see how the artist tests materials. Each sample, its own non-objective composition, experiments with media and surface.

Consider how Christopher Wilmarth (1943–1987), a sculptor known for his steel and glass works, uses his sketchbook. On this page we see ideas, not only for compositions but also for materials. He uses swatches of paper and fabric, each marked with a variety of materials. With each test he notes the materials used. A page of experiments, such as this, can be an instrumental stepping-stone to future works (**5.15**).

Industrial, architectural, and interior designer Karim Rashid (b. 1960) is recognized throughout the world for his modern, vibrant, and funky approach to design. Born in Egypt before emigrating to Canada, he now finds himself working in New York City. His sketchbook serves to empower his designs. Fast and linear, this sketchbook drawing outlines the layout for a room in a hotel (**5.16**).

Product and furniture designer duo Stefan Scholten (b. 1972) and Carole Baijings (b. 1973) use a sketchbook as a fundamental part of their studio design process. This can be seen in their Paper Porcelain Tableware project, in which careful drawings precede the production of three-dimensional prototypes. Closely working as a team, Baijings drew the cups, and Scholten drew the saucers (**5.17**).

5.16 Karim Rashid, *Sketchbook with Designs for Semiramis Hotel and other Objects*, 2000. Rollerball pen and black ink on white paper, 14 × 11 × ³/₈" (35.6 × 27.9 × 0.8 cm). Cooper Hewitt, Smithsonian Design Museum, New York

For many designers, a sketchbook is a studio essential, offering a tool to develop ideas, make thoughts visible, communicate with colleagues, and log activities and interests. This page lays out an interior design scheme. Made only with black pen lines, designers' notes are added regarding colors for the room.

5.17 Stefan Scholten and Carole Baijings, *Designs for Paper Porcelain*, 2009. Pen and black ink, graphite, and marker on two sheets of cream wove paper, 8³/₈ × 5¹/₄" (21.1 × 13.2 cm). Cooper Hewitt, Smithsonian Design Museum, New York

The creative partnership of Stefan Scholten and Carole Baijings sought to create porcelain tableware that mimicked the look of cardboard. These sketchbook drawings began their design process. From these sketches they created three-dimensional cardboard models. The final porcelain products closely realized the original concept drawings.

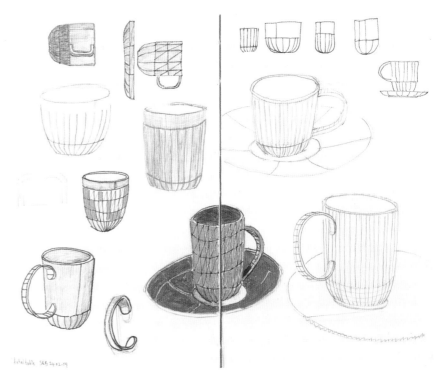

Challenges of Keeping a Sketchbook

To fill a sketchbook is to actualize the book's potential, but to devote yourself to regular sketchbook drawing does present some challenges. Perhaps the biggest in keeping a sketchbook is finding time to work. The patience required to draw is in direct opposition to the rush of modern life. In an age of high-speed digital media, there are increasingly fast and easy ways to record our inspirations visually—faster and easier, perhaps, but not always as effective or expressive as drawing. Taking time to draw gives you an unmatched advantage to edit what you record. A drawing allows you to emphasize formal aspects of art or manipulate observed features in order to make a more reflective work of art. For those who persist, there is great satisfaction in the habit of drawing daily. A distinct artistic vision is not something that can simply be turned on or off. A portable sketchbook gives you the option to draw wherever you may be, whether on vacation, in the studio, or waiting for food to be served at a restaurant. Each drawing session—no matter how long or short—has the potential for new discoveries.

It can be a challenge to adapt to working in certain locations. Standing or sitting for

5.18 Tony Foster with Ang Phury Sherpa painting Everest North Face, Tibet, April–May 2007

long periods of time or enduring undesirable weather conditions can create problems for the traveling artist. Anticipating potential setbacks is key to finding a comfortable drawing situation. Some people even find inspiration in challenging locations. Tony Foster (b. 1946) hikes, canoes, and rafts to some of the most remote locations on earth to draw (**5.18** and **5.19**). He feels that the journey is an important aspect of his art. In addition to a

5.19 Tony Foster, *Makalu and Kangchungtse looking South East from a Frozen Lake below Cho La Pass*, 2007. Graphite and watercolor on paper, 36 × 48" (92 × 122 cm). The Foster Art and Wilderness Foundation, Palo Alto, CA Drawing on location, as this artist did, is not always the most comfortable situation. New environments can test your resolve, forcing you to be flexible, creative, and persistent in your approach. For some artists, the challenges of the journey are what inspire them.

TIP

To become a more competent artist, it is most important to draw regularly. A sketchbook is a great place for this.

strategic choice of working location, portable stools, easels, umbrellas, and compact art kits can help make working outside of the studio more comfortable. At busy locations, often passersby will stop to watch you work. They may ask questions or simply be delighted by seeing how art is made. The human element in art, seeing a working artist, is fascinating for many people. This can be unsettling, and at times distracting. On other occasions, however, the random comment of a stranger may open your eyes to something you had not noticed, or unexpectedly help you resolve a problem area that had been bothering you. If you do feel uncomfortable working in public, remedies for this problem can be found in working quickly, wearing headphones, or finding an inconspicuous place in which to draw.

In the Studio Projects

Fundamental Project

Explore the pages of an artist's sketchbook. You may choose a sketchbook that has been reproduced online or in a book, or you could explore a friend's or classmate's sketchbook. Choose a few of your favorite pages and explain why you like them.

Criteria:

1. You should review the sketchbook in a thorough manner.
2. A few favorite pages should be thoughtfully selected from the sketchbook.
3. Your explanation as to why the favorite pages were selected should be clear and substantiated.

Materials: Presentation

Observational Drawing

From direct observation, draw all the food that you eat for one week. You may choose to draw your food before you eat it, such as a bowl of cereal, or you may draw the remnants of your meal after you have finished, such as leftover chicken bones or candy wrappers.

Criteria:

1. All drawings should be made in a sketchbook using a variety of media.
2. Each page of the sketchbook should demonstrate strong visual documentation skills through drawing.
3. The completed set of drawings should act as a visual diary of your daily diet.

Materials: Sketchbook, other media optional

Non-Observational Drawing

For one week, take time at the end of each day to draw and write about your day in your sketchbook. All work should be done from memory. Arrange, combine, and overlap your drawings and text in an interesting way, filling one page per day.

Criteria:

1. Each page of the sketchbook should recall your day in a comprehensible way. The completed set of drawings should act as a visual diary of your week.
2. Work should demonstrate thoughtful memories of the day, including events, experiences, and emotions.
3. Each entry of the sketchbook should fill the entire page with a combination of drawings and writing.

Materials: Sketchbook, other media optional

Chapter 6
How to Draw What You See

An artistic process is a general guideline for the development of a work. It provides a road map that leads to creativity and a better understanding of medium and technique. Developing a working routine can help you establish where to begin, how to treat information as you go along, and how to solve problems. The more certain you are about *how* to do something, the more natural the experience will become.

This chapter explains proper ways to establish a drawing setup and then demonstrates an effective process for drawing from observation.

It is reflective of a classical method that has been used successfully by many artists for a variety of fields. This drawing process can work equally well whether you are going to draw from a still life, human figure, portrait, or landscape. Although all of these subjects will be discussed more specifically later in this text (see Part 4, "What to Draw," p. 274), here we concern ourselves with the genre of still life. Although a choice of materials can slightly change the method, in general the drawing strategy will not differ. Charcoal on paper will be used as an example in this chapter.

Setting Up to Draw

Before the drawing process begins your setup should be considered. Very often overlooked, the way in which you set up to draw has a huge impact on the result of a drawing. Whether you have a whole room to yourself or just a tiny space in a corner, a devoted place to draw is helpful. A poor setup can lead to frustrations, whereas a proper setup makes the job of the artist easier and more comfortable, and will help create a more enjoyable working experience. There are ideal ways to set up when drawing from observation. While it is not always possible to set up in a perfect situation, it is smart to try to get as close to best practice as possible. Your effort to create a good setup will be time well spent.

Whether working on an easel, a drawing horse, drafting table, or perhaps one's own lap, the artist's view of the page should be perpendicular (90 degrees) to the center of the paper (**6.1**, **6.2**, **6.3**, **6.4**). If the paper lies at a skewed angle to the artist, for example on a table that is parallel to the floor, there is a distortion built into the setup, and compensating for this distortion while drawing can be very hard to do.

It is important to keep a single station point when drawing. This simply means that

6.1 (left) Setup with easel
When drawing from an easel, you should stand almost an arm's length away from the drawing. Your eyes should be located approximately at the same height as the center of your drawing paper. The angle connecting your eye and the surface of the paper should be 90 degrees. If you are right-handed the easel should be on your right, allowing you to observe your subject from the left side of the easel. If you are left-handed the easel should be on your left.

6.2 (below, left)
Setup with drawing horse
When using a drawing horse, use a drawing board to support your paper or pad. Adjust the board so that it is at a 90-degree angle compared to your line of sight. Sit back so that your arm can be fully extended.

6.3 (below, center) Setup with table
When using a table to draw, tilt the top so that its angle compared to your line of sight is reduced as much as possible. This will help to reduce distortion. Standing at arm's length is often recommended to encourage loose and expressive drawing.

6.4 (below) Setup on lap
When drawing on your lap, try to distance your paper from your face. This will help you to see and work the entirety of the drawing at once. Hold your drawing at a 90-degree angle to prevent distortion.

you should keep a fixed position. Ideally, you will be able to see your page and the objects that you are observing at the same time, requiring only the shift of your eyes or a slight movement of your head. You should be at a comfortable arm's length away from the work. Retain a good posture, keeping enough space to move freely during the drawing process. Your drawing paper should be well lit so that you do not have to strain to see your work. Your drawing materials should be kept close at hand.

The proper drawing posture also extends to the correct way to hold drawing media. Most

people use an over-the-palm grip when writing with a pencil. On the contrary, for drawing an under-the-palm grip is advisable, holding the drawing tool between the thumb and the first and second fingers (**6.5**). This allows freer movement, encouraging the motion of one's entire arm, not merely short movements at the wrist. The under-the-palm grip enables opportunities to create a far greater variety of marks. It allows the artist to rotate his or her media more effectively, using all sides of the tool. For those of you who have not used this type of drawing grip, it can seem uncomfortable and hard to control at first. With persistence, however, this awkwardness quickly subsides and you will find the new way to be most effective and quite natural.

The type of media you choose will often govern the setup. The setup for wet media may be different than for dry media due to the flowing characteristics of wet media. For example, to limit dripping, some artists who work with ink prefer tables rather than easels. When adjusting your setup to accommodate for media or other circumstances, make sure to retain a clear vantage point of your entire drawing as well as what you are going to be drawing, and to maintain a setup that feels comfortable.

6.5a and **b** Drawing grip
Above, the pencil is held with an over-the-palm grip. Most people are comfortable with this grip because they are used to writing in this manner. For many people it offers ample control. On the right, the pencil is held with an under-the-palm grip. This grip is recommended for drawing as it encourages a wider and freer range of drawing motion.

A Process for Observational Drawing
Process is important, and having a defined strategy provides a sense of control each step of the way. It creates structure for the methods of drawing. Becoming comfortable with a process can lead to better organization and a stronger understanding of what could otherwise be a daunting task. Drawing from observation is no exception.

The key to observational drawing is to make direct relationships between what you see and the marks that you draw on the paper. In order to do this effectively, a functional and practical working strategy is a great advantage. While there are many different processes that artists utilize when drawing from direct observation, the following is a practical approach that works well:

Viewfinder A small, window-like tool to assist with planning and framing a composition from observation.

1. **Decide What to Draw**
 » Refinement
 (through a viewfinder and thumbnails)
2. **Compositional Gesture**
 » Refinement
 (through sighting and measuring)
3. **Introduce Values**
 » Refinement
 (through value comparison)

In this process, each step is equally important, and every step can be challenging. Some may choose to put a greater emphasis on one or more of the steps in order to achieve a different type of result. To refine your skills, it is a good idea to focus on one step at a time. (For example, make many compositional gestures before attempting to introduce values.) Notice that each of the drawing steps suggests a strategy of working from general to more refined and specific. Every step provides a chance to revise and revisit your work. This type of gradual development will often result in a rich and sensitive drawing.

Step #1: Decide What to Draw

When viewing a potential subject, try to understand the intent of your drawing and what you wish to capture about your observed subject. Know what to include in your drawing and why—in other words, decide what to draw. It helps to envision the finished drawing before beginning. It is not enough just to copy what is seen: try to know what it is *about* the subject that you wish to capture. Any and every object has the power to breathe life into a drawing. Be creative; let yourself unleash the potential of your subject matter. To create an outstanding drawing you must look and investigate through creative eyes.

Refine What to Include

After establishing a general idea of what you want to capture, you can refine your idea by making compositional studies or thumbnail studies (see pp. 35 and 38).

Using a Viewfinder

You may have seen an image of a movie director peering through upheld fingers to frame a shot on set. Instead of your fingers, a **viewfinder** is an excellent tool to assist with planning a composition from observation (**6.6**). Plastic viewfinders can be purchased, but you can easily make an effective one yourself. By paper-clipping two L-shaped cards together

6.6 Viewfinder

you can adjust your viewfinder's window to match the proportions of the drawing paper you are using. Pencil marks on the center of each side can help to transfer what you see through the window onto the paper.

To use a viewfinder, simply look through it and allow the frame to crop unwanted areas. It may help to close one eye in order to flatten the space between the frame and the view. Various compositions can easily be explored this way. You can consider zooming in very closely to the subject, panning out, or shifting the focus to the left or right, up or down. A viewfinder can be thought of as a camera that helps to capture the best view.

Using Thumbnails

When you find an inspiring view, try making a thumbnail study. This should be done in a sketchbook or on a separate piece of paper. Making a composition perceptible by way of a thumbnail study carries stronger significance than merely imagining what a drawing could be. When an idea for a composition is preserved as a thumbnail we are better able to analyze its potential.

To begin your thumbnail study, draw a small rectangle that has the same proportions as the window of your viewfinder, as well as the same proportions of the paper that you will use for your final drawing. Then, transpose what you see through the viewfinder to corresponding locations within the small rectangle of the thumbnail. You may wish to make pencil lines that denote the halfway points of the thumbnail rectangle. Use the window's edges, the pencil marks on the viewfinder, and the halfway points on the thumbnail rectangle as guides (**6.7**). At this time, it can be helpful to add the elementary dark areas to the drawing, as these have a strong impact on an overall composition. The more thumbnails that you make, the stronger will be your understanding of which composition will make the best drawing.

6.8 Compositional gesture

After making multiple thumbnail studies and arriving upon a composition, a compositional gesture is made on a larger piece of paper. Compositional gesture is step #2 of the drawing process. At this stage detail is not important. The goal is to place the objects on the page in a manner that is similar to the thumbnail.

change throughout this stage of the process, and it is best to use free and quick moving lines. Your eyes should be darting around the setup as they make comparisons of all the objects that will be included in the drawing. Draw light, exploratory lines, and only start to draw progressively darker marks as you become confident that your lines are in the correct locations. Resist committing to lines too soon as this may lessen your chances of accuracy (**6.8**).

Refine Compositional Gesture

Sighting and measuring techniques help make refinements to a compositional gesture. These techniques include: (1) horizontal and vertical alignment; (2) measuring angles, and; (3) measuring proportions. The goal at this stage of the process is to make adjustments to the drawing in order to match what is observed in the setup. The act of refining a drawing requires a circular process of analytical observations, making corrections, and then pausing to decide if further changes are needed. At this stage, portions of the drawing will be restated and redefined. Shapes begin to enclose, and a more decisive statement emerges. It can be very hard to scrutinize one's own drawing at this stage, but it is important to remain open to continual refinement throughout the process. It is challenging to fit all of the drawing pieces together in an accurate way. When analyzing a subject you must continually remind yourself that you are translating what is three-dimensional into a two-dimensional representation. Closing one eye when viewing the subject helps with this translation as it gives the illusion of a flatter space. The more you practice sighting and measuring, the faster and more accurate you will become at using these techniques. Persistence will help you attain perceptual correctness.

A **sighting and measuring stick** is needed when refining a drawing. Typically, artists use a ruler or a straight dowel for this purpose; 12" is a good length (see pp. 136–139). If you are drawing with a pencil or a long, straight piece of charcoal, these also can be used.

Compositional gesture
A quick, generalized drawing that is concerned with the placement of objects on the page.

Sighting and measuring
Techniques used to refine the angles and proportions of a drawing.

Sighting and measuring stick A straight, thin stick used when sighting a measurement. A thin dowel or a pencil is often used.

Step #2: Compositional Gesture

Once you have chosen what to include in your composition, step #2 can begin: drawing a **compositional gesture**. This step is comprised of upscaling your best thumbnail study to your drawing paper. Details at this stage are not important; instead, create a generalized drawing that is concerned with the placement of objects as suggested by the thumbnail study.

Follow the thumbnail as a guide. Then—as soon as possible—move toward using only the actual objects as your reference. This stage is about placement and making adjustments. You are searching for size relationships between objects and negative spaces. You must embrace

6.9 Student work. Dan Muangprasert, *Untitled*. (Instructor: Adriana Bergos)

Vertical and horizontal alignment was used to refine the measurements in this observational drawing. Holding a stick at arm's length and closing one eye, the student was able to assess how the location of objects related to others. Vertical and horizontal lines that correspond to what was seen were drawn on the paper and then objects were positioned accordingly.

Alignment A sighting process whereby the artist compares landmarks by extending imaginary vertical and horizontal lines.

Horizontal and Vertical Alignment

Making comparisons of landmarks by extending imaginary vertical and horizontal lines helps refine the compositional gesture of a drawing. If objects in the setup line up along the same horizontal or vertical lines, then an accurate observational drawing should be arranged in that way, too.

To check for horizontal **alignment**, close one eye and hold your measuring stick at arm's-length away from the body, locking your elbow. This is important with any of the sighting and measuring techniques, as it will keep consistency among measurements by maintaining a constant scale. Make sure not to tip the measuring stick into space (which is a natural tendency). Instead, keep the stick parallel to your face, and hold it in a true horizontal position. While holding the stick this way, make comparisons between landmarks of different objects, such as the bottom of one object compared to another. This will give you valuable information as to whether the objects in your drawing are positioned correctly, or whether an object should be drawn higher or lower on the page.

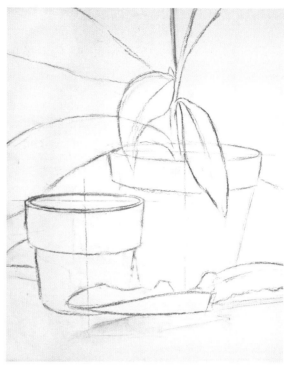

6.11 Drawing lines to bisect symmetrical objects
To assist in making the clay pots symmetrical, construction lines are lightly drawn. These lines will act as vertical and horizontal axes. Having these lines in place helps to gauge if the top ellipses are drawn correctly. These lines also aid in judging proportions. This is part of the refinement stage in step #2 of the drawing process.

6.10a (top) and **b** (above) Invisible grid
Using a dowel as a measuring tool, the artist holds the dowel horizontally to make comparisons. The top image shows that the edge of the small pot aligns closely with the tip of the hanging leaf. In the second image, above, the artist checks to see if the same occurs in the drawing. If not, the drawing must be adjusted. In a similar way, the artist will hold the dowel vertically to make more comparisons. This is part of the refinement stage in step #2 of the drawing process.

TIP

Close one eye when sighting angles. This will help you to align a pencil in your hand with the angle of an object in the distance. Once matched, transfer that angle of your pencil to your drawing.

As you go along, make all corrections that are needed. While working, step back and look at the drawing from a distance. Doing this frequently will help you evaluate your progress by making areas that need additional correction more obvious.

To check for vertical alignment, repeat this refinement step, but this time by holding the stick in a true vertical position to make comparisons of landmarks as they relate to a vertical axis. Some artists use a plumb bob (a weight suspended by a string) for this purpose.

By repeatedly checking horizontal and vertical alignments, you are in essence creating an invisible grid to reaffirm the correct positioning and sizes of objects in your composition. Sometimes artists choose to draw grid lines on the page as a reference, while other artists imagine an invisible grid as they make horizontal and vertical comparisons of object placements (**6.10**).

The vertical and horizontal alignment technique is also useful for creating accurate symmetrical objects, such as ellipses. By lightly drawing a line that bisects a symmetrical object, one can more easily maintain similarity on both sides of the drawn object (**6.11**).

Measuring Angles

Angles should also be measured. First, choose an angle that needs refinement. To measure this angle, again close one eye and hold the measuring stick an arm's length away from the body. Rotate your wrist so that the stick turns like the hands of a clock. Visually line up the stick with the angle that you are measuring. Consider the angle's degree of slant. Does the

drawing possess this same angle? Carefully, without changing the angle of your stick, bring the stick to the drawing in order to compare and correct angles. This should be done repeatedly to insure correctness. As before, step back and look at your work from a distance many times during this refinement step to evaluate your progress (**6.12**).

Measuring Proportions

To define objects more accurately, it is possible to measure proportion (the relative sizes of objects). To do so, a standard measuring unit must be established. This single unit can be used to compare all parts of a drawing. As before, close one eye and hold the measuring stick an arm's length away from the body. Find a measurement that you wish to use to check

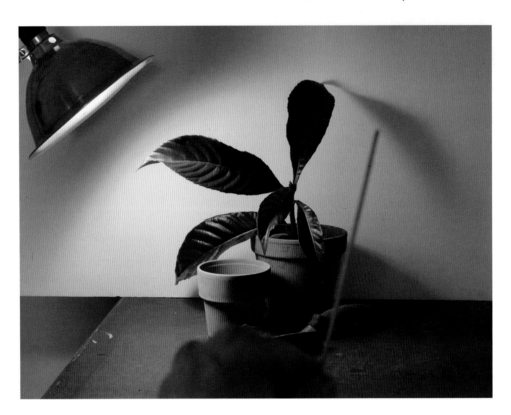

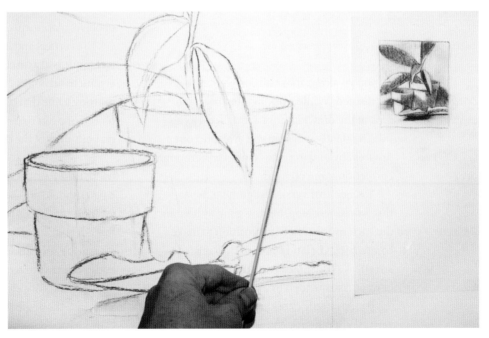

6.12a and **b** Using a stick to measure angles
These photos show the artist using a measuring dowel to analyze angles. In the first image, above, we see him checking the angle of the side of the large clay pot. In the second image, right, he makes sure that the corresponding angle in the drawing is accurate; if it is not, he will correct the drawing. He will continue refining angles throughout the drawing. This is part of the refinement stage of step #2 in the drawing process.

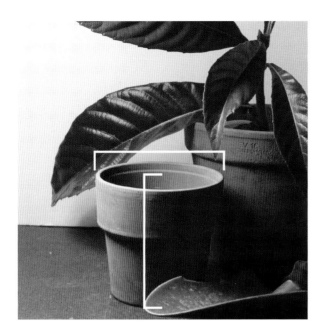

6.13 Comparing the height to the width of a pot
Continuing to refine the compositional gesture, the artist compares the height to the width of the small clay pot. He notices that the pot is slightly wider than it is tall. He makes the pot in his drawing the same way. He will continue to compare the height and width of all of the objects in his still life.

6.14 (below) Measuring proportions: the width of a pot compared to the height
To assess the proportions of the still life further, the artist chooses one unit of measurement: in this example, the height of the ellipse found on the top of the small pot. So, one unit equals the height of the small ellipse. He uses that increment to judge the proportions of objects throughout the drawing. For example, we can see that the distance from the front lip of the small pot to its base measures 4 units. We see that the width of the pot is equal to 4½ units.

TIP

Use a pencil to practice sighting and measuring. Compare the height of an object to the width of the object. Do this with many different subjects: cups, trees, buildings, furniture, cars, *etc.* (**6.15a** and **b**).

the proportions of the rest of the drawing. In figure drawing, the model's head is often used as a unit of measure. In a still-life drawing, the height or the width of an object could be used. In **6.13**, the width of a pot was selected as the measuring unit and compared to the height of the same pot.

After you have settled on a measurement unit, compare this unit to other objects and spaces within the drawing. In the diagram, the height of the pot's ellipse has been used as a measurement to assess how parts of the still life relate to others (**6.14**). As discrepancies are

found, corrections should be made. Continue to repeat the unit vertically, as diagrammed, to see where objects start and stop. This can be very important when trying to replicate how objects appear to diminish in size—and how spaces appear to compress—as they move away from the viewer. Do this horizontally as well. This will give valuable information as to where objects should be placed across the picture plane.

Once again, step back and look at your drawing from a distance many times during this step. Standing at least 5 feet away from the work will help to evaluate the accuracy of one's sighting and measuring.

Step #3: Introduce Values

By this stage of the process, a well-measured linear drawing should have been established. Values can now be added. (For more information about the element of value, including value scales, see Chapter 9, p. 182.) To make the values more apparent and therefore easier to distinguish, it is advisable to have a strong directional light source on your subject. You may wish to arrange your still life next to a bright window, or aim a spotlight at your subject. For clarity, lighting from the left or right side of the subject is desirable, as it will generate an obvious contrast of light on the objects. As with other steps of this process, value should first be applied simply throughout the entire drawing, and then refined and made more specific as the artist continues to work.

To begin, look at your subject through squinted eyes. This will obscure details and simplify the values you see. Generalize what you see into separate value areas. Try to assign each area one of four categories: lightest, medium-light, medium-dark, or darkest. A simple four-step value scale can help as a guide (**6.16**).

Now "**block in**" or "**map out**" the general regions of value within the composition. Areas of the composition that are deemed the lightest should be left as the white of the page. All areas of the subject that appear closest to the medium-light value on the value scale should be applied as a medium-light in the drawing. Do the same for medium-dark, and the darkest areas of the composition. Although the darkest values should be quite dark, do not use the medium to its darkest strength at this stage. The very darkest areas can be enhanced later.

Once the four values are distributed throughout the composition, the drawing

Block in or **Map out**
Adding approximate values to a drawing. Often used as a first step when applying value.

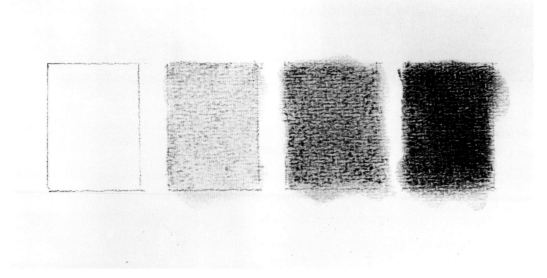

6.16 Four-step value scale
This is a four-step value scale made with charcoal. It will help the artist as he begins to introduce value in the drawing process. The far-left value is the white of the page. The far-right value is very dark, but not to the fullest ability of the medium. The two middle values are visually distributed in an equal way between the light and dark.

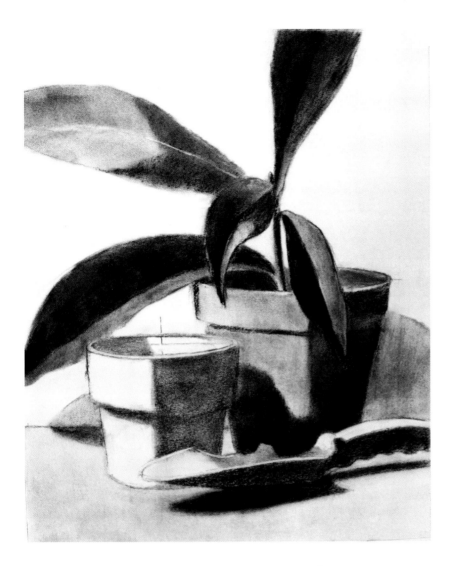

6.17 Drawing with mapped values
Beginning step #3 of the drawing
process, the artist introduces the
general values of the composition. With
his value scale as a guide, he uses only
four values in the entire drawing. At this
stage many of the outlines disappear.
There should be a relatively clear
depiction of a light source at this point
of the process.

TIP

Work from the general to
the more specific: sketch
the full composition
loosely and then refine
the drawing with sighting
and measuring. Block in
basic dark, middle, and
light values throughout
the drawing and then
slowly increase the
number of values to
match what you see.

should reveal a wide range of values and
clarity of a light source (**6.17**). Notice that
most of the lines have disappeared and
objects are now defined not with outlines,
but with value. This more closely resembles
what is observed. Continue judging the
drawing from a distance periodically to help
decipher if corrections should be made.

Refine Values through Value Comparison

To refine the general values of the drawing,
comparisons need to be made and more
values need to be added. To begin, it helps
to choose the single lightest area of the setup.
In theory, especially when one light source
is used, there should be only one lightest
area, probably a highlight. The white of
the paper should be reserved for this area;

all other light areas should be slightly toned
down. Likewise, examine the setup for the
very darkest areas. The very blackest portions
of the dark zones made in the previous step
should now be made even darker. Your drawing
instrument's darkest potential should be used
in these areas.

Compare the medium-light zones. In the
mapping stage there is probably more than one
area with this value. Compare them, deciding
which ones are darker or lighter than the
others. Add more to the darker areas. Slightly
erase to lighten zones, if needed. Do the same
with the medium-dark zones.

Adjustments to the values should be slight,
with a focus on making the drawing more
similar to what is observed. As modifications
are made it is important not to lighten or
darken any zone so much that it becomes too
light or too dark for that value zone. This will

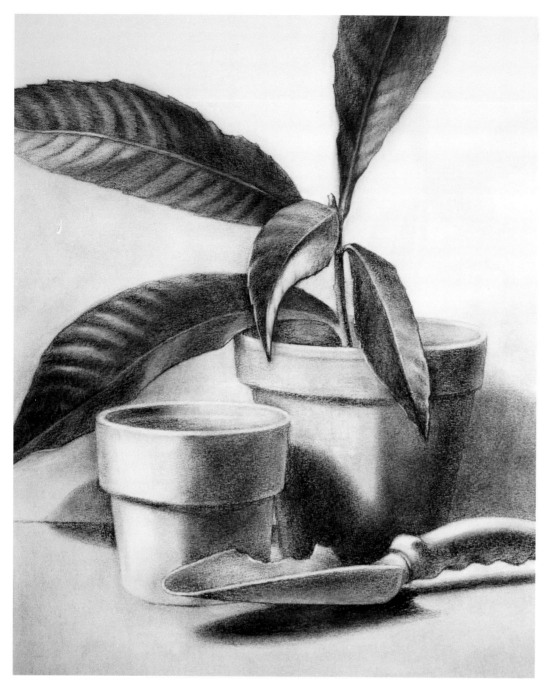

6.18 Completed drawing using drawing process
The artist refined step #3 of the drawing process by comparing values. As an example, the artist noticed that the left side of the big pot appeared slightly darker than the left side of the small pot. He adjusted his drawing accordingly. The more refinements the artist made increased the number of values included in the finished drawing from the original four. The artist continued to hone values until the drawing accurately represented the subject, as seen in the above.

ensure that the finished drawing will retain the appearance of light throughout.

As the drawing becomes more refined, comparisons of both sides of all edges should be made. Determine which side of an edge is darkest and then make it so in the drawing. The elements of drawing such as line, shape, form, and space should be considered (see Part 3, "Drawing Elements," p. 148). Depending on the artist's goals, this process can be used to create a drawing that is a suggestion of reality, or it can be refined to be hyper-realistic (**6.18**).

Drawing at Work Charles Bargue

The French lithographer and painter Charles Bargue (1826–1883) was an excellent copyist. Bargue collaborated with renowned painter and teacher Jean-Léon Gérôme (1824–1904) in the creation of *Cours de Dessin,* (*Drawing Course*, published between 1866 and 1871), intended as a textbook for students of industrial arts, design, and fine art. For this book of loose pages, Bargue created 197 lithographic copies of charcoal drawings. Together, they constituted a road map to attaining proficiency in drawing, which was considered to be the single most essential component of art and a requirement for admission to the most influential art schools of the nineteenth century. *Drawing Course* followed the standard art school program for beginning art, a curriculum that emphasized imitation of nature, accuracy, solidity, and finish. Students were instructed to start by copying plaster casts, then to copy master works, and finally to draw from the male nude model. The first two sections were considered to be the best way to teach drawing to students studying design and industrial arts. The third section was additional for students studying fine art. Such artists as Vincent van Gogh (1853–1890) and Pablo Picasso (1881–1973) were trained using this Classical process.

The first volume of *Drawing Course* provided examples of a plaster-cast drawing process. Each page of this section consists of a simplified linear structure next to a finished version of the same sculpture. Before drawing from actual plaster casts, art students were instructed to copy the two-dimensional images. Bargue's plates were considered good examples to copy, both for acquiring skill and for the

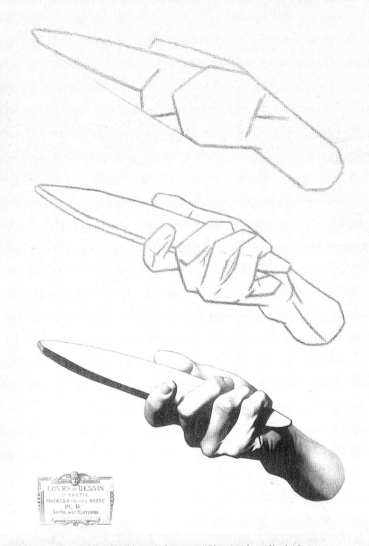

6.19 Charles Bargue, "Hand Holding a Whetstone," Plate 1.14 from *Charles Bargue: Drawing Course*, 1866–71. Lithograph, 23⁷⁄₈ × 18½" (60.6 × 47 cm)

development of good taste. Students were encouraged to work through the sequence of plates in order to develop a working process. The lithograph shown in **6.19** is an example of one the studies included in the cast portion of *Drawing Course*. The first drawing shows a simplification of the form made by drawing a few lines that join measured points. It also includes a diagonal line that references the overall angle of the hand. In the middle drawing, Bargue finds the smaller shapes of the hand and adds lines to indicate the major

shadows. The final step in the process was to develop the form by adding value. The students were to make their copies using vine charcoal and then finish with charcoal pencils. Accuracy was promoted throughout the process.

The traditional academies that used Bargue's drawing method almost died out after the nineteenth century, but today there is renewed interest in following this traditional approach, and once again academies that teach Classical techniques of representational art exist around the world.

Each Step as an End Result

Each step acts as a part of a larger process, but a single step can also be a primary focus of a finished drawing. Let us look at three artists who have done just that: Ann Gale, Eric Elliott, and Cindy Wright.

These small figure drawings by Ann Gale (b. 1966) demonstrate step #1 of our drawing process, "Decide What to Draw" (**6.20**). The artist uses spare marks to present her subject. Loose and impulsive lines place the subject within the composition. Organization appears to be a primary focus. If it were another artist's work, he or she might have chosen to further develop these drawings, but their simplicity is beautiful even without further embellishment.

6.20 Ann Gale, *Compositional Studies*, 1993. Graphite on paper, 14 × 11" (35.6 × 27.9 cm). Collection of the artist
Each of these compositional studies could stand alone as a finished work of art. This demonstrates the fact that while step #1 of the drawing process can be used as one part of a larger process, it could also be the sole motivation of a finished work.

The Work of Art
Leonardo da Vinci

Who: Leonardo da Vinci
Where: Italy
When: *c.* 1499–1500
Materials: Charcoal heightened with white chalk on paper, mounted on canvas

The drawings of Leonardo da Vinci (1452–1519), whether large or small, reveal his constant involvement with visual brainstorming. His wide range of subject matter included nature, anatomy, engineering, physics, architecture, and military weaponry. He filled thousands of pages in his private journals with scrupulous notes recording his observations, designs, theories, and ideas. Central to Leonardo's work was the belief that the accumulation of knowledge was based on the act of direct observation. Even his compositions made from imagination, such as *The Burlington House Cartoon*, were based on ideas collected from careful observations.

Artistic Aims

Following up on his sketchbook work, Leonardo made large preliminary drawings for the purpose of being transferred to make a final painting. Such drawings as these are called **cartoons**. *The Burlington House Cartoon* is one such preparatory study. This drawing was made from his imagination and depicts the Virgin Mary holding the infant Jesus. She sits on the knee of her mother St. Anne with Jesus' cousin, St. John the Baptist, depicted on the right.

Artistic Challenges

Composing a large-scale, four-figure drawing is a challenging undertaking. *The Burlington House Cartoon* illustrates

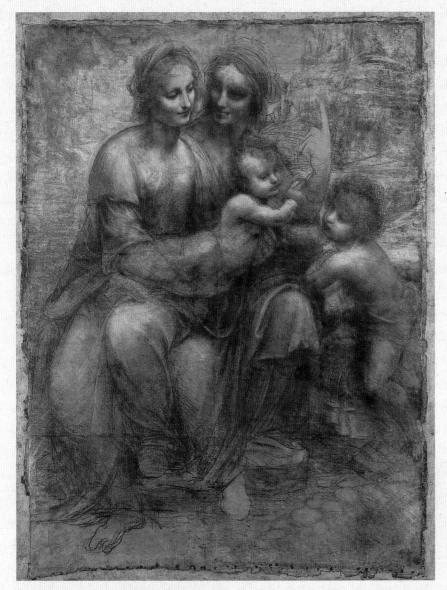

6.21 Leonardo da Vinci, *The Burlington House Cartoon*, c. 1499–1500. Charcoal heightened with white chalk on paper, mounted on canvas, 55⅝ × 41⅛" (141.5 ×104.6 cm). National Gallery, London, England

refining the positioning and contours of the figures, he models light and form using curved hatching. White chalk is added, while the mark-making is blended together to giving the drawing a hazy three-dimensional appearance (a technique known as *sfumato*, for more on which see p. 213).

The Results

The Burlington House Cartoon was drawn on eight attached pieces of paper, measuring around 4' 8" × 3' 5" in total. Although it was made as a preparatory drawing for a painting, no painting exists that was made from a transfer of this image. Along with Leonardo's most famous works, *The Last Supper* and *Mona Lisa*, it is considered to be one of his great masterpieces.

In 1986, the drawing was severely damaged by a mentally ill vandal with a shotgun. Luckily, it was possible to restore the artwork. To preserve it and to make it available to the public, the drawing currently hangs in a small, dimly lit gallery at the National Gallery in London, England.

Sketchbook Prompt

Quickly sketch an object in your sketchbook with a light pencil. Go back over the sketch with a darker pencil, this time slowly and accurately. Following Leonardo's example, be open to adjustments and corrections.

Leonardo's ability to do so. The interaction of four figures is made even more complex by Leonardo's desire to show the tender relationship between the characters, giving the scene appropriate religious significance. The rhythmical placement of the heads and knees causes the viewer's eye to travel from one to the other. This rhythmic circulation harmonizes and unifies the massing of the forms. Also binding the composition together are the twisting movements of the bodies, the flowing garments, and the directional glances of the characters.

Artistic Method

Leonardo sketched on loose sheets of paper in the studio and on location. He collected the pages in dozens of notebooks arranged by themes: painting, architecture, mechanics, and human anatomy. Both his notebook drawings and his large cartoons show how he adjusted visual ideas as he worked. In **6.21** the viewer can see how Leonardo's drawing transformed and evolved. He begins with rough charcoal outlines, such as those seen in Mary's foot or in St. Anne's arm and hand. After

Cartoon A full-sized drawing made as a guide for a final work. From the Italian *cartone*, meaning an artist's preliminary sketch.

6.22 Eric Elliott, *Studio 17*, 2008.
Pencil on paper, 11 × 15" (27.9 × 38.1 cm).
Collection of the artist

Some artists choose to focus on the refinement of a compositional gesture. In this drawing we can see light lines that appear to have been drawn first. The artist then darkened some lines, reassessing them as he drew. The drawing's abstract nature comes from the emphasis on the size, shape, and angles of the lines.

6.23 (below) Cindy Wright, *Black Mirror*, 2014. Charcoal on Kopie paper, 49½ × 73" (126 × 186 cm). Collection of the artist

As seen here, some artists desire to work primarily with value. Such a drawing as this can be inspirational to us as we address step #3 in our drawing process, "Introduce Values." Notice that the drawing shows a full range of values, from very dark to very light. The use of values gives the work a highly representational appearance.

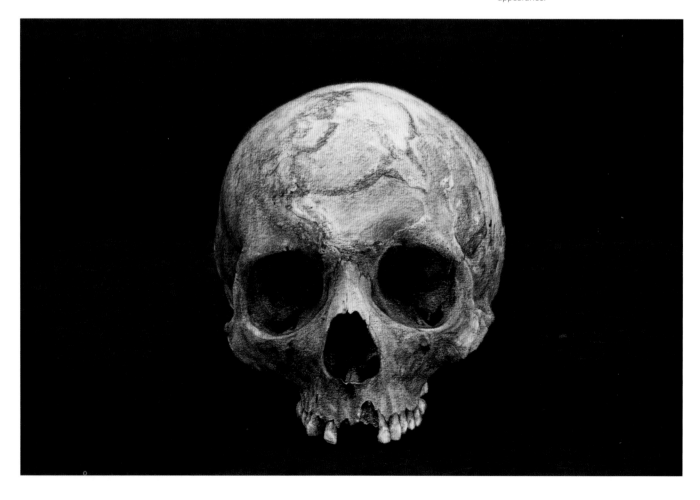

This drawing by Eric Elliott (b. 1975) exemplifies step #2 of our drawing process, "Compositional Gesture," including refining through sighting and measuring (**6.22**). The artist focuses much of his energy on making comparisons between objects. The length of lines and angles are carefully sighted. In some places we can see that the edges of objects are extended into space, making reference to other objects. This drawing demonstrates that outstanding results can be achieved even if we focus on only one part of our drawing process.

Cindy Wright (b. 1972) is a highly skilled renderer. Her drawing represents step #3 of our drawing process, "Introduce Values" (**6.23**). To learn from this work, we can study it in terms of general value areas. Every part of the drawing can be considered as either very dark, medium, or lightest in value. Within each of the value areas, Wright refines and hones the nuances of light and dark. Concentrating on value can lead to exceptional results.

In the Studio Projects

Fundamental Project

Place a drinking cup on a table in front of you. Using the sighting and measuring strategies discussed in this chapter, analyze the angles and the proportions of the cup. Try to replicate these proportions as accurately as possible in a line drawing. Repeat this exercise multiple times on separate pieces of paper.

Observational Drawing

Arrange a still life of three or more objects. Illuminate the setup with a strong directional light source. Use the process discussed in this chapter to create an accurate drawing from observation:

1. Decide What to Draw
 » Refinement
2. Compositional Gesture
 » Refinement
3. Introduce Values
 » Refinement

Research Project

Research the processes that artists use in the creation of their work. Choose one artist and create a digital presentation that describes his or her working method. If possible, include unfinished works, statements by the artist, and finished works. Presentations can be shared with a group.

Criteria:
1. Angles of the cup should be replicated accurately.
2. The proportions of the cup should be replicated accurately.
3. Multiple line drawings should be made, each demonstrating a dedication to sighting and measuring.

Criteria:
1. The completed drawing should demonstrate a thoughtful composition based on the use of a viewfinder.
2. The completed drawing should depict refined measurements, including placement, angles, and proportions.
3. The completed drawing should exhibit a full range of values that accurately depict a light source.

Criteria:
1. The presentation should thoroughly describe an artist's working method.
2. The presentation should include visual examples of the artist's work.
3. If shared with a group, the project should be logically presented.

Materials: 9 × 12" sheets of paper, graphite pencil

Materials: Vine charcoal, compressed charcoal, and/or charcoal pencils, 18 × 24" sheet of white drawing paper

Materials: Digital presentation

Part 3
Drawing Elements

The formal elements of art are the visual
vocabulary that make up our artistic language
and enable us to structure our work. When
you produce and examine drawings you should
consider these important elements, as they
have long been utilized in great works of art.
In this part you will study the formal elements
individually, and in doing so become familiar
with what each has to offer. You will learn
how to incorporate them into your drawings,
and why each is valuable. You will see how
other artists have employed such elements in
their works. These chapters provide helpful
strategies for developing your use of the
elements in your drawings.

Fig. 3

Fig. 1

Fig. 2

Chapter 7
Line

Line is a primary element in art and has a central role in nearly every drawing. A remarkable amount of information can be reduced to a single line. This reductive quality of line carries strong communicative properties as well as aesthetic force. Despite line's economy, it is highly descriptive and can create spontaneous gesture, emotion, meaning, and beauty.

A number of line types can be used and combined by the artist. This chapter will address a range of lines, such as descriptive, emotional, outline, contour line, line weights, soft, lost, and implied lines, and lines used for linear modeling. By studying the use of line by other artists, you can increase your own line-making repertoire from which to select an appropriate type of line when drawing.

There are a myriad of line types available to an artist that offer a vast range of expression, from communicating ideas to creating emotional works. The type of line you choose determines the outcome of your drawing.

7.1 Jean-Auguste-Dominique Ingres, *Portrait of Madame Simart*, 1857. Pencil on paper, 13⅛ × 10" (33.5 × 25.4 cm). Albright-Knox Art Gallery, Buffalo, NY

This highly realistic drawing relies on the descriptive element of line. The carefully refined lines describe the textures and forms in a believable way. Although such lines as these are not actually present in reality, line is a device that we have come to accept as definitive.

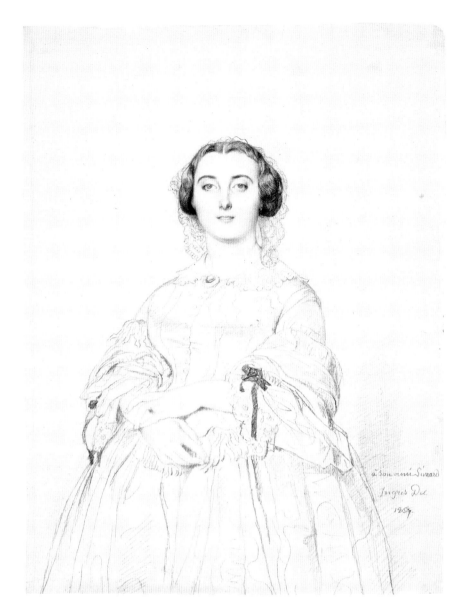

Descriptive Line

When learning to draw, children often first make jabbing marks with their crayons. Soon, however, these dashes and dots take on the scribbling shape of cyclones as the young artists become fascinated with their power to make a continuous, linear mark with their drawing tools. Within just a few tries, children discover the power of line and soon become accustomed to its visual language. They quickly equate linear marks with the objects that they represent, accepting line as resembling nature. But lines do not actually replicate objects as they are in reality, or even as they actually appear; instead, lines imply and infer objects as they are understood in our minds. You might refer to a detailed line drawing as being realistic, but in reality objects are not defined by line.

The French artist Jean-Auguste-Dominique Ingres (1780–1867) was a master draftsman and therefore highly skilled at drawing with line. His compelling portrait of Madame Charles Simart was made predominantly with line (**7.1**). The drawing displays a remarkable sense of realism. Within the sitter's luxurious dress a great array of lines gives the viewer a palpable feeling of the different fabrics and textures. With line, Ingres contrasts the lace collar, the tightly corseted bodice, the gathered folds of the sleeves and skirt, and the suppleness of Madame Simart's arms and hands. Logically, we understand that fabrics do not have lines that describe their physical boundaries, but

through the expert use of line, those forms are conveyed believably.

A digital rendering made by the industrial designer Filip Chaeder shows how clearly line can describe an object (**7.2**). These drawings articulate the form and details of a watch from multiple viewpoints. Clean and precise, Chaeder's lines are an efficient communication tool.

Alice Aycock (b. 1946) is well known for her large-scale installation sculptures. She uses line drawings to create schematic representations of imagined environments (**7.3**). Resembling a mechanical engineer's drawing, they specify the structure and appearance of her ideas clearly. Her drawings are equal parts logic and fantasy.

Descriptive line drawing does not have to be done with tight and exacting lines. A spontaneous line approach can be equally communicative. Lina Bo Bardi (1914–1992), one of the most expressive Brazilian architects, collaborated with Milanese architect Carlo Pagani (1913–1999) on this drawing, which uses spontaneous gestures to explain an interior design (**7.4**). The loose line work with added color pairs well with their people-friendly designs.

7.2 Filip Chaeder, *Watches*, 2016. Digital rendering
This computer-aided drawing of watches was developed in stages, beginning with simple geometric shapes and then further enhanced with details. Multiple viewpoints of the watch increase our understanding of the object. This drawing is an example of how clear and descriptive line can be.

Descriptive line
A representational line.

7.3 Alice Aycock, "Collected Ghost Stories from the Workhouse," *How to Catch and Manufacture Ghosts*, 1980. Pencil on paper, 42 × 54" (106.7 × 137.2 cm). Rose Art Museum, Brandeis University, Waltham, MA
This is a graphic representation of an imaginary mechanical device. The lines reference the kinds of drawings made by engineers. This rational approach to drawing with line contrasts with the artist's fictional subject.

7.4 Lina Bo Bardi and Carlo Pagani, "House Aquarium,"
Lo Stile: Nella Casa e Nell'Arredamento 10 (October 1941)
This drawing represents a spontaneous approach to line drawing.
Even though the lines that describe the architecture are not
perfectly straight and the plants in the room are not delicately
refined, the viewer can understand the space. The drawing
suggests the concept and mood for a glass-and-concrete house.

7.5 Willem de Kooning, *Seated Woman*, *c.* 1941.
Pencil on paper, 7 × 5" (17.8 × 12.7 cm). Private collection
Line can be a powerful and emotional tool. We see this
when in the hands of an Abstract Expressionist, such
as Willem de Kooning, who constantly experimented
with different types of line work throughout his career,
most often when drawing the figure. In this drawing he
made aggressive and frantic lines. As he redrew his lines
repeatedly, parts of the figure dissolved into abstraction,
while others emerged more emphatically.

Emotional line A line
that we associate with
certain types of feelings,
expressions, or moods.

TIP

Study the type
of lines that your
favorite artists use
in their drawings.
Try to describe the
emotions that these
lines convey. Use
similar lines in your
own drawings.

Emotional Line

Line is representative, but it also has visual power
in its own right. An artist can choose different
types of lines to impart emotion to the viewer.
The quality of these lines can conjure up different
responses because we associate certain types
of lines with specific feelings, expressions, or
moods. The selection of which personality of
line to use in a drawing often happens naturally,
or it can be a conscious choice by the artist.
Various linear drawing tools, as well as the right
selection of drawing surface, can be used to coax
out the type of **emotional line** that an artist
wishes to make.

The Dutch-born painter Willem de Kooning
(1904–1997) was a leader in the American
movement of Abstract Expressionism.
His drawn spontaneous gestures are turbulent
and aggressive; his line-making often appears
fearless. The distorted figure in *Seated Woman*
moves in and out of clarity (**7.5**). In places,
the lines are descriptive, but in other areas the
lines free themselves from the figure and take
on lives of their own. They are fast, emotional,
and violent. The quality of line in De Kooning's
work can be appreciated aesthetically, and even
independently of the subject.

7.6 Dame Zaha Mohammad Hadid, sketch of *Edifici Torre Espiral, Barcelona, Spain,* 2005. Drawn on A3 sketchpad. Zaha Hadid Foundation
For the architect, line is the facilitator of invention. This drawing reveals the designer's complex thoughts about architectural forms and relationships. While drawing is a practical part of the architect's process, it can also inspire and express the emotional aspect of creative vision.

7.7 Matsumi Kanemitsu, unused preparatory drawing for *In Memory of My Feelings,* by Frank O'Hara, 1967. Ink on acetate, 14 × 11" (35.5 × 27.8 cm). MoMA, New York
This modern, non-objective drawing was influenced by traditional East Asian calligraphy. Follow the line in this drawing. It was slowly and skillfully dragged down the page. It is meditative and emotional, demonstrating the power of a single line.

Outline The outermost line of an object or figure, by which it is defined or bounded.
Figure/ground relationship The manner in which positive and negative shapes visually interact.

Consider the drawings by the Iraqi architect Zaha Hadid (1950–2016). Her drawings were made to communicate architectural structures, but they also possess an emotional charge. Her drawings release the expressive character from within her architectural geometries (**7.6**).

The non-objective drawing in **7.7** by Matsumi Kanemitsu (1922–1992) has striking visual power. His lines are hard-edged and grand. Although modern, his drawing reflects his proficiency with the traditional Japanese *sumi-e* (ink painting) style, both through materials and line work. His drawings present controlled emotions.

Outline

Outline is a line around the outside edge of an object. A pure outline avoids overlap and interior lines. It creates a silhouette. Outlines are an abstract way to represent objects. In actuality, there are no outlines in the physical world; in fact, what we see are edges. The edges are observable because of contrasts, such as those of value and color. When drawing, the natural tendency is to draw these outer edges by using outline. Viewers instinctively perceive a drawn outline as a solid within the composition.

Outlines create flat shapes that highlight the differences between objects and the spaces in which they exist, or positive and negative space. The association between these two parts is referred to as the **figure/ground relationship**. When you draw an object, or figure, within

7.8 Ellsworth Kelly, *Burdock*, 1976. Graphite on paper, 26¼ × 30⅝" (66.7 × 77.8 cm). SFMOMA, San Francisco, CA
The task of drawing the outline of a leaf involves more than one consideration. As outlines define the object, they also create shapes between the sides of the object and the edges of the picture plane. These are the positive and negative spaces, sometimes known as the figure and ground. It is important to think about the relationship between these areas when drawing.

a composition, you are drawing the ground at the same time. A balanced relationship between the two is important to the cohesive quality of a drawing. This is evident in *Burdock* by Ellsworth Kelly (1923–2015) (**7.8**). Much of Kelly's work is concerned with the careful observation of outline and how it bounds space in order to create the utmost aesthetic sensation. This reductive and simplified drawing is elegant in its arrangement.

The contemporary British sculptor Rachel Whiteread (b. 1963) made the outline drawing in **7.9** using pen and ink. It relates to her sculptural series in which she casts the inside of a hot-water bottle with plaster. Her drawing searches for the quiet, contemplative outlines that those pieces share. Never fully closed, her lines imply the full outline.

7.9 Rachel Whiteread, detail of *Untitled (Torso)*, 1990. Ink on paper, 25¼ × 35⅜" (64 × 90 cm). Private collection
Typically, outlines surround an object. The lines in this drawing do not fully connect, but they do seem to imply a continuous outline. Multiple attempts to arrive at just the right lines create an abstract representation of a hot-water bottle.

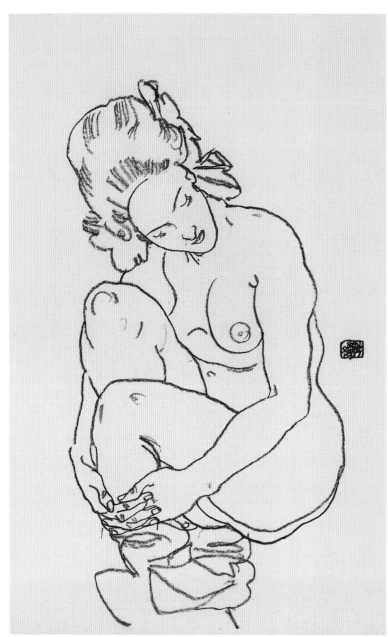

7.10 Egon Schiele, *Kneeling Female Nude*, 1917.
Black crayon, 18¼ × 11¾" (46.3 × 29.8 cm).
Staatliche Graphische Sammlung, Munich, Germany
One type of contour line drawing is an outer-contour
line drawing. This work by Egon Schiele is an example.
Both the outside edges and the interior forms have
been delineated. Notice that space is suggested,
a fundamental requisite for this type of drawing.

Contour line Lines that
delineate the edges of
both interior and exterior
forms to enhance the
description of space.
Volumetric
The impression of
three-dimensionality
in a drawn form.
Outer-contour line
A type of contour line in
which the exterior lines
separate interior and/or
exterior forms.

Contour Line

Contour line differentiates itself from a pure
outline by suggesting a third dimension.
It requires close inspections of overlaps
and of the details that make a drawing
appear **volumetric**. Contour line drawings
often delineate the edges of both interior
and exterior forms to enhance spatial
descriptiveness. Different types of contour
line drawings can be made including outer-
contours, blind-contours, and cross-contours.

Outer-Contour Line Drawing

Outer-contour line drawings use exterior
lines to separate interior or exterior forms.
These drawings often emphasize overlap.
By delineating the outlines of all visible
forms, not just the silhouette, the viewer
is invited into the space and an illusion
of form begins to take place. Consider
the drawings of the Austrian Expressionist
Egon Schiele (1890–1918), such as *Kneeling
Female Nude* (**7.10**). This drawing appears to
have been spontaneously executed. It shows
an understanding of the subject and how
she fills space. Notice the clear overlapping
of body parts as they move away from the
viewer. There is a progressive movement into
space from her left arm, to her left leg, to her
right leg, to her right breast. Well known for
his raw and expressive drawing style, Schiele
utilized outer contour line drawing very often.
The results are naturalistic and often sexually
provocative.

In outer-contour line drawings, artists
often exploit contrasting lines in order to
enrich space and form. By exaggerating
heavier and lighter lines, the illusion of
volume can be increased. The drawings of
the Latvian-born American painter Hyman
Bloom (1913–2009) exemplify this. The pencil
lines of *Wrestlers* were built gradually, starting
with extremely light lines and building darker
marks by applying heavier pressure (**7.11**).
The darkest lines are strategically placed to
set foreground forms in front of those that lie
behind, which creates a sense of depth. Both
interior and exterior forms are drawn.

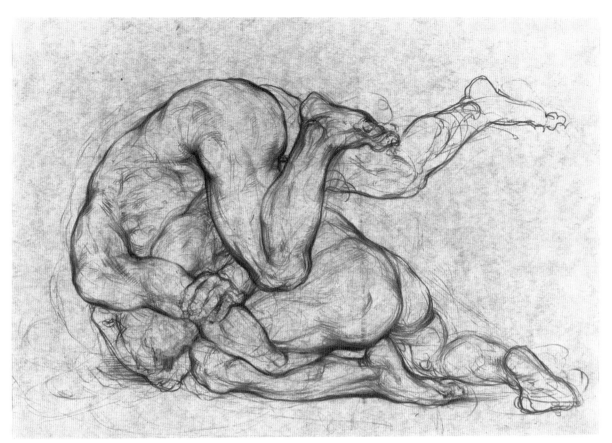

7.11 Hyman Bloom, *Wrestlers, c.* 1930. Black crayon over graphite on brown wove paper, 10 × 14" (25.5 × 35.6 cm). Harvard Art Museums—Fogg Museum, Cambridge, MA

Analyze this drawing in terms of overlap. In most cases, we see that a line is made darker when it passes in front of another line. This enhances the space between the two parts. Utilizing this type of contrast is effective when making outer-contour line drawings.

7.12 Student work. Alexander Hicks, *Contour Ram Skull.* (Instructor: Victoria Paige)

This contour line drawing demonstrates the student's keen attention to the details of the ram skull. The lines not only describe the outer edges of the form, but in some places (such as within the horns) also define the volume. The variation of line weight in this drawing adds visual interest.

Drawing at Work Jenny Saville

7.13 (above) Jenny Saville, *Study for Intertwine*, 2012. Charcoal on paper on board, 4' 11⅞" × 6' 6⅝" (1.52 × 2 m). Private collection

Notable for her depictions of nude women on a monumental scale, the English painter Jenny Saville (b. 1970) is centered in figurative traditions. She makes reference to such earlier artists as Leonardo da Vinci (1452–1519) and Willem de Kooning, and has found new and inventive approaches to drawing and painting. At the end of Saville's schooling the influential British art dealer Charles Saatchi noticed her paintings. He bought the work in her senior show and supported her while she created new pieces for her next show, held at his gallery in London. Since then, her art has been admired throughout the world.

Jenny Saville created the drawings in **7.13** and **7.14** using charcoal on large sheets of paper. These works contain some shading, but they are predominantly constructed with line. She develops her figures with a variety of line types, including flowing contour lines, a variety of line weights, and soft and implied lines. Some marks are confident, long, sweeping and bold, yet in other areas they appear to be tender and fragile. Some disappear into the distance. Saville's line work is both descriptive and abstract: lines accurately portray her subjects, but they also become obscured in agitated networks of marks on top of marks.

Both drawings superimpose changing positions of figures. The animated layers of line introduce a quality of life and an illusion of movement to the scene. In *Study for Intertwine* we understand the layers as the repositioning of the models over time. In *Reproduction Drawing I*, a self-portrait, the layers capture the squirming energy of her young toddler.

In both drawings, line creates the illusion of volume and depth. Alternating line weights develop solid, naturalistic volumes. Soft and interrupted lines make some masses transparent. Bold lines thrust into the foreground, and erased strokes and fading marks retreat into atmospheric space.

7.14 Jenny Saville, *Reproduction Drawing I (after the Leonardo Cartoon)*, 2009–10. Charcoal on paper, 7' 5⅛" × 5' 9½" (2.26 × 1.77 m). Private collection

7.15 Hannah Elizabeth Caney, *Harmonica*, 2015. Blind drawing, ink on parchment, 4¾ × 7½" (12.1 × 19.1 cm). Collection of the artist

This quirky drawing is a result of the blind-contour line drawing technique. When making such drawings as this, try to move your drawing tool at the same speed as your eyes move over the surface of the subject. This practice of drawing enhances observational skills.

Blind-Contour Line Drawing

Blind-contour line drawings are made when the artist's eyes follow the form of the subject without ever looking at the paper while drawing. (Drawings made while looking occasionally at the paper are called modified blind-contour drawings.) It is essential to coordinate the movement of the eyes with the movement of the drawing tool. To avoid losing one's place, artists often do not lift the drawing tool while making blind-contours. Over time, practicing this drawing technique improves their hand-eye coordination and focuses them on practicing the skills of observation. Because distortions are inevitable, blind-contour drawings often possess unpredictable expressiveness.

Hannah Elizabeth Caney is interested in the abstract qualities of objects. Using an ink pen, she made a series of blind-contour line drawings from objects that she encountered at a museum (**7.15**). Some edges do not connect and proportions are not accurate, but this seems only to heighten our fascination. By looking at her paper in only a limited way, she can hardly make aesthetic drawing decisions, imparting to her line work an unusual energy.

TIP

When making blind-contour line drawings, draw lines at the same speed as your eyes travel around the edges of your subject.

Blind-contour line
A type of contour line in which a drawing is made as the artist's eyes follow the form of the subject without looking at the paper.

Cross-contour line A type of contour line that utilizes parallel lines that move across a form to depict volume and space.

Cross-Contour Line Drawing

Cross-contour line drawings contain parallel lines that move across a form to depict volume and space. They resemble the lines found on a typographical map or a wire-frame model of a three-dimensional object in computer graphics. They serve to represent the surface terrain of a solid form. Sometimes these lines actually exist, such as stripes on fabric, and sometimes the lines are invented by the artist to suggest volume. This technique is often used when drawing rounded organic forms. Lines can be drawn closer together in the distance and further apart in the foreground to create an illusion of space. They can fade in and out of focus to enhance plasticity.

The French painter Antoine Watteau (1684–1721) was a gifted eighteenth-century artist who created scenes of pastoral charm. His drawings, mostly done in red and black chalks with pencil, often feature superb costume renderings.

Watteau uses cross-contour lines in *Woman in a Striped Dress* (**7.16**). Not only do the parallel lines indicate the striped pattern of the dress, but they also capture the subtle movements of drapery as it falls over the body. Cross-contour

7.16 Antoine Watteau, *Woman in a Striped Dress*. Red and black chalks and graphite, 5¾ × 7⅛" (14.6 × 18.1 cm). British Museum, London, England

The stripes in the gown of this figure also act as cross-contour lines that describe the structure of the surface. The artist was sensitive to directional changes of the lines as the topography of the garment shifts. The end result depicts convincing volume.

The Work of Art Louise Bourgeois

7.17 Louise Bourgeois, *The Tapestry of My Childhood—Mountains in Aubusson*, 1947. Ink and gouache on paper, 19 × 12" (48.3 × 30.5 cm). National Gallery of Art, Washington, D.C.
Study the cross-contour lines throughout this drawing. Find lines that are straight and lines that curve. Look for lines that are relatively parallel and locate others that taper toward each other. What are the effects of the different sorts of cross-contour lines? Consider how those types of lines could be used in your own work.

Who: Louise Bourgeois
Where: United States of America
When: 1947
Materials: Ink and gouache on paper

The twentieth-century painter, printmaker, and sculptor Louise Bourgeois created works centered on the basic theme of the human body and its need for nurturing and protection. Having experienced a troubled childhood, her art reflects her view of the world as a frightening place. As she drew throughout her life, Bourgeois's imagery ranges from figurative to abstract. She taught drawing for many years in colleges and public schools.

Artistic Aims

Bourgeois's focus was not on creating an art object, but was instead on re-creating emotions. She tapped into events from her childhood as a source for these emotions. Well known for her large-scale sculpture and installations, she also made many drawings and textiles, and explored many other media.

Artistic Challenges

Bourgeois's drawings explore a variety of themes including nature, family, sexuality, the body, and death. Her personal challenge was to use these subjects as a way to address the distressing psychological events that she endured during her childhood. When she was a child her father was persistently unfaithful to her mother; he had a long-term affair with her English governess. This had a profound influence on Bourgeois throughout her life.

In *The Tapestry of My Childhood*, Bourgeois created an image that reads both as a landscape and as fabric. On a symbolic level it connects to her childhood years. To her, the natural

terrain is a metaphor for the human body. The suggestion of fabric connects to her years as a child when she helped out in her family's tapestry workshop.

Artistic Method

Abstraction was a tool for Bourgeois to cope with her emotions. She described the process of drawing repetitive cross-contour lines, such as those we see in this work, as calming. She associated the act of drawing as a way to fix damaged relationships and address psychological pain. She considered the process of making art a highly personal, therapeutic, and cathartic process; it was a way of releasing and understanding repressed emotion.

The Results

The Tapestry of My Childhood was made at the time when Bourgeois was struggling with the transition of emigrating to America from France. She slowly developed more confidence in her work and eventually joined the American Abstract Artistic group in New York City. Her work would continue to hark back to her troubled past with imagined pieces of figures, cages, and giant spiders.

Sketchbook Prompt

Create a landscape using cross-contour lines. Imbue your lines with some type of emotion, for example, calmness or anger.

lines were rendered lighter or darker to enhance the volume of the dress.

The cross-contour lines in *The Tapestry of My Childhood*, by Louise Bourgeois (1911–2010), describe surfaces, some flat, others curved (**7.17**). The lines suggest the direction of the plane. For her, the parallel lines recall both the magic and the grievances of her childhood in her parents' tapestry-restoration shop. Bourgeois felt that her art was confessional, enabling her to slip into her memories and exorcize her unconscious.

The American artist Martin Puryear (b. 1941) uses intricate traditional crafts to build sculptures that are modern and abstract. This untitled print is an image of an invented form comparable to those he develops in his sculptures (**7.18**). Puryear etches loose cross-contour lines to develop his organic form. In the larger image, parallel lines curve and converge to suggest the surface of a rounded, tapering, hat-like form. The small drawing in the upper left-hand corner diagrams a similar form, this time transparent and angular.

7.18 Martin Puryear, *Untitled*, 2001. Drypoint, color hard-ground and soft-ground etching on *chine-collé*, 23⅞×17⅞" (60.5×45.4 cm). Cincinnati Art Museum, OH
The cross-contour lines of this image show roundness, evoking a wire structure. They follow the form, curving and disappearing as they go around to the other side, and work together to give this invented form an illusion of three-dimensionality.

Line Weight

Line weight is the quality or physical characteristic of a line. It refers to the width or thickness of a line, whether it is wide, heavy, thin, slight, or anywhere in between. Line weight is a factor in an assortment of other types of lines as well, such as dashed, dotted, and tapering lines. Line weight can be modified by the darkness or lightness of the line. The weight of a line is relative to the other marks made on the page as well as to its contrast with the background. The variation of line weight adds interest to a drawing. Line weight is affected by the amount of pressure applied to a drawing tool when in use, as well as by the amount of medium applied to the surface. The El Salvadoran caricaturist Toño Salazar (1897–1986) takes advantage of this in *Self-Portrait*, where we can see very wide lines made with a loaded brush contrasting with much thinner scrolling lines (**7.19**). By incorporating diverse line weights, a drawing can gain emphasis, clarity, and a wide range of emotional effects.

Using different line weights helps make sense of complex drawings. Skillful use of line weights can aid in the legibility of a drawing. By utilizing contrasting line weights, an artist can suggest three-dimensional form, introduce spatial effects, indicate a light source, and distinguish changes in surface. For example, consider how dotted lines might imply a certain type of texture. Varying the darkness of that dotted line could suggest light and space. Line thickness can emphasize certain parts of a drawing by expressing dominance while causing other parts to be subordinate. Thick or thin lines read as value changes (see Chapter 9, p. 182). They also communicate important details, such as overlap and depth. The fact that heavier lines appear to advance is responsible for this effect, something that is apparent in drawings by the Jewish German-born sculptor, Eva Hesse (1936–1970) (**7.20**).

Line weight The quality or physical characteristic of a line, such as its width or thickness.

TIP

To create interest, use a variety of line types in your drawings.

7.19 Toño Salazar, *Self-Portrait*, 1930 Imagine this drawing as having only one line weight. This can easily be done by tracing the reproduction onto thin paper using a small-size felt-tip pen. How does the single-line-weight drawing compare with Salazar's self-portrait? You will find that multiple line weights add impact and interest to an image, as seen here.

7.20 Eva Hesse, *No Title*, 1960. Watercolor, brown ink, and black ink on paper, 13½ × 11" (34.2 × 27.9 cm). Collection of Gail and Tony Ganz, Los Angeles, CA This drawing embraces a diverse assortment of line weights. The lines not only vary between light and dark but also change color. Following a single line, we notice changes in the line quality as it moves in and out of space. The lightest parts of these lines appear to fall back into space. The darkest seem to advance forward.

Gateway to Drawing Orozco, *Man Struggling with Centaur*

Line

7.21 José Clemente Orozco, *Man Struggling with Centaur,* n.d. Graphite, with pen and brush and black ink, on cream wove paper, 7⅞ × 15" (28 × 38.2 cm). Art Institute of Chicago, IL

7.22 (below) Orozco's *Man Struggling with Centaur,* detail

During his early years as an artist, José Clemente Orozco (1883–1949) supported himself by working as an editorial cartoonist for independent newspapers. His graphic work helped him to develop a linear style that he could use to create emotional visual stories.

Orozco's drawing *Man Struggling with Centaur* shows his command of line (**7.21** and **7.22**). In this drawing, the element of line not only delineates the figures but is also responsible for the expression of passion in the narrative. The many types of lines enliven the drawing. Throughout, we can see sharp and jagged scribbles, and layers of quickly hatched lines. Some lines are lost in the oblivion of marks, while others have been restated over and over again in bold emphasis.

None of the lines is relaxing. Look, for example, at how lines were used to draw the centaur. Initial outlines seem to have been made in the fastest way, without concern for proportional accuracy. Subsequent lines feverishly build upon the initial ones to bring the beast into existence. Behind the centaur, crisscrossing lines consolidate to create background values. Line weights change throughout the drawing. Orozco makes some strokes darker than others by adding pressure to the pencil. Certain lines are made bold by repeating and drawing over previous ones, adding to the sense of energy and movement.

Before finishing, Orozco restated parts of the drawing with ink, charging those areas with the severest of appearances, and in effect intensifying that part of the drawing. Orozco's varieties of line work together in a frenzied storm of emotion.

For the other *Man Stuggling with Centaur* boxes, see p. 62 and p. 242

7.23 Josef Albers, *Structural Constellation*, n.d. Ink and pencil on paper, 18 × 23" (45.7 × 58.4 cm). The Josef and Anni Albers Foundation, Bethany, CT

This non-objective, geometric construction is enhanced by the addition of weight of line. The lightest are the colored lines that make up the graph. They appear to establish a background. There are pencil and ink lines, the darkest ones being those made with ink. These darkest lines call most for our attention. They are the organizing forces of the drawing.

7.24 Rico Lebrun, *Brecht's Three-Penny Novel B*, 1961. Lithograph, 22¼ × 29⅞" (56.4 × 75.8 cm). MoMA, New York

As an animator, Lebrun developed a lively style of line work that rolls and tumbles around his subjects. His lines vary dramatically in their weight, while the curving lines accentuate the curvaceous forms. His line imparts life.

Josef Albers (1888–1976) was one of the most influential art educators of the twentieth century. A teacher at the Bauhaus art school in Germany during the 1920s, he later came to the United States, where he introduced a generation of art students to important fundamentals of art and design. He taught that lines in a drawing form relationships and can push and pull a viewer in and out of space. In his drawing, *Structural Constellation*, his message seems clear (**7.23**). The darkest lines appear to project toward the viewer. The contrast of line weight adds tension that establishes a dimensional rhythm in the drawing. Without the heavier lines the drawing would lose experiential focus, leaving the viewer stranded in a merely geometric arrangement.

Implementing a range of line weights in a drawing produces expressive qualities. This has an enormous effect on how a drawing is perceived. Depending on the type of line chosen, the drawing can be imbued with different meanings and emotions. This can be seen in the drawings of Rico Lebrun (1900–1964), originally a commercial artist and Disney animator. His graceful, undulating lines provide a flowing movement for the audience to follow. Made with conviction and speed, his lines give his subjects undeniable strength and presence. They also have a calligraphic quality, as if they were handwriting. In and of themselves, they are decorative and beautiful (**7.24**).

Soft, Lost, and Implied Lines

When we view an object carefully, we become aware that while parts of it have sharp, focused edges, in other areas the forms appear softer, or even fuzzy. Finally, some other areas may appear to dissolve into the background. (This observation is easier to perceive if you squint.) This phenomenon happens because of contrast, or lack of contrast. Strong contrast between the two sides of an edge creates sharpness. If the values on both sides of an edge are equal, then the edge can soften or even fade to be undetectable. Areas of value fade into those of similar value: if areas are light, they dissolve into a light background; and if areas are dark, they dissolve into background areas of darkness.

This phenomenon confronts the artist with the question of how to depict lines that describe such edges. In principle, the answer is simple: lines can be employed in the same manner as they are observed by contrasting sharp and clear lines with **soft**, **lost**, and **implied lines**. In practice, the answer requires utmost sensitivity.

Since the tendency in drawing is to make an edge obvious to the viewer, an artist often ends up making strong lines throughout a drawing. This results in a drawing with all-over strong contrast, unlike what we usually observe in the physical world. Beautiful and poetic results can be achieved, however, by using soft, lost, and implied lines. A more naturalistic, volumetric, and atmospheric image can result from their use. Since they are aesthetically effective, especially when used in contrast with hard lines, many artists look for opportunities to include them in drawings. To avoid overly vague results, though, it is wise to balance obvious lines carefully with lines that are allowed to fade.

The contemporary artist Erika Radich is inspired by plants. Their movement and energy are the motivation of her drawings, in which soft and blurry lines appear to recede into the background and quietly recede

Soft line A line that is faintly drawn.
Lost line A line that seems to disappear.
Implied line A line not actually drawn but suggested by elements in the work.

7.25 Erika Radich, *Fungi 7*, 2016. Graphite on printmaking paper, 22 × 22" (55.9 × 55.9 cm). Collection of the artist
The hairy lines in this non-objective drawing are ideal for studying soft and lost lines. The entire drawing is made of similar types of lines, with one key difference: some are lighter than others. As these lines lighten, they disappear. The lines toward the edges of the form scatter as they vanish into the paper.

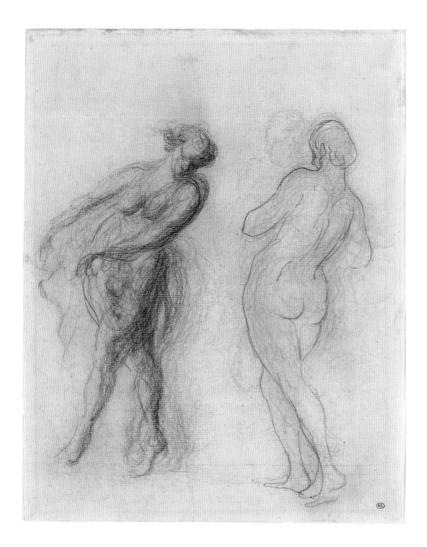

7.26 Honoré Daumier, *Study of Female Dancers*, n.d. Black chalk and conté crayon, 13¼ × 10¾" (33.8 × 27.3 cm). Musée du Louvre, Paris, France

This drawing was drawn and redrawn, producing many layers of mistakes and corrections. The surviving pentimenti provide insight into some earlier stages that were erased. The left figure uses light and dark lines to create space as well as imply a light source. The right shows the hardening of lines as the artist commits to a final version.

The figure on the right-hand side of the page appears to have been drawn on top of initial attempts, evidenced by the pentimenti (visible traces of earlier work revealing that an alteration was made to the drawing) on the page. Daumier's final delineation uses sharp, crisp lines as well as lost lines. Compare the figure's left shoulder to her disappearing arm on the right. Despite not having firm edges, the drawings do not appear unfinished. The use of line gives the figures a sensation of life and movement. Both appear to exist in space, fading at points into the depth of the page.

Often, while making a drawing, a pattern of lost and found edges begins to emerge. Lines end—either stopping abruptly or slowly disappearing—and then begin again. The disappearance and reappearance of lines is closely related to the way we recognize objects visually. Our minds seamlessly fill in the places where there is a suggestion of a line, known as an implied line. The artist can create an implied line by purposefully positioning lines that the viewer's eye automatically connects. Color, value, or texture can also be used to create an edge in the absence of a line.

The chalk drawing *Soldiers Driving Ox Carts with Banners* by Giovanni Battista Tiepolo (1696–1770) exemplifies how implied lines can be utilized effectively in a drawing (**7.27**). Here, lines on the top of the carts and the backs of the oxen all but disappear. In other areas, such as the wheels in the background or the left sides of the carts, edges are not described with line at all. Instead, Tiepolo introduces shading in order to suggest edges and imply lines. Tiepolo was a master of design, and his greatest works

from our attention (**7.25**, p. 165). Radich's lines become progressively softer and softer until they eventually disappear, becoming lost. Lost lines mimic lost edges, and link the object with its surroundings.

The French lithographer, sculptor, and painter Honoré Daumier (1808–1879) was best known as a caricaturist. His work often satirized French politics and poked fun at the bourgeoisie and their daily life. He was a prolific draftsman, who used the craft to express his interest in the world around him. Daumier comfortably merged hard lines with soft and lost lines in his drawings. In *Study of Female Dancers,* neither of the two figures is rigidly outlined (**7.26**). The figure on the left of the page shows an accumulation of searching lines. Daumier restated the right side of the figure until it became pronounced, the dark lines projecting this side toward the viewer. The figure's right arm is softly drawn and dissolves into the background.

Linear modeling
A technique in which line is used to create shading to suggest volume and space.
Hatching The use of single direction, parallel lines to convey value.
Cross-hatching The use of lines drawn at different angles to overlap and convey value.

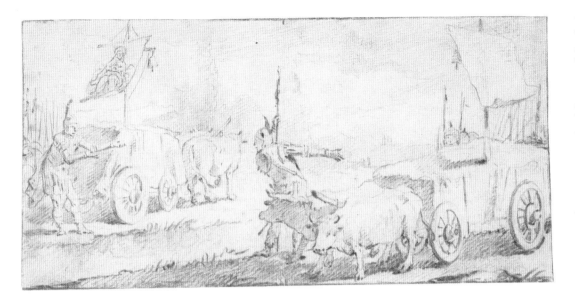

7.27 Giovanni Battista Tiepolo, *Soldiers Driving Ox Carts with Banners*, 1696–1770. Black chalk, 3 × 6⅛" (7.6 × 15.4 cm). Metropolitan Museum of Art, New York
This drawing is an excellent example of how lines can be implied rather than explicitly drawn. Some lines are so understated that they are nonexistent: they are merely suggested. The wheels on the carts are a good example of this.

7.28 (below) Isabel Bishop, *Tidying Up*, 1946. Etching and aquatint, 3⅞ × 3" (10 × 7.5 cm). Metropolitan Museum of Art, New York
The individual hatch marks in this drawing are mostly vertical. To create value, the artist made the hatch marks darker, overlapped them, and gathered them closer together.

were immense frescoes that adorned the ceilings of wealthy churches and palaces. For such large-scale commissions, drawings were an indispensable part of the planning process.

Linear Modeling: Hatching and Cross-Hatching

Linear modeling refers to the technique by which line is used to create shading to suggest volume and space. This can be done with parallel lines, referred to as **hatching**, or lines that crisscross each other, called **cross-hatching**. Strokes can be rendered in any direction: straight, vertical, horizontal, angled, or curved. The density of marks determines the value of the modeled area. This can be controlled by how strokes are layered, how far they are spaced apart, how thickly the lines are drawn, or how dark the lines are made. The artist's choice of media and surface will have an impact on these. In addition to creating tone, hatching and cross-hatching can be made as cross-contour lines to give the illusion of certain surface structures. Curved hatching on an object will give the viewer the sensation that the object is rounded. The addition of linear modeling to a drawing tends to take attention away from the contours, accentuating volume and light instead.

Hatching is usually composed of strokes that are similar in length. Hatching is effective in its ability to darken areas of a composition. Most right-handers tend to hatch from upper right to the lower left of an area. Left-handers tend to hatch from upper left to lower right. In *Tidying Up* by Isabel Bishop (1902–1988), vertical hatches are mostly used. She controls the values of her image by clustering her marks closer or further apart (**7.28**).

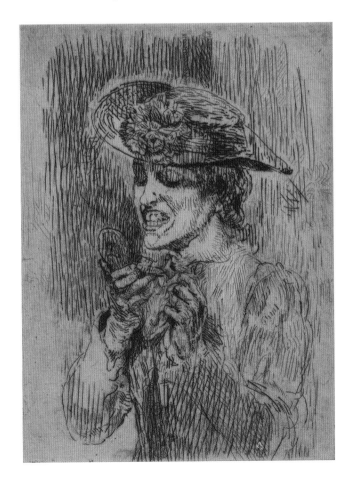

7.29 Titian, *Castle on a Mountain; Trees to Left*, n.d. Pen and brown ink, 5¼ × 10½" (13.3 × 26.7 cm). British Museum, London, England
The hatch-marks in this drawing have been made in a strategic way. The parallel hatching works in a similar way to cross-contour lines to describe surface. We see lines that are hatched vertically and horizontally, and other lines that curve across the topography of the land.

7.30 (below) Celia Paul, *Kate in Shadow*, 1991. Etching, 6⅛ × 4⅝" (15.6 × 11.7 cm)
This drawing utilizes straight cross-hatching to establish the values of the drawing. Some parts have single-direction hatching, but darker areas of the drawing crisscross multiple layers of hatching from different directions. Most of the hatch marks remain relatively straight.

Study the effective simplicity of the various uses of hatching by Titian (b. Tiziano Vecelli, 1490–1576) (**7.29**). Different surfaces are hatched differently: compare the treatment of the strokes on the castle to the lines that make up the cliff. The hatches on the castle are vertical and dense, while linear shading models the angles and curves of the cliff's surface.

Cross-hatched lines are drawn perpendicular or at an oblique angle to an underlying set of

7.31 (below) Maurice-Quentin de La Tour, *Portrait of Louis de Silvestre, c.* 1753. Black and white chalk, blue and rose pastel on faded blue paper, 12¾ × 8" (32.5 × 21.4 cm). J. Paul Getty Museum, Los Angeles, CA
La Tour curves cross-hatches with different-colored chalks, using white chalk in the light areas and darker-colored pastels in the shadows. His marks curve around the form, giving the portrait convincing volume.

hatched marks. This is a quick and direct way to cover the paper and to increase the media's density. Compare and contrast the approach of contemporary artist Celia Paul (b. 1959) (**7.30**) to the cross-hatching technique of Maurice-Quentin de La Tour (1704–1788) (**7.31**). Paul utilizes mostly straight lines, often cross-hatching perpendicular to an underlying set of marks. In some areas she thickly layers cross-hatching in order to create a fuller range of values. La Tour's portrait drawing was made with mostly black, white, and blue pastels. The white pastels were used in the lighter areas, and the black pastels describe the darkest areas. His marks curve with the surface contours of the face in the manner of cross-contour lines, modeling roundness. His cross-hatching slightly changes direction from layer to layer in order to emphasize lights or darks.

In the Studio Projects

Fundamental Project

Choose a complex object. Draw the object using the blind-contour method discussed in this chapter. (See the drawings reproduced in the section on "Blind-Contour Line Drawing," p. 159, for examples.) Repeat this exercise four times on four different sheets of paper.

Observational Drawing

Choose a natural object (such as a leaf, stick, or rock) as your subject. Draw the object twice. In the first drawing, carefully and accurately draw your object's outline. In the second drawing, draw the same object, but this time using contour line. Utilize various line weights and linear modeling to suggest three-dimensional form. Consult the images in this chapter for inspiration.

Non-Observational Drawing

Focus on using line to create a non-representational drawing. Begin by intuitively making a variety of linear marks on a 16 × 20" piece of paper with graphite. Consider layering long lines, short lines, angles, curves, lines that go off the page, or lines that remain on the page; the more the better. Next, use a kneaded eraser to create soft and lost lines. Finally, choose strategic parts of the erased drawing to reinstate boldly with new lines. Other parts can remain light, providing a type of background for the image. Erika Radich's drawing (see **7.25**, p. 165) might inspire you.

Criteria:
1. Only blind-contour line drawing should be used to describe the object.
2. The drawing should be relatively large on the sheets of paper, not leaving too much background area.
3. The four drawings should reveal your focus on the object's details.

Criteria:
1. Both drawings should have strong compositions.
2. Both drawings should demonstrate accurate observational skills.
3. The second drawing should suggest volume through the use of line weight and linear modeling.

Criteria:
1. The drawing should include a variety of types of lines, including heavy, light, soft, lost, and implied.
2. Dark lines should appear to be in the foreground, and light lines should recede into the background.
3. The redrawn areas should be chosen with composition in mind.

Materials: Four 9 × 12" sheets of paper, marker

Materials: Graphite pencil, one sheet of 18 × 24" drawing paper cut into two pieces measuring 9 × 12"

Materials: A variety of graphite materials, one 16 × 20" sheet of drawing paper, kneaded erasers

Chapter 8
Shape

A **shape** is a two-dimensional area with a defined outer edge. In drawing, a shape reads as a flat and enclosed configuration. These contained areas can be created by line, value, texture, or color (an enclosed outline, for example, creates a shape). Shapes have length and width, but do not suggest space or volume. For instance, a circle is a shape, but its related three-dimensional form is a sphere. The simplicity of shapes makes them a powerful force in drawing. They exert visual prominence and are readily perceived by the viewer. A drawing is strongly impacted by the way individual shapes interact with one another, and how they relate to the whole of the drawing.

All drawings can be examined in terms of their shapes, which, as we will see, play a vital role in the making of a drawing, and are central to an analysis of a completed drawing. They possess an abstract quality, the capacity to unify, and the ability to convey meaning.

Shape A two-dimensional area, the boundaries of which are defined by lines or suggested by changes in color or value.

Shape as Abstraction

Objects and scenes can be reduced to basic shapes by defining where an object begins and where it ends. The act of simplifying or considering something in general terms, such as its shape, requires a process of abstraction. Once an object is simplified into a shape, it can then be further subdivided into smaller shapes. This can be done when drawing either simple or complex objects. Shapes can also describe volume and space when they are used as facets or planes. This will be discussed later in this text under planar analysis (see p. 204).

Using pastels on paper to create abstractions, the Nigerian artist Osi Audu (b. 1956) concentrates his efforts on the basic and fundamental element of shape. In *Trans-Figure*, the strong, graphic shapes represent the human head (**8.1**). The shapes are arranged for aesthetic reasons rather than to copy a head as it appears in the natural world. Audu creates an expression of life and existence through a most economical approach.

The American artist Kara Walker (b. 1969) uses shape to create narrative scenes inspired by the pre-Civil-War South of the United States that address gender and racial conflicts. To tell her stories, she often relies upon stereotypes and horrific imagery, such as the example shown in **8.2** (p. 172), where she depicts a woman about to smother a man with a pillow as he sleeps in bed. The reason for this act is unexplained, and left to the viewer to decide. A figure in the background witnesses the event. Best known for her large cut-paper silhouettes, Walker relies upon a similar use of shape in this ink drawing to depict her message. While economical, her drawing also has clarity as well as mystery. The starkness of the black, gray, and white shapes heightens the drama.

8.1 Osi Audu, *Trans-Figure*, 1995. Pastel on paper, 40⅛ × 59⅞" (102 × 152 cm). National Museum of African Art, Smithsonian Institution, Washington, D.C.
This black-and-white drawing of a face uses shape to create a composition that relates to the visual world, but exists with a degree of independence from pictorial references. (This is a characteristic of abstract drawing.) As viewers, we assimilate the artist's creative interpretation and invention with an interpretation of our own.

The Work of Art Kara Walker

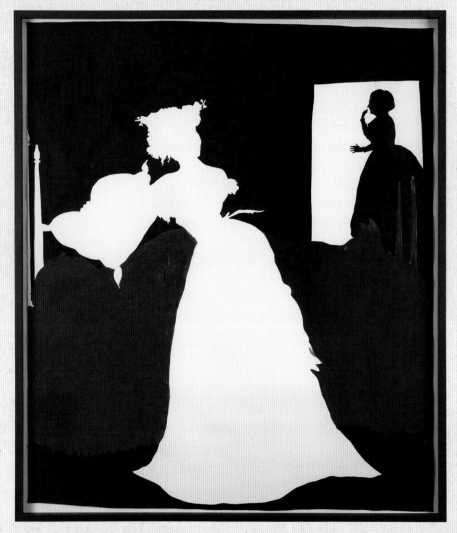

8.2 Kara Walker, *Untitled*, 1996. Ink, paper, and graphite on paper, 7'1¼" × 6'¼"
(2.17 × 1.84 m). Virginia Museum of Fine Arts, Richmond, VA
This ink-and-graphite drawing is a grouping of silhouettes, creating a strong two-dimensional
appearance. Simplifying figures and objects into general shapes in this way is a type of abstraction.
In this case, the image has not been reduced so far as to lose its depictive quality. Instead, the use
of general shapes becomes a storytelling language for the artist.

Who: Kara Walker
Where: United States of America
When: 1996
Materials: Ink, graphite,
and collaged paper

Artistic Aims

The American contemporary artist
Kara Walker confronts social issues
surrounding black history. As in the
traditions of storytelling, her narrative
scenes blend fact and fiction. Her
use of silhouettes creates blunt and
powerful visual images that also serve
as metaphors for our stereotypes and
our oversimplified views of one another.
Walker aims to confront us with
statements that question and challenge.

Artistic Challenges

How does one visually address the
history of American slavery in relation
to racism today? How can one address
modern and historical social concerns
about hatred, race, gender, and sexuality
in a drawing? These are the themes that
Walker addresses in her works. She
invents tales, beautiful and unsettling,
that simultaneously fascinate and
accuse her viewers.

Artistic Method

Walker's work takes the form of
drawings, life-sized installations,
collages, prints, and shadow-puppet
film animations. Whether in large
scenes composed of freehand cut-paper
silhouettes or in her carefully drawn
notebook-size ink drawings or other
media, Walker simplifies figures and
environments into traditional Victorian-
style silhouette shapes, recalling
a popular art craft from the 1700s
and 1800s. Using this old-fashioned
technique lends her work an appearance
of sentimental prettiness that contrasts
with her themes. The characters in her
narratives, usually stark black figures
with exaggerated features, caricature
racial stereotypes. Her flattened
tableaus appear historically accurate,
yet are invented.

The Results

There is a striking balance between
realism and abstraction in Walker's
work. She is able to communicate the
essence of complex social issues using
simple shapes. Her work has been both
celebrated and savagely criticized for its
challenging messages.

Sketchbook Prompt

Choose an object that has many
negative shapes. In a sketchbook,
draw only the negative shapes,
taking care to locate them correctly
in relationship to each other.

When an abstract shape is drawn on a page, the surrounding area becomes very significant. The viewer is affected by the way in which a drawn shape relates to the edges of the format. Within the drawing, every time a shape is drawn, the areas around that shape become another shape as well. Shapes beget more of their own kind: straight-edged shapes produce more straight-edged shapes; curvilinear shapes create new curved shapes. This phenomenon is easily observed in prints by the American artist Richard Serra (b. 1938), known primarily for his monumental steel sculptures. Serra's ponderous two-dimensional prints convey the same type of movement, weight, and massive forms as his sculptural works. The black rectilinear shapes in *Promenade Notebook Drawing IV* create sharp and angular white shapes around the edges of the drawing (**8.3**). In *Tilted Arc*, the curved edges of the central shape create new curved shapes on the perimeter of the composition (**8.4**). In both works, the areas around the drawn shapes become important parts of the composition.

8.3 Richard Serra, *Promenade Notebook Drawing IV*, 2009. Etching, edition of 50, 15¾ × 11¾" (40 × 29.8 cm). Collection of Jordan D. Schnitzer, Portland, OR

The focus of this non-objective work is the way in which shapes interact. Examine the bold, black, rectilinear shapes. Consider the white shapes that they create. The straight sides of one generate the same edges for the other. The black and white shapes are equally important in the composition.

8.4 Richard Serra, *Tilted Arc*, 1986. Paintstick on paper, 19⅛ × 24¾" (48.6 × 62.8 cm). MoMA, New York

Relating to Serra's famous sculpture of the same title from 1981, this drawing was completed later, as a reflection on a curved shape. Compare and contrast this to his piece shown in **8.3**. Both are non-objective, but the shapes that define the images are dramatically different. In this work the central and outer shapes have curved edges.

Drawing at Work Sidney Goodman

Shape is a powerful abstract element in a drawing. It can be used to develop unity and to support the intended meaning of a drawing. Even with its strong abstract quality, however, shape can be employed in realist work, which aims to depict the physical world as accurately as possible.

Born in Philadelphia, Sidney Goodman (1936–2013) was recognized as a leading realist artist in America. His work often utilized available subjects, such as his family members and himself. He investigated themes of human emotions and psychological states. Goodman's works often suggest thought-provoking narratives that are left unresolved for the viewer.

In Goodman's drawing *Maia with Raised Arm*, a girl is drawn in an uncommon pose (**8.5**). She covers her face with one arm, as the other bends upward until her hands interlock. Her shirt is raised, exposing her stomach. Extra time and emphasis seem to have been placed toward the top of the figure, while the rendering progressively diminishes toward the bottom of the page. Shading dissolves to reveal lines that were made during the beginning stages of the drawing. Using charcoal, Goodman's lines are fast and direct. His shading is rich and dense, creating a vivid illusion of depth and space.

Despite the realism of the drawing, Goodman conceives of his subject in terms of abstract shapes. The complex form of the human figure is reduced to a simple geometric abstraction. Like a column, the girl occupies the center of the paper. She has been subdivided into medium and smaller shapes. Her left arm bends to create concentric triangles that surround the lower portion of her face. Below, a clearly delineated arched

8.5 Sidney Goodman, *Maia with Raised Arm*, 2000. Charcoal on paper, 29 × 17" (73.7 × 43.2 cm)

shape outlines her stomach. The lowest portion of the figure forms a rectangular base that runs off the bottom of the page. The straight-on view of these geometric shapes creates a type of formality that adds strength and visual force to the drawing. *Maia with Raised Arm* challenges its audience with a contradictory combination of realism and abstraction.

8.6 Pierre Bonnard, preparatory sketch for *The Bowl of Milk*, c. 1919. Graphite on paper, 4⅞ × 7⅛" (12.3 × 18.1 cm). Tate, London, England

This preparatory sketch was made with composition in mind. Instead of drawing details, the artist establishes shapes. Small shapes are encased in larger ones. The light window, table, and vase of flowers on the left of the composition establish one large shape, while the figures and background space on the right are contained in another, dark one.

Shape as Compositional Arrangement

An entire compositional arrangement can be conceived as a collection of shapes. When beginning a drawing, one often starts by looking for large shapes that represent the major objects. The placement of those general shapes will dictate the composition, and choosing a satisfying positioning of objects within the format is essential to the harmony of the drawing. Larger shapes can then be subdivided as objects are refined.

The sketch in **8.6** by Pierre Bonnard (1867–1947) exemplifies this process. Bonnard appears to search for shapes, making artistic decisions based on how they fit together. We can see how he freely moved the parts of his composition before settling on a final arrangement. Indeed, the harmonious arrangement of large geometric shapes appears to have been his primary concern here. His addition of simple values not only helps to define the shapes, but also establishes a source of light in the drawing. As a preliminary study Bonnard needed to take the drawing only to this state, but it is an excellent illustration of how one can explore an idea through shapes that can then be further developed.

Designers also think about their work in terms of overall shape. Suzy Ehrlich (1919–2006) considers a women's long coat as one robust silhouette (**8.7**). Here, detail is not the most important thing. She draws the curving profile, fitting nicely on the page, to highlight the garment's shape.

TIP

Think of every object that you draw in terms of its shape. Where is the best place for that shape to reside in your composition?

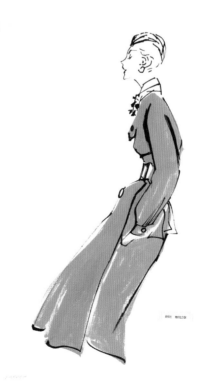

8.7 Suzy Ehrlich, *Women's Long Blue Belted Coat or Dress*, c. 1950–69. Ink and gouache, 18 × 12" (45.7 × 30.5 cm). New School Archives & Special Collections, New York

This fashion illustration defines the predominant shape of a design. Established with a single color, the shape indicates the manner in which the fabric and the cut of the garment will flatter the figure.

Gateway to Drawing
Burne-Jones, *The Tomb of Tristram and Isoude*
Shape

Making a design for a stained-glass window, such as *The Tomb of Tristram and Isoude* by Edward Burne-Jones (1833–1898), challenges conventional notions of how a drawing is made (**8.8**). Such a drawing must navigate between fine art and functional design. The technical requirements of the project demand special attention to the element of shape. The designer must understand how glass needs to be supported and what shapes the material will tolerate. In this application, shapes must define the structure of the window while also depicting a figurative composition.

Bold ink-outlined shapes are evident throughout the drawing. These shapes communicate to the craftsperson how the stained glass should be cut, giving consideration to the supporting structure of the window. The heavy lines designate the layout of the lead channels, defining the shapes of the individual glass pieces, as seen in the finished window (**8.9**). While being essentially practical, these shapes also join to form a striking abstract arrangement, and work together without dominating one another.

Examine the shapes in Burne-Jones's drawing (see **1.21**, p. 28). Three horizontal rectangles, the largest at the top and the shortest at the bottom, anchor the entire composition. Each of these areas contains an arrangement of unpredictable smaller shapes, which are derived from the pictorial image, but seem to stand on their own as distinct parts of a compositional arrangement. The shapes help to structure and simplify the otherwise intricate and busy design.

For the other *The Tomb of Tristram and Isoude* boxes, see p. 28 and p. 299

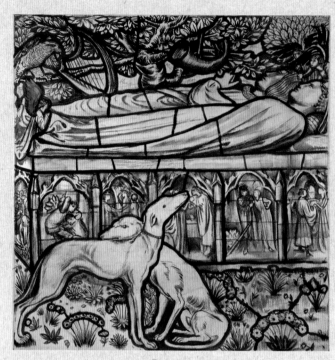

8.8 Edward Burne-Jones, design for *The Tomb of Tristram and Isoude*, 1862. Indian ink and brown wash over pencil, 25¼ × 25¼" (64.1 × 64.1 cm). Birmingham Museum and Art Gallery, England

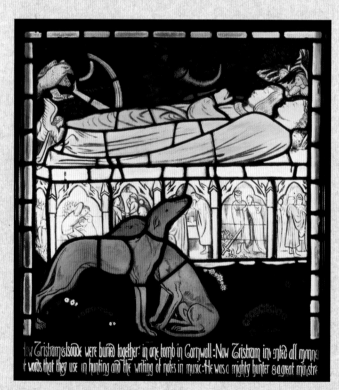

8.9 Edward Burne-Jones, *The Tomb of Tristram and Isoude*, c. 1862. Stained glass, 26¾ × 23⅞" (68 × 60.5 cm). Bradford Museums & Galleries, England

8.10 Norman Lundin, *Blackboard and Light Switch*, 1978. Charcoal and chalk on paper, 38¾ × 50⅛" (98.5 × 127.3 cm). MoMA, New York

Search for as many shapes as you can find in this drawing. Both large and small, the simple shapes instill an abstract, geometric structure. The refined rendering creates a sense of realism. This blending of abstraction and realism is an appealing combination in a drawing.

A completed drawing can be evaluated by how the shapes within the composition relate to one another. When shapes fit together in a visually pleasing manner, the drawing will have a sense of unity. The underlying structure of *Blackboard and Light Switch* by Norman Lundin (b. 1938) is based on shapes (**8.10**). This realistically rendered drawing hints at its shape-based construction by including geometry on the blackboard. In this drawing, an intriguing visual tension arises between the flatness that the strong shapes establish and the illusion of a shallow space.

Geometric and Organic Shapes

All shapes can be classified into one of two categories: geometric or organic. **Geometric shapes** are regular and ordered. They relate to geometry and include such polygons as triangles, squares, and rectangles, or curvilinear shapes, such as circles and ellipses. **Organic shapes** are the opposite of geometric shapes. They are not based on a regular measurable structure and they lack the symmetry that is often found in geometric shapes. Organic shapes are typically free-flowing and are often found in nature as opposed to being man-made.

TIP

Conceive of complex objects as a combination of simple shapes. Draw the simple shapes first and then add more details.

Geometric shapes Regular and ordered shapes that relate to geometry.
Organic shapes Shapes, often found in nature, without a regular measurable structure or symmetry.

8.11 Wade Schuman, study for *The Virtues: Sacrifice*, 2011. Ballpoint pen and gel pen on paper, 15¾ × 19½" (40 × 49.5 cm). Forum Gallery, New York

This pen drawing brings together geometric and organic shapes. Triangular and circular shapes form the background and an irregular, organic shape dominates the foreground. Echoing the surreal amalgamation of human and fish, the incorporation of differing shapes is striking.

Combining geometric and organic shapes is one way of creating a dynamic drawing. Wade Schuman (b. 1962) utilizes this type of contrast in his visually exciting compositions. In his pen drawing study for *The Virtues: Sacrifice*, strong geometric shapes establish a background for the surreal combination of natural shapes in the foreground (**8.11**). This example is typical of Schuman's drawings, in which he creates hybrids by morphing human forms with animals.

Positive and Negative Shapes, Figure/Ground Relationships

When the subject of a drawing is regarded as a shape it is called a **positive shape**. These figures appear closer to the observer than the background. The shapes around positive shapes, often considered the background, are called **negative shapes**. The way in which these shapes visually interact is sometimes called the figure/ground relationship. When drawing, one tends to focus on positive shapes, but the negative shapes are just as important. Negative shapes have much to do with the way the subjects in a drawing are understood. The

features of the negatives shapes can enhance or decrease the impact of the positive shapes. For instance, if the color or brightness of the negative space is very similar to that of the positive shape, the positive shape will be perceived as distant; it will become one with

Positive shape The shape created through the presence of an object.
Negative shape The shape created through the absence of an object.

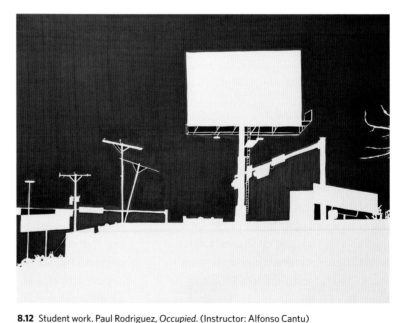

8.12 Student work. Paul Rodriguez, *Occupied.* (Instructor: Alfonso Cantu)
This student work highlights positive and negative shapes. Negative shapes were blackened with a marker, while positive shapes were left as the white of the page. Even when drawing only flat shapes, the student communicates a remarkable amount of information to the viewer.

8.13 Lee Krasner, *Past Conditional*, 1976. Collage on canvas, 27 × 49"
(68.6 × 124.5 cm). The Pollock-Krasner Foundation, New York

This abstract work is composed of different pieces that were drawn
from observation, cut into pieces, and then collaged together. Some of
the parts have been separated, creating negative spaces between them.
This establishes an easily distinguishable figure/ground relationship.

8.14 M. C. Escher, *Thirty-Six Different Motifs (No. 83)*, 1951.
Pencil and chalk, 3⁵⁄₈ × 5⁶⁄₈" (9.2 × 14.6 cm). Private collection

The individual motifs in this drawing are contained within dark or light
geometric shapes, which fit together seamlessly. The positive and negative
shapes, however, appear to fluctuate. By focusing on the white creatures,
the dark animals take on a subordinate role. The opposite is also true.

the environment. Higher contrast between
the figure and ground will create emphasis
and separation.

Lee Krasner (1908–1984) created a series
of collages in 1976 from her old figure drawings.
By cutting them apart and then separating
and rearranging the pieces, Krasner created
distinct juxtapositions between the positive
and negative shapes. In the newly composed
drawings, the densely worked charcoal pieces
contrast against the shapes of the blank canvas
where they are pasted (**8.13**). The new drawings
epitomize Krasner's commitment to reworking
and reexamining her own work.

The Dutch graphic artist M. C. Escher
(1898–1972) made works that employed
repeated patterns called tessellations, in which
shapes are arranged to fit together without gaps
or overlaps. Much of the success of these works
relies on the viewer's ability to switch his or her
perceptions of shape from positive to negative
and then back again. The pencil-and-chalk
drawing entitled *Thirty-Six Different Motifs
(No. 83)* takes full advantage of both positive
and negative shapes (**8.14**). The shape of each
black creature helps to define the adjacent
white figures, and vice versa.

Positive and Negative Shapes, Figure/Ground Relationships **179**

8.15 Giorgio Morandi, *Still Life*, 1959. Watercolor on smooth handmade paper, 8 × 9¼" (20.2 × 23.4 cm). Private collection
It is difficult to distinguish between the positive and negative areas in the image, lending this drawing an enigmatic quality. Uncertain as to which shapes are parts of objects and which are the spaces between them, we find ourselves intrigued and mystified.

TIP

Make sure that the negative shapes in your drawing are as visually pleasing as the positive shapes.

Positive and negative shapes should be carefully balanced, as otherwise a drawing may feature some areas that are too dominant. Also, if a visual equilibrium is not achieved between positive and negative shapes, some areas may appear insignificant and will not actively contribute to the composition. Ill-conceived figure/ground relationships can result in areas of a drawing becoming confusing or visually boring.

The Italian painter and printmaker Giorgio Morandi (1890–1964) limited his subject matter to a few favorite still-life objects. Dedicated to working from direct observation, he studied the relationships between his simple objects and the space around them. In *Still Life*, Morandi gives the space between the objects special importance (**8.15**). Negative shapes and shadows are treated as objects. The figure and ground in his watercolor merge and dissolve into each other. Morandi's intent is not for the viewer to be able to identify each object clearly; instead, the drawing reconstructs a visual experience. Morandi's drawings often possess an unusual combination of unsettledness and calm tranquility.

The Meanings of Shapes

Shapes can carry meaning and symbolism. This enables artists and designers to suggest a certain mood or emotion, although the way one understands a shape may shift depending on that shape's context within a drawing. Similarly, it may vary based on a viewer's cultural perspective. Shapes and symbols represent ideas, qualities, and characteristics that are often different from their literal appearance. For example, for many people squares and rectangles feel weighted and grounded, and therefore elicit an impression of stability. Their geometric shape, which is based on symmetry and balance, can be seen to represent order, formality, and honesty. Rectilinear shapes are most often derived from made objects, and so

8.16 Joan Miró, *Figures in front of the Sun*, 1942. Charcoal pencil, gouache, India ink, and pastel on paper, 40½ × 23⅝" (103 × 60 cm). Fundació Joan Miró, Barcelona, Spain
This drawing, which is abstract in its approach, contains meaningful symbolic shapes. Although they do not truthfully resemble reality, they imply more familiar pictorial forms.

they are the most common of shapes as well as the most familiar within our man-made world.

Shapes with curved edges prompt different interpretations. They produce visual movement and energy in a drawing. Curved shapes, such as many organic ones, are most often seen as feminine, whereas geometric shapes tend to be seen as masculine. To many people curvilinear figures evoke feelings of freedom, sensuality, and pleasure.

There are an infinite number of unique shapes that can be drawn, each with the potential to convey meaning. When combined, their messages are unlimited. The Spanish Surrealist Joan Miró (1893–1983) created imaginative artworks based on a rich variety of simple shapes. His drawings tend toward abstraction, but in combination, his shapes represent people, animals, and nature. The drawing in **8.16** is a lively play of invented shapes and symbols, which describe a familiar scenario of people enjoying the outdoors, eliciting feelings of joy and playfulness. We bring our own interpretations to the shapes; alone, the red circle is just a shape, but here it may represent a sun, warmth, or freedom.

In the Studio Projects

Fundamental Project

Collect a variety of objects, both large and small. Trace them on a sheet of paper in a manner that will result in obvious negative shapes. Consider repeating and overlapping tracings as many times as you wish in order to create the most exciting negative shapes.

Observational Drawing

This project is an investigation of observed shapes. Choose as your subject a complex object that has plenty of positive and negative shapes. Consider such objects as a folding chair, a potted plant, or perhaps a bicycle. Draw all of the positive and negative shapes that you see. Sight and measure carefully and take note of how the shapes are cropped on the edge of the composition. Finally, choose either the positive or negative shapes to blacken with compressed charcoal.

Non-Observational Drawing

Find an old drawing that you would not mind destroying. Cut the drawing into pieces and rearrange the shapes to create a new composition. Carefully consider the newly created shapes, both positive and negative. Glue the new design onto a piece of paper.

Criteria:
1. The objects should be selected for their interesting shapes.
2. Tracings should be arranged so that the page is fully utilized.
3. The negative shapes should clearly emerge between the traced objects.

Criteria:
1. Positive and negative spaces should be measured accurately.
2. Positive and negative spaces should be distinguished with black and white.
3. Composition should be carefully considered.

Criteria:
1. New positive shapes should be created by combining smaller shapes.
2. Negative shapes should be created in contrast with the positive shapes.
3. The new composition should be dramatically different from the original drawing.

Materials: 18 × 24" sheets of paper, felt-tip pens (this drawing could be done in color or in black and white)

Materials: Charcoal pencil, compressed charcoal, 18 × 24" drawing paper

Materials: Mixed media

Chapter 9
Value

Value refers to the relative lightness or darkness of an area or object. The addition of value to a drawing is a painterly act. It is the opposite of a line drawing, addressing not only edges but also area and surface. Once you learn to see value and the conditions that affect it, you can learn to apply the techniques for establishing value in a drawing. Acquiring and practicing such skills will enable you to create light, shape, form, space, and emotion.

A **value drawing** is one that is devoid of color. It relies on black, white, and grays to translate and represent color and light patterns. Despite this absence of color, however, viewers will still accept a well-made value drawing as "real" without hesitation. It should be noted that although value is perhaps easiest to study in value drawings, the element of value itself is also a very important characteristic in color drawings. The key to using value successfully lies in the establishment of relationships between the different values in the composition.

Value drawing A drawing devoid of color.

9.1a and **b** Comparison of values of two different colored objects (color image above black-and-white image)
This comparison shows how colored objects appear when translated into black and white. Sometimes the values can be surprising. To draw in black and white it is important to train your eye to see objects in terms of value.

9.2a and **b** Values of an illuminated object. Color image next to posterized black-and-white image (an image using only a small number of different values)
When objects are illuminated from one side there is a natural progression of value, from the area of the form closest to the light to the area furthest away. The posterized black-and-white image shows how values progress from light to dark. Notice that a similar value pattern occurs in the background.

 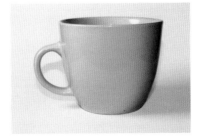

9.3a and **b** Middle-value gray object surrounded by light and dark values
The same object can appear to have different values depending on the value of the background. On the left the cup looks to be light in value because of the dark background. On the right, by switching the background, the same cup appears darker.

Conditions that Influence Value

The appearance of a value changes depending on its circumstances and its context. Values are affected by an object's local color, by the amount of light an area receives, and by other surrounding values.

Local Color

All objects have a **local color**. This is the actual color of the surface as it would appear if it were unaffected by light or shadow. This characteristic affects the value that we see. For example, the value of a pale-blue object will be light in comparison to a red object, a distinction that is made clearer when the objects are photographed in black and white (**9.1**).

Light

Light is essential to our perception of value. When an object is illuminated from one side, that side will appear lighter in value than the side of the object that faces away from the light. Areas where the light is interrupted by a shadow will be darker than that same surface in full light (**9.2**).

Context

An area that appears to be a light value in one context may be seen as a dark value in another. For example, a middle-value gray will look dark if it is surrounded by a light value. That same middle-value gray will look light when it is surrounded by a very dark value (**9.3**).

Local color The actual color of the surface, as it would be if it were unaffected by light or shadow.

Techniques to Establish Value

With slight differences, the terms shading, blending, and modeling all describe techniques of establishing value in a drawing. Shading is the application of dark or light values. Blending creates a seamless gradation from one value to the next. Modeling uses shading techniques to render the illusion of volume.

To establish value, one can utilize straight application or optical mixing. Straight, or direct, application is created when a value is applied to a drawing in the state it means to be seen. (In other words, it does not rely on the eye visually unifying a series of marks.) Direct application can be achieved by blocking in mass values or by creating **continuous tone**. Optical mixing is created by such techniques as hatching systems (see p. 167). The marks created in these techniques can visually unify into certain values.

Blocking in Mass Values

A straight application of value in a drawing can be made by "blocking in" values, sometimes referred to as "mapping values"

(see Chapter 6, p. 140). This additive approach to value drawing is often employed using such wet media as ink, gouache, or other media that easily produce large areas of single value. This approach is not concerned with details or the subtleties of gradation, but instead focuses on general values. Jacob Collins (b. 1964) uses graphite to block in the dark areas of the strongly lit figure with one large value in **9.4**. This straightforward massing of value effectively establishes the contrast of light and dark on the subject.

The technique of blocking in values can be used at an early stage of a drawing's development or it can be the ultimate goal of a work. The latter is exemplified by contemporary artist Wendy Artin (b. 1963), whose goal is to capture the integration of light with the human form. In this detail of her drawing *Laura on Side*, parts of the figure blend together as she applies value to the large areas of darkness (**9.5**). In so doing, the illusion of light is created.

Mass values can also be used to organize and define a composition. We saw this in Chapter 4 in our discussion about rhythm, where David Park's figure drawing was a

Continuous tone A type of value application in which values are blended to create smooth and even transitions.

9.4 Jacob Collins, *Seated Nude Dusk*, 2011. Graphite on paper, 12 × 18" (30.5 × 20.3 cm) This drawing demonstrates the technique of blocking in mass value. First a line drawing was made, then the dark side of the figure was shaded with only one value. This straight application of value does not use variations in value to render form. It does, however, clearly describe a directional light source.

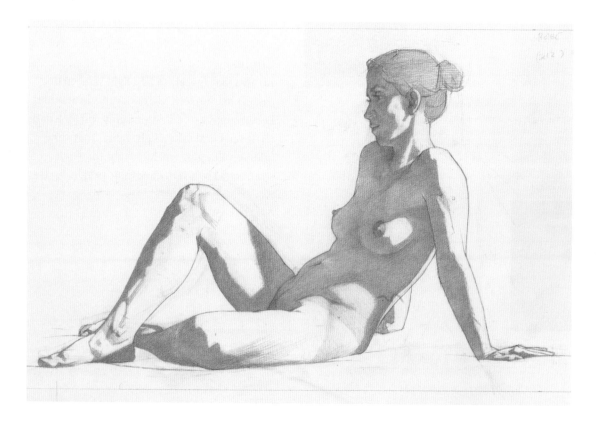

Value pattern A distinct pattern or configuration that emerges from the repetition of lights and darks.

9.5 Wendy Artin, detail of *Laura on Side*, 2012. Watercolor on Fabriano Ingres paper, 7⅛ × 13⅜" (18 × 34 cm). Collection of the artist
Blocking in values gives this figurative drawing an abstract quality as the dark values of different forms merge. For example, notice how the values of the arm and the stomach connect to form one large shape. This occurs again between the lower legs. By adding dark washes in this manner, by means of contrast light seems to appear.

particularly good example (see **4.30**, p. 111). For a slightly more complex example, consider the effects that values create in *The Holy Family on the Steps* by Nicolas Poussin (1594–1665) (**9.6**). Poussin simplified his composition into distinct light, middle, and dark areas. Starting with a line drawing, premixed values of ink were applied. The values were blocked in as individual masses; little variation occurs. A distinct pattern, however, emerges from the repetition of lights and darks. It provides a type of compositional cohesion, sometimes called **value pattern**. Value patterns result from a thoughtful choice of values that guide a viewer's eyes through a composition, while imparting to the drawing a unifying influence. Even without nuance, Poussin's drawing remains clear and descriptive. It evokes a sense of light and atmosphere. Poussin does not place the focus on the drawing's individual parts; he is more concerned with its overall value structure.

TIP

To assess the general values of an object, try blurring your eyes. This will reduce the amount of detail that you see in favor of value perception.

9.6 Nicolas Poussin, *The Holy Family on the Steps*, n.d. Pen and bister wash, 7¼ × 10" (18.4 × 25.3 cm). Morgan Library & Museum, New York
In this drawing the values were blocked in with premixed values of ink. Follow the pattern that the artist has established. From left to right, an alternating pattern of light and dark occurs. This configuration establishes the value structure of the image.

Continuous Tone

The blending of values, rather than the application of them in segments, defines continuous tone. Instead of distinctly separated areas of value, continuous tone drawings blend and merge different values, making smooth and even transitions. This type of value application can create cohesiveness in a drawing.

Using wet media, Marlene Dumas (b. 1953) employs continuous tone in her ink drawings. In this drawing Dumas models the portrait by adding ink to a wet wash (**9.7**). The spread and the blooming of the ink on the damp paper blend the values. This effect can be

seen throughout the face, especially around the eyes, nose, and mouth.

A skillful blending of values appears in *Two Bosque Pears*, a pencil drawing by Martha Alf (b. 1930). The subtleties of continuous tone in this drawing are captivating (**9.8**). Not only is the gradation of values on the surface of the pears beautiful, but the mix of lights and darks in the background also attracts our attention. Alf renders the large background an exciting part of the drawing by making gradual value changes, with tonal differences ranging from left to right as well as from top to bottom.

9.7 Marlene Dumas, *Copy of a Model,* 1996. Ink wash and Indian ink, 9⅞ × 7⅞" (25 × 20 cm). Private collection

Wet media is particularly suitable for creating continuous tones. The natural tendency of the medium helps to create fascinating effects. In this drawing, inspired by photographs cut out from newspapers or magazines, one value of watercolor is encouraged to bleed into another area of a different value.

The Work of Art Martha Alf

9.8 Martha Alf, *Two Bosque Pears*, 1986. Colored pencil on paper, 14×17" (35.6 × 43.2 cm). Metropolitan Museum of Art, New York

This still life was drawn using continuous tone. Values are smoothly blended from light to dark. This occurs throughout the drawing, both on the objects and in the background. This type of value application is appropriate for realistic representations, such as this one.

Who: Martha Alf
Where: United States of America
When: 1986
Materials: Colored pencil on paper

Artistic Aims

Many of Martha Alf's drawings use everyday items as subject matter—she has studied pears for years. By replicating the subtle distribution of values that she sees, Alf aims to elevate her common objects, making them the subjects of luminous and beautiful drawings.

Artistic Challenges

The challenge of capturing the ever-changing qualities of light and atmosphere has engaged artists for centuries. To respond to this, Alf uses a sensitive eye and keen technical understanding of drawing media.

She is aware of the way that light travels in space and illuminates forms. In the case of *Two Bosque Pears*, she skillfully uses colored pencils to reproduce the values that she sees. Alf's drawings rely on her ability to trigger the emotions of the viewer by creating a convincing illusion.

Artistic Method

Alf arranges the pears on a flat plane with a simple background. They are lit from one side by daylight. Alf smoothly blends multiple layers of pencil to create gradual value changes, leaving few signs of mark-making. Utilizing continuous tones, she carefully distributes a full range of values across the composition to match her observations. Even the vacant spaces are treated with the utmost care, maintaining their importance in the composition.

The Results

Martha Alf is a prolific artist whose drawings have been exhibited nationwide. The appearance of accuracy displayed in her still-life drawings is derived from her detailed attention to light and value. Her drawings, such as *Two Bosque Pears*, convey an atmosphere of tranquility.

Sketchbook Prompt

Draw a piece of fruit.
Focus on rendering light.

9.9 Rembrandt van Rijn, *Self-Portrait with a Cap, Open Mouthed*, 1630. Etching, 19⅝ × 17¾" (50 × 45 cm). Rijksmuseum, Amsterdam, The Netherlands
Optical mixing can be seen in the shading of this etching. Dark values are made when the hatch marks are close together and overlap. When marks are furthest apart, such as in the bottom-left corner, the values are lightest.

9.10 (right) Pierre-Paul Prud'hon, *Study of a Female Nude*, c. 1800. Black and white chalk with stumping on blue paper, 23¾ × 12½" (60.3 × 31.8 cm). J. Paul Getty Museum, Los Angeles, CA
Here, the blue paper operated as the middle value from which Prud'hon developed lights and rendered darks. It was left visible in areas where its value resembled the corresponding values observed in the model setup.

Optical Mixing

Values can be established in a drawing by **optical mixing**. Darks and lights are controlled when individual marks blend visually so that they are perceived as an area of value. Stippling and linear modeling techniques (such as those discussed in Chapter 7) can create this effect. For example, consider the drawing technique of the young Rembrandt van Rijn (1606–1669) in *Self-Portrait with a Cap, Open Mouthed* (**9.9**). The individual marks are essentially the same in terms of darkness, but Rembrandt adjusts the density of those marks to create a range of gray values. When viewed, the lines mix optically, establishing a strong contrast between the light side and the dark side of his face.

Optical mixing
A type of value application in which individual marks visually blend so that they are perceived as an area of value.

Using Toned Paper

One traditional way of establishing value in a drawing is to work on toned paper. In this technique, the artist leaves the paper exposed in those areas of the composition that match the tone of the paper. Light and dark media are added to extend the value range. For example, a middle-value paper can be exposed to act as the middle values of a shaded drawing. The French artist Pierre-Paul Prud'hon (1758–1823) often used middle-value blue paper in such a manner (**9.10**). From this middle value, he could build dark values with black chalk and light areas with white chalk. Notice that the blue paper is exposed in the areas where the middle value is appropriate to the lighting

9.11 Violet Oakley, *The Virgin Mary*, 1903. Charcoal and white chalk on tan paper, 24½ × 19⅛" (62.2 × 48.6 cm). Woodmere Art Museum, Philadelphia, PA

Compare Oakley's drawing to the one made by Prud'hon (**9.10**). Both use a similar technique, but Prud'hon's was made on a middle-value blue paper and Oakley's was made on a dark-tan paper. How does the choice of paper influence the final result of the drawing?

Stumping Using a soft blending tool (a "stump") to smudge or blend media.
Value scale A diagram representing an incremental progression of values from black to white.

situation. Prud'hon's drawing process is cyclic, building layers of chalk, rubbing out the marks by **stumping**, and then refining the drawing by adding chalk again. By repeating this process many times, his drawings gradually acquire a strong range of values.

Violet Oakley (1874–1961) uses toned paper in a similar way in her drawing *The Virgin Mary* (**9.11**). Her choice of paper is dark tan. It contrasts sharply with the white chalk, adding intensity to the lightest areas. Even in the head—the most heavily shaded area—Oakley does not cover the paper fully. She allows the tone of the paper to act as a dark value in the drawing. Some of her shading marks are evident, while others are blended together.

Value Scale, Value Contrast, and Value Schemes

To create a harmonious value drawing, it is best to start by considering which values will be used and how they will work together. Making a **value scale** is an effective way to do this even before beginning to draw.

A value scale, or gray scale, is a diagram of shades. It starts with the lightest value on one end, and gradually descends in stages to the darkest value on the other end. The number of grays that the human eye can detect depends very much on the lighting conditions and the background against which they are viewed; for many people it can be hard to perceive more

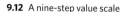

9.12 A nine-step value scale
This is a nine-step value scale, illustrating an incremental progression from black to white. It can be used to establish which values are needed or have been used in a drawing. Utilizing the full range of values enriches a drawing.

9.13 A five-step value scale
This is a five-step value scale. Artists who prefer to simplify their use of values might refer to such a scale as this. Flip through this book to find examples of limited-value drawings. You might notice that many of them represent these five values.

9.14 Paule Vezélay, *Forms*, 1936. Charcoal on canvas, 28¾ × 21¼" (73 × 54 cm). Tate Modern, London, England
Vézelay's drawing displays a full range of values: light, medium, and dark. The values make her invented objects seem tangible, and add authority to her pliable science-fiction-type world.

Value scheme
The combinations of values within a drawing.

than about nine values in a drawing. Also, drawing tools and media sometimes restrict the value range that an artist can create.

For these reasons, artists often use a standard nine-step value scale for their work. The value scale demonstrates an even distribution of values from white to black in nine steps (**9.12**). Of course, an effective and believable drawing does not have to represent all values. Sometimes artists limit themselves to three to five values in order to simplify their compositions. This can be seen in many of the drawings in this chapter, such as Nicolas Poussin's *The Holy Family on the Steps* (**9.6**, see p. 185) or Andrew Wyeth's *Open House Study* (**9.18**, see p. 193). The scale in **9.13** shows a five-step value scale that would be used for this kind of limited-value drawing.

Value scales help to envision value contrast. Values that are next to each other on the scale exhibit low contrast, while those that are far apart have high contrast. Value contrast is what enables objects to be seen. By executing contrasts strategically, softening some and elevating others, one can direct the viewer's eye movement to travel through a drawing in a desired way. Strong contrast captures attention. Similar values, or lower contrast, appear to fade away, generating lesser emphasis. A skillful artist takes advantage of these facts when developing the values in a drawing.

Value scales can also act as a reference when visualizing combinations of values, or **value schemes**. Planning a value scheme during the early stages of a drawing can lead to the cohesiveness of the values in a work. For example, it is often desirable to represent a full range of values in a drawing. This type of value scheme utilizes white, black, and a balanced range of the grays that fall between. Notice the full range of values used by Paule Vezélay (1892–1984) (**9.14**). Even when drawing invented shapes and compositions, she uses very dark values, middle values, and also the white of the page.

Often artists with less experience struggle to create a complete range of values; a recurring issue tends to be the omission of the darkest

9.15 (above) Georges Seurat, *Trees (Study for La Grande Jatte)*, 1884. Black Conté crayon, on white laid paper, laid down on cream board, 24³⁄₈ × 18³⁄₄" (62 × 47.5 cm). Art Institute of Chicago, IL

TIP

Consider the white of your paper as your lightest value. Expose the brightness of the paper only where it is most needed. Other parts of the drawing should be toned down.

values. A value scale can help to remind you of the values that you may be missing.

It is up to you to select and produce a value scheme that will create the impression you wish to make. Compare these two Conté crayon drawings by Georges Seurat (1859–1891). Seurat's *Trees (Study for La Grande Jatte)* possesses a high-value scheme, being predominantly composed of very light values (**9.15**). Distinctly different in its value selection is *Courbevie: Factories by Moonlight* (**9.16**). In this drawing Seurat used a low-value scheme: except for the moon, this composition contains mostly very dark values. These two drawings not only depict a different time of day and lighting situation, but also project distinctly contrasting moods. One feels sunny, airy, and dreamy, while the other evokes a gloomy and mysterious atmosphere.

9.16 (below) Georges Seurat, *Courbevie: Factories by Moonlight*, 1882–83. Conté crayon, 9³⁄₈ × 12¹⁄₄" (23.6 × 31.2 cm). Metropolitan Museum of Art, New York
Compare and contrast these two drawings by Seurat. Both landscapes are made with Conté crayon. One utilizes a vertical format, while the other is horizontal. Perhaps the most striking distinction, however, is the use of value schemes. **9.15** maintains a high-value scheme and **9.16** a low-value scheme.

Gateway to Drawing
Heysen, *Gum Trees, Hahndorf*
Value

Subtle in its application of pencil and white chalk on a gray-green paper, *Gum Trees, Hahndorf* by Nora Heysen (1911–2003) is exemplary in its use of value (**9.17a**). The values create an illusion of light and at the same time develop a visual rhythm that unifies the composition.

Heysen establishes a light source within her drawing by maintaining a consistent arrangement of light and dark values. She gradates values smoothly to create continuous tones. Values are concentrated in the center of the page and then diminish toward the edges of the composition. The left side of each tree is lighter in value than the right, giving the impression that the trees are illuminated from the left. The contrasts are not harsh. Heysen avoids very dark values in favor of value patterns that depict a soft daylight. Value contrast is reduced even further in the background, fading away as if to invite the viewer further into the woods.

Heysen's arrangements of value create a compositional structure for the drawing. The diagram in **9.17b** illustrates the placement of values within it. An exchange of light and dark values emerges. By seizing upon this alternating rhythm—a rhythm often observed in nature—Heysen is able to direct the viewer's eye across the page, engaging the attention and encouraging us to explore her composition.

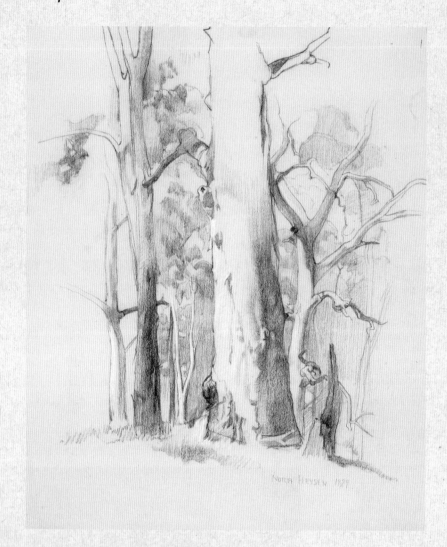

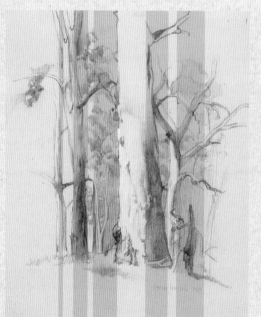

9.17a Nora Heysen, *Gum Trees, Hahndorf*, 1929. Carbon pencil, white chalk on green-gray paper, 16 × 13⅛" (40.6 × 33.4 cm). Art Gallery of New South Wales, Sydney, Australia

9.17b Value overlay applied to Heysen's *Gum Trees, Hahndorf*

For the other *Gum Trees, Hahndorf* boxes, see pp. 102–3 and p. 339

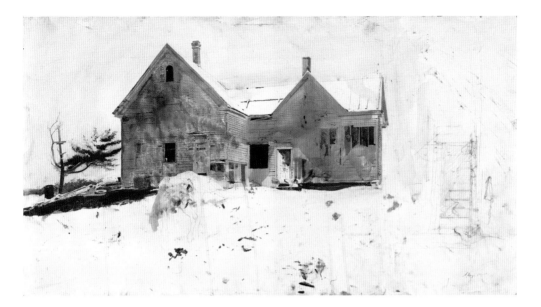

9.18 Andrew Wyeth, *Open House Study*, 1979. Watercolor and pencil on paper, 21¼ × 39¾" (53.98 × 101 cm). The Andrew and Betsy Wyeth Collection
Determining the shape of a value is an important skill. In this drawing we can see how the artist visualized the whole front of the house as one. In reality it might have been made up of smaller shapes, but consolidating them in a single value makes a strong assertion in the drawing.

Value Shapes

The shape in which a value is applied is key to the representation of an image. The relationship between value and shape gives an object its sense of materiality, light, and substance. **Value shapes** can be inspired by reality or be invented more subjectively for creative visual effect.

The American artist Andrew Wyeth (1917–2009) demonstrates his ability to visualize and consolidate parts of a scene into large value shapes in his watercolor-and-pencil sketch *Open House Study* (**9.18**). In this drawing, he conceives the entire front of the house as one value. In contrast, the brightest white of the paper is reserved for the rooftop and snow-covered hill.

Edna Andrade (1917–2008) consolidates *Cliff and Pebbles* into two large value shapes, despite the intricate detail in the drawing (**9.19**). Most of the top portion of the drawing is encapsulated in a middle value. The left side and bottom of the composition are separated into a light area, with the exception of the bottom left, which reverts to the middle value. The large value shapes unite the details of the rocks into a cohesive graphic configuration and help the viewer to assimilate the scene.

Value shape The shape in which a value is applied to a composition.

9.19 Edna Andrade, *Cliff and Pebbles*, 1996. Graphite on paper, 24¼ × 41¼" (61.6 × 104.8 cm). Woodmere Art Museum, Philadelphia, PA
Find the dominant value shapes in this drawing. The many representational details are contained within them. Why might an artist organize a complex drawing into simpler value shapes? Can you imagine how this drawing would differ without them?

9.20 (left) Student work. Yang Wang, *Deer Head and other Stuff.* (Instructor: Jason Zimmer)
Working from a still life, the student who made this drawing demonstrates her understanding of value. Using only a limited number of pastels, she was able to represent a full range of values. The strong contrast between the light side and the dark side of each object produces a dramatic impression of light.

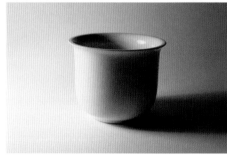

9.21a and **b** Two images illustrating different strengths of light source (strong and soft light)
These photographs show the consequences of a strong light source versus a soft one. In a bright light (top), the darks are bolstered and value contrast is greater. A weak light source homogenizes values, making them more similar to each other. Light source is therefore an important consideration when drawing.

Depicting Light with Value

One of the most profound ways to use value in a drawing is to depict light. Light is responsible for visual perception: objects would be invisible without the value contrast that it creates. Beyond pure representation, the depiction of light can elevate objects to become beautiful and emotionally resonant. As a consequence, artists have long been preoccupied with capturing qualities of light.

Source of Light

Light and shadow vary according to the source of light that illuminates a scene. The strength of the light source and its distance from the illuminated object will determine the degree of value contrast that is seen. This means that a strong light source will create higher contrasting values. On the other hand, a drawing comprised of similar values will suggest a softer type of light (**9.21**).

Natural light is desirable for its color and true-to-life characteristics, but it is also ever-changing. Artificial light offers more control, but its very artificiality can create an unattractive or harsh impression. Frequently, no matter the type of light, an artist will modify the observable light and shadow conditions to suit his or her intentions.

Drawing at Work
Caspar David Friedrich

Sensitive to delicate atmospheric values, the German painter Caspar David Friedrich (1774–1840) was interested in rendering the qualities of natural light. This is demonstrated in *View from the Artist's Studio, Window on Left*, where natural light itself becomes the subject.

Friedrich, along with many artists before and since, understood the benefits of working from natural light. The basking light in this image is typical of north light (light coming into an artist's studio from a north-facing window). It produces subtle and controlled value changes, and is much sought after by artists for its consistency. Light coming from a different direction would appear more direct, displaying stronger bright areas and starker contrasting shadows.

Friedrich used a variety of media in his work, including watercolor and black and sepia inks. *View from the Artist's Studio* was made with pencil and sepia on paper. With these media, Friedrich was able simultaneously to create contrasting values and blend tones. The values found outside the window contrast distinctly with those inside the studio. Utilizing a full range of values heightens the differences. With continuous tone, Friedrich renders the interior walls in subtle gradations of values. These gentle shifts are consistent with how light naturally falls over smooth surfaces. Carrying out such careful and observant drawings as this one expanded the painter's understanding of the way in which the depiction of light could add beauty and expressiveness to a work of art.

9.22 Caspar David Friedrich, *View from the Artist's Studio, Window on Left*, c. 1805–6. Pencil and sepia, 12⅜ × 9¼" (31.4 × 23.5 cm). Österrerichische Galerie, Belvedere, Vienna, Austria

Surfaces Reflecting Light

Solid, opaque objects absorb, scatter, and reflect light. The way that the eye collects light is based on how much is received from an object. The brain processes what the eye perceives. While this is a complicated process, the effects of light generally behave in a predictable manner. Depicting light in a believable way requires the ability to replicate the natural patterns of light and shadows. Depending upon the angle of the light path, one will see a lighter or darker value. The lightest values will appear on the areas of a form that directly face the light source. When drawing on white paper, the brightest value that an artist can achieve is the bare, untainted page. For this reason the white of the paper should be used sparingly, and should be reserved for the brightest areas of the composition.

Parts of a form that are further away from the light will increasingly take on a darker value as the light weakens. Segmented and contrasting values suggest changing planes. Gradation of values usually suggests a continuous surface, either flat or rounded (**9.23**). The quality of light reflected from a surface to the eye is also affected by the properties of an object's surface, including the material of the object, the texture of the surface, and its color.

9.23 Round and planar surfaces
This photograph depicts the difference between how light falls over a round surface and how it travels over a planar surface. The round form has smooth gradations of value. The planar form displays a sharp value contrast from side to side. These properties should be mimicked when drawing similar forms.

9.24 Detail of cast shadow
When an object interrupts a light source it creates a shadow. Analyze the cast shadow in this image. Notice the variety of values that can be found within the shadow. The further that the cast shadow projects from the object, the softer and lighter it becomes.

Cast Shadows

Cast shadows are created by the interruption of light. They do not appear as a solid value, but instead present a wide variety of dark values. Often a cast shadow is darker when close to an object, and then becomes lighter as it moves away from it. Typically, one can see a difference in value between the inside of a shadow compared to the shadow's outer edge: the edge of a shadow tends to be darker. Cast shadows that are drawn in a naturalistic manner will appear transparent, just as shadows do in reality (**9.24**).

Multiple Light Sources

Throughout history, artists have usually limited their drawings to one light source, and have most often favored natural light. In fact, a single light source provides an unmatched sense of clarity. Some artists, however, have also experimented with multiple light sources. The value effects created by multiple lights, whether

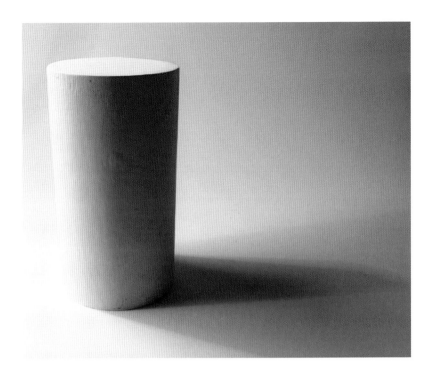

9.25 Multiple light sources
Multiple light sources result in multiple shadows. In this image two lights come from the left side, one more toward the front and the other from the rear. Individual shadows can be seen. Also, evident is the overlap of the shadows creating a triangular area of dark value.

natural or artificial (or a combination of both), are many. The principal effect of more than one light is seen in the casting of shadows. Multiple light sources result in multiple shadows. Any cast shadow will be darkened where a second shadow crosses it (**9.25**).

Emotional Quality of Value

Values and light carry strong connotations, and the conscious manipulation of value can create an atmosphere or mood that viewers can share and feel. This encourages viewers to identify with the experience of the artist or with the subject of the drawing.

Heightened or diminished value contrast create varying emotional qualities. High-contrast drawings are imbued with an enhanced dramatic quality. Drawings composed with values that are next to each other on the value scale often express a softer, quieter emotion. Deploying a majority of dark values produces a somber and mysterious effect. *Opulence XIV*, a non-objective work by Alain Kirili (b. 1946), uses high value contrast (**9.26**). Kirili draws with a variety of materials, including spray paint and charcoal, to heighten the contrast. Backed by dark values, the white areas appear especially bright. The darkest values are reserved for the spontaneous-seeming lines in the foreground. Kirili's

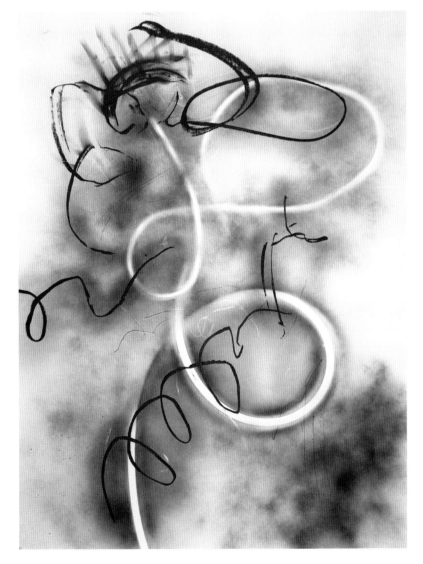

9.26 Alain Kirili, *Opulence XIV*, 2016. Spray paint and charcoal on paper, 50 × 38" (127 × 96.52 cm). Collection of the artist
All types of drawings benefit from the careful consideration of value. This non-objective drawing, made with unconventional materials, utilizes a full range of darks and lights. The dark values heighten the light ones, and vice versa. The choice of values amplifies the apparent spontaneity and emotional content of the work.

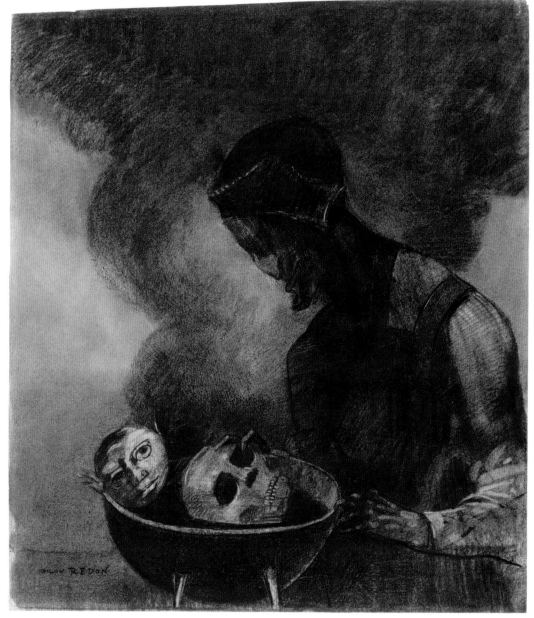

TIP

To heighten visual drama in a drawing, plan your composition so that the darkest value will be next to the lightest value.

9.27 Odilon Redon, *Cauldron of the Sorceress*, 1879. Various charcoals, with stumping, erasing, and incising, on pale-pink wove paper with red and blue fibers altered to a golden tone, 16⅛ × 14⅝" (40.8 × 37.1 cm). Art Institute of Chicago, IL

Values carry emotional qualities. The dark and subdued use of charcoal in this image deepens the sinister theme of the drawing. Very few light areas exist. Dark regions dominate the composition, generating a menacing atmosphere.

decisions about value result in work of vivid emotional intensity.

When the appropriate values are paired with the right theme, value can enrich a feeling that is already inherent in the subject matter. For example, consider the work of the French painter, printmaker, and draftsman Odilon Redon (1840–1916). *Cauldron of the Sorceress* was made on pink drawing paper that was first altered to a golden color by Redon, on which he layered, stumped, and erased charcoal (**9.27**). Expressive of his imagination as opposed to reflecting strict visual perception, the drawing conveys an ominous atmosphere rather than creating feeling through the subject alone. Mostly dark, the values inevitably convey a sense of dread and looming threat, a perfect counterpart to the haunting, macabre theme.

In the Studio Projects

Fundamental Project

This project is an exercise in continuous tone. The goal is to improve your ability to control drawing media.

Choose four different drawing media. Among others, you could select graphite pencil, charcoal, pastels, and ink. On 2 × 6" strips of paper, create a value gradation that starts at one end of the paper with the darkest value and ends at the other end with the lightest value.

Observational Drawing

Choose four different complex scenes, each with a strong single light source. You may consider landscapes, interior spaces, or still-life arrangements. Lightly draw your subject with line. Next, use just five values to depict the lights and darks that you observe. Utilize the block-in method to apply value. Revisit the images in this chapter as examples.

Before beginning, you may wish to create a five-step value scale using the media of your choice. Try to match the five-step value scale illustrated on p. 190 of this chapter.

Non-Observational Drawing

Use Alain Kirili's non-objective work *Opulence XIV* (**9.26**, see p. 197) as inspiration for your own value drawing.

Begin by arranging objects on a sheet of paper. Consider using disposable man-made or natural objects. Spray paint around the objects to create a base layer on which to draw. Add light and dark values as you see fit. Try to include both high and low value contrast somewhere in your composition.

Criteria:

1. The darkest value that can be made with the media should be represented on one end of the paper strip.
2. The lightest value that can be made with the media should be represented on the other end of the paper strip.
3. A very smooth gradation from light to dark should be created.

Criteria:

1. All four drawings should clearly represent a light source.
2. Drawings should include obvious contrast of only five values.
3. Drawings should successfully utilize the block-in technique to apply values.

Criteria:

1. The drawing should appear to be inspired by Alain Kirili's *Opulence XIV*.
2. The drawing should contain area(s) of high value contrast.
3. The drawing should contain area(s) of low value contrast.

Materials: Four 2 × 6" paper strips, four different drawing media

Materials: 18 × 24" drawing paper cut into four equal pieces measuring 9 × 12", any media that can create a full range of values

Materials: 18 × 24" paper, spray paint, black and white charcoal, oil pastels, or any other black and white media

Chapter 10

Form

Throughout this text, we discuss drawing as an independent art **form**. When drawing, our ideas are transformed into an object through the use of drawing materials and techniques. But while drawings are physical objects, their expression usually exists on a two-dimensional surface. In many cases, drawings rely on an illusion of three-dimensionality. It is this three-dimensional characteristic—the illusion of form within a drawing—that this chapter addresses.

There is a magical quality in drawing that creates an illusion of form. The form that arises within a drawing is an interaction between the artwork and our minds. By tricking the eye, even just for a moment, a drawn image relates to our three-dimensional world, giving an impression of solidity, volume, weight, and even permanence. In drawing, there are a number of ways in which form can be created, including the use of line, planes, and value.

Form (1) A type of creation (drawing as a "form" of art); (2) A three-dimensional object, or an illusion of three-dimensionality.

Defining Form

The term form (as it relates to drawing) has two principal usages:

1. As an independent activity that, in its totality, comprises an artistic creation: drawing as a "form" of art.
2. As an illusion of three-dimensionality in a drawing.

Whether using line, planes, or value to create form, it is first necessary to analyze and extract the basic geometric structure that defines the object you wish to draw. Details and nuances of light can often distract from an object's overriding structure. Therefore, it is helpful to recognize details as secondary to the general volumetric structure of the subject. It is the latter that will establish a convincing form.

Consider these diagrams of a pile of fruit (**10.1–4**). When analyzing such a complex subject as this, it is useful to comprehend its simplified geometry. Once the fundamental structure of the subject has been understood, it can be drawn more effectively, whether using line, plane, or value.

10.1 Photo of a pile of fruit
Before starting to draw, it is important to recognize the overall structure of your subject. In this case the structure of the entire stack of fruit should be understood before drawing the individual pieces. This is best addressed in the early stages of making a drawing, whether by line, plane, or value. Compare each approach.

10.2 Linear drawing of a pile of fruit
This is a first step in making a linear drawing. First assess and draw the overall shape of the subject. Draw the largest forms lightly. Next, add the mid-sized forms. Then, to continue, begin to refine your drawing using sighting and measuring.

10.3 Planar diagram of a pile of fruit
Another way to assess the structure of a subject is by recognizing planes. In this example the pile of fruit is simplified into flat planes. This highlights the geometry of the entire mass rather than focusing on details. As you proceed, gradually define the individual fruits more carefully.

10.4 Value modeling of a pile of fruit
In this case, the drawing is begun by representing the general values of the entire pile of fruit. The subject is drawn as one large volume rather than individual parts. The focus is on showing the light and dark sides of the complete subject.

Line to Describe Form

As discussed in Chapter 7 (p. 150), the illusion of form can be created with line. Linear modeling and cross-contour lines are effective ways to establish the appearance of physicality and imply the tangible properties of objects in a drawing. For example, take a close look at the image of George Washington on the front of the American $1 bill (**10.5**). This portrait is based on an unfinished oil painting by the artist Gilbert Stuart (1755–1828) from 1796, when Washington was sixty-four years old. On the note, Washington's head appears three-dimensional and volumetric. A close inspection reveals that many areas (such as the nose) are described using cross-contour lines. These parallel lines traverse the head to depict volume. In other areas, such as on the side of the face in shadow, cross-hatching is used. This linear modeling technique is used to build the density of marks and create the darker values. At a distance, linear marks combine visually (a process known as optical mixing) to describe an illusionistic form.

Drawing Through

To "draw through" is to draw an object as though it were transparent. A linear construction that highlights the form of an object is sometimes called "transparent construction." In this approach, objects are described as simple geometric forms. When drawing in transparent construction, it is advisable to begin with very light and loose lines. Progressively, as the general structure of the subject becomes clear, darker lines can be added. Sometimes, the light construction lines are left as evidence of the working process. We saw this technique in Scott Robertson's drawing, *Sci-Fi Bike Hauler* (**2.22**, see p. 40).

This drawing method is not designed to record detail; instead, the focus is on understanding the form and proportions of objects. Because both visible and hidden portions of objects are drawn, the artist must understand how the concealed parts relate to the whole. This helps maintain an accurate rendering of angles, distances, and proportions.

10.5 Close-up of George Washington on the American $1 bill
George Washington's image on the $1 bill is a good example of how line can create the illusion of form. Compare the straight lines that are used in the background to the curved lines used on the face and neck. Cross-contour lines curve according to the roundness of the head. These cross-contour lines contrast with the straight lines in the background that establish a flat backdrop.

10.6 Anonymous student, *Shoe Drawing*, 1976. Pencil drawing (using soft pencil), 23⅜ × 16½" (59.4 × 42 cm). Drawn for a course at Schule für Gestaltung Basel, Switzerland
Drawing through is a useful technique when drawing the form of an object. Although drawn from observation, the shoe was rendered as though it was transparent, from two different angles. Doing this allows the artist to consider the subject in-the-round, which is particularly important when developing the illusion of three-dimensional form.

The Foundation Program at the School of Design in Basel, Switzerland, enforced the drawing-through approach during the 1970s, when this type of drawing was considered to be an essential part of design education. An example of this approach can be seen in **10.6**. This drawing of a shoe was made from direct observation. Notice how the transparency and linear structure in the drawing convey the shoe's three-dimensional form clearly.

A form of drawing through can often be seen in the sketches of such architects as the American Michael Graves (1934–2015). *Tempietto del Bramante*, a drawing from his early schooling in Rome, reveals his aim to capture and comprehend the three-dimensional forms of Renaissance architecture (**10.7**). In this drawing, the volumes of the forms have been accentuated by drawing through. As with every design discipline, drawing is a profound part of the thought process of architectural design, useful for remembering ideas and solving problems, as well as formalizing plans that guide workers.

TIP

When drawing through, imagine what your subject would look like if it were transparent. Draw all edges, both of the front and back.

10.7 Michael Graves, *Tempietto del Bramante*, 1961. Ink on paper, 41 × 28" (104.1 × 71.1 cm). Private collection

This work is an observational drawing that analyzes the form of an existing architectural structure. The architect seems to draw both the front and the back of the building. This drawing was not meant to capture an image as a photograph might, but instead considers the space that the form occupies.

10.8 Jesse Smith, screen capture of *Excavator Paper Model Design*, 2017
This drawing was made on a computer. It simplifies the structure of a complex object into basic planes. In this process, the artist must engage in planar analysis. This approach is often used to draw volumetric forms.

10.9 Catherine Kehoe, *Model on Fainting Couch 2*, 2016. Graphite on paper, 6 × 9" (15.2 × 22.9 cm). Collection of the artist
Analyzing a subject according to planes is a reliable way to establish its form. This drawing uses a limited number of straight lines to imply volume. This approach can be used to make studies, or it can be the means to a finished work.

Planar analysis
The investigation of how an object can be divided into planes.

Planes to Describe Form

A plane is a flat surface. Planes can be the basic structural unit of a drawing. When joined at angles to each other, combinations of planes can create faceted geometric forms. By paying close attention to planar shifts, an artist can simplify complex structures, thereby enabling the development of dynamic volumes in a drawing. The investigation of how an object can be divided into planes is called **planar analysis**.

Elementary solids, or simple geometric forms—such as pyramids, cubes, cylinders, and spheres—have obvious structures defined by planes. Other objects (such as organic objects), which are irregular and multifaceted, require the invention of planes in order to interpret their forms. Jesse Smith used commercial 3-D computer graphics and computer-aided design application software to make this drawing, a design for a paper model (**10.8**). It uses planes to simplify a complex excavator down to its fundamental geometry.

By subdividing forms into planes, an artist can establish the presence of a subject. We can see how this information is used in the work of the contemporary artist Catherine Kehoe (**10.9**). In this drawing she first established the outermost dimensions of the figure with

10.10 Alex Beck, *Planar Analysis Figure Drawing,* n.d.
Study this drawing carefully. The planes do not divide the figure randomly. The facets are inspired by the changes in the surface of the form.

Envelope method
The technique of establishing the outermost dimensions of a subject by using lines to encase it.

lines that encase the pose, a technique known as the **envelope method**. (This technique is particularly useful as a first step when drawing complicated subjects, such as the figure.) Kehoe then drew straight lines to distinguish the top and side planes of each part of the figure.

Taking the process further, Alex Beck (b. 1990) makes more subdivisions to his figure drawing (**10.10**). Notice the lines that establish the geometric planes of the body: their edges correspond to changing directions of form. You could also apply value to planes, in accordance with the direction of light, to add depth.

10.11 Pablo Picasso, *Mother and Child* from Sketchbook 77, 1922. Pencil on paper, 16½ × 12" (41.9 × 30.5 cm)
The rounded forms in this drawing follow a configuration of a light value on one side and a dark value on the other. This contrast creates the illusion of light and form. The addition of value in the background is crucial to the result, as it heightens light on the figure.

Value to Describe Form

One purpose of using value in a drawing is to describe form. This is very often the case in representational drawing. The visibility of form is caused by the tonal arrangement found on the surface of objects. Therefore, a convincing illusion of form is created in a drawing when an artist mimics the natural way that light falls over a three-dimensional form. In nature, with every change that occurs on the surface of a form, there is a change of value.

A certain amount of value contrast is required in order to characterize how light lands on an object, and thus value contrast is also needed in order to establish form in a drawing. The strength of the light source will dictate the contrast in a drawing. Creating a proper value contrast from the dark to the light side of a subject is key to creating a convincing volume. *Mother and Child*, a value drawing by Picasso (1881–1973), exhibits contrast as a result of many layers of pencil cross-hatching (**10.11**).

Drawing at Work Margaret Bowland

10.12 Margaret Bowland, *Blue J*, 2011. Pastel and charcoal on paper on linen, 52 × 44" (132.1 × 111.8 cm). Private collection

The contemporary New York artist Margaret Bowland (b. 1953) grew up in North Carolina during the time of desegregation, the period in which the state's policies of racial segregation were questioned and changed. Her memories of racial injustice brought her to question society's expectations about femininity, race, and beauty. Her works explore what it means to be beautiful, and her personal images force us to question ourselves.

Margaret Bowland's highly realistic drawings employ techniques derived from the European tradition of figurative representation. *Blue J*, made from pastel and charcoal on paper, creates the illusion of form through the careful rendering of light using value (**10.12**). Subverting pictorial tradition, she depicts her subject in an unusual negative lighting situation, inverting our expectations about light and shadow, positive and negative. This challenges us to see things from another person's perspective. Here, the light and form have an aesthetic and psychological power that confronts us with the unexpected other.

The rendering of strong volumes in the drawing in **10.11** (p. 206) is typical of Picasso's Neoclassical style, which he experimented with following the First World War. The forms (the head, arms, legs, and torso) are depicted as geometric solids. Each form has contrast between the side facing the light and the side that turns away from it. No part within the dark region of a form is as bright as the areas facing the light source. Similarly, the areas facing the light are never as dark as the regions that turn away from it. This clarifies the light in the drawing, and also implies volume. The smooth transitions of value impart to the figures an impression of roundness.

Chiaroscuro

Chiaroscuro is a term derived from Italian that refers to the modeling of forms using value. The word literally means "light-dark" (*chiaro* + *oscuro*). To create the illusion of form on a two-dimensional surface using value, one must be well acquainted with the way in which the pattern of light and shadows affects three-dimensional objects. Since viewers are naturally accustomed to the manner in which light models form, the arrangement of values on forms in a drawing must also seem natural. The transition between values needs to be carefully considered. For example, a rounded form, such as a sphere or cylinder, will display a smooth gradation of tones.

Chiaroscuro From the Italian "light-dark," the modeling of forms using value to create the impression of volume.

10.13 Student work. Madilyn Bedsole, *Stuffed Zebra*. (Instructor: Stephen Gardner)
Through the careful rendering of light and shadow, the student who made this drawing has created a compelling illusion of three-dimensional form. We can see the student's attentiveness to the nine different light and shadow features. The result is a strong impression of visual reality.

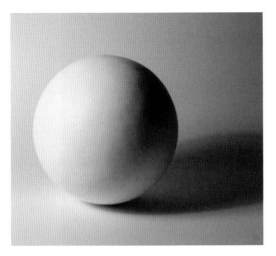

10.14 Diagram of sphere with light and shadow features
The basic features of value on a sphere when illuminated with a single light source.

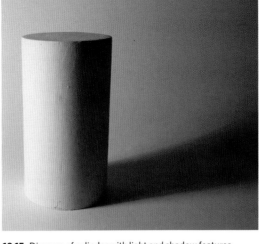

10.15 Diagram of cylinder with light and shadow features
The basic features of value on a cylinder when illuminated with a single light source.

TIP

By representing the different features of light and shadow, you will be able to create a drawing that gives the illusion of volumetric form.

Based on the observation of rounded forms with a single light source, nine basic features can be discerned in terms of value gradation (**10.14** and **10.15**). Representing the relationships between these when drawing an object will create a sense of visual truth. The key features are:

1. **Light zone**: This area faces the light source and is composed of the lightest values.
2. **Highlight**: The area in which the light is reflected most intensely. On a sphere, the highlight will appear between the center and the point that faces the light.
3. **Light half-tone**: The lightest of the transitional values located toward the light zone.
4. **Half-tone**: The transitional value that lies halfway between the light and dark sides of a form. This is the area where the form turns away from the light source. Its value is a mid-tone between the light and dark sides.
5. **Dark half-tone**: The darkest of the transitional values, located toward the shadow zone.
6. **Form shadow**: This area of the form turns away from the light source and is composed of dark values.
7. **Core shadow**: This part of the shadow zone lies just past the impact of light. It is the darkest part of the shadow zone because

it receives the least amount of light. It is essential to the description of a three-dimensional form. On a sphere the core shadow is a crescent shape.

8. **Reflected light**: The part of the shadow area that receives indirect light from the environment. Essentially, light is redirected from a secondary surface back onto the subject. This causes a light area to appear within the shadow zone, typically on the subject's edge. The reflected light will not be as bright as the light zone. Reflected light helps to give definition to the dark side of the object.
9. **Cast shadow**: The absence of light created by an object that interrupts the light source. There is substantial value variation within a cast shadow. The more distant it is from the object, the more diffused its edges will become. Some shadows appear lighter in the center as the reflected light reflects back, once again, into the cast shadow.
 a. **Occlusion**: The darkest part of the cast shadow. It can be found closest to the object. This area has the most obstruction from light.
 b. **Penumbra**: The soft, outer edge of the cast shadow. It is formed where light is partially obstructed by the object. The penumbra widens as it distances itself from the object.

Light zone The area that faces the light source and is composed of the lightest values.
Highlight The area in which the light source is reflected most intensely.
Light half-tone The lightest of the transitional values located toward the light zone.
Half-tone The transitional value that lies halfway between the light side and dark sides of a form.
Dark half-tone The darkest of the transitional values located toward the shadow zone.
Form shadow The area of the form that turns away from the light source and is composed of dark values.
Core shadow The darkest part of the shadow zone.
Reflected light The part of the shadow area that receives indirect light from the environment.
Cast shadow The absence of light created by an object that interrupted the light source.
Occlusion The darkest part of the cast shadow.
Penumbra The soft outer edge of a cast shadow.

10.16 Willem de Kooning, *Still Life (Bowl, Pitcher, and Jug)*, c. 1921. Conté crayon and charcoal on paper, 18½ × 24¼" (47 × 61.6 cm). Metropolitan Museum of Art, New York

This drawing was made by De Kooning as a young artist. We can see his attentiveness to the essential features of light and dark values as they appear on the surface of forms. De Kooning, whose artistic training included a traditional academic foundation of drawing, later shifted his approach and became a leading Abstract Expressionist.

10.17 (below) James Valerio, *Towel*, 1996. Pencil on paper, 23 × 29" (58.4 × 73.7 cm). Private collection

The illusion of form in this drawing is produced by the application of value, involving the subtle gradation of tone from the light side to the dark side of each fold. The artist has included the light half-tone, half-tone, and dark half-tone. This full range of values enhances the illusion.

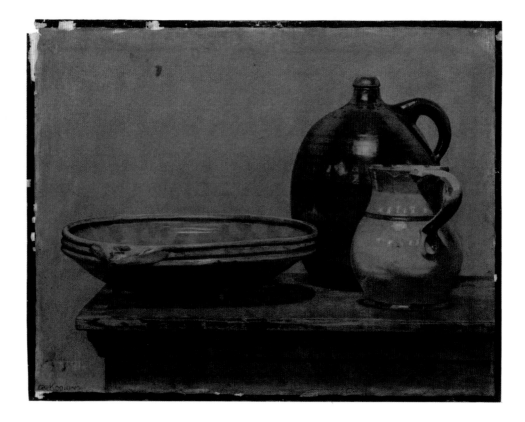

When viewing objects lit from a single light source, a distinction of light and shadow features is discernible. This was captured in the drawing *Still Life* by the Abstract Expressionist Willem de Kooning (1904–1997), which was made in the artist's formative years (**10.16**). Notice how De Kooning creates light values on each object that obviously contrast with the form shadow. Within the light zones there are highlights. The paper is exposed in these areas, and used exclusively for the brightest values.

The transition areas of value are very important in the depiction of three-dimensional objects. They should be drawn with attention paid to the gradation of value from the light side of the form to the dark side. James Valerio (b. 1938) does this exceedingly well in *Towel* (**10.17**). Despite the details and surface texture of his subject, Valerio is able to model a smooth and regular progression from the light half-tone to the half-tone and then to the dark half-tone.

It is the form shadow, and especially the core shadow, that convinces the viewer that a form is volumetric. The form shadow and its features not only add to the three-dimensionality of a rendered object, but also add drama and impact. The Flemish painter Peter Paul Rubens (1577–1640) is well known for his Baroque style. In his drawings, such as *Seated Male Youth*, one can see the use of a dark form shadow to create the dynamic and bold forms that are typical of the Baroque movement (**10.18**). Special attention has been paid to the inclusion of core shadows throughout the drawing.

10.18 Peter Paul Rubens, *Seated Male Youth (Study for Daniel)*, n.d. Black chalk, heightened with white chalk, on light gray paper, 19⅝ × 11¾" (49.8 × 29.8 cm). Morgan Library & Museum, New York

In this sketch, look for the core shadows in the face, shoulder, arms, and leg. The darkest part of the form shadow helps to create a sensation that a volume is turning away from the light. It also helps to establish the solidity of forms.

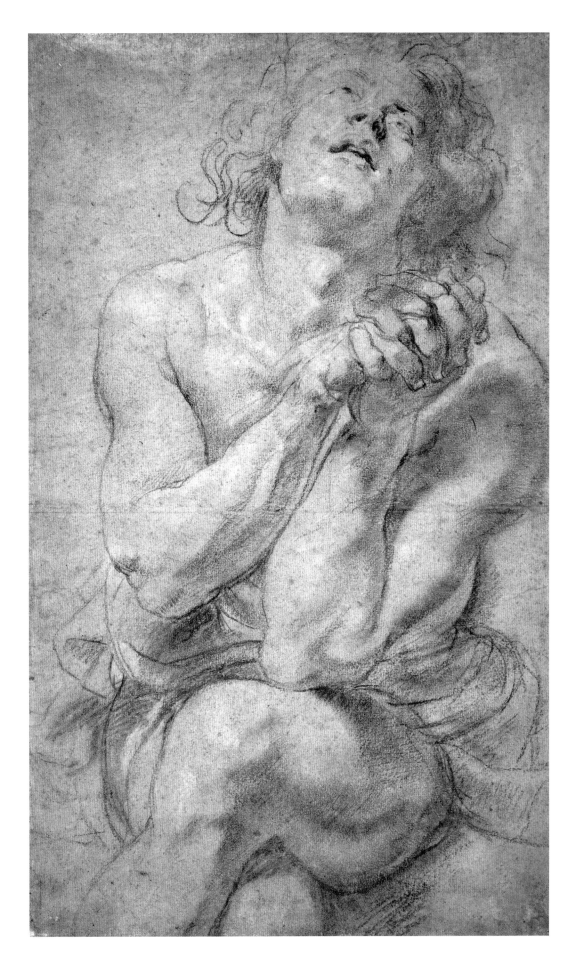

The Work of Art Bailey Doogan

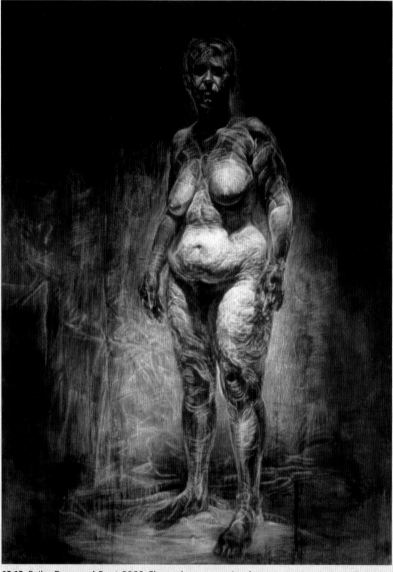

10.19 Bailey Doogan, *A Front*, 2002. Charcoal on gesso-primed paper, 6' × 4' 5" (1.83 × 1.35 m). Collection of the artist
Bailey Doogan is able to model realistic form with value. Study her drawing. Can you locate the nine basic features of value gradation within her work?

Who: Bailey Doogan
Where: United States of America
When: 1997 and 2002
Materials: Charcoal on gesso-primed paper

Artistic Aims

As Bailey Doogan has aged, she has become focused on the physical changes of her own body. She strives to depict older flesh through her representation of light and form in her drawings, while at the same time she challenges the taboo of mentioning and depicting the ageing female body.

Artistic Challenges

The mature female body, complete with the natural signs of ageing, is not often a focus in art. In taking on this challenge, Bailey Doogan depicts the details of older women's skin and body form. To challenge traditions even further, she also exploits unconventional figurative poses. Doogan makes the viewer question the definition of female beauty as she works to highlight the splendor of individuality.

Artistic Method

Bailey Doogan utilizes a subtractive drawing method. She begins by blackening a large gesso-primed paper with charcoal. She then removes the charcoal, using erasers and sandpaper, to achieve her intended values. These articulate the sagging of the skin, as well as the bony and fatty areas. Although the body parts are rendered bit by bit, the overall illumination produced by a single, powerful light is not lost.

Doogan's drawings make clear distinctions between the nine basic features of value gradation. For example, consider her drawing *Spell I* (**10.20**, opposite). While isolating the buttocks or the legs or arms, we can identify highlights, half-tones, core shadows, and reflected lights, as well as other features. The cast shadows include an array of values. The full range of light and shadow features creates drama, the illusion of mass, and a believable impression of reality.

The Results

Bailey Doogan's figure drawings are far from idealized. She often uses contorted poses and renders natural-looking skin. There is a clear understanding of form, and how forms are affected by light. The drawings believably address a physical reality, the ageing body, which has been silently avoided by many artists over time.

Sketchbook Prompt

Blacken a page of your sketchbook with charcoal or graphite. Use an eraser to draw a subject. Focus on creating an illusion of form.

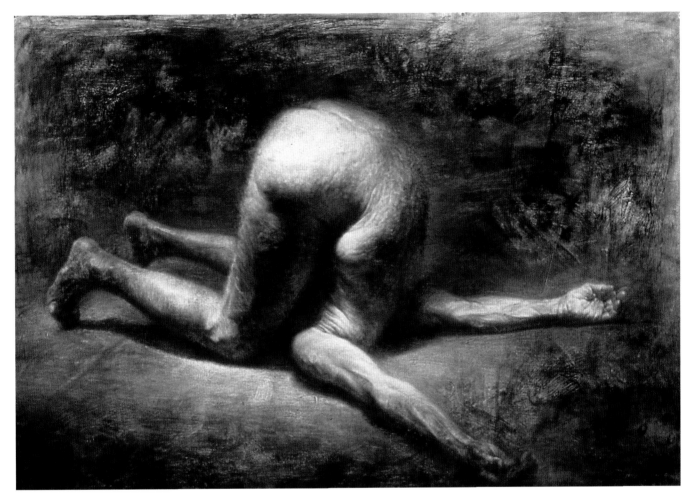

10.20 Bailey Doogan, *Spell I (Assman)*, 1997. Charcoal on gesso-primed paper, 5′ 2″ × 7′ (1.58 × 2.13 m). Collection of the artist
This drawing was made using a subtractive charcoal technique that enables the creation of a full range of values, including the subtle changes that occur as light travels over rounded forms. Can you find the nine basic features of value gradation that are outlined in this chapter?

Bailey Doogan (b. 1941) creates rounded forms in her drawings by working subtractively. By erasing from a charcoal base, she is able to create a full range of light and dark values (**10.20**). The light zones are made more brilliant by the rich darks. Notice how she represents the nine basic features of value gradation.

Sfumato

When rendering an object's light and dark features, it is also important to consider the values that surround the object. The background values contribute greatly to the perception of an object's darkness or lightness. In some areas the background may be lighter than the bordering side of the object; in other cases it may be darker. Sometimes a value on the object's edge will match that of the background, resulting in the loss of an edge. Including this loss in a drawing can enhance an illusion of form.

The subtle gradation of tone used to blur areas of light to dark is referred to as **sfumato**, an Italian word meaning fumes, or smoke. The use of *sfumato*, evaporates lines and edges and creates illusionistic and atmospheric effects. Leonardo da Vinci was one of the first and most notable artists to practice the technique. We saw his use of *sfumato* in *The Burlington House Cartoon* reproduced in Chapter 6 (**6.21**, see p. 145).

Sfumato The subtle gradation of tone used to blur areas of light to dark, creating a hazy or smoky appearance.

10.21 Terese Rogers, *Le Petit Fleur*, n.d. Charcoal on paper, 7 × 6" (17.8 × 15.2 cm). Private collection

This drawing exemplifies the delicate blurring of light and dark values, known as *sfumato*. The technique creates convincing form and atmosphere. The edges of some objects become lost as their values are so close to the space around them. While *sfumato* is clearly evident in the foreground, blurring is amplified amid the background objects.

Many artists wishing to produce illusionistic renderings have followed Leonardo's method. *Le Petit Fleur*, a charcoal drawing by Terese Rogers (b. 1957), shows how the act of blurring values together and softening contours can create illusionistic forms (**10.21**). In Rogers's drawing the *sfumato* effect appears to increase as the viewer looks deeper into the space.

The Canadian-born artist Walter Tandy Murch (1907–1967) renders the forms of his still-life objects in such a manner that they almost dissolve into the space around them. The watercolor-and-charcoal drawing *Study #18* displays the elementary features of value gradation as well as an expressive use of *sfumato* (**10.22**).

10.22 Walter Tandy Murch, *Study #18*, 1962. Transparent and opaque watercolor and charcoal on very thick wove paper, 23 × 17½" (58.4 × 44.5 cm). Hood Museum of Art, Dartmouth College, Hanover, NH

The blurring of edges in this drawing is so extreme that objects fade into their atmospheric surroundings. Despite being lost in a haze, light is still represented accurately, as it would naturally fall over forms.

In the Studio Projects

Fundamental Project

Using graphite pencil on white paper, copy the diagram of a cylinder in **10.15** (p. 209). Try to make an exact copy, including all light and shadow features.

Observational Drawing

Choose a volumetric object and hang it on the wall. You may choose an object such as an apple hanging from a string, a stuffed animal pinned to the wall, or a coffee cup on a hook. Light your object from one side using a strong single light source. Make sure that your setup has obvious light and dark zones and a cast shadow. Use the drawing process described in Chapter 6 (p. 133):

1. Decide What to Draw
 » Refinement
2. Compositional Gesture
 » Refinement
3. Introduce Values
 » Refinement

Analyze and draw the observed values, including the nine features described on p. 209. Consider continuous tone.

Non-Observational Drawing

Using the medium of your choice on 22 × 30" paper, invent three large forms. You may choose curvilinear forms, rectilinear forms, or a combination. When drawing on the page, draw through the forms to ensure their three-dimensionality. Arrange your forms so that there is at least one overlap, and ensure that they fill the composition in a visually pleasing manner. After the forms are constructed, add value using *chiaroscuro* and/or *sfumato*. Refer back to this chapter for assistance if necessary.

Criteria:

1. The copy should be a faithful representation of **10.15**.
2. All nine of the light and shadow features should be clearly represented in the drawing.

Criteria:

1. The drawing should clearly represent a single light source.
2. The drawing should create the illusion of form through the use of *chiaroscuro*.
3. The drawing should include the nine features of value gradation that are described in this text. Continuous tone should be used effectively.

Criteria:

1. The artist should invent three original and visually exciting forms.
2. The drawing should be well composed and include some overlap between the forms.
3. The drawing should create the illusion of form through the use of *chiaroscuro* and/or *sfumato*.

Materials: Graphite pencil on white paper

Materials: 22 × 30" drawing paper, charcoal

Materials: 22 × 30" drawing paper, optional media

Chapter 11
Space

In the context of drawing, the term "**space**" refers to the expanse within which all the parts of the drawing appear to exist. To create an illusion of space in a drawing is to suggest a feeling of depth or distance on the two-dimensional surface, with the intention that the viewer will forget that he or she is looking at a purely flat surface.

Over centuries artists have used and refined different means of representing pictorial space. Such techniques are often used in combinations to convey particular effects. The basic methods for creating the illusion of space in a drawing are:

1. Position on the picture plane
2. Overlap
3. Size
4. Diagonals
5. Atmospheric perspective
6. Linear perspective

Space Also known as depth. Refers to the expanse within which all parts of a drawing appear to exist.

Using Position on the Picture Plane to Suggest Space

The position of objects or elements within a composition tends to generate a sense of distance. Items placed toward the bottom portion of the picture plane typically appear close to the viewer, while things located toward the top of the plane seem relatively further way. This simple tactic for creating depth has served artists for centuries and continues to be effective today.

This approach was implemented by artists who made such Persian miniatures as this one by Shaikh Zada (active 1510–1550) (**11.1**). Here, the artist illustrates the scene so that it can be easily understood. Instead of depicting people and objects at angles to the viewer, he draws them flatly and stacks them. The figures ascend the page to suggest their positions in space. Zada uses the size of the figures to describe their status, as per the conventions of Persian art at the time; the largest drawn figures are typically those of the greatest authority. As such, size is not used to communicate space, and so the positioning of figures on the picture plane is the primary source of space in the image. This can at first be confusing to the modern-day eye. The floor and architectural planes are turned to the viewer so that they can be more readily seen. In a manner that is typical of Persian miniatures, vivid colors and gold accents decorate the space.

11.1 Shaikh Zada, "Laila and Majnun in School," Folio 129 from a *Khamsa* (Quintet) of Nizami, 1524–25. Ink, opaque watercolor, and gold on paper, 7½ × 4½" (19.1 × 11.1 cm). Metropolitan Museum of Art, New York

Within this sixteenth-century Persian miniature, the positioning of figures and objects on the picture plane is used to suggest space. Objects higher on the page are intended to be read as further away. An advantage of this approach is that it allows for every object to be seen fully.

11.2 Carl Randall, *Study for a London Café Scene*, 2003. Charcoal and collage of drawings on paper, 39⅜ × 74¾" (190 × 100 cm). Private collection
Compare this contemporary charcoal and collage work with the Persian miniature in **11.1** (p. 217). Each relies on the placement of items on the picture plane as its primary means of describing where objects are positioned in space. In both, background figures are situated higher on the page than foreground figures.

Overlap The effect created when one object partially covers another.

The contemporary figurative artist Carl Randall (b. 1975) also creates intriguing spaces through his deliberate placement of objects and figures within the composition. In his *Study for a London Café Scene*, the row of people and plates along the bottom of the page projects forward in comparison to the people and plates toward the top (**11.2**).

11.3 Diagram of side-by-side squares

Using Overlap to Create Space

The use of **overlap** is another simple and effective technique to create space. When one object blocks the view of another, it is understood that the first object is positioned in front of the other. Logically, space must be present in this situation. Consider the two diagrams in **11.3** and **11.4**. Each shows two squares. In the top diagram (**11.3**) we cannot be sure which of these two squares is closest to the viewer, since we do not know if the squares

11.4 Diagram of overlapping squares
These diagrams illustrate how overlap suggests space. In the first image, we cannot tell if one square is closer than the other without knowing the sizes of the squares that they represent. In the second image the spatial relationship is clear.

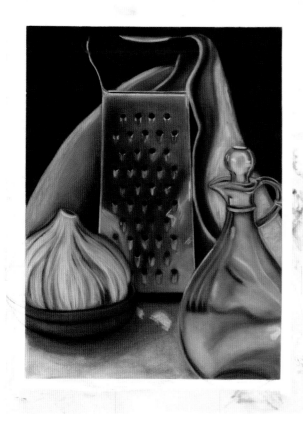

11.5 Student work. Gabriela McDonald, *Prep Time*. (Instructor: Gaylen Stewart)
This student makes deft use of overlap in her arrangement of these objects. The obvious overlaps clarify where the items are located in space.

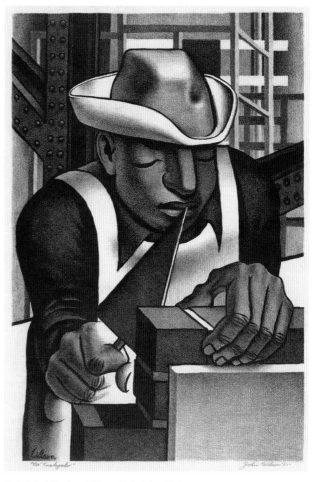

11.6 John Woodrow Wilson, *Trabajador*, 1951. Lithograph, 19½ × 13½" (49.5 × 34.3 cm). Metropolitan Museum of Art, New York
This drawing utilizes overlap throughout the composition to create space. Follow the successive overlaps from the foreground, through the middle ground, and into the background. Observe how each overlap indicates a spatial relationship.

are supposed to be perceived to be the same size but at some distance from each other, or whether one is meant to be understood to be larger than the other. On the other hand, the bottom diagram (**11.4**) makes the spatial relationship obvious through the use of overlap: it is clear that the small square is closest to the viewer. An artist concerned with creating depth in a drawing will find it beneficial to choose subjects that possess overlaps, or arrange subjects in such a way that such overlaps will be created.

John Woodrow Wilson (1922–2015) is best known for his depictions of African American working men. His lithograph of a bricklayer, *Trabajador*, was made while living in Mexico, an experience that further established his commitment to making socially conscious art. *Trabajador* is an effective application of overlap (**11.6**). Starting in the foreground, the bricks overlap the trowel, the trowel overlaps the figure, the figure overlaps the structure, and so on, thus conveying a sense of deep space. In a manner similar to the bricklayer himself, Woodrow uses overlaps to structure the elements in the picture, each layered on top of one another. They recede into the picture, creating a substantial, spatial world.

11.7 Image of hydrant demonstrating the impression of diminishing size from foreground to background
Try this experiment for yourself. Measuring an object in the distance with your hand helps demonstrate how objects in the distance appear to diminish in size. Artists can use this phenomenon to imply space in a drawing.

11.8 View of three plates on table showing diminishing size, the diagonal lines denoting the sight lines from the artist's eye to the corners of the plates, and the vertical red lines indicating the drawing on the glass
Sight lines from the eye travel through the picture plane to the corners of the plates. The red lines on the picture plane indicate the sizes that the plates would be in the drawing. The plate closest to the viewer would be drawn largest, and the plate furthest from the viewer would be drawn smaller.

Using Diminishing Size to Create Space

Close one eye, extend your arm forward, and look at your thumb. Gauge the perceived size of distant objects by comparing them to your thumb (**11.7**). This little experiment quickly demonstrates a visual phenomenon: objects appear to diminish in size as they recede into the distance. Artists can create depth by using this basic principle in a systematic way.

To picture the concept of diminishing size more accurately as it pertains to drawing, consider **11.8**. This diagram illustrates a person looking through a piece of glass at three equally spaced plates on a table. If the person's view

were traced onto the glass, that drawing would accurately depict the sizes of the plates as they appear to the eye. The glass would act as the picture plane for this drawing.

In the diagram, compare the sizes of the objects as they are drawn on the glass, indicated in red. Notice the further the object is from the viewer, the smaller the drawing is on the glass. Also, consider the sizes of the spaces between the drawings of the plates. The spaces appear smaller when they are further from the viewer. As discussed earlier in this chapter, the objects that are closer to the viewer appear on the lower portion of the picture plane; the furthest objects are positioned toward the top.

Diminishing size creates depth especially well when the same object is repeated. This two-part concept drawing, made for the large installation work *The Umbrellas* by Christo (b. 1935), illustrates this. The vast space of the valley is suggested by the obvious variation of size between foreground and background umbrellas (**11.9**).

The way in which space distorts the size of objects is sometimes faithfully recorded by artists and at other times modified or enhanced. This distortion is called **foreshortening**. It is seen when an object or figure is viewed at a strong or unusual angle. When captured in a drawing, foreshortened objects may seem to project out of the picture plane. We can see this in Rebecca Venn's drawing of the male figure (**11.10**).

Foreshortening
The appearance of a form when depicted at a very oblique (often dramatic) angle to the viewer in order to show depth in space.

11.9 Christo, *The Umbrellas (Joint Project for Japan and USA),* 1988. Collage in two parts: pencil, fabric, charcoal, pastel, wax crayon, enamel paint, and topographic map, 26¼ × 30½" (67.3 × 77.5 cm) and 26¼ × 12" (67.3 × 30.5 cm). Collection of the artist
This presentation for an installation relies on diminishing sizes to represent depth. The foreground umbrellas are drastically larger than those in the background. In this way, Christo imitates the way the eye perceives objects when viewed over distances.

11.10 Rebecca Venn, *The Male Landscape,* 2017. Graphite, 14 × 11" (35.6 × 27.9 cm). Private collection
This drawing uses foreshortening to amplify space. It recreates the optical illusion of how objects that are closer to us appear larger than those in the distance. In this drawing, the size of the feet are much larger than other parts of the body. For example, the thigh appears compressed when compared to the feet. Although this seems to contradict reality, it correctly represents what we see.

11.11 Xu Bing, "Stone Village," study for the woodblock
Stone Village, 1980. Drawing in pencil on paper, 12 × 15⅜"
(30.4 × 39 cm). British Museum, London, England
Diagonals in a drawing have the ability to direct the viewer's
gaze through a composition, and can lead the viewer into a space.
This drawing does both. As we walk the paths visually, we find
ourselves slowly working our way to a distant village.

Using Diagonals to Create Space

Vertical and horizontal lines echo the sides of
the rectangular picture plane, and thus remind
us of the flat surface of the drawing. Oblique
lines have the opposite effect; we perceive them
as receding into space. As such, diagonals can
be utilized by artists to guide the viewer's eye
from foreground to background, consequently
maximizing the impression of distance in a
drawing.

In *Stone Village*, a pencil drawing by Xu
Bing (b. 1955), the illusion of space is achieved
amid the mass of details and upright walls
(**11.11**). This space is a result of the many
diagonal paths in the image, which lead the
eye and direct the viewer back into space.
The observer becomes active rather than
passive, zigzagging through the composition.

Atmospheric perspective
Sometimes called aerial perspective, a technique that simulates the reduced visual clarity of things seen at a distance.

No. 4 from Five Aquatints with Drypoint, an abstract print by Richard Diebenkorn (1922–1993), uses diagonals that at once create flat shapes and seem to drive us back and forth in the space. The image is evocative of the suburban landscapes that were the focus of much of Diebenkorn's work (**11.12**).

11.12 Richard Diebenkorn, *No. 4 from Five Aquatints with Drypoint*, 1978. Sugarlift aquatint with burnishing, 11 × 8" (28 × 20.3 cm)
This abstract print takes advantage of strong opposing diagonals. The angles zigzag across the composition. The large shapes they create have a flattening effect, but at the same time the diagonals direct us in and out of depth. The contradiction of a drawing that appears both flat and spatial is intriguing.

Atmospheric Perspective

Atmospheric perspective is a technique that simulates the reduced visual clarity of things seen at a distance. (Atmospheric perspective is sometimes called aerial perspective, but it should not to be confused with the alternative usage of the term "aerial perspective," which refers to a bird's-eye view.)

Because the presence of moisture and airborne particles obstructs vision, in reality the appearance of objects seen at a distance is affected in a number of ways, including:

1. Reduction of focus: objects that are closer to the observer can be seen in more detail and with sharper edges. The further objects are from the viewer, the less they are in focus.
2. Lessening of value contrast: values become more similar as the distance from the viewer increases. Distant objects appear to fade into the atmosphere around them. In a drawing, this can be replicated by making the marks progressively darker or increasingly lighter as one moves from foreground to background.
3. Color changes: objects that are furthest in a scene take on a cool, blue-gray cast. Objects in the foreground tend to appear warmer and possess more saturated color.

Atmospheric perspective can be exaggerated to suit the purpose of creating the illusion of space. For instance, when drawing a still life, you may be able to see each object very clearly, but to create dramatic space you may wish to exaggerate what you see by rendering the background objects with reduced focus, less contrast, and cooler colors.

Olive Trees at Tivoli, by the American landscape artist George Inness (1825–1894), is a particularly strong example of how atmospheric perspective can create the illusion of space (**11.13**, p. 224). Inness implies distance with his sensitive gradation of clarity, value, and color. The foreground details and the bold colors eventually disappear into the soft features of a much lighter blue-gray background.

11.13 George Inness, *Olive Trees at Tivoli*, 1873. Gouache, watercolor, and graphite on blue wove paper, 7×12⅜" (17.8 × 31.4 cm). Metropolitan Museum of Art, New York

The deep space in this drawing is a result of the artist's application of atmospheric perspective. Reduction of focus, lessening of value contrast, and color changes have all been utilized. The space appears as though it continues eternally.

Hillary Brace (b. 1956) created small charcoal drawings on Mylar that suggest a huge expanse of space (**11.14**). We believe in this space because of her adept use of atmospheric perspective. Brace makes obvious differentiations between the foreground and background, which we see in terms of focus and value contrast.

Atmospheric perspective can be used not only to express space, but also to convey emotion. This can be observed in *Tube Shelter Perspective* by the English artist Henry Moore (1898–1986) (**11.15**). Made from memory, the image depicts Londoners sheltering in subway tunnels from nighttime bombing raids during the Second World War. In contrast to Inness's use of atmospheric perspective in *Olive Trees at Tivoli*, Moore's drawing recedes into spatial darkness, generating a chilling and oppressive feeling. Compared to the reclining figures in the foreground, those in the deep space are drawn as mere suggestions of form in the darkness.

11.14 Hillary Brace, *Untitled #8*, 2003. Charcoal on polyester film (Mylar), 3⅝ × 8⅞" (9.2 × 22.5 cm). Private collection

This tiny drawing suggests vast space. Although we may never have seen such a skyscape in person, we are convinced by it because of the drawing's believable depth. Forms seem to dissolve into the atmosphere. We find ourselves plunged into the space, lost in a complex universe.

The Work of Art
Henry Moore

Who: Henry Moore
Where: England
When: 1941
Materials: Graphite, ink, wax, and watercolor on paper

Artistic Aims

Henry Moore's work was almost always based on forms that he observed in the natural world, often the human figure. Non-Western art was important to the development of his ideas; the influence of pre-Columbian art is evident in some of his most famous works. He spent considerable time studying other cultures in the anthropology galleries of the British Museum in London, England.

Predominately a sculptor, Moore nevertheless drew throughout his life, often making drawings that were not related to specific sculptures. His intent was not to copy the natural appearances of things, but to penetrate deeper into his subjects to reflect their reality and significance as form.

Artistic Challenges

During the Second World War, Moore and his wife were walking home from dinner when they were directed into a subway station to take shelter from air raids. There, Moore witnessed hundreds of people hiding for their lives. For some artists, such a traumatic experience might permanently disrupt their production of art. Some may choose never to think about an unsettling event again, but Moore chose to face his past directly. His distressing memories became a fascinating source for his drawings.

Artistic Method

For Moore, the materials of art had their own life. Just as his sculptures reveal his

11.15 Henry Moore, *Tube Shelter Perspective*, 1941. Graphite, ink, wax, and watercolor on paper, 19 × 17¼" (48.3 × 43.8 cm). Tate, London, England
While this drawing is not meant to be realistic in the same manner as a photograph, it does convincingly express space as well as emotion. Atmospheric perspective facilitates both. Can you describe how, as we move into the distance, marks and values change? Does this drawing appear realistic or abstract?

hands-on involvement when modeling clay and plaster, or carving wood and stone, Moore's drawings exhibit his love for tangible mark-making and drawing materials. *Tube Shelter Perspective* does not hide the pencil, ink, wax, and watercolor with which it is made. These marks were important in the development of the reclining figures, a recurrent theme for Moore, and also in the creation of space. Here, the illusion of deep and ominous space is enhanced through atmospheric perspective.

The Results

This drawing reflects Moore's strong interest in the dignity and welfare of the people depicted. Moore was subsequently appointed as an Official War Artist, and in this role he continued to make drawings of this subject.

Henry Moore is considered to be one of the most important British artists of the post-Second World War period. His drawings and sculptures possess a humanist quality for which he achieved international critical acclaim.

Sketchbook Prompt

Invent a drawing that suggests great depth in space.

Linear perspective
A way of representing space based on the principle that parallel lines appear to converge as they move away from the viewer.

Perspective view
A drawing of an object as it is seen by the eye.

Linear Perspective

Linear perspective is an approach to representing space on a two-dimensional surface as it would be perceived from a single point of view. It was developed in the West in the early fifteenth century. In drawing, linear perspective replicates the natural appearances of objects and spaces as they appear if you look through one eye. Despite its effective ability to suggest space, it is worth noting that linear perspective does not exactly imitate *how* we view the world. For example, it assumes that our head does not move at all. Nevertheless, by understanding the fundamental rules of linear perspective, we will be able to imbue our drawings with an illusion of space.

As a drawing system, linear perspective is based on the principle that parallel lines appear to converge as they move away from the viewer. This is based on the simple fact that, as we have seen earlier in this chapter, objects appear to reduce in size as their distance from the observer increases. For example, although the sides of a rectangular table may be parallel, when we view the table from the side, the edges that recede from us will not look parallel. They seem to converge as they move away from the viewer, and the edge that is furthest away will appear shorter than the edge that is closest, even though we know these two parallel edges to be equal in length (**11.16**).

The fundamental principles of linear perspective were formulated by the Italian architect Filippo Brunelleschi (1377–1446). Taking these ideas further, in 1435 the Florentine artist and clergyman Leon Battista Alberti (1404–1472) wrote *Della Pittura* ("On Painting," 1463), the first book that outlined the laws of perspective. These ideas had an enormous impact on the subsequent development of Renaissance art in Europe. Since then, linear perspective drawing has developed to suit a variety of purposes. The essential principles of representation through linear perspective remain evident today in fine art, architecture, and design, including video games and computer art.

In architecture, linear perspective is especially useful for communicating ideas and proposing projects to people who may not be able to read technical drawings. Using the principles of perspective, architects can construct accurate drawings from measured plans and elevations, either by hand or with the aid of a computer. *Lodge Type Cabin* from the studio of Frank Lloyd Wright (1867–1959) is a hand-drawn work that incorporates both a **perspective view** as if we were looking up at the building, and a floor plan, also using linear

11.16 Photo of table with edges converging into space
Although we logically understand that the sides of the top of a table are parallel, when viewed at an angle they do not appear to be so. Instead, parallel lines seem to converge as they move away from the viewer. This illusion is a fundamental rule of linear perspective.

11.17 Frank Lloyd Wright, *Perspective and Plan for Lodge Type Cabin, Lake Tahoe Summer Colony, California*, 1923. Graphite and colored pencil on Japanese paper, 21⅜ × 13¾" (54.3 × 34.9 cm). Canadian Centre for Architecture, Montreal, Canada
Linear perspective is often used by architects for design and communication purposes. This drawing from the studio of Frank Lloyd Wright includes a floor plan in perspective at the bottom of the page, and a perspective side view at the top. Together they thoroughly and accurately describe the architectural design.

perspective (**11.17**). If we drew lines straight down from each corner of the top drawing, they would align with the corners of the plan drawing. These architectural perspectives help us picture the structure as it was envisioned.

The continuous development of computer-generated imagery and visual display technology has not overlooked linear perspective. In fact, computer graphics take advantage of it as a common indication of depth to manipulate and create virtual spaces and objects. This can be readily seen in video-game design. *The Sims4* showcases imaginative levels of linear perspective and has received much praise for its visual design. This image is an example of how linear perspective encourages the viewer to explore the three-dimensional space (**11.18**). Objects placed in what seem to be the further recesses of the rooms entice us to venture into the imaginary, illusionistic space.

11.18 Tony Ianiro, graphic from *The Sims4*, 2012. Maya and Photoshop illustration
Game designers utilize linear perspective as a way to engage viewers in their virtual environments. Imagined landscapes can feel realistic if their spaces feel relatable. This image was taken from *The Sims4*, a life simulation video game. Can you think of other video games that employ linear perspective?

TIP

Your point of view is the most important thing to consider when making a drawing that follows linear perspective. Your eye level, or the height of your eyes, is represented by an imaginary line that is called the horizon line. You look up at objects above the horizon line, and down on objects below it.

Horizon line In linear perspective, this represents the actual height of the viewer's eye level when looking at an object or scene.
Orthogonals, also known as **convergence lines** Lines that trace the receding parallel lines of an object, eventually appearing to converge.
Vanishing point In linear perspective, the point at which receding parallel lines appear to converge.

Essential Components of Linear Perspective

Perspective has similarities to geometry, and similarly to that branch of mathematics, linear perspective is concerned with points, lines, angles, shapes, and solids. It can be explored in simple ways, but it can also be quite complicated as you extend the complexities of what you wish to draw. No matter the subject, there are three components essential to any linear perspective drawing: the **horizon line**, **orthogonals**, and **vanishing points**. With an understanding of how these components work together, the rest of the technical rules follow.

Horizon Line

Linear perspective illustrates things from the perspective of the viewer. Therefore, the most important consideration is the *position* of the viewer—in this case the location of the *eye* of the viewer. Linear perspective is contingent on this single eye level. When drawing in linear perspective, the horizon line represents the actual height of the viewer's eyes, or eye level, when looking at an object or scene. Objects that are below eye level will be seen from above, while those above that level will be seen from below.

The horizon line is a theoretical axis line around which a perspective drawing is constructed, extending off the page infinitely to the right and to the left (see **11.21**, p. 230). When beginning a perspective drawing, a horizon line is often the first thing to establish. Where the

horizon line is placed on the page determines if most of the objects in the composition are at eye level, or if we are looking up or down upon the scene. The diagram in **11.19** illustrates this. While these three examples are drawn with the horizon line on the page, often an artist imagines that the horizon line falls above or below the visible limits of a drawing.

In *Architectural Drawing for High Yaller* by Reginald Marsh (1898–1954), we can estimate the location of the horizon line by our relationship to the stairs (**11.20**). The eye level must be located above the bottom stairs because we can see the tops of them. The stair treads disappear just before we reach the top stairs. Where their angles level out is the point at which the horizon line is located. This height must also have been the height of Reginald Marsh's eye level.

11.19 Illustration from Jean Thomas Thibault's *Application of Linear Perspective in the Graphic Arts*, 1827
This diagram shows the same landscape drawn from a low vantage point (top), middle vantage point, and high vantage point (bottom). As the elevation of the viewer raises, we see more of the ground.

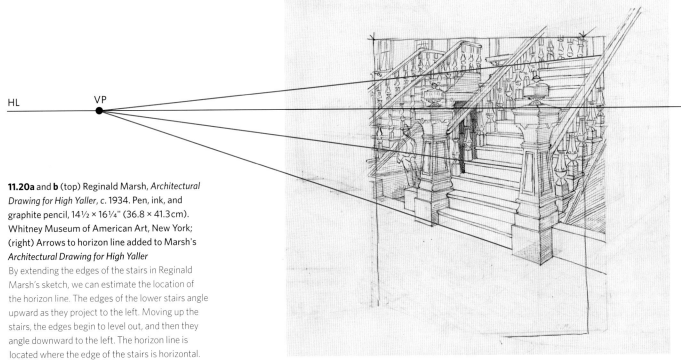

HL · VP

11.20a and **b** (top) Reginald Marsh, *Architectural Drawing for High Yaller*, c. 1934. Pen, ink, and graphite pencil, 14½ × 16¼" (36.8 × 41.3 cm). Whitney Museum of American Art, New York; (right) Arrows to horizon line added to Marsh's *Architectural Drawing for High Yaller*

By extending the edges of the stairs in Reginald Marsh's sketch, we can estimate the location of the horizon line. The edges of the lower stairs angle upward as they project to the left. Moving up the stairs, the edges begin to level out, and then they angle downward to the left. The horizon line is located where the edge of the stairs is horizontal.

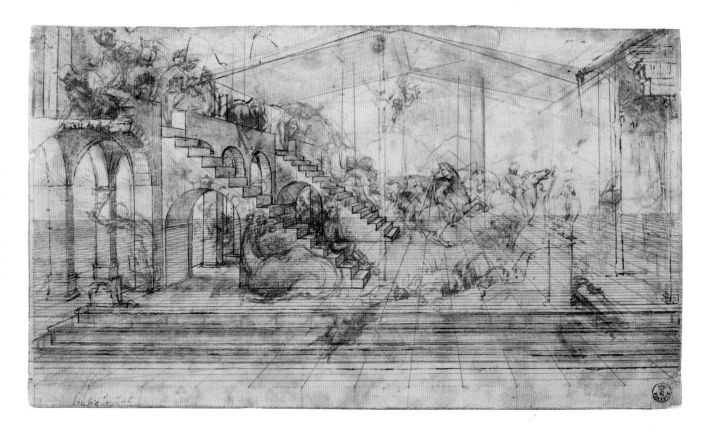

11.21a and **b** (above) Leonardo da Vinci, preparatory study for the background of the *Adoration of the Magi*, 1481. Pen and ink over metalpoint with brown wash and traces of white heightening, 6½ × 11⅜" (16.5 × 29 cm). Uffizi Gallery, Florence, Italy; (right) Arrows to horizon line, orthogonals, and vanishing point applied to Leonardo's study

This preparatory study shows an approach to linear perspective. After establishing a horizon line and vanishing point, a kind of perspectival grid is developed. It includes horizontal and vertical lines and lines that extend from the picture plane into space, called orthogonals. After establishing the perspectival space, animals, people, and architectural details are added.

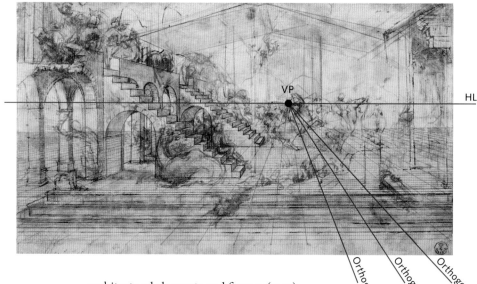

Orthogonals

Orthogonals are diagonal lines that trace the receding parallel lines of an object. They depict the illusion of how parallel lines seem to converge as they move into the distance. These lines define an object's shape and height. They are sometimes called convergence lines because they come together as they move into space.

In a preparatory study for his *Adoration of the Magi* altarpiece, Leonardo da Vinci (1425–1519) uses orthogonals to help create a grid-like structure that guides the placement and sizes of architectural elements and figures (**11.21**). In this drawing, the diagonals converge to the right of center. The horizon line, vanishing point, and grid are constructed just as Leon Battista Alberti outlined in *Della Pittura*.

Vanishing Points

A vanishing point is a point where receding parallel lines (the orthogonals) meet in the distance. The edges of planes that extend into the distance will have vanishing points on the horizon line. Objects that are parallel to each

other, such as boxes in a row, will use the same vanishing point. Objects that are oriented in different directions, such as randomly placed boxes, will each have their own vanishing points. In Leonardo's preparatory study, the orthogonals that make up the floor tiles, walls, and stairs all meet at the same vanishing point, on the horizon line. This is because in reality their edges would be parallel to each other.

Sometimes one drawing will have many different sets of vanishing points. These can be referred to as **multiple-point perspectives**. In this drawing by Remedios Varo (1908–1963), the walls, table, floor, and rug utilize the same two vanishing points (**11.22**). We can visualize this in our minds by continuing the edges of these objects into space. They will meet at the same two spots. The chair on the right and the woman's briefcase each have their own set of vanishing points because they are not parallel to anything else in the room. The chair on the left is tipped, so not only does it have its own set of vanishing points, but additionally,

these points will not be located on the horizon line. The vanishing points for inclined or declined planes will be above or below the horizon line.

Types of Linear Perspective

There are several different types of linear perspective. Each kind is named for the number of vanishing points used in the drawing. The quantity of vanishing points to be used is largely determined by the vantage point of the artist. If an object is parallel to the picture plane, then it most often will be drawn in **one-point perspective**. If the object has one corner that is closer to the artist than its other corners, and has two receding sides (one to the right and one to the left), it calls for **two-point perspective**. Some drawings combine one- and two-point perspective in the same work. **Three-point perspective** is typically used for extreme views of objects from above or below.

Multiple-point perspective
A perspective system with many different sets of vanishing points.
One-point perspective
A perspective system based on one vanishing point.
Two-point perspective
A perspective system based on two vanishing points.
Three-point perspective
A perspective system based on three vanishing points. Gives the illusion of looking up or down.

11.22 Remedios Varo, *Visita al Pasado*, 1957. Graphite
This drawing contains multiple vanishing points. When objects are parallel to each other, such as the walls and table, they share the same set of vanishing points. When objects are skewed, such as the chairs, they will utilize their own set of vanishing points.

Drawing at Work Ronald Searle

The Rake's Progress : The Don BY RONALD SEARLE

1. ADVENT *Born in an almshouse in Middlesbrough of poor but honest parents*

2. TRIUMPH *Major scholarship to Oxford*

3. TEMPTATION *Fellow of All Souls and invited to write a column for the Daily Mirror*

4. GLORY *Outspoken views lead to national reputation on TV Quiz programmes*

5. DOWNFALL *Insulting Gilbert Harding leads to expulsion from Lime Grove. Spurned by his friends*

6. RUIN *After a period of writing fourth leaders on The Times fails to make a comeback in Reynold's News. Dies in penury on the doorstep of Everybody's Weekly.*

11.23 Ronald Searle, "The Don," from *PUNCH magazine*, February 1954

The Don is one of a series of storyboard cartoons that was published in the humorous and satirical British magazine *Punch* during the mid-1950s. Its creator, Ronald Searle (1920–2011), also contributed drawings to many other publications, including *The New Yorker*, *Le Monde*, *The New York Times*, and *The International Herald Tribune*. Searle's work uses ridicule and sarcasm to speak to the weaknesses and struggles of all classes of people. With scratchy and often decorative lines and ink washes, he communicated elaborate narratives clearly. His cartoons continue to influence cartoonists and illustrators today.

The Don is made up of six captioned images illustrating the life of a teacher at Oxford University. We see his advent, triumph, temptation, glory, downfall, and, finally, ruin. Studied individually, each scene uses basic methods for creating the illusion of space. The strong diagonal arrangement of the first frame invites the viewer to move into the distance. Within the second frame, atmospheric perspective is accentuated by the use of strong value contrast in the foreground and much lesser value contrast in the background. In the remainder of the frames, the position of objects on the picture plane and the techniques of overlap, diminishment of size, and linear perspective, particularly apparent in the final frame, are used to indicate space.

One-Point Perspective

The diagram in **11.24** depicts boxes in a definitive one-point perspective view. The presence of horizontal lines is a clue that this arrangement uses one-point perspective. Also note that the vertical lines of the boxes remain vertical and parallel.

The American figurative artist George Tooker (1920–2011) regularly made perspective drawings during the planning stages of his paintings. The influence of the drawing on the final work is clear, as can be seen by a comparison between the preparatory drawing for *Government Bureau* and the finished painting (**11.25** and **11.26**). This work is an example of one-point perspective. The walls of the interior either directly face the viewer or recede to a single vanishing point located on a horizon line. The low point of view helps to convey the eerie feeling of isolation and alienation often present in Tooker's work, as the figures seem to loom above us. Here, this is intensified by the fact that the figures do not connect with one another.

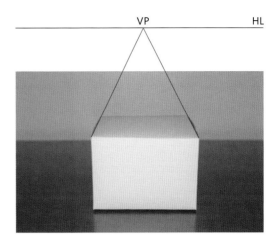

11.24 Superimposed horizon line and orthogonals superimposed on photo of box (one-point perspective)

The box in this photograph is in a one-point perspective view. The parallel edges that seem to move away from us come together at one point on the horizon line. Also indicating a one-point perspective view is the presence of horizontal lines and the front plane of the box facing the viewer flatly.

11.25 (right) George Tooker, study for *Government Bureau*, 1956. Graphite, chalk, and wash on paper, 25¾ × 32¾" (65.4 × 83.3 cm). Addison Gallery of American Art, Phillips Academy, Andover, MA

11.26 George Tooker, *Government Bureau* finished painting, 1956. Egg tempera on wood, 19⅝ × 29⅝" (49.8 × 75.2 cm). Metropolitan Museum of Art, New York

By viewing the preparatory drawing together with the finished piece we can understand how this image was created. All of the angles of the architecture extend back to one vanishing point on a horizon line located near the bottom quarter of the page. All other structural lines are either vertical or horizontal. After the linear perspective was worked out in the drawing, it became the basis of the final painting.

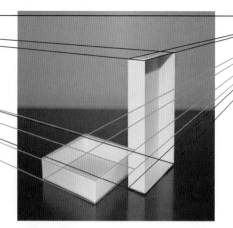

Two-Point Perspective

The diagram in **11.27** depicts boxes in a two-point perspective view. Because the boxes are positioned parallel to each other, they share the same set of vanishing points. If the boxes were not parallel to each other, then each box would have its own set of vanishing points on the horizon line. Notice that one corner of each box is closest to the viewer, and that the vertical lines remain vertical and parallel.

Animators often use linear perspective in their work, such as this inviting two-point perspective background for the Warner Bros. animated film, *The Iron Giant* (1999). Background art is responsible for setting the mood and lighting for many animated films (**11.28**). The furniture and the interior architecture share two vanishing points, one on the left and one far to the right, off the page.

11.27 Horizon line, orthogonals, and vanishing point applied to image of boxes
The boxes in this photograph are in a two-point perspective view. The parallel edges that seem to move away from us converge to points to the right and to the left on the horizon line. Each box has one corner that is closest to us; this is a key way to identify a two-point perspective view.

11.28 Chat and Chew Diner background from *The Iron Giant*, Warner Bros.
Animators often use linear perspective to create imaginary worlds in which their characters can exist. This example from *The Iron Giant* is a two-point perspective construction. The space contains elements that vanish both to the right and to the left.

> **TIP**
>
> When using one- or two-point perspective, make sure that vertical lines remain vertical.

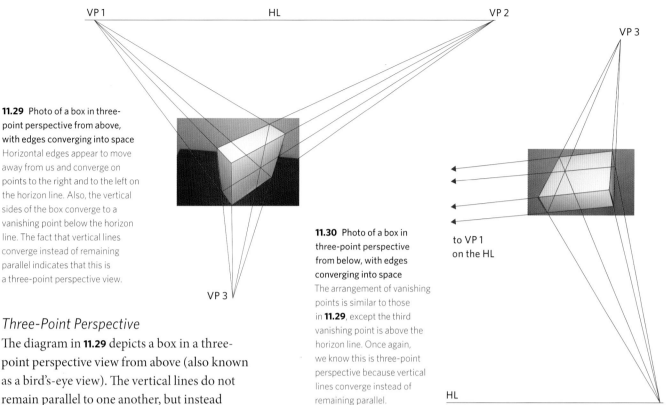

11.29 Photo of a box in three-point perspective from above, with edges converging into space
Horizontal edges appear to move away from us and converge on points to the right and to the left on the horizon line. Also, the vertical sides of the box converge to a vanishing point below the horizon line. The fact that vertical lines converge instead of remaining parallel indicates that this is a three-point perspective view.

11.30 Photo of a box in three-point perspective from below, with edges converging into space
The arrangement of vanishing points is similar to those in **11.29**, except the third vanishing point is above the horizon line. Once again, we know this is three-point perspective because vertical lines converge instead of remaining parallel.

Three-Point Perspective

The diagram in **11.29** depicts a box in a three-point perspective view from above (also known as a bird's-eye view). The vertical lines do not remain parallel to one another, but instead converge as they recede from the viewer. The horizontal edges of these boxes meet at two points on the horizon line, and the vertical lines meet at a third point below the horizon line. Thus the viewer seems to be looking down on the box. Three-point perspective can also be used to create the sensation of looking up; by placing the third vanishing point above the horizon line, an appearance of a low eyeline is suggested (**11.30**).

Delmonico Building by Charles Sheeler (1883–1965) was drawn using three-point perspective (**11.31**). We can see the tops of the buildings angling toward vanishing points that are off the page on both the left and right. The sides of the buildings, instead of remaining vertical and parallel, come together as they approach the top of the page. If extended beyond it they would eventually meet at a third vanishing point.

11.31 Charles Sheeler, *Delmonico Building*, 1926. Lithograph on paper, 15⅛ × 11½" (38.4 × 29.2 cm). Smithsonian American Art Museum, Washington, D.C.
Study the edges of the building in this drawing. The rooftops and windows are angled either toward a vanishing point on the left, or toward a vanishing point on the right. The sides of each structure angle toward a vanishing point above the page. Because this third vanishing point is above the horizon line, we experience an almost dizzying sensation of looking up at the subject.

11.32 Ronald Davis, *Open Cube*, 1995. Watercolor on Arches 300, 22 × 28" (55.9 × 71.1 cm). Ronald Davis Studio, Arroyo Rondo, NM
Compare the perspective of this drawing to that of the Charles Sheeler drawing in **11.31**, p. 235. They both deploy three-point perspective, but this drawing's third vanishing point is below the horizon line, resulting in a view from above. As an experiment, turn this book upside down. How does this image seem to change?

The artist Ronald Davis (b. 1937) often employs linear perspective to create hard-edged, illusionistic images of geometric forms. With the horizon line and the three vanishing points far off the page, the watercolor *Open Cube* is a good example of Davis's use of three-point perspective (**11.32**). *Open Cube* displays an interesting combination of rigid linear construction and expressive handling of wet media and color.

Drawing Circles and Ellipses

When making drawings that suggest space, it is important that objects are drawn as they would truly appear. Round and circular objects are common and should be rendered with accuracy, but their smooth edges and symmetricality can be challenging to draw (**11.33**). Most often the shape of the circle is not viewed frontally, meaning that it appears as an ellipse instead of perfectly round. This type of oval figure can be drawn successfully using the following methods.

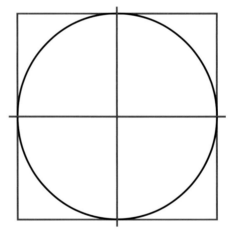

11.33 Geometry of a circle
This diagram shows the geometry of a circle. Divided in half both height- and width-wise, we can see that each quadrant is the same. A smooth and even circle can be challenging to draw by hand without a compass. Practice making circles in your sketchbook.

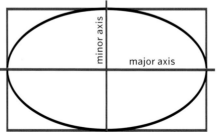

11.34 Geometry of an ellipse
Viewed at an angle, as in a perspective drawing, a circle looks like an ellipse. Even though we are seeing the circle from an angle, it should still remain smooth and even, with each quadrant mirroring the one adjacent. Notice the location of the major and minor axes.

With any method of ellipse construction, some simple facts are worth remembering. One is that any ellipse can be contained within a rectangle. The second is that an ellipse is symmetrical along two axes that bisect each other (**11.34**). These rules are true whether the ellipse is seen frontally or in perspective. A major axis divides the figure horizontally at the widest part of the ellipse. A minor axis divides the figure in half vertically at the highest part of the ellipse.

Freehand Drawing of an Ellipse

To draw an ellipse freehand, first draw a set of construction lines that will guide the drawing, including the major axis, the minor axis, and the rectangle that will contain the ellipse. The size of the rectangle will govern the height and width of the ellipse. When drawing from direct observation, the proportions of these dimensions can be measured (see Chapter 6, p. 135). Once the construction lines have been drawn, each quadrant of the ellipse should be drawn, taking care to make each part a mirror reflection of the other three (**11.35**). Accurate ellipses should not have flat sides, nor should they come to points on the ends. These are two common mistakes when drawing freehand ellipses (**11.36**).

Perspective Drawing of a Circle

When drawing a circle in linear perspective, you will need to draw an ellipse. One should first visualize the size and shape of the rectangle

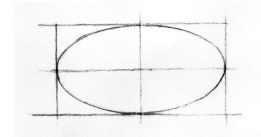

11.35 Freehand drawing of an ellipse
Practice making ellipses in your sketchbook. Begin by making a rectangle. Divide the rectangle with a major and a minor axis. Smoothly draw the ellipse, concentrating on making each quadrant the same as the others.

11.36 Two mistakes when drawing an ellipse
The most common mistakes that occur when trying to draw an ellipse are illustrated above. The first attempt suffers from pointed ends. The ends should remain smooth and round, even when the ellipse is very thin. The second attempt has flat sides. This should also be avoided when drawing ellipses.

that will contain the ellipse. This rectangle should be drawn in perspective, utilizing the horizon line and the vanishing point that are appropriate for the scene (**11.37**).

Next, draw lines from opposite corners of the rectangle, forming an X. This is the center of the circle. Note that the center of the X does not lie on the major axis: the major axis is the widest part of the ellipse, and will be located just below the center of the circle. Using all of these lines as a guide, a smooth and symmetrical ellipse can be drafted, either freehand or with an ellipse template. Keep in mind that the minor axis of the ellipse follows the vanishing point of the rectangle.

TIP

When a circle is viewed at an angle, in perspective, it appears to be an ellipse.

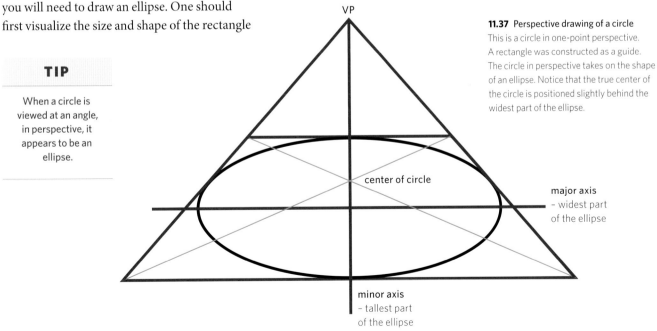

VP

center of circle

major axis
– widest part
of the ellipse

minor axis
– tallest part
of the ellipse

11.37 Perspective drawing of a circle
This is a circle in one-point perspective. A rectangle was constructed as a guide. The circle in perspective takes on the shape of an ellipse. Notice that the true center of the circle is positioned slightly behind the widest part of the ellipse.

The work of the conceptual designer George Hull (b. 1969) often calls for ellipses drawn in a variety of orientations. Hull's drawing of a hovercraft for the motion picture *The Matrix: Reloaded* (2003) is a good example of ellipses drawn in linear perspective. Despite their orientation, the ellipses and all other features of the machine share the same horizon line (**11.38**).

Using Perspective in Observational Drawings

The theories of linear perspective are useful for checking and refining observational drawings. Acting as a structural or imaginary framework, perspectival space can provide a measure of coherence while making a drawing.

11.38 George Hull, "*The Matrix: Reloaded" Concept Design, Novalis, Hovercraft Redesign,* 2002. Blue pencil, ink, and pantone marker inks on paper with gouache, 11 × 14" (27.9 × 35.6 cm). Collection of the artist
A pre-production work for *The Matrix: Reloaded,* this drawing includes excellent examples of drawn ellipses. Each ellipse is smooth, symmetrical, and follows the linear perspective of the scene. Notice how this artist has combined simple shapes that follow perspective to create a more complex object.

11.39 Anna Alma-Tadema, *Sir Lawrence Alma-Tadema's Library in Townshend House, London,* 1884. Brush and watercolor, gouache, pen and ink, and graphite on white paper, 13 × 17¾" (33 × 45 cm). Cooper Hewitt, Smithsonian Design Museum, New York
By plotting vanishing points, linear perspective can be used to refine the angles of a drawing. This realistic work, drawn on-site, conforms to one-point perspective. It stands as an example of how perspective can support observational drawing.

Applying linear perspective to an observational drawing follows the perspective construction process, except the steps take place somewhat in reverse. The traditional process of developing a linear perspective space usually begins with establishing a horizon line, placing vanishing points, and then developing orthogonals. Objects are then added, always adhering to the established structure. When drawing from observation, on the other hand, first establish a compositional gesture (see p. 135). Then, find the horizon line and establish vanishing points based on what you have observed. From these vanishing points, draw the orthogonals, refining the compositional gesture. While this is an effective way to find measuring mistakes, a certain amount of approximation will also necessarily take place.

The British artist Anna Alma-Tadema (1867–1943) clearly had a strong understanding of linear perspective, as evidenced in her mixed-media drawing of her father's ornate library (based on direct observation) (**11.39**). Despite the complexity of the interior space, all of the angles in the drawing converge to one point located at the wooden panel in the back of the room. Alma-Tadema created this one-point perspective drawing when she was a teenager.

In the Studio Projects

Fundamental Project

From a magazine (or printed from the Internet), select two photographs. One should be an image of an interior space, and the other an exterior of a building. Using a ruler and a pencil, extend every diagonal line in the photograph. Draw and label all vanishing points as well as the horizon line. You may need to tape the photographs onto a larger piece of paper in order to draw the extended lines. Identify what type of linear perspective is present.

Observational Drawing

Choose an interior space that you would like to draw. Emphasize three of the basic methods of creating space discussed in this chapter (position on the picture plane, diagonals, overlap, size, atmospheric perspective, linear perspective).

Non-Observational Drawing

Consider three of the basic methods of creating space discussed in this chapter (position on the picture plane, diagonals, overlap, size, atmospheric perspective, linear perspective). Use these to create an imaginary space. For example, you may begin by strategically positioning shapes on the picture plane. These shapes might overlap and be affected by atmospheric perspective. Utilize materials and mark-making in a creative manner.

Criteria:
1. Photographs of interior and exterior spaces should be selected with linear perspective in mind.
2. All vanishing points, whether one- or two-point perspective, should be accurately depicted.
3. The horizon line for each image must be correctly located.

Criteria:
1. The drawing should exhibit a convincing illusion of space.
2. The artist should clearly employ three distinct methods of creating space as listed above.
3. The drawing should accurately reflect the interior space from which it was made.

Criteria:
1. The drawing should exhibit a convincing illusion of space.
2. The artist should exaggerate three distinct methods of creating space chosen from those listed above.
3. Materials and mark-making should be used creatively.

Materials: Two photographs, pencil, paper

Materials: 18 × 24" drawing paper, optional media

Materials: 18 × 24" drawing paper, optional media

Chapter 12
Texture

Texture is the tactile quality of a surface. In a drawing, texture can be physical or can be visually simulated or implied. The sense of touch is one of the key ways in which people experience the world around them; so too, texture influences the experience of making and looking at drawings.

As with all elements, texture can help to support artists' ideas and strengthen the content of a drawing. It carries strong emotional qualities; consider how a spiked, rough texture might provoke feelings of unease, or a smooth, undulating texture could evoke a sense of calm. Texture can reveal an artist's individuality, and communicate information about a drawing's media. As you proceed with this chapter, consider how you can utilize texture effectively in your own drawings. This chapter will explore four principal types of texture: visual or implied, replicated, surface, and invented. Also, rubbings, photo transfers, and collage are explained as interesting ways to create texture in a drawing.

Texture The tactile quality of a surface.

Visual or **implied texture**
A visual illusion expressing texture through mark-making or pattern.

Visual Texture

Consider the appearance of the different fonts on this page. If we could actually touch the words in 𝔏𝔲𝔠𝔦𝔡𝔞 𝔅𝔩𝔞𝔠𝔨𝔩𝔢𝔱𝔱𝔢𝔯 𝔣𝔬𝔫𝔱, 𝔱𝔥𝔢 𝔠𝔲𝔯𝔰𝔦𝔳𝔢, 𝔊𝔬𝔱𝔥𝔦𝔠-𝔰𝔱𝔶𝔩𝔢 𝔱𝔶𝔭𝔢𝔣𝔞𝔠𝔢 𝔲𝔰𝔢𝔡 𝔥𝔢𝔯𝔢, 𝔱𝔥𝔢𝔶 𝔴𝔬𝔲𝔩𝔡 𝔣𝔢𝔢𝔩 𝔰𝔥𝔞𝔯𝔭 𝔞𝔫𝔡 𝔞𝔫𝔤𝔲𝔩𝔞𝔯. The **Cooper Black font, the extra-bold, serif typeface used here, appears very different; the letters look soft and rounded**. Although this page is smooth to the touch, the typeface, size, line weight, and spacing affect its **visual texture**. Much as fonts can imply texture, so too can the marks that you make when drawing.

In the drawings of Kathy Prendergast (b. 1958), one can easily appreciate the way in which mark-making can result in **visual texture**. She uses pencil to transcribe maps of cities around the world, such as Tehran (**12.2**). Floating on the page, the compulsive network of lines in this drawing results in a crackled and grainy appearance. The texture dissipates toward the edges of the city.

Visual texture, also known as implied texture, can be suggested not only by mark-making but also by the consistent and recurring characteristics of pattern. Angela Piehl (b. 1975) researches, collects, and then combines in her abstract drawings patterns from a variety of sources. In her works, she arranges a mixture of textures—both mark-making and patterns—

12.1 Student work. Addison Jones, *Amid the Falling Snow*. (Instructor: Victoria Paige) Texture is a prominent element in this drawing. The student who made this work used additive and subtractive techniques, creating marks by applying and erasing charcoal. Instead of replicating the appearance of nature precisely, this drawing eloquently implies textures found in the landscape.

12.2 Kathy Prendergast, *City Drawings Series—Tehran—n44*, 1997. Pencil on paper, 12¼ × 8¼" (31 × 21 cm). Irish Museum of Modern Art, Dublin, Ireland
Mark-making can result in the appearance of a tactile surface. This perceived surface quality is visual texture. Although made with pencil on smooth paper, the intricate, web-like city structure in this drawing creates the impression that the surface would feel irregular, although this would not be the case if it were actually touched.

Gateway to Drawing Orozco, *Man Struggling with Centaur*

Implied Sense of Texture

For the other
*Man Stuggling
with Centaur*
boxes, see p. 62
and p. 163

12.3 José Clemente Orozco, *Man Struggling with Centaur*, n.d. Graphite, with pen and brush and black ink, on cream wove paper, 7⅞ × 15" (28 × 38.2 cm). Art Institute of Chicago, IL

12.4 Orozco's *Man Struggling with Centaur*, detail

Imagine if you could run your fingers over *Man Struggling with Centaur*. What would it feel like? In actuality, it would not have much texture, but visually the layers of aggressive marks imply a very irregular surface. This implied sense of texture—the visual texture of the drawing—impacts the viewer's experience.

José Clemente Orozco's (1883–1949) energetic and spontaneous approach borders on abstraction. Every part of the drawing could be interpreted as being an exercise in

texture. By isolating any portion of this work, one can see that the marks are not intended to depict the subject matter realistically; rather, Orozco uses them to build a sense of tactility that emphasizes the spontaneous expressive qualities of the work. For example, consider the man's hair. In this area of the drawing Orozco is not drawing with faithful adherence to the way hair might actually appear. Instead, his marks are wild and harsh, bordering on reckless. Calligraphic ink lies atop a quickly drawn network of pencil zigzags.

The texture takes the drawing beyond visual likeness and connects the viewer more physically with the subject's conflict and fervor.

Man Struggling with Centaur shows how the element of texture can be used to enhance a drawing; in this case, it conveys much of the scene's passion and immerses the viewer in an intense struggle (which was a recurring theme throughout Orozco's work). Because of the power of such works, Orozco helped raise modern Mexican art to a position of international distinction.

12.5 Angela Piehl, *Shivaree*, 2012. Colored pencil on black paper, 38 × 56" (96.5 × 142.2 cm). Private collection
This drawing is an amalgamation of various types of textures. Within this abstract assemblage are textures that derive from repetitious patterns, suggestive of both organic and man-made structures.

Replicated or **simulated texture** Works that use replicated textures imitate texture so convincingly that it almost appears to be real.

and the diversity of decorative, organic, and synthetic textures can be interpreted as representing a range of notions, from decadent femininity to loneliness and decay (**12.5**).

Replicated Texture

Replicated texture, also known as simulated texture, is a technique used to represent an object's surface appearance. With attention to detail, artists can create the illusion of texture. This is used in representational art, where aspects of an image might seem to possess the subject's texture, and hyper-realism, where an image imitates reality so closely that the subject—and its texture—appears to be real.

The botanical and landscape drawings of German artist Paulus Roetter (1806–1894), such as his drawing of a Whipple's Devil's-claw cactus (**12.6**), rely on the representation of

T fig. 1. *Echinocactus Whipplei E. & B.*

12.6 Paulus Roetter, *Echinocactus (Sclerocactus) Whipplei*, 1856. Pencil on Bristol board, 8½ × 5¾" (21.6 × 14.6 cm). National Museum of Natural History, Smithsonian Institution, Washington, D.C.
This representational drawing of part of a cactus highlights the complicated surface texture of the plant, suggesting what we would feel by touching it. Replicated texture can have a major impact in a drawing.

Adding texture to
your drawings is a
great way to enrich
visual interest.

Trompe l'oeil An extreme
kind of illusion meant to
deceive the viewer that the
objects included are real.

texture to convey nature in a precise way. This
pencil drawing simulates the sharp and spiny
texture of his subject. Notice the contrast of
textures between the inner portion of the plant
and the outer part.

One type of art that relies on the artist's
technical competency to reproduce textures
is **trompe l'oeil**, French for "to fool the eye."
Alexandre Isidore Leroy de Barde (1777–1828)
was an artist who deployed replicated texture,

illusionistic lighting, sensitive attention to
color, and accurate perspective, to create
realistic illustrations of natural history
specimens that convincingly describe real
life. His *Selection of Shells* replicates various
textures, from irregular and prickly to smooth
and glossy (**12.7**). Leroy de Barde's delicate
rendering of objects calls attention to the
individuality of his subjects.

12.7 Alexandre Isidore
Leroy de Barde, *Selection
of Shells*, n.d. Watercolor
and gouache, 49¼ × 35⅜"
(125 × 90 cm). Musée du
Louvre, Paris, France
This work is an example
of *trompe l'oeil*. The highly
illusionistic rendering is
meant to fool the viewer
into thinking that the
artwork is not an image, but
actually real. The artist's
dedication to replicating
texture is important to
creating this illusion. Notice
the variety of textures that
are included in this work.

Drawing at Work Alice Leora Briggs

The winds are dying down from the gale
of Darwin when a reading of his work
made some see the world
as a factory floor with a top and bottom
and a production line with death
of a species as the signature of failure.

12.8 Alice Leora Briggs, *U.S. Route 71*, 2012. *Sgraffito* with acrylic on panel, 24 × 36"
(61 × 91.4 cm). Words by Charles Bowden. Museum of Texas Tech University, Lubbock, TX

Severe in subject matter, skillful in technique, and palpable in surface, the drawings of Alice Leora Briggs (b. 1953) are intensely brutal. *U.S. Route 71*, made in response to a manuscript by the writer Charles Bowden, is no exception (**12.8**). In this work Briggs combines image and text to illustrate extreme and harsh realities.

Many of Briggs's drawings deal with death. Her approach to the theme is personal and contemporary. In *U.S. Route 71* she records a dead mother opossum that she discovered while traveling north from New Orleans. The still-alive babies that are trying to nurse heighten the emotional impact of this tragic event. The drawing is naturalistic and symbolic. As a viewer, one cannot

accept this image only as a singular event; rather it seems to convey a larger problem of explicit and widespread violence. Here, the depiction of death offers a stinging commentary on modern life.

U.S. Route 71 is teeming with texture. The tiny and obsessive scratches on the surface of the drawing arrange themselves into tangible surfaces. The various textures of the opossum's skin, fur, and teeth contrast with the rough and granulated road in the background. Briggs replicates every texture intensely, making every part of the drawing a priority.

Briggs's drawings are made subtractively by scratching away a top layer of India ink or black acrylic

to reveal a white clayboard underneath. This long-standing technique, similar to its modern cousin scratchboard, is called **sgraffito**. This method was used in ancient times in European and African ceramics and ornamental wall decorations, and has remained in use since. In her modern-day application of the technique, Briggs mostly uses an X-Acto knife to carve away her image articulately.

Sgraffito A subtractive drawing technique in which a top layer of a medium is scratched away to reveal the layer beneath.

12.9 Robert Arneson, *Eye of the Beholder*, 1982. Acrylic, oil pastel, alkyd on paper, 52 × 42" (132.1 × 106.7 cm). Private collection
All drawing materials impart characteristic textures that they leave behind on a drawing surface. Many artists take advantage of the build-up of materials to enhance their work. This mixed-media drawing does just that. Its labored surface seems to invite us to touch it.

Surface Texture

Surface texture, the physical texture on the surface of the drawing, is strongly responsible for the visual appearance of a work. Although surface qualities are usually lost in photographic reproductions of drawings, when viewing drawings in real life, they are important parts of the totality of the work.

Drawing media naturally dictate the types of textures that can be made. All drawing media leave some remnants of themselves on the surface of the drawing, creating actual texture. Drawings can possess very subtle textures, such as when a pencil lightly brushes across the surface of a piece of paper. Some surface textures are so understated that they are only observable under very close scrutiny. Other materials, such as oil pastel, can leave obvious impasto textures so thick that they stand substantially off the surface of the drawing. Artists are fortunate to have a wide range of media available, each capable of producing a variety of textural possibilities.

Robert Arneson (1930–1992) was a leader of the California Funk Art movement during the 1960s and 1970s who combined a variety of media to create a highly visible, all-over surface texture. His whimsical self-portraits, such as *Eye of the Beholder*, use oil stick and acrylic paint to create graffiti-like marks that establish a dense, highly tactile surface (**12.9**). The surface

12.10 Franz Kline, *Untitled II*, c. 1952. Brush and ink and tempera on cut-and-pasted telephone book pages, 11 × 9" (28.1 × 23 cm). MoMA, New York
Manipulating the drawing surface can introduce texture to a drawing. This work collages parts of drawings together to make a new composition. Imagine if this non-objective drawing were made on a single smooth piece of paper. How would this affect the outcome of the final work?

12.11 Julie Mehretu, *Parts for a Peace Pipe*, 2008. Graphite, watercolor, gouache, ballpoint pen, and tape on paper, 22 × 30" (56 × 76.2 cm). Private collection
Invented textures are the building blocks for this non-objective drawing. Hundreds of marks of countless shapes and sizes combine to create an energetic landscape. Areas of layered and compressed activity give way to more open, less dense regions of the composition.

Surface texture
The physical texture on the surface of a drawing.
Invented texture
Texture conceived by the artist, i.e. not necessarily based on reality.

texture reminds the viewer of Arneson's hand, something that is very often valued in a drawing as it adds individuality to an artist's work.

The artist's choice of ground also affects the surface texture of a drawing. Many artists manipulate their ground to add dimension to their work. The Abstract Expressionist Franz Kline (1910–1962) made ink drawings on telephone book pages, sometimes on single sheets and at other times pieced together. The collaged surface of *Untitled II* creates a shifting background texture that complements Kline's fast, angular, calligraphic ink marks (**12.10**).

Invented Texture

Invented texture comes from the artist's imagination (in other words, the artist does not consciously borrow or try to replicate textures found in nature). Instead, invented texture is used independently of the subject as a way to add interest to a portion of the drawing. Invented textures can create contrast and add visual balance to a drawing. They are often found in non-representational drawings, as this type of drawing derives entirely from the artist's mind.

Using graphite, watercolor, gouache, ballpoint pen, and tape, Julie Mehretu (b. 1970) exploits invented textures in her drawing *Parts for a Peace Pipe* (**12.11**). As with much of her work, this drawing conveys a sense of the future and of modernity. The variety of textured

12.12 Wangechi Mutu, *Blue Rose*, 2007. Ink, paint, mixed media, plant material, and plastic pearls on Mylar, 23 × 22⅛" (58.4 × 55.9 cm)

This work is an amalgamation of invented textures. Collaged pieces mingle with colorful hand-drawn designs to form an unexpected figure. Texture enriches the strength of the image. Mixing reality with fiction opens up endless possibilities for an artist.

mark-making in the work—precise in some areas and spontaneous in others—constructs an energized composition. The textures seem to emphasize the surface of the paper, and suggest that some parts of the drawing are closer to us than others.

Invented texture, when used without variation, can result in the image being flattened. In art theory, this idea is celebrated as a characteristically modern artistic concept. Before the early twentieth century, artists focused on creating illusionistic spaces. Drawings were typically finely rendered to trick viewers into forgetting that they were looking at a two-dimensional surface. Later, artists began to highlight the flatness of their work, reminding the viewer that the work is, in fact, two-dimensional. For some twentieth-century artists, such as Jackson Pollock (1912–1956), the surface was the image. For artists of today who wish to create flatness in the manner of their predecessors, adding invented texture to areas of a drawing is an effective tool.

The portraits of Wangechi Mutu (b. 1972) capitalize on texture (**12.12**). She mixes collaged photographic elements with diverse hand-made techniques including airbrush, stenciling, spilled paint, and hand-drawn surfaces. The textures cause the eye to shift between a spatial representational image and a two-dimensional invented one.

Rubbings and Photo Transfers

Two interesting techniques to embellish texture in a drawing are **rubbings** and **photo transfers**. Both are ways of incorporating readymade textures into a work. These techniques allow an artist to select, combine, and arrange found textures into a creative composition. Both rubbings and photo transfers can be accomplished using a variety of different techniques.

Rubbings Sometimes referred to as *frottage*, a technique or process of taking an impression from an uneven surface to form a work of art.

Photo transfer One of many different techniques for transferring a photo image to a drawing surface.

Rubbings

Rubbings utilize a process of taking an impression from an uneven surface to form a work of art. This is sometimes referred to as *frottage* (from the French "to rub"). For example, one can place a sheet of thin paper on a textured object and then rub the paper with a graphite stick. The texture of the object will transfer to the paper (**12.13**). The effects can be altered by varying the paper, media, marks, and pressure used when making the rubbings.

Max Ernst (1891–1976) used rubbing techniques as a creative way to generate textures in his surrealist images. Made in around 1925, *The Fugitive* is an early example. Such drawings foreshadow Ernst's continued fascination with found textural surfaces, which became inspirations for his later works in other media (**12.14**).

Jean Dubuffet (1901–1985), a French artist known for his unconventional use of materials, devised a related approach to the rubbing

technique. As seen in his work *Leaves with Bird*, Dubuffet experimented with pressing ink-soaked objects onto paper to create impressions (**12.15,** p. 250). Instead of rubbings as described above, Dubuffet essentially did the opposite by printing textures onto the paper. *Leaves with Bird* is a wonderful example of how found plant textures can be used as the source material for an invented image.

12.13 Rubbing of wood with graphite stick
A graphite stick can be used to create a rubbing. This technique can be implemented as a way to study textures, or it can be a means to incorporate texture into a drawing. Make rubbings of a variety of textures, and envision how they could be featured in a drawing.

TIP

When making rubbings, you will find that textures transfer easiest when you use thin paper.

12.14 Max Ernst, *The Fugitive (L'Évadé)*, *c*. 1925. One from a portfolio of 34 collotypes after *frottage*, composition: 10⅛ × 16⅝" (25.7 × 42.3 cm); sheet: 12⅝ × 19⅝" (32.3 × 49.8 cm). MoMA, New York
Many artists use rubbings to obtain impressions of surface textures for their images. This technique is inherently experimental, as it often produces unanticipated results. The Surrealists used *frottage* to spark the process of "free association," an exercise in which one allows the mind to react freely to stimuli, without being confined by a predetermined process. This image is an example of how this exercise can be applied in a drawing.

The Work of Art Jean Dubuffet

12.15 Jean Dubuffet, *Leaves with Bird*, 1953. Lithograph on paper,
18⅝ × 19⅛" (47.2 × 48.7 cm). Tate, London, England

This drawing was made by soaking found objects in ink and
printing them onto paper. This technique allows us to lift exciting
textures from the world around us and place them into our work.
In this case the artist selected leaves and plants, ideal for creating
a natural environment.

Who: Jean Dubuffet
Where: France
When: 1953
Materials: Lithograph on paper

Artistic Aims

Jean Dubuffet (1901–1985) rejected the notion of high art. Instead, he preferred seemingly simple, childlike representations of the world around him. He felt that this approach expressed a more complete truth that had not been communicated before.

To do this, Dubuffet aimed to create a new and distinctive visual language. He felt that art should be a result of the material used, and that these materials should dictate the expressive quality of the artwork. It is this ideology that steered Dubuffet's work toward an emphasis on texture and materiality. The artistic experiments and inventions that he would carry out throughout his life were always executed with the goal of reflecting the real world.

Artistic Challenges

How does one come up with new ideas? How does one invent new ways of drawing? These are difficult challenges for artists to face. Dubuffet consciously avoided traditional standards of beauty, which challenged him to find new, more truthful ways of portraying the world. His search led him to explore more primitive approaches to image-making.

Artistic Method

Dubuffet's artistic experiments embrace the occurrence of accidents. He used found objects and items from nature to create his unconventional textural works. Often his finished pieces were unusual, hard-to-categorize abstractions. He looked for ways to carry his vision into all of his art, including his drawing, painting, sculpture, and printmaking.

Dubuffet's active drawing practice led him to lithography. Lithography is a printmaking process that relies on the fact that grease and water resist each other. The process begins with drawing on a smooth stone with a grease pencil. The stone is then fixed and dampened, and then oil-based ink is applied. The grease drawing repels the water, but holds the ink. The printing is done in a specially designed press.

As usual, Dubuffet abandoned traditional methods when he engaged in lithography techniques. Instead of grease pencils, he drew on lithographic stones with such things as sandpaper, burning rags, chemicals, and by pressing leaves and other natural materials onto the printing surface. He also experimented with transfer processes that gave him the freedom to assemble pieces into compositions before printing. His methods were improvisational, leaving plenty of room for chance effects. With such experiments, Dubuffet introduced new possibilities that revolutionized lithography.

The Results

Leaves with Bird is one of a series of lithographs in which Dubuffet embraced unconventional processes and materials. He used impressions of actual plants to produce the composition, and the image displays a pronounced, all-over surface texture. In some areas, the image borders on abstraction. Despite the improvisational nature of his methods, the resulting image possesses a rich sense of unity.

Dubuffet is remembered for a free and childlike aesthetic that ultimately reveals the reality of his subject.

Sketchbook Prompt

Change the texture of a sketchbook's paper by collaging papers onto the page. Draw on top of the collage with mixed media.

12.16 Transfer sheet
This image demonstrates the use of a graphite transfer sheet. By placing a transfer sheet between a photograph and the drawing paper, images can easily be traced. Some artists use this technique as a starting point; others use it repeatedly at multiple points during an artwork's progress.

TIP

Graphite transfer sheets come in different colors so that you can use them on different colored papers.

12.17 Photo transfer
This image demonstrates the use of a colorless blender marker to transfer a photocopy to a piece of paper. Images, textures, and values can be exploited and manipulated. Photo transfer offers a creative way to integrate photography with drawing.

Photo Transfers

Transferring found photographs or prints to a drawing can create interesting tensions between the artist's hand-drawn marks and the texture of printed images. There are many different techniques that can be used to transfer a photo image. For example, photos can be transferred using graphite transfer sheets or carbon paper (**12.16**). These useful materials are thin paper coated with carbon or another pigmented substance. Simply tracing a photo with a transfer sheet underneath will cause the image to appear onto your drawing paper. Tracings can be the first step of new creations.

One quick and easy method of photo transfer—this one even transfers values—is to use a colorless blender marker. This must be done outside or in a well-ventilated area, as some markers contain hazardous materials when used in large amounts. For this technique, a toner-based (laser-printed or photocopied) print is needed. Images and text from newspapers also work. Place the image face down in a desired location and firmly rub the back of it with a blender marker until the paper is saturated. The image will transfer to the new location (**12.17**). Remember always to work in a well-ventilated area when working with any potentially hazardous materials.

The American artist Robert Rauschenberg (1925–2008) was interested in exploring alternative ways to introduce texture into his works, and began experimenting with transfer drawings in 1958. The drawings that he made during this time combine hand drawing with transfers of scraps of printed materials. Such combinations incorporate both the past and the present. In this illustration—one of thirty-four—Rauschenberg uses recognizable imagery from mass media to depict a scene from Dante's "Inferno" (the first part of Dante's poem *Divine Comedy*). To create this image, he saturated magazine clippings with chemical solvent and then transferred them to his paper (**12.18**). Notice the range of mark-making that results from pressing the images for transfer. On top of his photo transfers, Rauschenberg adds finishing touches in pencil and colored pencil.

12.18 Robert Rauschenberg, "Canto XXXI: The Central Pit of Malebolge, The Giants," from the series *Thirty-Four Illustrations for Dante's Inferno*, 1959–60. Transfer drawing, colored pencil, gouache, and pencil on paper, 14½ × 11½" (36.8 × 29.3 cm). MoMA, New York

Rauschenberg is noted for his original combinations of materials. This work is an excellent example of how multiple media can be made to cohere in a single composition; the photo transfer, colored pencil, gouache, and pencil all work together as a unified whole.

12.19 Eileen Agar, *Collage consisting of the Lower Legs of a Statue Cut out of a Magazine or Photograph and Glued onto a Painting of the Head and Torso of a Man*, n.d. Watercolor and printed paper on paper, 3¼ × 3⅛" (8.2 × 8 cm). Tate, London, England

Collage is a way to unite photographic imagery, as well as any other kinds of clipped or shorn material, into a drawing. The juxtaposition of printed imagery and hand-drawing creates a visual tension.

Collage

A more direct way to incorporate photography into a drawing is through **collage**. Collage is a technique in which images, clippings, or any other materials are glued or attached directly to a surface. Combining this process with drawing can lead to outstanding results, as seen in Carl Randall's charcoal-and-collage *Study for a London Cafe Scene* (**11.2**, p. 218) and Wangechi Mutu's mixed-media-and-collage work *Blue Rose* (**12.12**, p. 248). The Surrealist artist Eileen Agar (1899–1991) had a love for combining materials in her paintings, sculptures, and drawings; in **12.19** she collages printed photographs with watercolor.

Collage A work of art assembled by gluing materials onto a surface. From the French *coller*, "to glue."

In the Studio Projects

Fundamental Project

Experiment with texture rubbings. Using thin papers, make a series of four rubbings of textured surfaces. Test different materials, such as graphite sticks, colored pencils, and pastels.

Observational Drawing

Choose two objects that have pronounced surface textures, such as a pineapple, a cactus, a wool sweater, or a rough rock. Divide an 18 × 24" paper in half. Using a medium of your choice, draw one texture on the left and the other on the right. Fill each side completely. Try to depict the object's texture as precisely as possible. Consider zooming in very close to your object.

Non-Observational Drawing

Experiment in your sketchbook by creating ten different textures. Consider hand-drawn textures, rubbings, and photo transfers. Select at least five of these to combine into a non-objective drawing. You may wish to replicate your chosen textures, or cut them out and arrange them as part of a finished work.

Criteria:

1. Engaging textures should be used for the project.
2. All four rubbings should successfully capture texture.
3. The series of rubbings must demonstrate your willingness to experiment with materials and the rubbing process.

Criteria:

1. The drawing should utilize two close-up drawings to form one two-part composition.
2. You should successfully depict the object's texture.
3. Your choice of media should be used effectively.

Criteria:

1. Ten different textures must be made in your sketchbook, including hand-drawn textures, rubbings, and photo transfers.
2. You should experiment with texture as a primary element in a non-objective drawing.
3. The textures should be united in such a way that there is a sense of harmony in the drawing.

Materials: Four 9 × 12" lightweight papers and optional drawing media

Materials: 18 × 24" drawing paper, optional media

Materials: 18 × 24" drawing paper, mixed media

Chapter 13

Drawing with Color

Color is perhaps the most appreciated and accessible element of art. It can enhance a visual experience in many ways. For most people, color carries strong associations and can stir emotional responses. It is little wonder that artists of all types—creative writers, filmmakers, painters, and many others— are often inspired to use color in their work.

Drawing is no exception. A skillful artist can use color to create an illusion, as a compositional element, or to evoke emotions. To work with color effectively, however, a familiarity with color principles and theory is useful. This includes understanding the fundamental properties and characteristics of color, the principles of color unity and schemes, and the use of color as an expressive force. Color theory does not dictate how color should be used, but a good understanding of theory will free you to use color as you wish.

13.1 Isaac Newton, *Drawing of the Two Prisms' Experiment*, n.d. Pen and ink on paper. New College, Oxford, England

This sketch shows how scientists can utilize drawing in their work. Newton's diagram shows a plan for using a prism to break a ray of sunlight into a spectrum of different-colored rays. The diagram also shows a second prism used to consolidate the spectrum back to white light. (See text below for more explanation of how prisms work.)

13.2 Isaac Newton, "Symmetric Color Wheel Correlating Colors with Musical Notes and Planetary Symbols," 1704, from *The First Book of Opticks*, Part II

Newton was the first person to arrange color in the format of a wheel, an important concept when considering color relativity. His color wheel not only related colors to each other, it also hypothesized connections between the color spectrum, the planets, and the musical scale.

The Color Wheel

In the late seventeenth century, Isaac Newton (1643–1727)—known for his theory of gravitation, laws of motion, and the development of calculus—began a series of optical experiments with sunlight and prisms. As seen in his sketch in **13.1**, he passed a ray of white sunlight into a room through a small hole, and used a clear glass prism to split the light into a spectrum of different colors, including red, orange, yellow, green, blue, indigo, and violet. Using a second prism, he reversed the process, bringing the colors back together to make white light. This was the first demonstration of the idea that sunlight contains a mixture of colored rays.

Later, in 1704, Newton diagrammed the colors of the light spectrum into a circle (**13.2**). His organizing framework shows his interest in relating colors to the seven planets (the only ones known at the time, as Uranus was not discovered until 1781) as well as to a musical scale of seven notes, a notion derived from ancient Greek belief. As the first to conceive of arranging color on a wheel, Newton paved the way for other scientists and artists to

experiment with color relativity (the study of how colors relate to one another).

Color produced by mixing light, as seen in Newton's experiments, is called **additive color**. When two or more colors of light are combined, the result is brighter than the original colors. (The term "additive color" comes from this increase of lightness.) Computer and television screens and theater production lights are common examples of the principle of additive color.

Colored paints, pastels, and pencils are not composed of light, however, but pigments. Color pigments absorb (or subtract) all the color rays in sunlight except for the color they reflect, which is the color that we see. (For example, blue pastel will absorb all the color in light except for blue.) When mixing two or more pigments, their absorption increases and lightness tends to decrease, and so the term **subtractive color** is used to refer to colors produced by mixing pigments. This chapter focuses on the principles of subtractive color, and mixing techniques to obtain it, as applicable to conventional drawing materials.

Color-Wheel Relationships

The **color wheel** makes it easy to visualize the relationships between colors. In this simple color wheel we can see primary, secondary, and tertiary colors (**13.3**). The three primaries are red, yellow, and blue. These colors are called primary because no other colors can be mixed to produce them. **Primary colors**, however, can be mixed to create three **secondary colors**: orange, green, and violet. When secondary colors are mixed with primary colors, six **tertiary colors** are made, including red-orange, yellow-orange, yellow-green, blue-green, blue-violet, and red-violet. In theory, creating such mixtures as these could continue indefinitely, resulting in unlimited variations of colors. For clarity's sake, however, artists ordinarily identify color based on a twelve-step color wheel.

Study this expanded version of the color wheel (**13.4**). This color wheel reveals the gradual blending of colors as one turns into the next. Each color is understood in the context of its relationship with the other colors. **Pure color** is represented around the perimeter of the circle. Looking at colors on opposite sides of the circle, we find **complementary colors**. Notice that as complementary colors mix, they lose purity and become neutralized. Intensity of color is lost toward the center. In theory, the center of the circle, an equal mixture of complementary pigments, would be a perfect middle-value gray.

Color Fundamentals

Color should be used purposefully. With an understanding of its essential properties and characteristics, one will be able to identify and implement color in a drawing more effectively.

Additive color Colors produced by mixing light.
Subtractive color Colors produced by mixing pigments.
Color wheel A diagram of color relationships.
Primary colors Colors from which, in theory, all others are derived: red, yellow, and blue.
Secondary colors Such colors as orange, green, and violet, obtained by mixing two primary colors.
Tertiary colors Colors obtained by mixing a primary and a secondary color: red-orange, yellow-orange, yellow-green, blue-green, blue-violet, and red-violet.
Pure color A color of clarity and purity, approximating that which is seen in the spectrum of light.
Complementary colors Colors opposite one another on the color wheel.
Hue The general classification of a color.
Saturation The degree of purity and brilliance of a color, sometimes called "color intensity" or "chroma."
Temperature A description of color based on our associations with warmth or coolness.
Tint A color plus white.
Shade A color plus black.
Tone A color plus gray, or a color plus its complement.

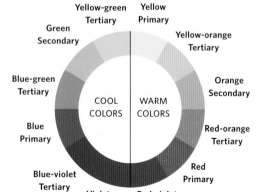

13.3 Twelve-step color wheel
The twelve-step color wheel is made up of primary, secondary, and tertiary colors. Laying colors out in this manner helps us to visualize how they relate to each other. Notice how so-called "warm" colors are collected on one side of the wheel and "cool" colors are on the other.

13.4 Gradated color wheel
Compare the twelve-step color wheel with this gradated one. The arrangement of hues is the same, but here we see the gradual merging of each color into the next. It reminds us that there are an infinite number of colors. This diagram also illustrates that when complementary colors are mixed together, they create a neutral gray.

Fundamental Properties of Color

First, one should understand the four essential properties that make up a color: **hue**, value, **saturation**, and **temperature**. The combinations of these properties ultimately determine the identity of a color.

Hue

Hue is the general classification of a color. The words *hue* and *color* are often used synonymously. A hue is the color type (such as yellow, green, or red-orange) as depicted on the twelve-step color wheel. Hues exist independently of intensity of light and dark.

Value

Value is just as important in a color drawing as it is when making a black-and-white one. In relation to color, value is the relative lightness or darkness of one hue when compared to another. For example, it would be inaccurate to describe green as a light value, unless it is compared to a color of a darker value. The same green may appear dark or light depending on the value of the color with which it is paired (**13.5**).

One way to lighten a color's value is to add white. A color plus white is called a **tint**. Black can be added to a color to achieve darker values. A color mixed with black is a **shade** (**13.6**). A **tone** can be created in two ways:

(1) an achromatic tone is created when both black and white are added to a color (**13.7**);
(2) a chromatic tone is created when a color's complement is added (**13.8**).

Tones are duller than the original color, and can end up being lighter or darker than the original hue depending on the proportions of black and white, or the colors that are mixed. Chromatic tones tend to be warmer and muddier than achromatic ones. Examples of both can be seen in **13.24**, p. 269.

Saturation

Saturation is the degree of purity and brilliance of a color (sometimes saturation is called the "color intensity" or "chroma"). The closer

13.5 Comparison of the same value of green as it appears next to a lighter and then a darker background
The value of a color is relative. A color may appear light in one context and dark in another. In this diagram the same green is shown surrounded by two different values, making the small square look lighter on the left than on the right. Trick question: is green a dark value? Answer: Compared to what?

13.6 Tint and shade scale
Examine this tint and shade scale. The values change as the scale moves from the pure hue located in the center. To the left, increasing amounts of black are added to make the color darker (shades). To the right, increasing amounts of white are added to make the color lighter (tints).

13.7 Color + (black and white) = achromatic tone

13.8 Color + complement = chromatic tone
Tones can be made in two different ways:
13.7 (above left) displays the results of adding gray to a color: this makes achromatic tones, as seen in the central square in this diagram;
13.8 (above) displays the results of adding a color's complement to it: this makes chromatic tones, as seen in the central square in this diagram. Compare the qualities of the different types of tones.

13.9 High saturation versus two low saturations (achromatic and chromatic)
Compare the saturated color in this diagram with the same color that has been lowered in saturation using two different approaches. On the left the saturation has been lowered by adding gray. On the right the saturation has been lowered by adding the color's complement (green). A hue with lowered saturation is a tone.

colors are to their pure hue, the higher their saturation. Highly saturated colors are often described as bright and vivid. When a tone is created, the saturation of the color is decreased (**13.9**). On the gradated color wheel (**13.4**, see opposite), the hues with the highest saturation are around the outside of the circle. As these colors approach the center, each is mixed with its complementary color, and its saturation is reduced as a result. When color intensity is changed, the value of the color also changes. Just like value, the saturation of a color is always relative to the colors surrounding it.

TIP

The value of color is very important, whether for conveying volume or organizing composition. To help reduce a color to a value, try squinting at it.

13.10 Student work. Radha Howard, *Moments*. (Instructor: Terry Moeller) Pastels are an excellent medium to use when exploring color drawing. The student who made this work used unexpected cool and warm colors throughout the drawing. Her sensitive approach to layering colors created rich and luminous color mixtures.

Temperature of Color

Colors are often described as having temperature. Colors containing blue or white tend to be considered cool (as in cold), while colors containing red, orange, and yellow tend to be considered warm. As can be seen in the twelve-step color wheel (**13.3**, see p. 258), the warm and cool colors oppose each other on the color wheel.

Just as the appearance of a color's value is relative to its surroundings, color temperature is affected by the temperatures of neighboring colors. A blue-green in a composition of warm reds may look cool, but when that same blue-green is placed in a composition of cool light-blues, it will appear much warmer.

The Long Gloves by Mary Cassatt (1844–1926) gives us an insight into the artist's process of making a color drawing by establishing cool and warm colors (**13.11**). The face and hair are warm compared to the arms, which are also surrounded by the exposed warmth of the

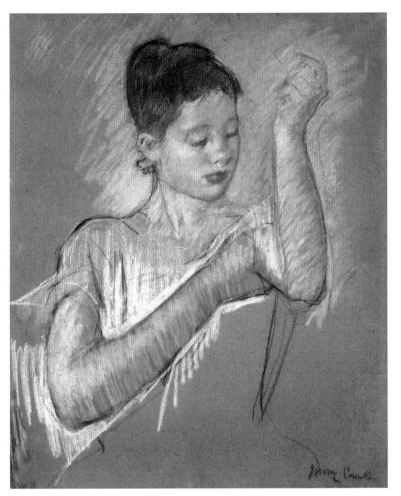

paper. The warmth of the face is increased by the thick layer of cool blue surrounding it. Establishing a cool ground on which to make your drawing is another way to enhance the apparent warmth of the other colors in the drawing.

Combining warm and cool colors in a drawing can impart richness to a color configuration. In *Foliage*, a late watercolor by Paul Cézanne (1839–1906), the patches of both warm and cool colors (warm reds and cool blues) overlap and gradate, imparting fullness to the color composition (**13.12**). The flashes of colors together suggest the light and form of rustling leaves.

Other Color Considerations

In addition to the elementary properties of color, other factors can be modified when using it in a drawing. Attention to these characteristics can expand the artist's ability to convey form, space, light, and emotions.

13.11 Mary Cassatt, *The Long Gloves*, 1889. Pastel on tan paper, 25⅝ × 21⅛" (65 × 53.5 cm). Private collection
Study Cassatt's pastel technique. On toned paper, she begins with loose, gestural line work. With directional mark-making, she applies first and second layers of color. Both warm and cool colors are used. The hair and face are further developed by using smaller marks and by careful blending.

13.12 Paul Cézanne, *Foliage*, 1895–1900. Watercolor and pencil on paper, 17⅝ × 22⅜" (44.8 × 56.8 cm). MoMA, New York
Warm colors often contain red, orange, or yellow. Cool colors tend toward blue or white. This image embraces a variety of cool and warm colors. Compare the colors used. What are the temperatures of each?

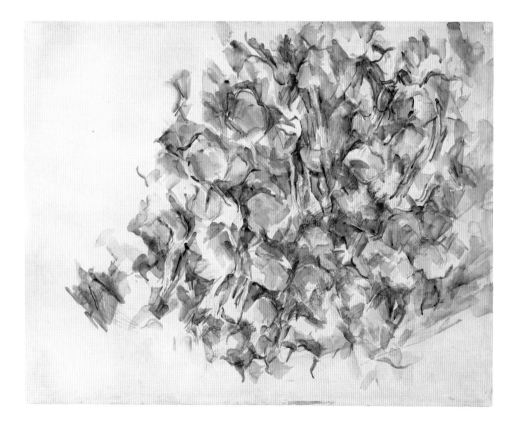

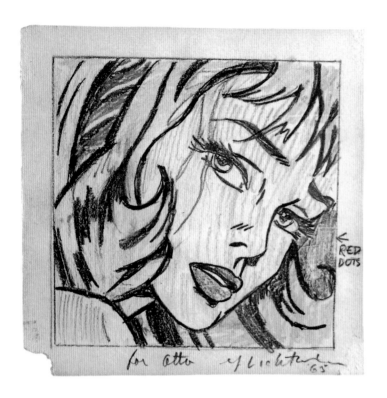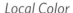

13.13 Roy Lichtenstein, drawing for *Girl with Hair Ribbon*, 1965. Graphite pencil and colored pencil on paper, 5⅝ × 5¾" (14.3 × 14.6 cm). Private collection
This drawing fills in spaces of the composition with local color. By restricting the application of color to local color, Lichtenstein imparts to the image a sense of simplicity and graphic clarity.

Local Color

Local color is the actual color of an object's surface as it would appear if it were unaffected by light or shadow. For example, a lemon's local color is yellow, despite the fact that one may be able to notice a variety of other colors on the dark side of the lemon.

Roy Lichtenstein (1923–1997) often used imagery from comic strips and advertisements in his Pop Art work. His sketch for *Girl with Hair Ribbon* demonstrates his practice of reducing objects down to their local color: red lips, yellow hair, and so on (**13.13**). While his final compositions are more defined and hard-edged than this sketch, they remain reliant on local color.

Spatial Cues of Color

Controlling color properties and characteristics enables the construction of illusionistic spaces and believable three-dimensional forms. It is the contrasts of value, saturation, and temperature that guide the perception of space, as we saw in Chapter 11, p. 223. Areas of highly contrasting colors will appear closer to the viewer than those that are very similar. Objects can be made to look further away by representing them with lower saturation. In addition, warm colors generally appear to advance, and cool colors seem to recede. In these ways, colors create atmospheric perspective.

13.14 Susan Ogilvie, *Valley Afternoon*, 2014. Pastel on panel, 8 × 6" (20.3 × 15.2 cm). Private collection
Color has the capacity to imply space. The calculated use of value, saturation, and temperature can create atmospheric perspective. What specific color choices has Ogilvie made in this drawing to suggest space? Hint: Contrast is crucial to producing a drawing with depth.

The American artist Susan Ogilvie (b. 1950) uses color as a primary means of creating space. In *Valley Afternoon*, the depth of the atmospheric scene is created through a deliberate use of colors (**13.14**). The foreground is made up of highly saturated colors and contrasting values, while the background is made up of cooler colors and values that are similar to each other.

Hierarchies of Color

Examine this watercolor-and-felt-tip-pen drawing by Atsuko Tanaka (1932–2005) (**13.15**). Composed of circles and lines, color plays an important role in this abstract work. The red circle is noticeably different and attracts the viewer's attention: its contrast with the rest of the drawing—due to its hue, value, temperature, and saturation—imparts a sense of importance to that part of the composition. By establishing a hierarchy using color, Tanaka creates a relationship between the different parts of the drawing.

In the same way, Mary Ann Currier (b. 1927), establishes a hierarchy using color in *Onions and Tomato*, a still-life drawing in oil pastel (**13.16**). Emphasis is placed on the bright-red tomato. This creates a dominant focal point for the composition, which otherwise comprises non-competing colors. Such a warm and brilliant color as this shade of red also creates the illusion of space in the drawing by visually projecting the tomato forward.

13.15 Atsuko Tanaka, *Untitled*, 1956. Watercolor and felt-tip pen on paper, 42⅞ × 30⅜" (108.9 × 77.2 cm). MoMA, New York
When you look at this non-objective drawing, to what area does your eye travel first? Most people gravitate toward the red circle in the upper left-hand corner of the composition. The color—different in hue, saturation, value, and temperature—establishes this circle as a focal point.

13.16 Mary Ann Currier, *Onions and Tomato*, 1984. Oil pastel on mat board, 26½ × 56" (67.3 × 142.2 cm). Metropolitan Museum of Art, New York
This realistic oil-pastel drawing uses the hierarchy of color to establish an emphasis in the composition. The still life was designed so that all of the objects could be rendered in muted colors. The only exception is the bright-red tomato: because of its brilliance in relation to the rest of the drawing, it becomes a strong focal point.

13.17 Lorenzo Chavez, *Italian Wall*, 2016.
Pastel, 18 × 14" (45.7 × 35.6 cm). Private collection
Chavez sensitively discerns the colors of the dark
side of forms (form shadows) as well as cast shadows.
He notices not only color changes, but also temperature
changes. Including the color of shadows in a drawing
helps to create a naturalistic and luminous effect.

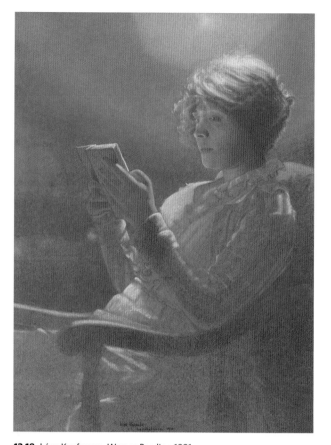

13.18 Léon Kaufmann, *Woman Reading*, 1921.
Pastel on gray paper, 30⅞ × 23" (78.5 × 23 cm).
Musée d'Orsay, Paris, France
The entire color spectrum appears to be represented
in this drawing, making the scene glow with light.
The darkest values are violets and the lightest are
yellow. The rainbow of pastels is smoothly blended
to create a naturalistic lighting effect.

Light and Color

When artists wish to address light in their
drawings, they will often be obliged to
modulate colors. For example, the artist might
notice that two things affect the colors of
shadows: (1) the color of the source of light;
and (2) the local color of the object on which
the shadow is cast.

On a clear day, shadows cast on a white
surface appear to contain blue. The shadows
appear blue because the yellow sunlight is
blocked from the shadow area, leaving there
only indirect blue light from other parts of the
sky. We could predict that this same shadow
would appear greenish if it were to be cast onto
a yellow surface.

Lorenzo Chavez (b. 1959) has a talent for
capturing the color of light and shadows in his
drawings. In his pastel drawing *Italian Wall*
the shadows in the folds of the hanging sheets
and the sheets' cast shadows are rendered as
combinations of cool and warm colors (**13.17**).
Observe how the cast shadow changes color as
it falls over different-colored surfaces.

The color of light also inspired Polish
artist Léon Kaufmann (1872–1933). A sensitive
colorist, Kaufmann often worked with pastels
to create gentle lighting effects, establishing a
sense of mystery. His drawings, such as *Woman
Reading*, are engulfed in fading light (**13.18**).
To create this, he rubs pastel dust in warm
and cool colors into the paper, subtly blending
them. Then, to boost the directional light, he
adds thick pastel highlights to the lightest areas
of his subject.

TIP

A drawing can
look dramatically
different depending
on the color of
paper that you use.
Experiment to see
what paper colors
you like most.

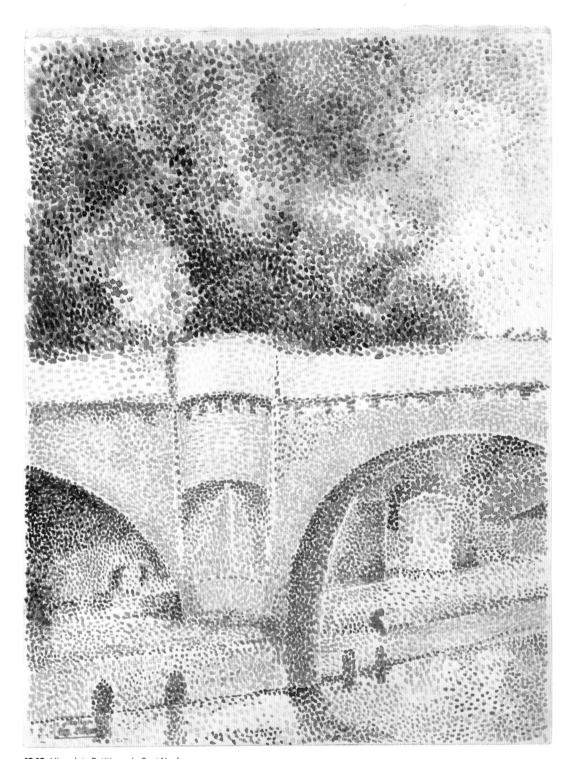

13.19 Hippolyte Petitjean, *Le Pont Neuf*, *c.* 1912–14. Watercolor and gouache on paper, 9⅞ × 7½" (25 × 19 cm). Metropolitan Museum of Art, New York

This drawing demonstrates how optical color mixing works. If we were to view this work up close, we would see an array of colored dots. From further away, our eyes and brains merge these dots, combining the different colors to create the illusion of a new color.

When applying color, the French artist Hippolyte Petitjean (1854–1929) used a technique called **pointillism**, in which dots are applied in different concentrations to form an image (**13.19**). When color dots are used (as in Petitjean's work), **optical color mixing** occurs. Instead of seeing hundreds of individual dots of color, our brains tend to mix the individual colors to create the illusion of a new color.

Pointillism A late nineteenth-century style of art using short strokes of color that optically combine to form new perceived colors.

Optical color mixing When individual color marks visually blend so that they are perceived as a new color.

13.20 Helen Frankenthaler, *Spring Veil*, 1987. Aquatint and drypoint, 25⅝ × 30¾" (65 × 78 cm)

This is an example of a monochromatic color scheme. By adhering to this color palette, all parts of the image seem to exist in the same pictorial world. The all-encompassing green hue becomes a unifying presence. The monochromatic color scheme also infuses the image with a mysterious mood.

TIP

Use a color scheme when you make a color drawing. It will unify your composition.

Color Unity and Color Schemes

Color unity is achieved when all the colors of a drawing have a harmonious relationship. Although this can be achieved intuitively, it is advisable to have a color strategy, or a **color scheme**, in place from the outset of a drawing. This can be developed in response to the subject matter, or it may come to you through a flash of creative inspiration.

Choosing a Color Scheme

When choosing a color scheme, a color wheel can be a helpful reference tool. There are well-tested color-scheme formulas that help avoid arbitrary and ineffective color selections. While using a color scheme restricts an artist's palette, it is also liberating in other ways, as it allows the artist to experiment freely, knowing the color scheme will maintain the work's unity. Whatever the drawing approach, technique, or subject matter, selecting and preserving a color scheme assures a degree of cohesion among the parts of the drawing. Furthermore, color schemes can establish atmosphere and help control the design of the page.

There are several different types of color schemes, including monochromatic, analogous, complementary, and tonal. No matter which is implemented, when a drawing is guided by the considerate choice of color relationships, the result is a color unity that is pleasing to the eye.

Monochromatic Color Scheme

A **monochromatic color scheme** utilizes only one hue and its various values (tints, tones, and shades). By using only one color, along with its darker and lighter variations, all parts of a drawing are effectively unified. The choice of color dictates the mood and the emotional tone of the drawing.

Spring Veil by Helen Frankenthaler (1928–2011) was made with a monochromatic color scheme (**13.20**). The radiant green looks as though it was spontaneously poured onto the paper. The limited color palette visually connects the different types of lines, marks, and shapes. The image has an intensity that seems to extend beyond the edges of the page.

Although drawn on beige-pink paper, the pastel drawing in *Waterloo Bridge, London* by Claude Monet (1840–1926) was achieved monochromatically, using only blue and white pastels (**13.21**). Monet's free and bold handling of pastels is unified by the limited color scheme. True to his Impressionist approach, he leaves out details in favor of capturing an overall impression of the moving and changing scene.

Color scheme
Color relationships that create visual harmony.
Monochromatic color scheme A color scheme that utilizes only one hue and its various values.

The Work of Art Claude Monet

Who: Claude Monet
Where: London, England
When: 1899
Materials: Colored pastels

Artistic Aims

Impressionist artists shared the desire to work outdoors from direct observation, *en plein air*. Claude Monet was a founder and key figure of this movement. Since the normal practice for a nineteenth-century artist was to work in the studio, the idea of creating finished works of art outside was controversial. This way of working motivated Monet and the Impressionists to transform the concept of "landscape" from the idealized depiction of historic places to the colorful impression of real places at a particular time.

Artistic Challenges

Monet made many trips to London between 1899 and 1904. There he found new inspiration, including Waterloo Bridge over the River Thames. He often had to contend with bad weather and heavy fog that sometimes made it nearly impossible to work outside. Turning this to his advantage, Monet used these conditions to create mysterious and romantic atmospheres. A harder challenge, however, was yet to come.

Between 1912 and 1922 Monet's vision was failing. Cataracts were blurring his eyesight and causing a progressive loss of color vision. He began to see the world in monotone. To compensate, Monet chose colors based on their names. He tended to overcompensate for his failing vision, which leaned toward browns and yellows, by adding more and more blue to his work. Perhaps his drawing *Waterloo Bridge, London* foreshadowed this event. Eventually he found himself painting mostly from memory.

After Monet underwent cataract surgery to correct his vision in 1923, he destroyed many of the works that he had made when his vision was poor.

Artistic Method

Monet was an accomplished draftsman and customarily used his sketchbook drawings as studies and visual notes for oil paintings. On the other hand, he considered his pastel drawings to be finished works of art, of equal importance to his oil paintings. Viewing Monet's drawings, it is clear that he was trying to record the initial visual excitement that he found for his subject. Pastels were an ideal medium for him, affording the spontaneous application of fresh color. With broad and open strokes, Monet could capture the dappled and flickering quality of changing light on shifting water.

The Results

Throughout his life, Monet found dedicated support among collectors, making him the most successful artist of his time. His dedication to his art despite the physical challenge he had to face is typical of serious and remarkably gifted artists. He was hugely inspirational to future artists and became one of the most significant figures in the history of Western art.

Sketchbook Prompt

Choose a multicolored subject. Use a monochromatic color scheme (only one color, including light and dark versions of that color) to draw your subject.

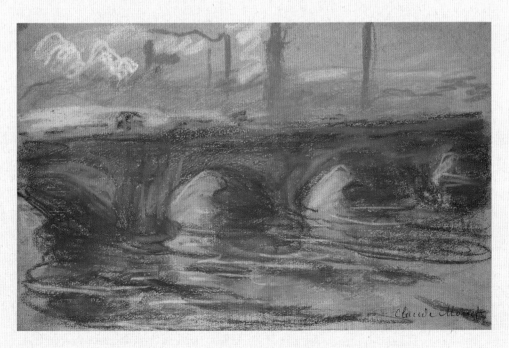

13.21 Claude Monet, *Waterloo Bridge, London*, c. 1899. Pastel on paper, 12⅜ × 19⅛" (31.3 × 48.5 cm). Musée d'Orsay, Paris, France
In this work, a monochromatic color selection of pastels on tinted paper was used to create an "impression." For Monet, the fleeting moment was all-important. How might this drawing appear if it were done on bright white paper? What if it were drawn on blue paper?

En plein air French for "in the open air"; used to describe art produced outside.

13.22 Janet Fish, *Oranges*, 1972. Pastel on paper, 28 × 31½" (71.1 × 80 cm). DC Moore Gallery, New York

When rendering the fruit in this drawing, Fish restricted herself to the use of yellow-orange, orange, and red-orange. As these colors lie next to each other on the color wheel, this is an example of an analogous color scheme. This color scheme unites the composition effectively because all parts of the fruit contain a shared color, in this case orange.

Analogous Color Scheme

An **analogous color scheme** is based on a group of colors that are found side by side on the color wheel. When three or four colors are next to each other on the spectrum, they share the same dominant color. This provides a natural visual connection when used in a drawing.

When setting up a still-life composition, the American artist Janet Fish (b. 1938) spends a lot of time considering the color of her arrangements. Rather than concentrating purely on the depiction of her subject matter, the focus of many of her works is color. In *Oranges*, she utilizes an analogous color scheme within the fruit using mostly yellow-orange, orange, and red-orange (**13.22**). These colors provide a unified environment for the objects.

Complementary Color Scheme

Complementary colors are those that appear opposite each other on the color wheel. When used together, complementary colors have two important characteristics. First, when mixed or blended together, complementary colors neutralize each other. Second, when placed next to each other in a composition, both are intensified. This means that if, for example, the complementary colors orange and blue are mixed together, they will create a neutral brownish color, but if orange is placed next to blue in an artwork, each will enhance the appearance of the other's strength and intensity.

Choosing a **complementary color scheme** for a drawing provides the greatest possible color contrast. *Corn and Peaches* by Charles Demuth (1883–1935) demonstrates how this type of color scheme can be an effective way to attract the viewer's focus toward the subjects of a drawing (**13.23**). The representation of the summer harvest is heightened by the red and green colors.

Tonal Color Scheme

Some drawings are made up entirely of tones. As discussed, there are two different types of

Analogous color scheme A color scheme based on a group of colors that are found side by side on the color wheel.
Complementary color scheme A color scheme that utilizes colors that appear opposite each other on the color wheel.

13.23 Charles Demuth, *Corn and Peaches*, 1929. Watercolor and pencil on paper, 13¾ × 19¾" (35 × 50.2 cm). MoMA, New York

This image deploys a complementary color scheme: the predominant colors are red and green. When opposite colors are used, the eye unconsciously fills in the missing colors, making us feel as though an entire spectrum is present. Complementary colors strengthen each other visually.

Tonal color scheme
A color scheme that utilizes only tones, either achromatic or chromatic.

tones: achromatic, when both black and white are added to a color; and chromatic, when a color's complement is added. Depending on which type of tones are used, a **tonal color scheme** could have a general appearance of cool grayness, or it could be comprised of warmer brown tones.

Three Men in a Canoe, a watercolor by Winslow Homer (1836–1910), was made using a tonal color scheme (**13.24**). The foreground of this work appears to have been made by mixing colors with grays (black plus white). The background appears to have been created with chromatic tones. All components of Homer's

13.24 Winslow Homer, *Three Men in a Canoe*, 1895. Gouache and ink wash on paper en grisaille, 16¾ × 20" (34.9 × 50.8 cm). Private collection

This work is made using chromatic grays in the background and achromatic tones in the foreground. Notice how the different layers of space have been treated slightly differently in terms of tone. Observe the artist's clever use of atmospheric perspective.

13.25 Joe Brainard, *Pears and Apples*, 1974. Gouache, graphite, and colored pencil on paper, 12¼ × 9⅜" (31.1 × 23.8 cm). Metropolitan Museum of Art, New York
None of the colors in this still-life drawing were acquired "straight out of the tube." Every color appears to have been mixed or modified specifically for its location. The soft and subtle grays combine to create a tonal color scheme. Can you guess which colors were mixed to make each of the colors that you see?

landscape—the foreground, middle ground, and background—contribute to the creation of a quiet, somber atmosphere.

The American artist and writer Joe Brainard (1941–1994) used a tonal color scheme for *Pears and Apples* (**13.25**). The fruit and their shadows inspired him to use beautiful and luminous color tones. Colors blend from cool to warm and from dark to light. Brainard's handling of transparent tones makes the dark side of the fruit absorbing for the viewer.

Color as an Expressive Force in Drawing

Color can be used to stir feelings within a viewer. It does this extremely well because colors carry emotional resonances. The perception of color touches one's moods and feelings: it can elevate a drawing from a straightforward depiction to the realm of expression; it can energize or calm, and stimulate joy or sadness. To arouse emotions has been considered by many, throughout history, to be one of the foremost goals of art.

Everyone has his or her own way of seeing color, just as everyone has a unique point of view and individual sense of expression. The use of color in drawing is therefore personal and subjective: colors can be enhanced or even invented by an artist. The color choices in your work can express and accentuate your particular interests and sentiments. Allowing

13.26 André Derain, *The Orchestra, the Musicians*, 1905–6. Watercolor, ink, and chalk on paper, 14¾ × 11⅜" (37.6 × 29 cm). Centre Pompidou, Paris, France
The Fauves saw pure color as a major tool for personal expression. Analyze the color choices in this drawing. Saturated primary and secondary colors are prevalent. Compare this color palette to other drawings in this chapter.

yourself the option to manipulate your color-based expression is a source of great freedom.

Fauvism flourished in France during the early twentieth century. The Fauves were a group of artists who focused on color as a primary means of expression. They rejected the confines of supposedly naturalistic color schemes, instead using brilliant saturated color in their work; it was not unusual for these artists to use pure colors straight out of a tube (i.e. without mixing). André Derain (1880–1954) was a co-founder of Fauvism.

His drawing *The Orchestra, the Musicians* exhibits powerful colors that were not derived strictly from direct observation (**13.26**).

Monica Aissa Martinez (b. 1962), an artist working in Phoenix, Arizona, uses color as an expressive tool. She layers a variety of media into aggregations of colors and unusual organic shapes that define larger images. *Subtle-Female Back Body* forms a colorful visual map that reveals Martinez's interest in the connections between the body, mind, and spirit (**13.27**). It is her personal color interpretation of the world.

TIP

You can create rich color combinations by layering colors in your drawings.

13.27 Monica Aissa Martinez, *Subtle-Female Back Body*, 2013. Mixed media on paper, 35 × 25" (88.9 × 63.5 cm). Private collection
This multimedia drawing is an amalgamation of colors. Colors are personal choices for Martinez, reliant neither on observations nor on formulas. She layers them to create interweaving visual textures that result in a highly individual expression.

Drawing at Work Wassily Kandinsky

When looking at *Watercolor No. 13* by the Russian-born artist Wassily Kandinsky (1866–1944), the eye moves upward and diagonally across a flattened landscape of shapes and color. Some images are recognizable, such as the landscape forms in the distance, but others are harder to understand. One tries to interpret meaning from the shapes and colors, but the artist appears to have been capturing impressions rather than depicting objects. Through abstraction, this drawing resonates on a level deeper than the appearance of things, perhaps even touching the viewer's soul.

After a successful career in law and economics, Kandinsky began sketching and life drawing at the age of thirty, and moved to Germany. He lived there until 1914, when war broke out and he was forced to return to Russia. He was able to return to Germany in 1921, and taught a variety of classes at the Bauhaus school of art, design, and architecture, including an introduction to color theory. The school sought to train students in art and design equally, profoundly influencing subsequent generations of artists and designers in all fields around the world.

Kandinsky spent years experimenting with color and developed theories of abstraction for which he became well known. These were first published shortly before this drawing was made. He believed that color could be used in a work independently, free from the visual description of an object. He felt that color has two effects: (1) a physical effect, whereby it captivates the eye; and (2) an inner beauty or a spiritual effect, whereby color touches the viewer's soul.

Many of Kandinsky's color works, such as *Watercolor No. 13*, are a balance of figuration and abstraction. While his work has a non-representational ambience, Kandinsky maintained that an artist should never surrender the study of nature, for this would ignore the essential source of inspiration, including for color. In his view, by choosing a color the artist imparts "meaning" to the work. Kandinsky felt that yellow denoted violence and blue a spiritual calm. In this way color forges a vital link between the artist and the emotional state within the viewer.

13.28 Wassily Kandinsky, *Watercolor No. 13 (Aquarell No. 13)*, 1913. Watercolor, ink, and pencil on wove paper, 12⅝ × 16" (32.1 × 40.6 cm). MoMA, New York

In the Studio Projects

Fundamental Project

This exercise provides an opportunity to experiment with color schemes. Choose four different schemes, such as the ones highlighted in this chapter (monochromatic, analogous, complementary, tonal). Using a color medium of your choice, make four color swatches that conform to each scheme. Label each color scheme.

Observational Drawing

Set up a still life using objects that are all the same color: for example, a yellow lemon and a yellow banana on a yellow table. Illuminate your objects from one side using a strong light source. You may consider using natural light for this assignment by working outside, or next to a window.

After lightly drawing your objects with line, add color. Observe the color changes in the still life carefully. Try to use a wide variety of colors, including dark and light values, warm and cool temperatures, and highly saturated and low-saturated colors.

Non-Observational Drawing

Choose two or more color media. Experiment in your sketchbook by mixing and combining multiple media. Try to invent techniques that result in exciting color mixtures and textures. Once you have discovered an inspiring color technique, use that process to make a larger non-objective drawing. The larger drawing should be unified by one of the color schemes discussed in this chapter (monochromatic, analogous, complementary, tonal).

Criteria:

1. Four different color schemes should be addressed.
2. Four suitable colors should be selected for each color scheme.
3. The presentation of the color swatches should be neat and well organized.

Criteria:

1. The completed drawing should capture the appearance of a directional light source.
2. Despite using a variety of colors to draw, the finished work should appear to be a one-color still life.
3. The finished drawing should include a variety of colors including dark and light values, and display experimentation with value, temperature, and saturation.

Criteria:

1. You should carry out in-depth study of color media combinations.
2. The finished non-objective drawing should embody intriguing color mixtures and textures.
3. The finished drawing should utilize a color scheme to create unity.

Materials: Paper and optional color media

Materials: 9 × 12" paper and pastels or colored pencils

Materials: 9 × 12" paper and any combination of color media

Part 4

What to Draw

Artists find inspiration in the world around them. It is clear that creative people across time and cultures have explored a number of similar subjects. In this part, we discuss the history and exciting possibilities of four genres: still life, the human figure, portraiture, and landscape drawing. Each genre offers the artist endless motivation and potential. These chapters will suggest directions in which each subject can be explored. The carefully selected contemporary and historical examples can be used to inspire your drawing.

Chapter 14
Still-Life Drawing

One of drawing's primary genres is still life. It is one of the first things that an artist studies, and for many artists it remains a central preoccupation throughout their lives. **Still life** is defined not only as a genre of art, but also as the subject matter of the genre, indicating an inanimate item or a group of objects. These are typically common items, such as books, bowls, and chairs. Often artists also include such natural objects as fruit and flowers, or sometimes even dead animals. While the genre is called "still life" in English, in French it is called *nature morte* (or "dead nature").

Either way, it is the non-living and non-moving aspect of the subject that defines the genre and makes it especially valued. More than other subjects, such as landscape or the figure, still life offers the artist unmatched control. Still-life drawings are usually made in a studio, where special attention can be given to the choice of objects, arrangement, lighting, and vantage point. As we will see in this chapter, such control affords the artist many opportunities to incorporate different types of objects, often chosen to suggest or express ideas and emotions indirectly.

Still life (1) A genre of art; (2) A scene of inanimate objects, such as fruits or flowers.

14.1 Jean-Baptiste Monnoyer, "Basket of Flowers," from the *Book of Several Baskets of Flowers*, n.d. Etching and engraving. Metropolitan Museum of Art, New York

Still life became a fashionable genre of art in seventeenth-century Western culture. Such floral works as this one were particularly popular, as they exhibited both elegance and botanical accuracy. The decorative nature of this kind of subject matter was also exploited by artisans and designers. Compare this drawing to the contemporary work by Angela Piehl in **12.5** (p. 243). What similarities and differences do you see?

Still Life in Western Culture

Elements of still-life drawing have been present since antiquity, but it was not until the seventeenth century that still life began to flourish as an independent genre. The global expansion of trade toward the West at the time generated a new excitement in material goods among the growing middle classes. In the Netherlands and Belgium, artists' fascination with detailed realism gave rise to still life as an independent art form in European art. Objects were no longer merely a subordinate part of a composition; they became a central subject.

Renderings of floral arrangements were particularly fashionable. A leading specialist of this motif was Jean-Baptiste Monnoyer (1636–1699). His grand floral style, as seen in his engraving *Basket of Flowers*, was very popular with clients seeking interior decorations (**14.1**). Monnoyer was even hired to help with the ornamentation of the Palace of Versailles in France. Long after Monnoyer's death, his picturesque still-life work influenced the decorative arts, including tapestry and textile design.

Although popular among collectors and patrons before the nineteenth century, still-life drawing was regarded by many as a minor art form limited to representation, the mere craft of a copyist who lacked imagination. The twentieth century brought new respect for still-life drawing. Artists who were concerned with developing new forms of art were

14.2 Georges Braque, *Fruit Dish and Glass, Sorgues*, 1912. Charcoal and cut-and-pasted printed wallpaper with gouache on white laid paper, subsequently mounted on paperboard, 24¾ × 18" (62.9 × 45.7 cm). Metropolitan Museum of Art, New York

The genre of still life was useful for twentieth-century artists as they sought to reinvent the depiction of space and form in art. This drawing is an example of Cubism in which the still-life arrangement is drawn from more than one point of view, resulting in a flattening of the space. Wallpaper collaged into the drawing further compresses the image.

fascinated by the symbolic potential of the still life (see p. 284), through which they aimed to communicate their inner intentions and expressive goals.

This approach to the still-life genre is evident in the work of such artists as Paul Cézanne (1839–1906). He, along with others of the time, was no longer interested in detailed realism, and was attempting new ways to represent form and space (see **13.12**, p. 261). Working from a still life was an ideal way to try out these innovative ideas. Subsequently, the painters Georges Braque (1882–1963) and Pablo Picasso (1881–1973) pushed these concepts even further, developing Cubism. Georges Braque's

Fruit Dish and Glass shows the results of the Cubist interest in using light and geometry to create abstractions (**14.2**). Here, objects appear to be analyzed from different points of view, fragmented, and then reassembled. The discord between the subject matter—often everyday items, with which a viewer would be familiar—and the artists' expressive techniques only served to emphasize their originality.

Cubism's multiplicity of viewpoint was not the final word in still life, however. Artists today find the arrangement of objects just as versatile and inspiring as their predecessors.

The current work of Annie Williams (b. 1942) is almost entirely based on still life.

TIP

Every time you look at an object, try to see it differently compared to the time before.

14.3 Annie Williams, *Patchwork II*, n.d.
Watercolor on paper, 16 × 20" (4.6 × 50.8 cm).
Private collection
For this contemporary representational artist,
still life provides an opportunity to study color
in a controlled manner. She is able freely to
arrange her subject, background, and lighting
to suit her specific goals. Notice how the
background that she constructed adds color
and variety to the composition.

Still life is an ideal subject for her slow process
of manipulating shapes, forms, patterns,
textures, and colors. Typically, she arranges
simple forms in the foreground, while in
the background she constructs complex
patchworks from textiles, newspaper cuttings,
and other found objects (**14.3**).

For Stuart Shils (b. 1954), still-life objects
allow him the opportunity to experiment with
formal abstraction while remaining faithful to
observational drawing (**14.4**). In his drawings,
some objects reveal their identities, but others
become almost unrecognizable.

If you were to set up and carry out a still life
drawing to represent your individuality, what
items might you include? What type of mark-
making could you use to reflect your subject
matter and convey your message?

Types of Objects

Any type of object, whether human-made or
from nature, can provide an excellent source
for a still-life drawing. While there are many
different types of objects, in general they can
be classified into two categories: regular forms
and irregular forms. Each object possesses
its own unique set of characteristics. Still-life
artists often mix and match types of objects
to accommodate their particular focus.

14.4 Stuart Shils, *Still Life from Several Years
Ago*, 2013. Graphite and lithograph crayon,
5⁷⁄₈ × 5⁷⁄₈" (15 × 15 cm). Private collection
This abstract drawing was made from a still
life. The drawing describes objects as they
move into space. Although this work is abstract,
the artist utilizes spatial cues derived from
representational drawing. Objects in the
background are positioned high on the picture
plane and are drawn with low contrast compared
to objects in the foreground.

Regular forms Objects
that are predictable in
structure.

Regular Forms

Regular forms are objects that are predictable
in structure. Their structure is consistent and
orderly, and generally symmetrical about one
(or more) centerline or axis. Regular forms

Drawing at Work Le Corbusier

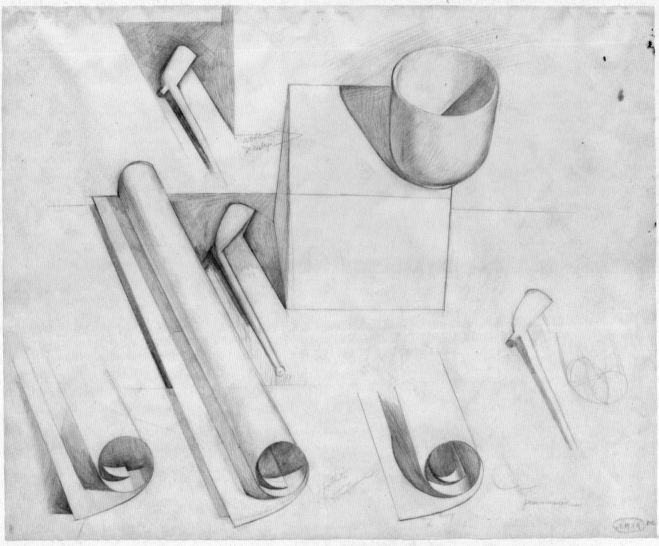

14.5 Le Corbusier, *Cup, Pipes, and Paper Rolls*, 1919.
Pencil on paper, 17½ × 21½" (44.5 × 54.6 cm). MoMA, New York

A pioneer of modern architecture and urban planning, Le Corbusier (b. Charles-Édouard Jeanneret, 1887–1965) once said, "I prefer drawing to talking. Drawing is faster, and leaves less room for lies."

Even from a young age, Le Corbusier used drawing as part of his creative process. For him it was a most important method of design research. One would ordinarily expect that an architect would draw buildings, but Le Corbusier was curious about drawing everything: landscapes, people, furniture, plants, food, natural and urban spaces, monuments, patterns, details, and still life. He often drew realistically, and then at other times with a degree of abstraction that revealed his interpretations and explorations of design concepts.

Cup, Pipes, and Paper Rolls, made in 1919, not only describes simple objects on a table, but also expresses design notions important to Le Corbusier's work as an architect (**14.5**). Just as in his architecture, Le Corbusier's still-life drawing tends toward simplification. His experience taught him that he could use clean geometric shapes to produce a powerful statement. Here, despite the realistic rendering of the rolls of paper, pipes, and pottery cup, the objects represent geometric shapes and are arranged and repeated in a harmonious and systematic way.

For Le Corbusier, drawing was the vehicle that enabled him to understand and then refine his concepts for urban architecture. Through drawing, he found new systems of harmony and proportion that were at the center of his design philosophy, a vision that has been credited with changing the face of the modern era.

14.6 Isabel Quintanilla, *Glass*, 1969. Pencil on paper, 13⅜ × 9⅞" (34 × 25 cm). Brockstedt Collection, Berlin/Hamburg, Germany
This is a drawing of a regular form. Its geometric structure is ideal for the artist's controlled and refined realist technique. Among many other things, regular forms pose the challenges of sighting and measuring, symmetry, and perspective.

can be found easily in human-made items that relate to geometric solids, such as spheres, cubes, and cones. (Common examples include such things as balls, bottles, bowls, chairs, and cups.) They may also contain ellipses and fixed curves. Regular forms offer ample opportunities to practice controlled sighting and measuring as well as perspective.

The closely observed drawings of Isabel Quintanilla (b. 1938) usually depict a few regular forms within a shallow space, often combining still life with interior or exterior scenes. In this drawing she concentrates on just one object: a single glass (**14.6**).

Irregular Forms

Irregular forms are those the parts of which are dissimilar in nature and not obviously based on simple geometric forms. There is inconsistency between their parts. They are usually asymmetrical and tend to have uneven contours. Irregular forms are most often natural or organic, such as plants, rocks, and food. Regular forms can be altered to become irregular forms, however, for example a teacup that is broken into pieces. Irregular forms offer opportunities to work from subject matter that is unpredictable in appearance. Deborah L. Friedman often uses irregular forms in her drawings. She thoughtfully arranges natural objects and then renders them in immense detail (**14.7**).

Irregular forms
Objects the parts of which are not regular nor based on simple geometry.

14.7 Deborah L. Friedman, *Balancing Act*, 2009. Colored pencil, 9¼ × 10" (23.5 × 25.4 cm). Private collection
This is a drawing of irregular forms in which the artist used commonplace objects to make a creative and unexpected arrangement. Consider this for a drawing subject. Can you use everyday irregular objects to construct an unusual still life?

14.8 Student work. Kirstyn Harris, *Face in a Bottle.*
(Instructor: Scott Thorp)
This still life represents a true challenge to representational
drawing. The student who made this drawing took
the occasion to refine her colored-pencil skills, study
transparency, and draw distorted reflections. Still life gave
her the opportunity to investigate ideas beyond the ordinary.

Artistic Practices

To a creative imagination, a still life is more
than simply a collection of items. It is an
occasion to experiment and develop drawing
abilities. Setting up a still life, or choosing
objects to draw, should be done with thought
and purpose. This can take time, but the right
arrangement can determine the success of
a drawing. The background and the lighting
are very important as well.

Arrange objects to suit your purpose.
Consider composing your still life according
to one of the organizing principles of design:
unity, balance, emphasis and focal point,
pattern, rhythm, variety and contrast, scale,
and proportion. As discussed in Part 3 (p. 148),
elements may also be an inspiration: line,
shape, value, form, space, texture, and color.
It can be helpful to use a viewfinder and
make a quick sketch, as this will enable you
to visualize the finished drawing better (see **6.7**,
p. 134). If any adjustments need to be made to
the arrangement, this should be done before
beginning to draw.

Still-life drawing can be considered an
exercise in the mastery of technique. Many
artists, such as Jane Lund (b. 1939), interact
with still life as the basis of their artistic
practice. Lund's capability to balance rich colors
and her skills in rendering detail are derived
from dedicated practice. Her considered
arrangements of simple objects create intimate
spaces (**14.9**). This seems to inspire Lund most.

14.9 Jane Lund, *Two Boxes*, 2004. Pastel on paper,
16 × 21" (40.6 × 53.3 cm). Forum Gallery, New York
Drawing a still life allows an artist to practice and refine
drawing techniques. Simple still-life arrangements, such as
this one, provide ample opportunities. Here, well-positioned
objects test the artist's linear perspective skills—the boxes
are shown in two-point perspective, and the table in one-
point perspective—and color choices challenge the artist's
abilities to represent color and light.

Think about different
arrangements
and alternative
viewpoints by making
lots of sketches and
using the viewfinder
to consider
lots of possible
compositions.

Still-life drawing can inspire poetic visions and provide a platform for working through ideas. New discoveries often emerge during the process of studying objects. In the 1950s, Richard Hamilton (1922–2011) turned to still life in order to examine the problem of how best to utilize drawing to create innovative expressions. His visual research led him to experiment with multiple viewpoints within one composition—a Cubist idea—resulting in abstract spaces defined by quivering overlaps of shapes and forms. Hamilton's work balances what may seem at first glance to be a chaotic appearance with an underlying cohesive visual order (**14.10**).

14.10 Richard Hamilton, *Still-Life?*, 1955. Engraving, 9⅝ × 6⅞" (24.5 × 17.5 cm). Tate, London, England
Here the approach to still-life drawing is abstract. This work illustrates Hamilton's interest in imagery that reflects modern life. The rhythmic, trembling lines capture the experience of present-day speed and change.

14.11 Susan Hauptman, *Still Life (Pear)*, 2012. Charcoal on paper, 26 × 32" (66 × 81.3 cm). Forum Gallery, New York

A still life can, and frequently does, represent more than the mere presence of inanimate objects. Drawn objects often express artistic ideas and sentiments symbolically. This illusionistic drawing of porcelain figures seems at first to conjure romantic narratives of days gone by, yet the rendering of a graphically printed image of a volcano in the background, although picturesque, seems to suggest that our nostalgia might be misplaced.

Symbolic Still Life: Metaphor

TIP

You might want to select still-life objects based on a theme in order to create a visual or intellectual relationship among the objects.

A still-life drawing can take the viewer beyond merely experiencing objects at face value. Still-life artworks can have personal, cultural, religious, or other associations. By imbuing objects with meaning, a drawing can embody a metaphor. A metaphor is one thing that is used to represent another; for example, a plant might represent life, or a bird could represent freedom. Many artists, such as Susan Hauptman (1947–2015), choose their still-life objects based on symbolic content.

Her drawings in the genre, such as *Still Life (Pear)*, are often collections of objects that are symbolic of another time. Her theatrical presentation can be interpreted as revealing a message about desire and nostalgia (**14.11**).

St. Teresa AHHH OH OH oh is a mixed media work by Audrey Flack (b. 1931) from a series that she calls "Transcendent Drawings" (**14.12**). The drawings in the collection feature female icons from history paired with objects from modern popular culture. Flack's choice of

subjects is not simply a matter of convenience. They are chosen as a way to question the notion of femininity. The way in which Flack subversively combines the religious subject matter with a lipstick and provocative text encourages us to question the roles women are expected to play in society. This feminist message is prevalent in much of her work, as can also be seen in **14.14**, p. 287.

14.12 Audrey Flack, *St. Teresa AHHH OH OH oh*, 2014. Digital pigment print with mixed media, 29 × 22" (73.7 × 55.9 cm). Hollis Taggart Galleries, New York
The disruptive juxtaposition of imagery in this drawing, such as the lipstick and the saint, is intended to challenge historical and cultural notions of womanhood. Flack asks the viewer to pause and question common stereotypes and cultural norms.

14.13 Herman Henstenburgh, *Vanitas Still Life*, n.d. Watercolor, gouache, and gum arabic on parchment, 13 × 11" (33 × 27.9 cm). Metropolitan Museum of Art, New York
The vanitas genre, often disturbing in its symbolism, reminds the viewer of the inevitability of death; such objects as skulls and insects are often featured. Study this drawing to find objects that represent the passing of time. Compare and contrast this still life to Monnoyer's flower arrangement (see **14.1**, p. 277).

Vanitas Still Life

"Vanity of vanities, saith the Preacher, vanity of vanities; all is vanity," (Ecclesiastes 1:2). This line from the Bible reminds us that the things of this world are fleeting and ephemeral. The genre of **vanitas**—symbolizing the brevity of life and the inevitability of death—expresses just this message. These complex still-life arrangements, first rendered in sixteenth- and seventeenth-century Flanders and the Netherlands, still challenge artists today.

Herman Henstenburgh (1667–1726) combines symbols of life with reminders of mortality in a work typical of vanitas drawings (**14.13**). In this example he juxtaposes colorful flowers and music props with bones, an hourglass, and a recently snuffed candle. Henstenburgh's work was, and still is, greatly admired, but for him—by profession a pastry baker—art remained mostly a hobby.

Vanitas A genre of still-life drawing that emphasizes the brevity of life and the transient nature of beauty.

The Work of Art Audrey Flack

Who: Audrey Flack
Where: United States of America
When: 1977
Materials: Mixed media

Artistic Aims

Audrey Flack is a photorealist painter, printmaker, and sculptor. Her drawings and mixed-media prints exhibit her traditional drawing skills while making reference to modern American culture. Her art aims to reinterpret historical and mythological images of women in ways that evoke a feminist message. In *Marilyn (Vanitas)*, Flack draws upon the vanitas genre to commemorate the American film actress Marilyn Monroe (1926–1962), while also highlighting the brevity of life by including objects indicating the passage of time, such as a clock and hourglass.

Artistic Challenges

Flack grew up in New York, and was greatly influenced by the Abstract Expressionist style from about 1948 to 1953. Afterward, feeling that this approach to art did not effectively communicate her views, Flack re-enrolled in art school to study a more realistic art form. Armed with this new knowledge, she became a pioneer of photorealism, copying photographs as accurately as possible. Instead of using arbitrary objects, she wanted her choices of subject matter to communicate poignant messages of femininity. Many of the objects in her works are traditionally used by women, and as such have been considered frivolous and are underrepresented throughout art history. Flack turns the lens on these items and tells us that the feminine can be deeply impactful.

Artistic Method

To create hyper-realistic paintings, such as *Marilyn (Vanitas)*, Flack first photographed carefully composed still-life arrangements. She then projected the image onto a canvas and used an airbrush to apply paint, capturing extraordinary amounts of detail.

Flack's drawings (such as *St. Teresa AHHH OH OH oh*; **14.12**, p. 285) were created in a different way. To make these multimedia works she began with digital prints of hand-drawings, on top of which she drew colorful, gestural marks and added collaged materials, such as stars and glitter.

The Results

Flack's work reminds us of the emotional and symbolic power that representational art can have. Her work continues to challenge our understanding of how objects possess meaning.

In the 1980s, Flack changed her primary medium of expression from drawing and painting to sculpture. Self-taught in this medium, she continues to deliver poignant messages by depicting religious and mythological figures.

Sketchbook Prompt

Arrange and draw a still life that represents masculine or feminine stereotypes.

14.14 Audrey Flack, *Marilyn (Vanitas)*, 1977. Oil over acrylic on canvas, 8 × 8" (20.3 × 20.3 cm). Collection of the University of Arizona Museum, Tucson, AZ

A Still-Life Drawing Demonstration

This still-life drawing demonstration uses pastel—both hard and soft—and pencils. In order to emphasize the element of color, the drawing is made on red paper. This will give the finished work a warm glow, and will make a nice contrast to the cool colors in the drawing. The demonstration employs some of the sighting and measuring techniques shown in Chapter 6 (p. 130).

TIP

When arranging objects in a still life, position them so that some objects overlap others. This strategy will help imply space (see Chapter 11, p. 218).

The artist thoughtfully arranges a still life, and illuminates the arrangement from one side with a lamp (**14.15**). The position of the lamp will determine how the shadows fall in relation to the objects.

Using clean simple lines, a portion of the still life is drawn using a colored pastel pencil. Special attention is paid to ensuring that angles and proportions are measured accurately (**14.16**).

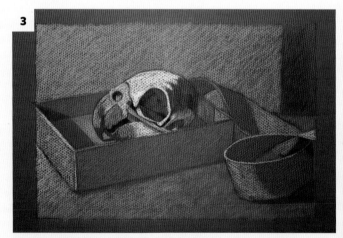

Color is filled in using hard pastels, approximating the colors that are observed. Hatch strokes are used without concern for blending, letting the mark-making show. Notice that both the dark sides of each form and the cast shadows register a color change in addition to a value change (**14.17**).

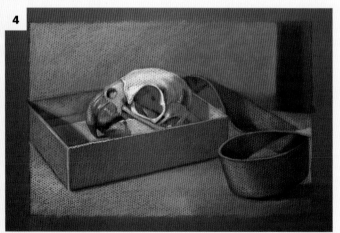

Layers of pastels, including the use of soft pastels, are added to refine and blend colors. Edges are sharpened as the drawing is brought to completion. Notice how the red paper is exploited throughout the drawing to create warmth and vibrancy of color (**14.18**).

In the Studio Projects

Fundamental Project

Arrange two different still-life compositions using a variety of regular forms for one, and a variety of irregular forms for the other. Take time to consider how the objects relate to one another. Consider the overall composition of the objects. Record each still life with a thumbnail study in a sketchbook.

Observational Drawing

Choose objects for their symbolic possibilities. Among other things, your objects could be symbolic of a person, place, emotion, idea, or current event. Consider how your objects should be arranged in order best to represent your chosen message. After making multiple thumbnail studies of your still life, use "A Still-Life Drawing Demonstration," opposite, as a guide to the drawing process.

Non-Observational Drawing

Choose a complex object; it could be a regular or irregular form. Closely study your subject. Collect information in your sketchbook that describes your object, including notes, drawings from different points of view, photos, textures, color swatches, *etc*. Record all aspects of your subject, such as details, textures, colors, corners, curves, and overall form.

Now use your sketchbook information as the sole source for creating a non-observational color drawing. Your drawing should not necessarily represent the way the object appears, but should instead be made by layering different characteristics of your subject. Make many thumbnail studies to investigate compositional possibilities before beginning a final drawing.

Criteria:

1. An interesting variety of objects should be selected for each still life.
2. The first thumbnail study should show evidence of an intriguing still-life arrangement of regular forms.
3. The second thumbnail study should show evidence of an intriguing still-life arrangement of irregular forms.

Criteria:

1. Objects should be chosen and arranged based on symbolism.
2. Thumbnail studies should record a variety of different compositions and viewpoints.
3. The method shown in "A Still-Life Drawing Demonstration" should be used effectively.
4. There should be a refined use of color in the drawing.

Criteria:

1. Sketchbook research should be relevant and extensive.
2. Thumbnail studies should investigate many compositional alternatives.
3. The non-observational drawing should exhibit risk-taking and the willingness to experiment with inventive approaches to drawing objects.
4. Layers of different characteristics of the subject should be present.

Materials: Sketchbook and optional media

Materials: 18 × 24" paper, a variety of hard and soft pastels

Materials: 18 × 24" paper, any color media or mixed media

Chapter 15

Drawing the Human Figure

Drawings that depict people or are inspired by the human figure are often representational. When depicting oneself or others, one experiences an unconscious emotional response that can generate strong personal expressions. For the viewer, a **figure drawing** (or **life drawing**) offers the opportunity to reflect and identify with others. Such empathetic feelings naturally occur in most people.

Drawing the human form is inherently challenging. Traditionally, the figure has been seen as the pinnacle of difficulty and achievement in Western art. In addition to being a complex structure, the figure has an energy that sets it apart from inanimate objects. The human body is active and vital, and it is this animation that gives life to form. Capturing the life in a figure drawing is difficult to do: a life drawing should combine the structure and anatomy of the figure with the gesture and nervous energy of the artist. With every pose or positioning of a figure, new sets of challenges await.

Life drawing or **figure drawing** The study of the human form, usually based on observation of a live model.

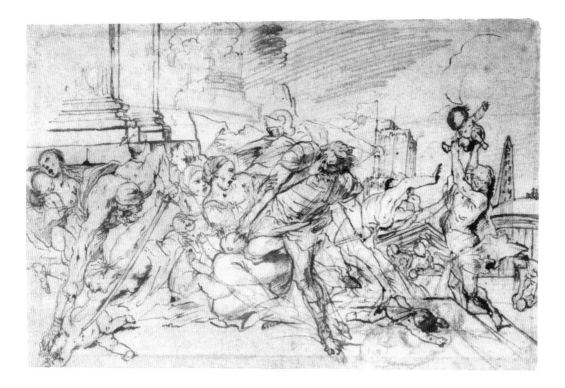

15.1 Pietro Testa, study for *The Massacre of the Innocents*, c. 1638-40. Pen over black and red chalk on paper, 7 × 10¼" (17.7 × 25.9 cm). National Galleries of Scotland, Edinburgh
This drawing depicts the biblical story of the Massacre of the Innocents. Stories from the Bible were regularly used as subject material for artists during the Renaissance. This sketch uses figures and the way they interact to tap into the viewer's innate ability to empathize.

Communicating Human Experiences

Because drawing is a means of communicating human experience, the human figure is a central and enduring theme in the visual arts. Nevertheless, there have been changes in the handling of the figure over time. Generally, such changes reflect the distinct time period and culture of the artist. This can be verified by looking at the diverse figure drawings reproduced in this book. In the past, figurative art was often dictated by academic philosophies, religious principles, or both. Many artists today have unconstrained creative freedom and can incorporate the figure into their work as they wish.

In his study for *The Massacre of the Innocents*, Pietro Testa (1612–1650) illustrates the horrifying biblical story of the mass slaughter of infants in Bethlehem at the time of Jesus' birth; fearing a prophecy that a new king has been born, Herod the Great is said to have ordered the massacre shown here (**15.1**). It is a scene frequently depicted in art from the Middle Ages onward. Testa presents the figures of the desperate mothers and dead and dying infants with powerful gestures that heighten the sense of tragic human experience.

In addition to working as a production designer for films, Kerry James Marshall (b. 1955) has distinguished himself as an important American figurative artist through his masterful depictions of the African American experience. Born in the segregated South, Marshall was raised amid racial turmoil in Watts, Los Angeles, where racial tension led to riots in 1965. His work evinces a strong sense of social responsibility, according respect and dignity where they have long been denied. By asserting his own humanity, he makes an empathetic and emotional connection with the viewer (**15.2**).

15.2 Kerry James Marshall, *Untitled*, 2004. Mixed media on paper, 30 × 44¼" (76.2 × 112.4 cm). SFMOMA, San Francisco, CA
Figurative drawings have the exceptional ability to communicate personal and shared life experiences. Marshall combines personal, cultural, and national history, as well as the history of art, in his accounts of the black experience in America.

15.3a and **b** (above and above right) Trisha Brown performing
It's a Draw/Live Feed, 2003

15.3c Trisha Brown, *Untitled*, 2007. Charcoal and pastel on paper,
51⅞ × 58⅛" (131.8 × 147.6 cm). Collection of the artist
Often, figurative drawing is about the life of the body. As a choreographer
and dancer, Brown reflects on gesture through performance. Here, she
captures her movements directly in her drawing.

15.4 Diane Victor, *Fader III*, 2010. Ash on paper, 54 × 38" (137.2 × 96.5 cm). David Krut Projects, New York

Victor often derives images from the media coverage of atrocities. Her characters seem stunned with deadened stares. The fragility of her drawing medium—ash—is a comment on the fragility of her subject.

Drawing the figure taps into who we are as physical, living beings. To capture her own gestures directly, the choreographer and dancer Trisha Brown (1936–2017) made drawings by moving across large sheets of paper while gripping pastels, charcoal, and graphite with her hands and feet (**15.3a** and **b**). Like her dancing, her drawing explores improvisational and unconscious movement. Her full-body "self-portraits" seize upon the relationship between the active body and its traces of energy in space (**15.3c**).

Some contemporary figurative artists use content and media to send a message. Diane Victor (b. 1964) uses the figure to comment on contemporary affairs in South Africa, her home. Her drawings often deal with violence and corruption, featuring people at vulnerable moments in their lives. She uses delicate ashes to draw her images, echoing the fragile nature of human existence (**15.4**).

Jinju Lee (b. 1980) uses the figure to depict troubling memories. Preoccupied by the resurgence of disturbing thoughts and feelings from the past, her symbolic compositions result from recomposing sketches of objects that linger in her mind. Her refined drawing skills facilitate visual storytelling (**15.5**).

15.5 Jinju Lee, The *Material of Mind*, 2010. Korean traditional pigment, animal skin glue, and water on linen, 59 × 59" (150 × 150 cm)

Drawn from memories, this image conjures uncomfortable events from the artist's past. The items may seem random to the viewer, but they are symbolic to her. Her color renderings of figures and objects are drawn with sensitivity to detail.

The Work of Art Artemisia Gentileschi

Who: Artemisia Gentileschi
Where: Italy
When: c. 1613
Materials: Black pencil on paper

Artistic Aims

Artemisia Gentileschi (1593–c. 1656) was an Italian Baroque painter. Her work emphasized realism and dramatic lighting, as was typical of the period. She found guidance and encouragement early in life, in her father Orazio Gentileschi's studio. By the age of sixteen she was producing exceptional work. Although at the time many women were allowed to assist in artists' studios, it was not easy for them to have successful independent careers.

Artistic Challenges

Gentileschi faced exceptional challenges. She was raped by one of her father's assistants, Agostino Tassi. Gentileschi was tortured during the 1612 trial in an attempt to verify her testimony. After the trial, Gentileschi's reputation was restored; she married another painter, Pietro Stiattesi, and the couple moved to Florence.

Although illiterate, Gentileschi nonetheless flourished and became, in 1616, the first female painter to be accepted into the Accademia delle Arti del Disegno in Florence.

Despite pressure to pursue less prestigious genres, which were also less lucrative, Gentileschi focused on religious and historical figurative compositions throughout her life.

Artistic Method

Perhaps reflective of her own life, Gentileschi painted many pictures of determined and suffering women from biblical and mythological stories. To do this successfully she made drawings

15.6 Artemisia Gentileschi, *Self-Portrait*, c. 1613. Black pencil on paper, 10⅜ × 7½" (26.4 × 19.1 cm). Private collection

15.7 (below) Artemisia Gentileschi, *Self-Portrait as a Lute Player*, c. 1615–18. Oil on canvas, 25¾ × 19¾" (65.5 × 50.2 cm). Wadsworth Atheneum Museum of Art, Hartford, CT

in preparation for her paintings, and sometimes used herself as a model. As we see in her self-portrait drawing in **15.6**, she appears to practice capturing an emotional intensity. The same power and strength can be seen in the figure in her painting (**15.7**). The tilt of her head, expression on her face, and dramatic lighting are all techniques that Gentileschi commonly employed to realize her powerful themes.

The Results

For many years most of Gentileschi's works were attributed to her father, or generally disregarded. Rediscovered during the twentieth century, today she has found her place among the great artists of the Baroque period. The first exhibition of her work was held in 1991.

Sketchbook Prompt

Use a mirror to create a figure drawing of yourself.

Life Drawing

Life drawing and figure drawing are interchangeable terms used to describe a drawn study of the human form in its various poses. Typically, the depiction of the live model is the primary objective. The ancient Greeks were probably the first to study live models and carefully observe the nude figure. The Greeks saw in the human figure the ideal form. The idealized male nude embodied not only physical superiority, but also virtue and moral excellence; the idealized female figure embodied beauty and grace. As they became increasingly interested in accurately depicting the human physique, Greek artists utilized models to inspire their depictions of conceptually perfect figures. This outlook of celebrating the nude body was not typical around the world. In most time periods and cultures nudity has long been considered shameful.

Artists looking for greater realism and eager to revive Classical learning resumed using live model studies for their work during the Renaissance. In 1563, Cosimo I de' Medici (1519–1574), a Florentine banker and benefactor of the arts, founded the first academy in Europe, the Accademia delle Arti del Disegno, or Academy of the Drawing Arts. The Academy offered the opportunity to study anatomy and to draw from life models. Among its well-known members were Michelangelo (b. Michelangelo Buonarroti, 1475–1564) and Artemisia Gentileschi, its first female member, who was accepted in 1616 (see opposite).

Upon the establishment of the Academy, drawing the nude became an essential part of training for visual artists. It was not, however, always fully accepted. During the Victorian era, for example, discretion sometimes required that female nude models pose with their faces draped. A drawing by Thomas Eakins (1844–1916) from around 1863–66 records one such drawing session at the Pennsylvania Academy of the Fine Arts (**15.8**). The effect of masking the woman's face while exposing her body to the male gaze tends to disturb the modern viewer.

During the twentieth century, the art world distanced itself from the academic tradition, yet the practice of figure drawing endured. For such artists as the American Abstract Expressionist Joan Mitchell (1925–1992), life drawing remained a core discipline. The fierce linear and tonal marks that Mitchell used in such life drawings as **15.9** are the same kind of marks that freed her later abstract works.

Today, life drawing remains the best path to understanding the human form in depth, and to training oneself to observe and render

15.8 Thomas Eakins, *Study of a Seated Nude Woman Wearing a Mask*, 1863–66. Charcoal and crayon with stumping on paper, 24³⁄₈ × 18³⁄₈" (61.8 × 46.7 cm). Philadelphia Museum of Art, PA

This drawing reminds us that while artists have long valued the practice of drawing from the nude, during some time periods and in some cultures, notions of discretion and modesty, particularly in regard to women's behavior, have been important considerations.

15.9 Joan Mitchell, *Untitled (Nude Study)*, 1944–46. Charcoal on paper, 25 × 19" (63.5 × 48.3 cm). Private collection

The marks in this drawing are fast and expressive. This work from a nude model was probably made during a limited-time work session. Working quickly encourages mark-making that suggests life and movement. Artists often choose to start model sessions with fast drawings before they begin to work from longer poses.

TIP

Empathize with the figures that you draw. Before drawing a figure, make the subject's pose yourself. Notice which areas of the body are stretched and where most weight is placed.

Contrapposto A pose in which the upper part of the body twists in one direction and the lower part in another, with most weight placed on one leg.

complex forms. A dedication to drawing the nude model rewards an artist with heightened visual sensitivity and a stronger grasp of truth and reality.

Working with a Model

Working from a live model in a studio session can be done in various ways, depending on the needs of the artist. In art schools and studios, models are usually posed on a raised platform in order to position the figure at eye level. Poses may be timed to be under a minute for gestural exercises, or may last for hours or even weeks for prolonged projects. Often, sessions start with shorter poses and then progressively increase in length in order to provide a variety of drawing opportunities. Drawings made from very short poses are seldom intended as final artworks. They do, however, offer an effective way to develop a spontaneous understanding

of the body's movement, stress, and balance in various poses. Many artists use short poses at the beginning of a drawing session to warm up and relax their bodies. Longer poses afford the luxury of time, which can be used to work out more complex drawings. While posing, a model is expected to remain essentially motionless and, ordinarily, silent. Life drawing is an activity that requires a high level of concentration. To accommodate a model's physical limitations, five- or ten-minute breaks are taken regularly. Before pausing for a break, chalk marks or masking tape can be used to mark the model's position. This helps him or her to resume the same position. When working from the model, artists are expected to maintain a sense of professionalism and decorum, and the process involves mutual trust and respect. Generally, photography is forbidden.

A variety of poses—such as reclined, prone (lying flat), sitting, or standing—can be agreed upon between the artist and the model. Multiple figures are sometimes used. **Contrapposto**, meaning "against position" in Italian, is a standing pose in which most of the figure's weight is placed on one leg, while the other is bent at the knee. With this shift in weight, the hips face in one direction, and the shoulders and head tilt in another, giving the figure a relaxed look. It can be seen in much Classical sculpture, and was revived in the Renaissance. This dynamic pose embraces a curving axis and provides an asymmetrical balance. If captured in a drawing, these subtle changes suggest the potential for movement and appear to imply life.

There is a lot to learn from the way Colleen Barry (b. 1981) handles the *contrapposto* pose. Her drawing in **15.10** is sensitive to the changing directions of body masses. Here, the shoulders drop to the left and the pelvis to the right, preventing a stiff and unnatural figure drawing.

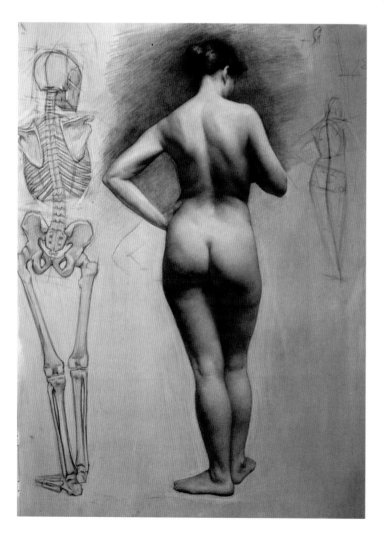

15.10 Colleen Barry, *Female Nude with Skeleton*, 2010. Graphite on toned paper, 24 × 18" (61 × 45.7 cm). Private collection
This life drawing exhibits the traditional *contrapposto* pose. With most of the model's weight placed on one leg, the hips tilt in one direction and the shoulders tilt in the opposite. This shifting of the body has been analyzed in the skeleton drawing on the left and the basic structural drawing on the right, and is enhanced by the value rendering in the middle.

Drawing at Work Ginny Grayson

15.11 Ginny Grayson, *Rest*, 2009. Charcoal on paper, 30½ × 44⅛" (77.5 × 112.1 cm). Kedumba Collection, Wentworth Falls, Australia

Born in 1967 in Palmerston North, New Zealand, Ginny Grayson was trained in film and media studies. Now, Grayson spends most of her time drawing from life models, memory, sketchbook drawings, and photographs.

Grayson's models are not professional studio models; rather, they are friends or family who volunteer their time. She is inspired by the energy and changes that occur in front of her. Grayson prefers long poses and likes to stand when drawing. As her subjects slump and tire, as can be seen in the resting figures of **15.11**, her drawings shift and change, too. She relishes

the way that her charcoal marks become representational and conversely, in other areas, her subject becomes unrecognizable. She seizes upon unintended marks and mistakes as part of her process. Lines are repeatedly smudged away and new delineations are made. Ghostly erased areas remind us of how fleeting singular moments are.

Just as her drawings are developed progressively, the finished images gradually reveal themselves to the viewer. Grayson's drawings shift between representational portrayals and abstracted constructions. Some

forms convincingly occupy space, while others seemingly fade into the atmosphere. In addition to capturing a sense of identity, her drawings seize upon the transience of her sitters.

TIP

Begin figure-drawing sessions with quick, thirty-second gestures. Working quickly will foster expressive mark-making and will help you to realize the directional movement of the entire pose better.

Construction of the Figure

Artists can take a variety of different approaches when drawing the human figure. These can be used whether drawing from the model, from photographs, or from imagination. When constructing a figure, artists most often use one of three approaches: **linear construction**, **box construction**, or **spherical construction**. Sometimes these methods are combined. Each has been proven effective by artists throughout history. To use these methods successfully, the artist must consolidate the details of a subject into their simplest essential forms. Once the fundamental structure of the body is established using one of these methods, the artist can sight and measure, add layers and detail, and refine the drawing to resemble the human form more closely.

Linear Construction

Using a linear construction in the beginning stages of a figure drawing is not only an excellent way to establish the placement of parts, but it can also create flow and movement. Linear gesture, as discussed in "Gesture Drawings: Both Process and Independent" (Chapter 2, p. 42), is perfectly suited for this first stage of a figure-drawing construction. This can be accomplished as a loose linear exploration, or with a more schematic line gesture. Both approaches to linear construction are valuable.

David Hewitt (b. 1970) creates many of his figurative drawings using a loose linear exploration (**15.12**). Notice the manner in which he works from the general to the specific. When using this approach, for most poses it is best to start with the head and neck and then move down the form into the torso. The drawn lines wander through the figure, establishing a visual flow. One line leads the viewer on to the next. As Hewitt "finds" the figure through scribbled and searching lines, his marks become darker and more permanent. The final drawing retains the life and energy of the preliminary construction.

15.12 David Hewitt, *Life Drawing*, 2015. Charcoal on 100-year-old gold-edged A3 drawing paper, 16½ × 11¾" (42 × 29.7 cm). Private collection

This figure drawing exemplifies a loose linear exploration method of figure construction. For the duration of the drawing, the lines meandered loosely across the forms of the body. In the beginning lines were made lightly, followed by darker lines as the drawing evolved.

Linear construction
In a drawing, the use of lines to construct forms.
Box construction
The construction of forms in a drawing using box-like forms.
Spherical construction
The construction of forms in a drawing using rounded forms.

Gateway to Drawing Burne-Jones, *The Tomb of Tristram and Isoude*
Figure Drawing for a Stained-Glass Window

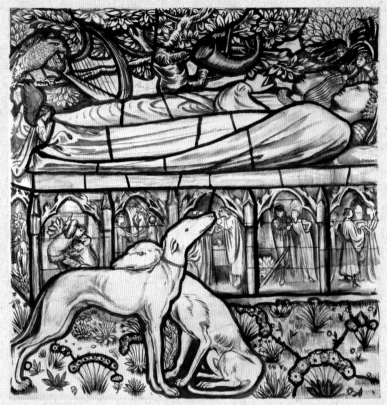

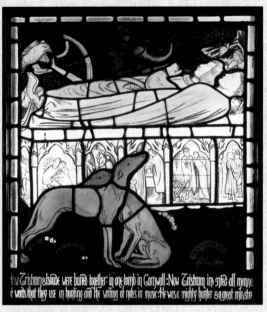

15.13 Edward Burne-Jones, design for *The Tomb of Tristram and Isoude*, 1862. Indian ink and brown wash over pencil, 25¼ × 25¼" (64.1 × 64.1 cm). Birmingham Museum and Art Gallery, England

15.14 Edward Burne-Jones, *The Tomb of Tristram and Isoude, c.* 1862. Stained glass, 26¾ × 23⅞" (68 × 60.5 cm). Bradford Museums & Galleries, England

Edward Burne-Jones (1833–1898) brought superb storytelling abilities to all of his projects. The dream-like moods that he created, most often based on biblical or historical subjects, were steeped in romance. For him, figure drawing was the most important way to express a vision. In fact, figure drawing was so vital to his work that he advocated it as a basic and essential part of training for young designers.

Burne-Jones's preliminary drawing *The Tomb of Tristram and Isoude* was the plan for one of a series of thirteen small stained-glass windows. These were installed into the home of a wealthy textile merchant. The series depicts scenes from the medieval story of Tristram and Isoude, a tragic tale of the adulterous love affair between a Cornish knight, Tristram, and an Irish princess, Isoude. Burne-Jones's figurative drawing depicts Tristram and Isoude's tomb, where they were laid to rest at the end of their lives. Around the tomb are symbols of Tristram's knighthood, such as an eagle representing his bravery, and flowers and hunting dogs are included to signify events that took place during Tristram and Isoude's lives.

Burne-Jones's work can be appreciated as a figure drawing, independent of the window that it prefigures. Burne-Jones used the figure to communicate human experiences. We can see his attention to lifelike proportions and accurate anatomy of the figure. Bold outlines and delicate rendering are carefully balanced to describe the subjects. These opposing approaches to applying ink complement each other and add to the strength of the design. The drawing is filled with large and small figures that symbolically tell the story of Tristram and Isoude's tragic and romantic love.

For the other *The Tomb of Tristram and Isoude* boxes, see p. 28 and p. 176

15.15 (above) Schematic linear gesture

A figure drawing can be made using a schematic line gestural approach. In this drawing the focus is not on the outline of the form; instead, the artist emphasizes the essential movements of the figure. Making a series of these very quick drawings can help you to understand the motion and presence of a pose better.

15.16 (above right) Student work. Atakan Basol, *Box Construction*. (Instructor: Jeff Markowsky)

Box construction can be used to develop a figure in a drawing. Working quickly, this student drew cubic forms to represent the major body parts as well as the overall pose of the figure.

The rapid drawing in **15.15** is an example of a schematic line gestural approach to figure construction. This drawing was made spontaneously. When using this approach, begin by making strong, deliberate marks in response to the largest directional movements of the body. Arms and legs can then be added. The intent of this part of the drawing is to show the action of the pose. Interior lines can express the posture and movement of the figure. Outside contours sometimes follow the directions of the inside lines, increasing the directional flow. In other places, outside lines can oppose the inner line directions, creating forceful dynamism. This type of drawing is driven by an understanding of the pose. From the sweeping marks, the figure emerges.

Box Construction

The complex forms of the human body can be represented as combinations of simple cubic forms. This construction method requires you to analyze and conceive of body masses in an abstract way. Front and side planes make reference to the volumetric anatomy of the figure. Blocks vary in direction, reflecting the shifting masses.

The drawing in **15.17** demonstrates the initial step of this construction method.

As in this example, the drawing should be made freehand, not using a straightedge. Also, the geometric forms should be drawn as transparent forms in order to understand the complete volume of the figure. Using this type of construction helps to define the figure as

15.17 Box construction

When applying the box construction method, conceive of the large body masses as cubic forms. If the model's head, upper torso, or pelvis area tilt, then the drawn box shapes that represent these forms should do so too. This is a particularly good construction method when you intend to emphasize volumetric form.

15.18 Luca Cambiaso, *Group of Cubic Figures*, n.d. Pen and bister (brown pigment) on yellowish paper, 13⅜ × 9½" (34 × 24 cm). Uffizi Gallery, Florence, Italy

The box construction method is used in this drawing to create a grouping of figures. Cambiaso uses this abstracted approach to establish form and space in a convincing manner. With box figures, it is easy to conceive of a consistent light source, as the planes facing the light will display the lightest value. Here, the light is coming from the left.

a three-dimensional object, and clarifies spatial relationships in the drawing. This later helps with the visualization of perspective as well as light and shadows.

In the 1560s, Luca Cambiaso (1527–1585) became interested in the novel idea of reducing the human figure to the simplest of structures. His drawings include perfect examples of the box figure construction technique (**15.18**). Cambiaso not only established volume and space with this approach, but also created strong movement and powerful drama. He learned this technique by studying masters that came before him, passed it down to his pupils, and it has subsequently become an important consideration for artists.

15.19 Spherical construction
When applying the spherical construction method, visualize body parts in terms of rounded forms. Each spherical shape changes direction depending on the nature of the pose. Collectively, the rounded parts can show proportion, volume, and movement of the figure.

15.20 Raphael, *Studies for a Virgin and Child, c.* 1506–7. Pen and brown ink over traces of red chalk, 10 × 7 ¼" (25.3 × 18.3 cm). British Museum, London, England
Notice how this Renaissance master develops figures using the spherical construction method. Compare and contrast this drawing with the drawings of Cambiaso (**15.18**, p. 301) and Hewitt (**15.12**, p. 298). Flip through this text to find other figurative works. What method of construction was used to develop the figures in them?

Spherical Construction

A preliminary foundation for a figure drawing can be fashioned from spherical and ovoid forms (**15.19**). These should be understood as volumes, not flat circular shapes. As with the box method, this construction method forces you to envision the details of complex forms as parts of a simple geometric whole. Notice that the spheres and ovoids are shaped differently in order best to represent the head, rib cage, pelvis, and extremities. It is the combinations of these forms and the relationships between them that replicate the dynamic structure of a pose.

Raphael (1483–1520), a Renaissance Italian painter and architect, used spherical and ovoid forms in the early stages of his figure drawings. In this page of energetic studies, he draws initial ideas for a painting (**15.20**). Raphael combines and overlaps a series of spheres to establish the volume and movement of the figures. With grace and ease, he uses simple rounded forms to represent the complex body masses.

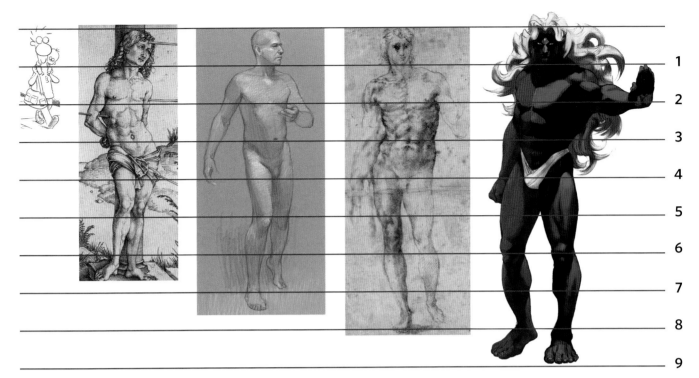

1
2
3
4
5
6
7
8
9

15.21 Proportions of five drawings: Rick Kirkman and Jerry Scott, "Darryl and Wren on shoulder," from *Baby Blues*; Albrecht Dürer, *Saint Sebastian Bound to the Column*; Dan Gheno, *Gesturing Male Figure, Walking*; Michelangelo, *Standing Male Nude*; Takashi Nishiyama and Hiroshi Matsumoto, "Gill" from the video game *Street Fighter*
The proportions of a figure are often worked out based on the size of the head, and can be changed to accommodate the desires of the artist. This diagram compares the proportions of five different drawings of figures. While all people are slightly different in real life, an average person is, when measured from the front, about 7½ heads high, as represented in the central drawing of this diagram. This diagram demonstrates how artists can choose to make decisions about proportions to suit their intentions.

TIP

Even when a figure is not standing upright, we can still use the head as a measuring increment. Measure carefully. Everybody is different and measurements vary depending on the pose and the artist's point of view.

The Proportions of the Figure

Drawing the figure requires an awareness of the proportions of the subject and how those proportions can be represented in a drawing. The unit of measurement used for drawing the human figure is the head. This unit is the distance from the top of the head to the underside of the chin. Although anatomical proportions vary among people, the usual height of a standing person viewed frontally is close to 7½ heads high, including the head. But just as the proportions of the figure can be measured for the sake of realism, proportions can also be manipulated for artistic and aesthetic purposes. For example, in **4.35** (see p. 114) we saw how Leonardo da Vinci (1452–1519) extended the height of the figure shown in *Vitruvian Man* to eight heads high in order to bring it in line with what were considered to be ideal geometric proportions.

In **15.21** five figure drawings by five different artists are scaled in order to make each figure's head the same size as the heads in the other drawings.

The drawing in the center by contemporary artist Dan Gheno (b. 1955) represents a figure measuring 7½ heads high. For most modern viewers, this figure appears to be naturally proportioned. To the left of Gheno's drawing is a work by Albrecht Dürer made in 1499. This figure measures 6½ heads and reflects the northern European aesthetic of the time. To the right of Gheno's drawing is Michelangelo's *Standing Male Nude*, measuring eight heads. This type of powerful and idealized appearance was Michelangelo's preference. Finally, on each end, we can see how artists can exaggerate proportions for effect; the mistake-prone Darryl from the comic *Baby Blues* measures less than three heads high while Gill from the video game *Street Fighter* is larger-than-life, at more than nine heads high.

Artistic Anatomy

As you delve deeper into the complex task of drawing the human form, there comes a point when you will wish to make sense of the lumps and bumps on the surface. Bones, muscles, and body fat, which together are known as the anatomy of a body, play a huge part in determining the body's outward appearance. Anatomy is a tool that can help give meaning to what you observe. Understanding what lies beneath the skin empowers you to draw the human form with insight and awareness, enriching the expressive act of drawing.

15.22 Diagram of the human skeleton
This skeleton diagram identifies the bony landmarks on the body. These points can usually be seen through the skin and can be used to identify anatomical features. They also make strategic points from which to sight and measure. The blue annotations show every bony landmark, and the arrows identify those that are most helpful to an artist when life drawing.

The Skeleton and Bony Landmarks

The human body is filled with **bony landmarks** that can guide a life drawing and help establish points from which to sight and measure. These points are part of the skeletal system that can be seen through the skin. You can think of these landmarks as station points, or visual clues, that can aid in the development of a life drawing. Bones are helpful landmarks because they do not change extensively between different body types. The skeletal structures of thin and overweight individuals are essentially the same.

Strategic landmarks on the skeletal system are identified in **15.22**. It can be very helpful to identify these points on your own body, or on a model or skeleton, before using them as landmarks in your drawing.

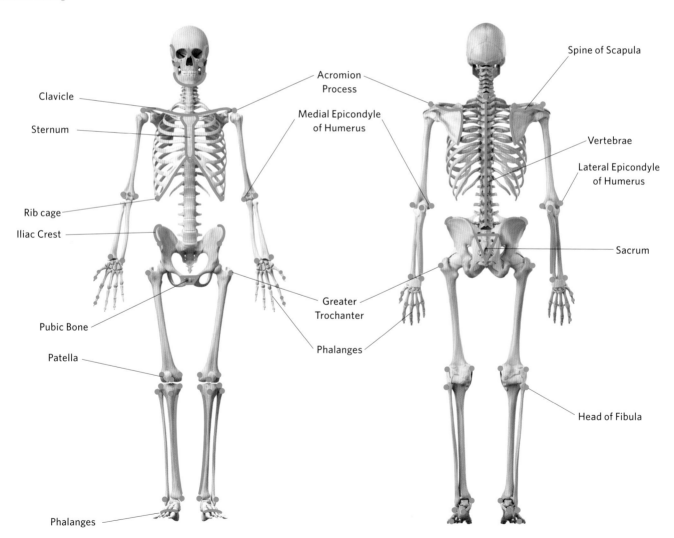

Clavicle
Sternum
Rib cage
Iliac Crest
Pubic Bone
Patella
Phalanges

Acromion Process
Medial Epicondyle of Humerus
Greater Trochanter
Phalanges

Spine of Scapula
Vertebrae
Lateral Epicondyle of Humerus
Sacrum
Head of Fibula

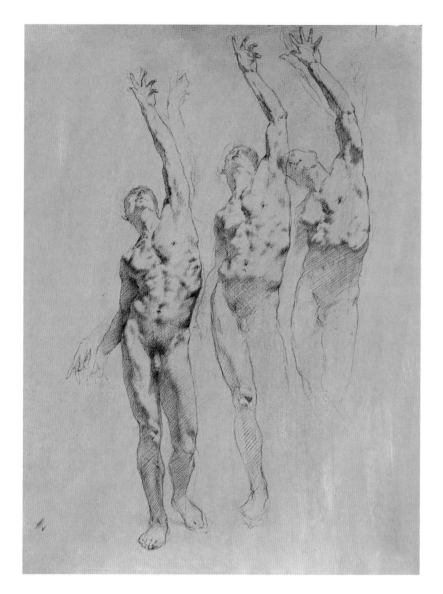

15.23 Robert Liberace, *Reaching Figure*, n.d. Silverpoint and wash on paper, 10 × 8" (25.4 × 20.3 cm)
It is clear from this drawing that the artist has an in-depth understanding of anatomy. Compare this drawing with the skeleton diagram opposite. Can you identify bony landmarks that the artist has included?

Robert Liberace (b. 1967) is a realist artist working in both sculpture and painting. He has an appreciation for Old Master techniques and an in-depth understanding of anatomy. Bony landmarks can be identified throughout his silverpoint-and-wash drawing *Reaching Figure* (**15.23**). These details add anatomical accuracy, and also contribute to the vitality of the drawing.

As well as helping the artist to understand the human figure as a whole, anatomy also plays an important part when it comes to drawing individual body parts, as demonstrated by this drawing of two hands by Henry O. Tanner (1859–1937) (**15.24**). His knowledge of skeletal anatomy not only helps him to create a feeling of realism, but also establishes an elegant expressiveness.

15.24 Henry O. Tanner, *Study of Two Hands*, n.d. Charcoal on paper, 7 × 11 ¾" (17.9 × 30 cm). Smithsonian American Art Museum, Washington, D.C.
By carefully observing and drawing parts of the body in isolation, we can discover how anatomy dictates the forms that we see. Tanner's depiction of the hands in this drawing illustrates that each finger is made up of multiple sections. This is because fingers are formed by several individual bones (called phalanges). This drawing captures their flexibility.

Muscles and Body Fat

An elementary understanding of muscles and body-fat tissue can be invaluable when drawing the figure. Even though the size and form of muscles and body fat can vary dramatically between different body types, their general areas of distribution do not. Considering these parts of the human form helps you to comprehend how the regions of the body connect, while articulating them lends believability to a figure drawing.

The human muscular system is shown in **15.25**. While studying muscles is a complex endeavor, the most important thing is to understand their locations and shapes, including how muscles change when they are stretched, relaxed, or flexed.

Luca Signorelli (1445–1523), a noted Renaissance draftsman, paid great attention to anatomy. He was able to execute the muscles in his drawings without overemphasizing them, a common problem found in beginner figure drawings. In his chalk drawing *Nude Man From Rear*, he emphasizes the pit of the erector spinae, the roundness of the gluteus, and the two external obliques found above the iliac crest on both sides (**15.26**). The muscles of the legs—including the quadriceps, the gastrocnemius, and the soleus—have also been suggested.

15.25 Front and back muscular system
Knowledge of the muscular system can enhance your ability to draw the figure in a convincing manner. Studying the location and shapes of muscles can help you to develop the structure as well as the subtle details of the human form in your drawings.

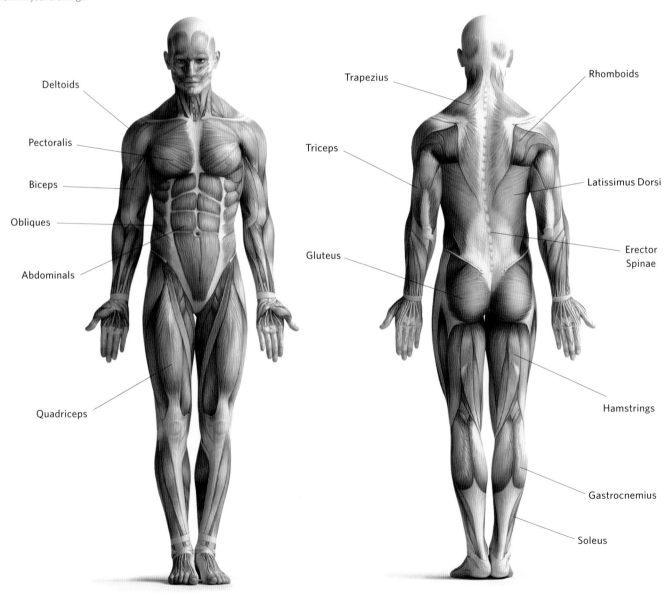

Deltoids

Pectoralis

Biceps

Obliques

Abdominals

Quadriceps

Trapezius

Triceps

Gluteus

Rhomboids

Latissimus Dorsi

Erector Spinae

Hamstrings

Gastrocnemius

Soleus

15.26 Luca Signorelli, *Nude Man from Rear*, 1504. Black chalk, 16¼ × 10" (41.2 × 25.3cm). Musée du Louvre, Paris, France
Muscular anatomy is evident in this drawing, and the artist clearly relied on it to develop the figure. Use the diagram of the muscular system, opposite, to identify the muscles in this drawing. How many muscles can you recognize?

There is often a layer of fat between the muscles and the skin that can play an essential role in shaping the volume and girth of the body. This layer of fat is not evenly distributed throughout the body, and in general is concentrated differently in men and women (**15.27**). In men, fat tends to affect the shape of the chin, chest, stomach, and buttocks; the stomach is most obviously affected in obese men. In women, fat tends to be concentrated in the chin, breasts, stomach, thighs, and buttocks. For obese women the width of the hips and buttocks is often noticeably increased. In both women and men, fat build-up can occur in the middle to upper area of the upper arm. Fat around the navel area is common in both sexes. It is one of the few fat deposits found even in very slim women.

15.27 Fat distribution in human bodies
Concentrations of body fat, or lack thereof, within the human body contribute to the outward appearance of the figure. Knowing where soft tissue most often collects enables us to understand and draw the figure better.

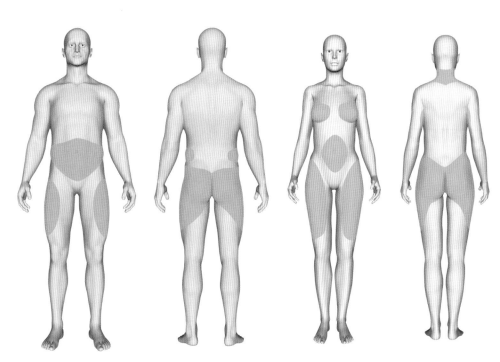

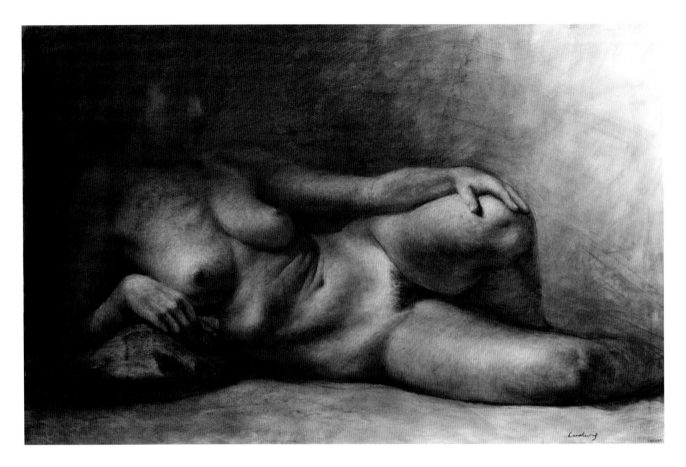

15.28 Daniel Ludwig,
Reclining Figure in Dark Space,
2006. Charcoal on paper,
26 × 40" (66 × 101.6 cm).
Collection of the artist
It is important to understand
and acknowledge soft tissue,
including muscles and body
fat, when drawing the human
figure. Here, the artist is able
to position and articulate
these parts of the anatomy
in a true-to-life manner.
Compare this image with
Eakins's drawing in **15.8**,
p. 295. While both women's
faces are concealed, the
relaxed pose in Ludwig's
work creates a far less
oppressive atmosphere.

Reclining Figure in Dark Space, a figure
drawing by Daniel Ludwig (b. 1959), displays
the artist's understanding of anatomical soft
tissues (**15.28**). The subtle rendering of muscles
and fat is important in the rich and naturalistic
depiction of this female figure. The partially
reclined pose is reminiscent of Classical
sculpture. This pose and the body type of the
model are ideal for the study of soft tissue.

Symmetry of the Figure

Most landmarks of the human body are
symmetrical about a centerline. The centerline
of the body as seen from the front runs from
the center of the head, through the neck,
sternum, and navel, and ends at the pubic
bone. From the back, the centerline is created
by the spine from the top of the neck down to
the tailbone.

As the torso twists, taking an asymmetrical
pose, the centerline significantly shifts. As such,
body parts that are found at right angles to
the centerline will also shift (**15.29**). Notice the
angles formed by the tilt of the shoulders, the

lower corners of the rib cage, and the corners
of the pelvis at the tips of the iliac crest.

The shift of the major bony landmarks of
the figure in an asymmetrical pose are shown
from the rear in **15.30**. Here, angles occur at the
shoulders, the line between the scapulas, and
the top of the iliac crest. The top angle of the
triangular-shaped sacrum can also indicate
the tilt of the pelvis. It is important to note that
shoulders and scapulas move independently
from the rest of the body, and the imaginary
lines between them are often not perpendicular
to the centerline.

Examine the drawing in **15.31** by Jacopo
Pontormo (1494–1557), a study for his painting
Deposition. Trace the curving centerline of the
figure from the head all the way to the ground.
Identify the many anatomical landmarks that
the drawing depicts, and note their relationship
to the centerline. Shoulders and scapulas move
independently from the rest of the body, and
the imaginary lines between them are often not
perpendicular to the centerline.

15.29 Shift in body symmetry (a)

15.30 Shift in body symmetry (b)
When standing perfectly straight, the human body is usually relatively symmetrical. This changes when the body changes position. The centerline shifts and major bony landmarks that were once directly across from each other now fall at angles to one another.

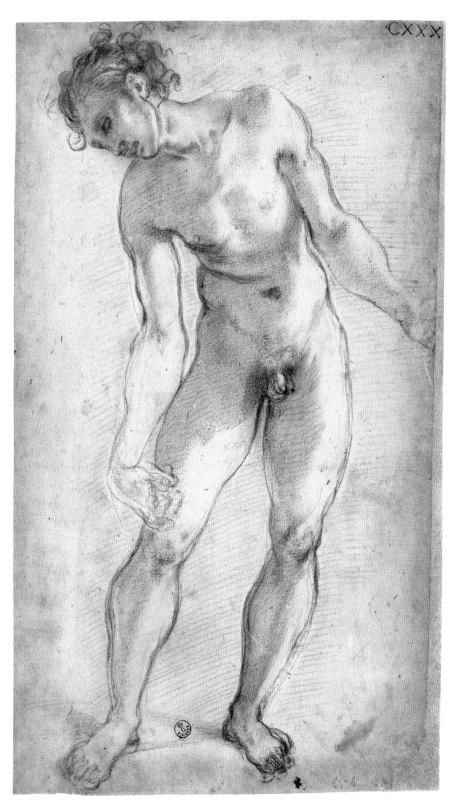

15.31 Jacopo Pontormo, study of a nude for the *Deposition* at Santa Felicita, 1525–26. Black chalk, black chalk wash, white lead on lightly browned white paper, 15⅜ × 8¾" (39 × 22.2 cm). Uffizi Gallery, Florence, Italy
Trace the centerline of the figure in this drawing. Consider the directional changes that take place throughout the body. Angles occur between each section of the figure: head and neck, upper torso, lower torso, and legs. Capturing these dynamic directional changes animates a figure drawing and gives it visual movement and rhythm. As is clear in the hand and feet, Pontormo does not need to overwork and refine every detail for the figure to feel lifelike and convincing.

A Figure-Drawing Demonstration

This life-drawing demonstration uses Don Gale's *Six Figure Composition* as an example of the linear-gesture construction technique. In this particular drawing we can see each step Gale used to develop the figure (**15.32**). The drawings were made from a model taking different poses.

15.32 Don Gale, *Six Figure Composition*, 1980. Lithograph pencil on paper, 13 × 20" (33 × 50.8 cm). Collection of the artist

1 Working with graphite very lightly, the artist draws the centerline of the figure as observed on the model. Notice the curving nature of the centerline in many of the figures.

2 Continuing with light, fast-moving lines, the artist develops the masses of the figure, including the head, neck, upper torso, hips, arms, and legs.

3 Going back over the preliminary construction, the artist darkens strategic contour lines. Special care is taken with the positions of anatomical landmarks, especially the angles between them.

In the Studio Projects

Fundamental Project

Draw people you see in public. Consider working in a well-populated area, such as a shopping mall, a park, or a train station. Use linear gesture to draw the poses of ten different figures.

Observational Drawing

This assignment can be carried out in the studio with a nude or clothed model. It can also be done by observing pedestrians in a public location; people waiting in long lines make excellent drawing subjects. In this assignment, draw multiple figures in three rows across the page. Orient an 18 × 24" sheet of paper vertically. Divide the page into three 8" rows. These lines will act as guidelines for the top and bottom of a standing figure. You may wish to subdivide the 8"-sections with 1"-marks (indicating 8 head measurements) in order to help with proportions. For each row, draw figures from observation while maintaining accurate proportions and correctly positioning anatomical landmarks.

Non-Observational Drawing

Think of an event from your own life. Who was there? What made it unique? In your sketchbook make a series of thumbnail studies considering compositions that would best communicate the event. Once you have arrived at a workable composition, make a finished drawing using the media of your choice on an 18 × 24" sheet of paper. Utilize one or more of the figure-construction methods outlined in this chapter (linear gesture, box, and spherical).

Criteria:

1. Drawings should be made with loose, searching lines.
2. Special attention should be paid to the shifts of the major bony landmarks in the pose.
3. A sense of movement and flow should be created in each drawing.

Criteria:

1. For the first row of figure drawings, you should utilize the linear-gesture construction technique. Use "A Figure-Drawing Demonstration," opposite, as a guide for the first line. Sight and measure to refine your drawing.
2. For the second row of figure drawings, you should utilize the box construction technique. Sight and measure to refine your drawing.
3. For the third row of figure drawings, you should utilize the spherical construction technique. Sight and measure to refine your drawing.

Criteria:

1. A series of thumbnail studies should be produced focusing on composition.
2. The drawing should incorporate two or more figures.
3. You should successfully utilize figure-construction methods outlined in this chapter (linear gesture, box, and spherical).

Materials: Sketchbook and optional media

Materials: 18 × 24" paper (or sketchbook if drawing on location), soft graphite pencils

Materials: 18 × 24" paper, optional media

Chapter 16
Portraiture

Portraiture, a specialized genre of life drawing, can be defined as the art of creating a pictorial likeness, usually concentrating on the face. It seeks to present a unique individual, focusing on his or her distinguishing features. Portraiture offers the artist the chance to fulfill the intrinsic desire to preserve and record those around us; very often, our subjects are those we admire or love.

This chapter will introduce you to different approaches to portraiture. You will learn about the natural structure of the head, and this will enable you to draw portraits with convincing likenesses, and perhaps create ones that tell a story.

Portraiture A specialized genre of life drawing involving the creation of a pictorial likeness, usually concentrating on the face.

16.1 Cesar Santos, *Head Study*, 2016. Charcoal and crayon on paper, 25 × 19" (63.5 × 48.3 cm). Private collection

This portrait combines different drawing styles in a visually cohesive way. The face is realistically rendered, while the lower portion of the drawing is a colorful array of decorative patterns. The yellow paper provides both a unifying effect and a dramatic backdrop.

16.2 (above right) Student work. Stephanie Tarascio, *Girl, Red.* (Instructor: Victoria Paige) Digital media can be an excellent way to create a portrait. This is evident in this student work that combines the realistic rendering of facial features with simplified red shapes that suggest the hair and clothing. Together, these different approaches create a dramatic depiction of the subject.

Approaches to Portraiture

Portraiture is an art form going back at least five thousand years. In the art of ancient civilizations around the world, such as those in Egypt and Mesopotamia, depictions of rulers, gods, and various tradespeople were common. While specific people were depicted, however, there seems to have been little attempt to create individual likenesses. Instead, it was considered important to adhere to stylistic conventions, such as the depiction of people in profile or as simplified figures. Unfortunately, relatively few of these earliest portraits exist today, and drawings are especially scarce.

Approaches to portraiture have changed over time. The individual likeness of the subject has become increasingly important in portraiture. In fact, while portraiture of today fundamentally deals with the sitter's external likeness, many modern portraitists even seek to depict the uniqueness of inner identity. Identity can encompass character, personality, profession, ethnicity, social standing, age, gender, and many other qualities. These qualities can often be suggested only by visual clues.

Of course, different artists have distinct approaches when working to create likeness and identity. This can be seen in Cuban-American artist Cesar Santos's (b. 1982) distinctive *Head Study* (**16.1**), in which a classical rendering of his sitter's features gives way to colorful childlike scribbling. This approach differs substantially to that of Alice Neel (1900–1984), whose style was uniquely her own. In her black pen-and-crayon portrait of the fellow artist Dorothy Cantor Pearlstein, Neel combines heavy meandering lines with bold applications of value (**16.3**, p. 314). Both Neel and Santos focus on capturing the likeness and identity of their sitters, but each in their own way.

The Work of Art Alice Neel

16.3 Alice Neel, *Dorothy Pearlstein*, 1973. Black fiber-tipped pen and black crayon, heightened with white on heavily textured, ivory wove paper, 40½ × 25¾" (102.9 × 65.4 cm). Art Institute of Chicago, IL
Neel draws her friend's external likeness with honesty and compassion. The drawing also conveys an inner essence of the sitter. Working to capture both the outer and inner uniqueness of an individual is a primary concern in modern portraiture.

Who: Alice Neel
Where: United States of America
When: 1973
Materials: Black fiber-tipped pen and black crayon, heightened with white

Artistic Aims

Alice Neel believed that making portraits was her way of recording history. Her portraits were more than first impressions; they also represented the era in which they were made. She tried to capture the unique qualities of her sitters. As Neel's subjects were often friends, neighbors, and acquaintances, there was usually an element of personal intimacy between her and her sitters. This was reflected in her work.

Artistic Challenges

In the middle of the twentieth century the art world was focused on abstraction, and Neel's devotion to realist and expressionist portraiture made her an outsider. During this time, the traditional values of portraiture were considered outdated and outmoded. Less value was placed on likeness and the artist's ability to capture three-dimensional form, and portraits of the time sought to represent more subjective and symbolic aspects of their subjects.

Despite art-world trends, Neel dedicated herself to figurative work throughout her life. She was an active supporter of feminist causes, and drew women from all social classes. Her commitment to figurative art was in part due to the potential it offered for social commentary; the figures she drew were unidealized, full of character and deeply human. Commissions were rare in Neel's early years as an artist, so she painted friends and acquaintances

instead. It was not unusual for her to ask someone she found visually interesting to pose for her.

Artistic Method

At a party Neel asked artist Dorothy Cantor Pearlstein, the wife of artist Philip Pearlstein, to pose for drawings and paintings. Neel approached these works as she did many others: she employed a simple composition, bold outlines, and controlled exaggerations. Cantor Pearlstein is depicted passively seated with her hands folded, engaging the viewer with her eyes. The artist's black pen and crayon lines wander around the subject, capturing her curly hair and long coat. Values create focus on her intelligent expression. Her appearance, inclinations, and psyche are uncovered by the drawing. We meet a complex personality who seems smart and self-confident.

The Results

As the momentum of the feminist movement increased in the 1960s and 1970s, so too did the interest in Neel's drawings and paintings. The sensitivity and psychological intensity of such works as *Dorothy Pearlstein* were lauded. Today, Neel's works remain as a reminder of important lives and stand for a specific and identifiable time in history.

Sketchbook Prompt

Draw a portrait of a friend.

Capturing a person's identity in a drawing requires careful observation heightened by expressive technique. Study the portrait of model Henrietta Moraes by Maggi Hambling (b. 1945), made the year before Henrietta's death (**16.4**). With fiery accumulations of lines, Hambling extracts the passion from her muse. To create such a portrait, Hambling celebrates the elements of drawing, especially line, value, and texture.

Romare Bearden (1911–1988) also captures the human presence of a sitter in *Obeah in a Trance* (**16.5**, p. 316). His image differs in that it primarily engages the element of color for expression. Whether drawing, painting, or making collages,

16.4 Maggi Hambling, *Portrait of Henrietta Moraes*, 1998. Charcoal on paper, 24 × 19" (61.0 × 48.3 cm). British Museum, London, England

Hambling does not draw people at random, preferring instead to draw people who touch her emotionally. She always "warms up" by making drawings in a sketchbook. This is her way to prepare her hand with a loose and sensitive touch. Whether painting or sculpting, drawing is key to her work.

16.5 Romare Bearden, *Obeah in a Trance*, 1984. Color and gouache on paper, 29⅝ × 19⅜" (75.2 × 49.2 cm). Private collection
Color can be a commanding and expressive force in a portrait. In this work, saturated colors blend from one to another. Shadows not only change in value, but their hues alter, as well. The brilliant colors create a sense of the intriguing personality of the sitter.

16.6 Bettina Steinke, *Arturo Toscanini*, 1937. Pastel and charcoal on paper, 15⅜ × 12¼" (39 × 31 cm). Smithsonian National Portrait Gallery, Washington, D.C.
Just as important as the details included in a drawing are those that are left out. In some places, this drawing includes refined and precise features. Other areas are drawn with utmost simplicity, yet others are not drawn at all. The artist has chosen the most telling aspects of the subject in order to capture a likeness.

16.7 Al Hirschfeld, *Whoopi Goldberg*, 1992. Ink on board, 27 × 21" (68.6 × 53.3 cm). Private collection
Caricatures are exaggerated portraits that overstate their subjects' physical attributes in order to emphasize their personalities or vocations. Effective caricatures balance likeness with intentional distortion. Central to successfully drawing caricatures is a strong understanding of the proportions and anatomy of the human head.

Bearden's use of color communicated the religious and spiritual essence of his subjects.

Some artists strive to convey aspects of a person's identity by emphasizing specific features. Notice how the illustrator Bettina Steinke (1913–1999) chooses to include only the head and hands of the acclaimed Italian conductor Arturo Toscanini (**16.6**). This compositional decision gives the drawing an intensity that reflects the personality and occupation of the subject.

Animators, cartoonists, and caricaturists also emphasize features, but in a different way, often by manipulating proportions. The caricaturist Al Hirschfeld (1903–2003) had a talent for capturing personalities through this kind of manipulation. His pen-and-ink drawing of Whoopi Goldberg is typical of his many portraits of celebrities and Broadway stars (**16.7**). The exaggerated features unmistakably define the charismatic quality of this superstar.

Drawing at Work Matthias Grünewald

Not much is certain about the details of the life of the sixteenth-century German artist known as Matthias Grünewald (c. 1480–1528). Relatively few works have been attributed to him—about twenty-two paintings and thirty-seven drawings—but those pieces are deeply moving and seem to suggest spiritual mysteries beyond their subject matter. His greatest accomplishment was the *Isenheim Altarpiece*, made for the hospital chapel of Saint Anthony's Monastery in Isenheim, near Colmar in northeastern France. This hospital was a place for the care of those with infectious diseases, such as leprosy. The altarpiece is a complex construction designed with sculptures and a series of hinged wings that enable the images displayed to be changed for different purposes. It includes paintings by Grünewald of the Crucifixion, Annunciation, Nativity, and Resurrection. He adorned the altarpiece with expressions of greater agony and suffering than any other depiction of the time.

Most powerful are Grünewald's portrayals of individual biblical figures in the altarpiece. The figures are distorted for emotional effect. Even Christ himself is pitted with sores as his fingers and feet curl with pain from the crucifixion. The depictions of horrific agony not only represented the figures' reality more fully, but also connected them directly to the sufferings of the hospital patients.

Grünewald's black-chalk drawing *Woman with Open Robe* was created as a study for Mary Magdalene in the *Isenheim Altarpiece*. Her figure is drawn sensitively and delicately. Her face, sad yet hopeful, and hands, wringing with worry, express feelings deep within. The unusual way in which Grünewald attaches Mary's head to her neck is an example of his deliberate distortions to embellish emotions.

16.8 (above) Matthias Grünewald, *Isenheim Altarpiece* (closed), c. 1510–15. Oil on wood, left and right side panels: 7' 6⅝" × 29½" (2.32 m × 75 cm); central panel: 8' 9⅝" × 10' (2.69 × 3.07 m); predella: 29⅞" × 11' 1⅞" (76 cm × 3.4 m). Musée d'Unterlinden, Colmar, France

16.9 Matthias Grünewald, *Woman with Open Robe*, c. 1512–16. Black chalk on paper, 15⅜ × 15¾" (39.1 × 40 cm). Staatliche Graphische Sammlung, Munich, Germany

16.11 Photo of a student's profile with overlay of facial divisions
Compare the proportions of this student's profile with those of Brad Pitt's image in **16.10**. Despite the angle of the view or the person depicted, the general proportions remain the same. When drawing a profile, measure the height of the head to assess its similarity to the width of the profile.

16.10 Photo of Brad Pitt's face with overlay of facial divisions
Although everyone is different, the general proportions of the human head are useful guides when drawing a portrait. In this diagram, Brad Pitt's face is used to show horizontal alignments of a frontal view.

The Structure of the Head

On close observation of a person, we tend to notice the specific facial features, complexion, and details that make that person unique. When beginning a drawing of the head, however, it is helpful to ignore the details that distinguish one head from another, and focus first on what all heads have in common. For example, all adult heads are relatively similar in size. They are generally symmetrical, and facial features are located in roughly the same places, so they are usually governed by similar underlying proportions.

General Proportions of the Head

When studying heads, it is helpful to observe their fundamental proportions. Common facial divisions found in the adult head are shown on the American actor Brad Pitt's face in **16.10**.

- Eyes are located roughly in the middle of the head. This line also helps to plot the location of the ear.
- The base of the nose is around one-third down in the space between the eyes and the chin. This line also loosely relates to the lower portion of the ear.
- The bottom lip is around two-thirds down in the space between the eyes and the chin.

Pitt's head aligns with these proportions, and most other people's will too. This is demonstrated by **16.11**, which shows a student whose face has been examined in the same manner, except this time in profile. The proportions between the two images conform. Notice also that the height of the head is similar to the distance from brow to the back of the head (diagrammed in blue); this fact is very useful when drawing a head in profile. (This relationship is commonly obscured by a person's hair.) Keep in mind, however, that

TIP

When drawing a portrait, begin with a standard head type as an underlying structure. Then, add the particular facial features of the sitter to individualize the portrait.

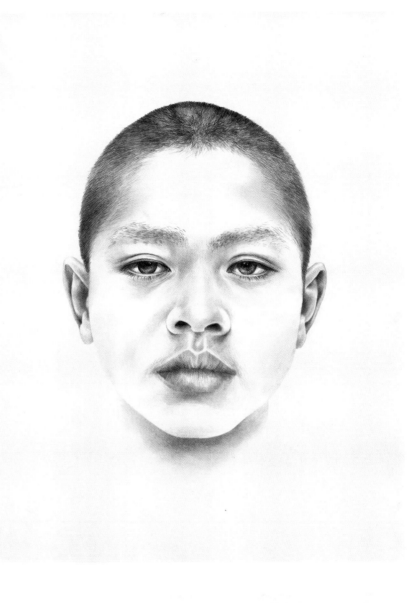

16.12a (right) Shahzia Sikander, "Novice Thon," from *Monks and Novices* series, 2006–8. Graphite on paper, 27½ × 24½" (69.9 × 62.2 cm). Collection of the artist

16.12b (below right) Superimposed facial division on Sikander's "Novice Thon" Remember the general proportions of the head. It is clear that this artist chose to conform to them in this drawing, capturing a lifelike quality in her portrait as a result. As you observe people, notice how their faces also conform to these general measurements.

everyone is different, and general proportions should not be taken as law. Indeed, some of the most interesting faces are those that do not conform to strict rules of proportion.

Proportional divisions are useful to remember when drawing the head as they can help guide the placement of facial features, providing an essential structure to build upon. We can see that Shahzia Sikander (b. 1969) has conformed to this structure in her graphite portrait (**16.12**). Capturing correct proportions in a portrait leads to naturalism, believability, and likeness.

When the head is not seen from straight-on (full frontal), our view of the facial divisions is affected by perspective; the guidelines that aid in the construction of the head now curve

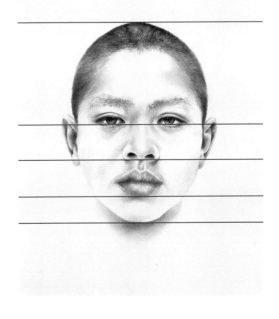

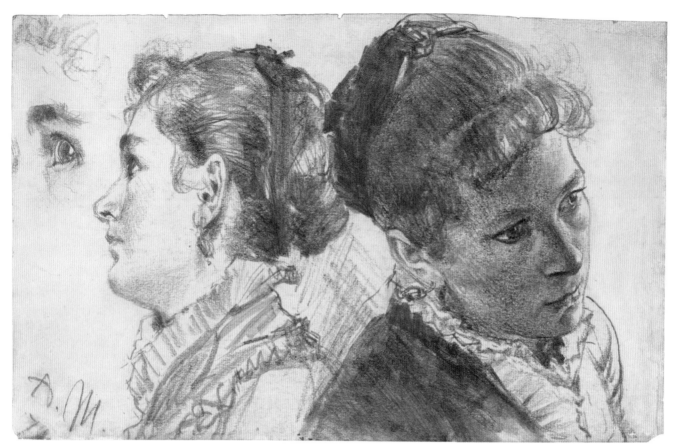

16.13 (above) Adolph Menzel, *Studies of a Young Woman*, 1870 or 1879. Graphite on paper, 6¼ × 9½" (15.9 × 24.1 cm). Metropolitan Museum of Art, New York

As diagrammed in **16.14**, place a sheet of tracing paper on top of this drawing. Superimpose lines that horizontally run around the surface of the heads in Menzel's drawings. Notice that features align in the same way as they do in frontal and profile views.

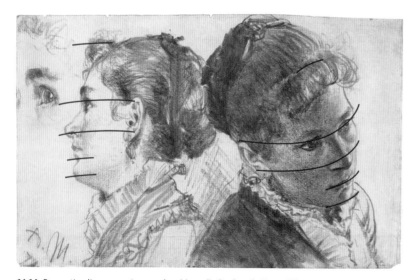

16.14 Proportion lines superimposed on Menzel's *Studies of a Young Woman*

around the form of the head. For example, notice the angles of the heads in this Adolph Menzel (1815–1905) graphite drawing (**16.13**). Lines that follow the curvature of the head

indicate an alignment of the ears with the nose and eyes. When drawing a head at an angle, make sure to check the relationships between areas of the face (**16.14**). For example, compare the distance from the eye to the hairline, and from the chin to the bottom of the nose.

Anatomy of the Head

The skull is a set of bones that, together with the jaw, forms the head and face. Twenty-two bones make up the skull. Eight of these are cranial bones, which encase the brain. They include the frontal bone that defines the forehead (7, in diagram opposite), and the parietal bones (8) that form the top and sides of the cranium (you can locate the plane of these bones by putting your hand on the back of your head). Fourteen bones make up the facial region. The diagram in **16.15** identifies the skull and jaw bones that are most important when drawing a portrait. As the locations of these bones are described, refer to the diagram to clarify their forms and positions.

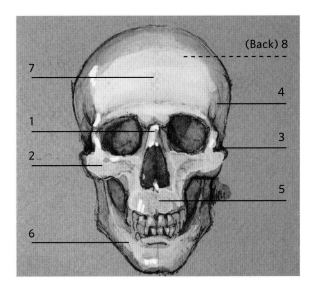

16.15 Labeled skull
1. Nasal bone; 2. Malar bone; 3. Zygomatic arch; 4. Temporal bone; 5. Maxilla; 6. Mandible; 7. Frontal bone; 8. Parietal bones.

Located in the center of the face and helping to define the bridge of the nose are two side-by-side nasal bones (1). These vary in shape and size in different people. They can be seen readily when viewing a person in profile. Protruding from the rest of the skull are the malar bones, or cheekbones (2). They help to form the zygomatic arch (3). This slender arch of bone forms a bridge between the cheekbone and the temporal bone (4) on each side of the skull. The malar bones attach to the upper jawbone, or the maxilla (5). This cylindrical bone structure holds the upper teeth. The lower jawbone, called the mandible (6), hangs from the temporal region. Although the rest of the skull is immoveable, the lower jaw is able to move up and down, with some flexibility left, right, and forward. This bone establishes the lower edge of the face.

Notice the subtle references to the skeletal anatomy in *Portrait of an Old Man*, attributed to the Master of the Pala Sforzesca (active 1490–1520) (**16.16**). Starting at the top of the drawing, the frontal bone extends down to its bony ridge above the eyes (the brow ridge). Surrounding the eye sockets we see evidence of malar bones and the zygomatic arches. The darkest shading suggests the nasal bones at the nose, and the rounded maxilla and mandible that comprise the upper and lower jaws. The indication of all of these anatomical forms gives the drawing a lifelike structure that it may not have had without them.

16.16 Master of the Pala Sforzesca, *Portrait of an Old Man*, n.d. Metalpoint highlighted with white on blue prepared paper, 7⅞ × 5⅜" (20 × 13.8 cm). British Museum, London, England
Awareness of anatomy gives an artist knowledge of structure and surface details that he or she would not otherwise be capable of drawing. Try to locate the bones of the head in this drawing.

TIP

Before beginning a portrait drawing, ask yourself what particular aspects of the sitter you wish to capture. Focus on these characteristics throughout the drawing session.

Facial Features

After gaining an understanding of the general proportions and anatomy of the entire head, the individual features should be considered.

The human face, with its combination of features, tells a story. A person's unique face conveys all sorts of information. It expresses emotions, personality, age, state of mind, and lifestyle. When angry or sad, our facial features fall. When happy or excited, the face does quite the opposite. Consider the facial features of an outdoor laborer compared to those of a young child. The stories revealed are quite different.

The careful depiction of facial features has enormous artistic potential. Portrait artists understand that by capturing the distinctive facial features of a sitter, their subject's character and emotions transfer to the viewer. As a figure in a drawing gazes back at us, we tend to lock eyes, and commiserate with the subject and their experiences.

Drawing the eyes, ears, nose, and mouth by themselves is an excellent way to become

16.17 (left) Jusepe de Ribera, *Studies of Eyes,* c. 1622. Etching, 5¾ × 8⅝" (14.5 × 21.8 cm). British Museum, London, England

16.18 (below left) Jusepe de Ribera, *Studies of the Nose and Mouth, c.* 1622. Etching, 5⅝ × 4½" (14.4 × 11.4 cm). Harvard Art Museums—Fogg Museum, Cambridge, MA

16.19 (below right) Jusepe de Ribera, *Studies of Ears,* n.d. Etching, 5¾ × 4¼" (14.5 × 10.8 cm). Harvard Art Museums—Fogg Museum, Cambridge, MA

These prints were part of a reference manual for art students. The line drawings enable us to see the basic structures, and the shaded drawings allow us to better understand the individual forms. Looking in a mirror, carefully draw the features of your own head.

16.20 Jules De Bruycker, *Self-Portrait in front of the St. Nicholas Church in Ghent, c.* 1934. Pencil, 16⅞ × 12¼" (43 × 31 cm). Foundation Jules De Bruycker, Ghent, Belgium

The self-portrait has been a staple of art since artists first had access to mirrors. In addition to improving figurative drawing skills, drawing a self-portrait often leads to new levels of self-awareness and expression.

familiar with their structure. Jusepe de Ribera's three pages of facial features can act as a guide (**16.17**, **16.18** and **16.19**). These pages were part of a group of prints intended as references for students. Such manuals were popular during the sixteenth and seventeenth centuries, and are still valid and useful aids today. Ribera's pages convey the anatomical structure as well as the outer appearance of facial details. Examples of linear construction and shaded drawings are present in each. Study these examples and then make similar studies of your own.

Self-Portraits

A **self-portrait** can be thought of as a visual autobiography. It allows the artist to make a self-examination exploring the concept of "the self," merging artist with sitter. For the viewer, self-portraits offer an inside view into the personality and private life of the artist. This example by Jules De Bruycker (1870–1945) exudes his stern and forceful temperament and disposition (**16.20**). It is as if the viewer is the mirror: we watch him draw, catching him

Self-portrait A portrait an artist makes of himself or herself.

16.21 Gwen John, *Self-Portrait*, 1907–9.
Pencil on paper. Private collection
Compare and contrast this self-portrait with that
by De Bruycker (**16.20**, p. 323). While there are
some similarities, there are also salient differences.
What emotional and physical traits have the artists
portrayed? What in the drawings reveals their
individual characters and temperaments?

16.22 Cian McLoughlin, *Tronie—Yellow Drawing*, 2016.
Chalk on paper, 27 × 20" (68.6 × 50.8 cm). Private collection
Self-portraiture provides an ideal, and always available, subject
for experimentation in drawing. Here, the artist works with
elements to enhance visual expression, using frantic lines,
sand, and vibrating colors.

before he finishes his work. Considered one of
Belgium's foremost twentieth-century graphic
artists, Bruycker's choice to record himself as
a draftsman is telling of his primary interest.

The British artist Gwen John (1876–1939)
created self-portraits that are known for
their autobiographical nature. She was self-
possessed, thoughtful, and introspective,
preferring solitude. Her restrained self-portrait
drawing reflects these qualities (**16.21**).

Self-portraits also offer the artist a
perennially available subject, allowing her
or him to experiment with different drawing
techniques. As Cian McLoughlin (b. 1977) tries
to work only with subjects that strongly affect
him, it makes sense that he often draws himself.
His self-portraits are intended not as portraits

per se, but as studies of expression. His
exploratory process involves an uninhibited
reworking of lines, colors, and forms.
McLoughlin, from Dublin, Ireland, started
out as an architecture and film studies student,
but later his creative path led him to a career in
fine art (**16.22**).

Another artist who uses herself as the
subject for her personal explorations is the
contemporary artist Ann Gale (b. 1966). Gale's
drawing process involves very slow and careful
measurements, and she works on her drawings
for a long time. Indeed, her search to record
her personal perceptions accurately becomes
the subject of her drawings. Her thick and thin
pencil marks variously accentuate and diminish
one's attention toward parts of the drawing.

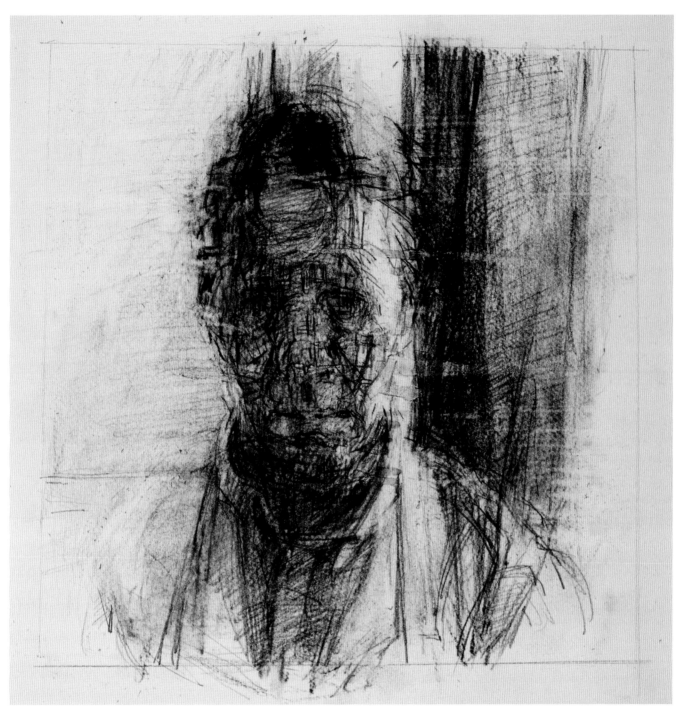

16.23 Ann Gale, *Self and Passage*, 2016. Pencil and gouache on buff paper, 12½ × 13" (31.8 × 33 cm). Dolby Chadwick Gallery, San Francisco, CA

This self-portrait is a result of many sight measurements: horizontal, vertical, and otherwise. The accumulation of marks is evidence of Gale's laborious drawing approach. Perhaps more significant than recording her appearance, the work documents her slow and thoughtful process.

Instead of likeness in a traditional realist sense, Gale's drawings focus on capturing emotional and meditative qualities (**16.23**).

Consider the other self-portraits we have discussed, such as those by Rembrandt van Rijn (**9.9**, p. 188) and Artemisia Gentileschi (**15.6**, p. 294). Compare them to the self-portraits in this chapter. What do you think each artist is trying to tell us about themselves?

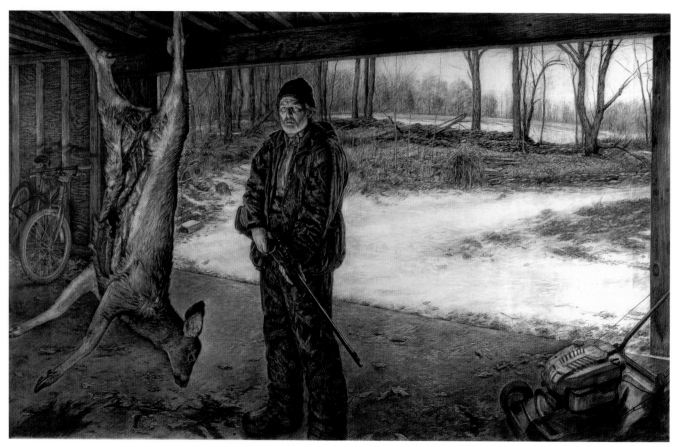

16.24 Edgar Jerins, *Prael and Prey in Rhinebeck*, 2008. Charcoal on paper, 5 × 8' (1.52 × 2.44 m). The Global Center for Latvian Art, Chicago, IL
In narrative portraits the figure and the setting work together to tell a story. To some, this picture may be disturbing. To others, it may echo the reality of their own lives. The interpretations and explanations of works of art are as varied as the artists who make them.

TIP

Portraits can convey more than just a likeness. Is there a story about the sitter that you wish to tell?

Narrative portrait
A portrait that tells a story.

Narrative Portraits

A **narrative portrait** tells a story. It brings together the sitter and his or her surroundings in order to portray a particular aspect of that person's life. This helps us understand the subject on a more personal and emotional level. By including the environment in a portrait, you can establish a particular moment in time, further exposing the life of the sitter. Narrative portraits can be made from observation; they can utilize references, from artistic to political or literary; or they can be invented by the artist. By establishing a story, an artist further describes an individual and fosters a connection with the audience.

Edgar Jerins (b. 1958) creates large narrative portrait drawings that typically portray subjects dealing with painful experiences, such as predicaments of addiction, violence, and loneliness. The subjects' surroundings are key to Jerins's ability to tell these stories. In his charcoal drawing *Prael and Prey in Rhinebeck*, a man stands alone in his garage with a freshly killed deer hanging from the rafters (**16.24**). The cold, bleak landscape outside adds to the quiet isolation of the figure. The bicycle and lawnmower remind the viewer of this man's ordinary life outside of the hunt, in stark contrast to the deer's corpse. Jerins's work exemplifies how an artist can successfully combine figure and setting to create a compelling, if disturbing, narrative portrait.

Beth Van Hoesen Adams (1926–2010), an artist known for her animal portraits, created a graphite drawing of her husband, Mark Adams,

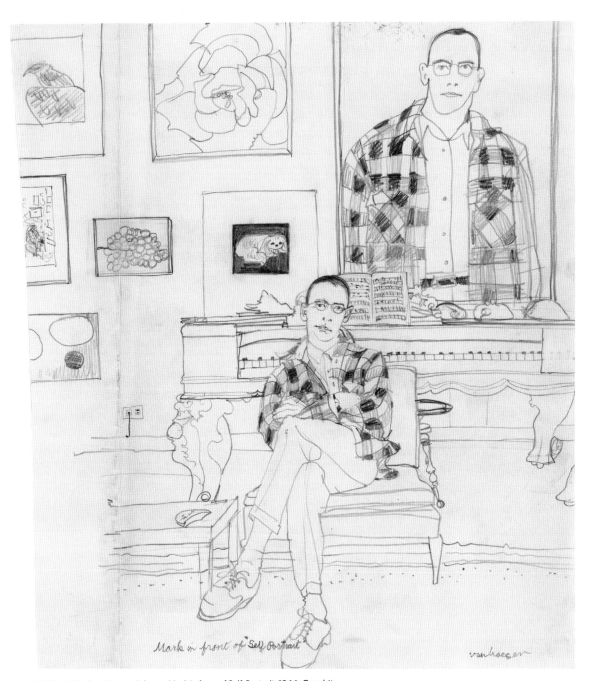

16.25 Beth Van Hoesen Adams, *Mark in front of Self-Portrait*, 1966. Graphite on cream wove paper, 14 × 12¾" (35.5 × 32.3 cm). Art Institute of Chicago, IL

This portrait drawing of the artist's husband, Mark Adams, contains attributes that depict their life together as an artist couple. The setting is their home. Unusually, within this portrait is a depiction of a self-portrait by the sitter. The paradox of Adams including her husband's self-portrait within her portrait of him playfully uncovers the conundrum of marital affections, and reveals the difference between the two artists' perceptions of the same subject.

that tells us more about him than just his physical appearance (**16.25**). Mark was a well-known designer of tapestries and stained glass. He was also a fine artist, and particularly noted for his ability to blend art with architecture.

Adams drew her husband's portrait in their San Francisco home, an appropriate choice as this home—a renovated firehouse—was also their studio. It became a gathering place for artists as they held weekly life-drawing and portrait sessions. Adams's line drawing places Mark in the midst of their well-appointed home, surrounded by drawings and paintings, including a dog portrait, and, tellingly, Mark's self-portrait. *Mark in front of Self-Portrait* tells the story of a life surrounded by the arts.

A Portrait-Drawing Demonstration

When drawing a half-length portrait, your chair should be about six feet from the sitter. If you are drawing only the head, then a distance of four or five feet from the sitter would be ideal. Consider illuminating your subject with an obvious directional light.

When following the steps of the portrait-drawing demonstration, remember that the likeness of a portrait has more to do with the general impact of the face as a whole than the details of the individual facial features.

First, loosely draw the general outlines of the head. These should approximate the sitter's proportions. Lines should be made loosely so that they can easily be changed (**16.26**).

Measure the angle of the neck. The neck should extend downward to fit into the shoulders, eventually meeting the collarbones. The neck meets the shoulders higher at the back and lower at the front. Notice that the angle of the sides of the neck often differs from the tilt of the centerline of the head. Draw guidelines to locate the facial divisions—the centerline of the face, the eye line, nose line, mouth line, and ears—as outlined earlier in this chapter, on p. 318. If seen from an angle, these lines should be drawn curving around the form of the head, as seen here (**16.27**).

Draw the facial features, including the hairline, the boundaries of the forehead, the eye sockets, and the cheeks and chin. This can be done with line, refraining from shading at this point. Make vertical and horizontal measurements to compare how the individual features line up with others (**16.28**).

Block in the values of the drawing. Remain conscious of the underlying anatomical structure of the head. In this example, the frontal bone, malar, maxilla, and mandible are indicated by the lightest value (**16.29**).

With this structure in place, details and shading can be added (**16.30**).

In the Studio Projects

Fundamental Project

First, choose three portrait drawings made by another artist; you might select drawings from this text. Consider Rembrandt van Rijn's self-portrait in **9.9** (p. 188), or *Max* by Stephen Gardner in **3.28** (p. 73). With a red pencil on a print-out, draw proportion lines as seen in **16.10** and **16.11**, p. 318. (This could also be done digitally.) Remember that proportion lines will curve around the head if the drawing is not fully frontal or profile.

Now, without tracing, copy one of your chosen drawings as faithfully as possible, giving special consideration to the placement of facial features.

Criteria:

1. Three master artist portraits should be chosen. Proportion lines should be added to the images accurately.
2. The masterwork should be copied faithfully without tracing.
3. The placement of facial features should be accurate according to the source.

Materials: Optional

Observational Drawing

Draw a portrait of someone you know from direct observation. (This project could also be done as a self-portrait.) Before beginning to draw, ask yourself what you find visually interesting about the subject. With this in mind, draw the head approximately life-size. Follow the steps described in the portrait-drawing demonstration opposite.

Criteria:

1. You should utilize the steps of the portrait demonstration found opposite.
2. The drawing should locate facial features correctly.
3. The portrait should capture the form and the general likeness of the sitter.

Materials: 18 × 24" paper, charcoal

Non-Observational Drawing

Search for examples of portrait drawings from the online collections offered by museums from around the world. Collect ten examples of different types of portraits, such as head only, half-length, full-length, frontal, profile, expressive portraiture, self-portraiture, and narrative portraiture. Consider different expressions and how they contribute to a portrait's effect or power. Create a digital presentation that describes the formal aspects of each work, and compares and contrasts the different approaches to portraiture. Is there one portrait in your presentation that you personally find most inspiring? Why?

Criteria:

1. The digital presentation should be well organized and include a range of different portrait types. Ten images should be included.
2. The presentation should thoroughly outline the formal aspects of each work, including the discussion of drawing elements and principles.
3. You should choose one drawing as most inspiring and substantiate that opinion.

Materials: Digital presentation

Chapter 17
Landscape Drawing

Location and environment are the central subjects of the genre of **landscape drawing**. The landscape presents an opportunity for the artist to explore the element of space. In order to develop spatial qualities in a landscape drawing, the artist often relies upon the devices of linear perspective, atmospheric perspective, overlap, and the strategic use of diagonal lines, as discussed in Chapter 11, p. 216. These techniques can be found in the examples of landscape drawings throughout this chapter. Artists often arrange their paper in the so-called "landscape format," where the width is greater than the height. This horizontal format alone suggests the panoramic nature of a landscape. Naturally, many examples in this chapter deploy this format.

Landscape drawing
A genre of drawing with the central subject of location and environment.

Landscape as a Source of Inspiration

The landscape, in its endless variety, is humbling and inspiring, timeless yet ever changing. Although an environment is impossible to record in its entirety, it provides unlimited possibilities for the artist to translate or represent the physical features of the world. Landscape art is a wide-ranging genre. Such drawings most often communicate the impression of a particular place, and can also be used to show deep meaning or emotion.

Place, with its physical and emotional characteristics, has remained a compelling source of inspiration for artists since ancient times, important to the traditions of both Western and Eastern art. Long before Western artists considered landscape an independent genre of art, Chinese artists saw in landscape the embodiment of their greatest philosophical ideals. Landscape art was associated with cultured and scholarly taste. Early Chinese landscapes, such as the eighth- or ninth-century-CE banner in **17.1**, were typically executed in ink with some Chinese watercolor. The landscapes they depicted were invented, idealized, and highly stylized.

The form soon spread to other parts of Asia, where it also achieved prominence. In the West, landscape elements have been present for some time, as seen in the refined backdrops of Renaissance art, yet it was not until much later that it became celebrated as the central focus. Attitudes to such art began to change with the rise of Romanticism in the nineteenth century, when landscape first became considered a high artistic genre. This movement valued individuality and emotion above all else, and it became accepted for nature to be used in art to express human emotion and creativity.

The English painter John Constable (1776–1837) was greatly influential in the movement to popularize the genre. He regularly made on-site sketches (photography was not yet commercially available) that he brought back to his studio to provide the basis for his large landscape paintings. These were frequently made in the area around his home in Dedham Vale, in east England (**17.2**, p. 332).

17.1 Painted banner showing three scenes from *The Life of the Buddha*, 8th–early 9th century. Ink and colors on silk, 23 × 7¼" (58.5 × 18.5 cm). British Museum, London, England
Landscape has long been an esteemed genre of art in China. This work uses a vertical format instead of the horizontal format common in Western landscape art. Imagined landscapes from *The Life of the Buddha* are stacked one on top of another, an ideal composition for telling a story. The silk surface on which this drawing was made has deteriorated at the top and bottom edges, but is otherwise well preserved.

The Work of Art John Constable

17.2 John Constable, *Coombe Wood*, 1812. Graphite pencil, 3⅜ × 5⅛"
(8.3 × 13 cm). Yale Center for British Art, New Haven, CT

The horizontal format of this drawing is typical of Western landscape art. Drawing from direct observation with a graphite pencil, Constable used diagonal hatch marks to represent textures and broad areas of light and dark. Beginning from the lower left-hand corner, volumes of foliage overlap to direct the viewer diagonally into space.

Who: John Constable
Where: England
When: 1812
Materials: Graphite pencil

Artistic Aims

John Constable was an English Romantic artist known principally for his landscapes. Romanticism was a reaction against ideologies of order, idealization, and Classicism, instead emphasizing the natural effects of light and atmosphere to portray the splendor of the natural world.

When beginning a sketch from the landscape, Constable tried to forget every other picture that he had ever seen, allowing the careful observation of nature to guide his drawings. He worked to capture the subtle and distinct qualities that he found in each scene.

Artistic Challenges

During Constable's time, landscape art had not yet gained full acceptance from the art academies of Italy and France. It was still considered to be a lower form of art in the hierarchy of artistic genres, and regarded of less value than history painting and portraiture. Constable, however, saw it as a most worthy subject, especially given the rigors of attentive on-site study, which he felt was essential to landscape art.

To avoid a formulaic approach, the continuous practice of on-site landscape drawing was critical to Constable's working method. In the landscape, he gave special attention to the light, including the time of day and the weather conditions. He considered light to be the key challenge in the representation of the scene, one that endures today, as many artists continue to be challenged by drawing a specific light that they observe in the landscape.

Artistic Method

In his pencil drawing *Coombe Wood*, Constable analyzes not only the shapes and edges of the trees, but also their values as they relate to each other and the sky. The details of the trees are not painstakingly copied; each leaf, for example, is not rendered. Instead, Constable favors a technique that seeks

to capture the general direction of the tree's growth, including attention to trunks, branches, and foliage. In this way, the essential character of the landscape is expressed.

Throughout *Coombe Wood*, Constable presents lights and darks with rhythmic order. The group of bushes in the bottom left side of the composition alternates in value: a light foreground bush overlaps a darker one, behind which a light bush overlaps another dark one. Similarly, the large mass of foliage in the upper left part of the composition alternates between light groups of leaves and dark values behind them. This alternating rhythm of values creates separation between masses and also replicates natural light. It creates a subtle sense of movement, as if a breeze is ruffling the leaves. This continues diagonally across the mass of the tree. Constable is careful to reserve the white of the page for certain areas of the drawing: the clouds, a few clusters of leaves, and the area of the gate. All other parts of the drawing are toned down, even if only slightly.

The Results

For Constable, it was important that his landscapes were visually accurate, including the correct rendering of tree species and cloud formations. He was able to do so by making careful reference studies on location. Working in the countryside, he wanted to express the increasing importance of rural life to people living in a time of rapid industrialization. Constable's landscape work would later become an important influence for the Impressionist artists.

Sketchbook Prompt

Draw a landscape, emphasizing light and atmosphere.

17.3 Student work. Dana Demsky, *Music School Path*. (Instructor: William Burgard) This student landscape drawing was made with charcoal. Notice the way the artist was able to imply different types of natural textures effectively. The way that space is implied by the diminution of size and the lessening of details in distant features is very successful.

Drawing Outdoors and Studio Landscapes

Deciding where to create a landscape drawing depends on whether one wishes to work from direct observation, from such sources as sketches or photography, or from memory or imagination. Before the mid-nineteenth century, drawing outdoors was done primarily to collect visual research. After that time, however, many artists took to making finished landscape works completely on location, immersed in the environment that was their inspiration.

En plein air

In the mid-nineteenth century, the French coined the phrase *en plein air*, or "in open air," to describe the act of creating finished art in an outside environment rather than in a studio. The condition of working from direct observation and the goal of faithfully conveying

17.4 Berthe Morisot, *Landscape*, n.d. Colored pencils, 9¼ × 6⅞" (23.4 × 17.4 cm). National Gallery of Art, Washington, D.C.
This drawing was made *en plein air*. With only a limited palette of mostly blue and yellow (orange was also added), the colors mix optically to create areas that appear green. Yellow implies bright sunlight. Blue describes areas in shadow. Where these colors overlap we perceive green, the hue that we would expect to see in a pastoral setting.

atmosphere were primary motivations for *plein air* artists. Their work generally depicted everyday subject matter using an intuitive and often sketchy approach. This vision soon became a standard way of conveying the outdoor experience.

The French artist Berthe Morisot (1841–1895) worked in this style. She was a member of the group of Parisian artists who were later known as the Impressionists. Morisot made direct portrayals of nature through studies of light and color as they affect the landscape (**17.4**).

The interest in *plein air* work has remained throughout the twentieth and twenty-first centuries, with many fine artists, as well as other creative professionals, finding that drawing in the field is important for their work. The architect and graphic designer Ch'ng Kiah Kiean (b. 1974) is known for his ink sketches

17.5 Ch'ng Kiah Kiean, *Port of Keelung*, 2012. Chinese ink on paper, 7½ × 22" (19.1 × 55.9 cm). Collection of the artist
This panoramic drawing was made on location. Rather than copying details, the artist is able to suggest the complicated structures of the urban setting by implying their presence with fast expressive marks.

TIP

Visually divide the landscape into three regions: foreground, middle ground, and background.

TIP

When drawing
in the landscape,
be prepared
with appropriate
materials and find a
comfortable place
to work.

of buildings and streetscapes in East and Southeast Asia. He makes large horizontal drawings with raw, gestural lines and minimal values. He shares his work with other *plein air* sketchers through Urban Sketchers, a global online community of artists who practice on-location drawing (**17.5**).

Joan Eardley (1921–1963) was noted for her landscapes of the northeast coast of Scotland. She often worked outdoors, even in the most severe weather. Striving to draw more than a visual likeness of the landscape, she tried to identify with the mood and power of her subjects. With this point of departure, many of her works became abstractions. Inspired by direct observation, her lines, shapes, and colors resound with emotion (**17.6**).

Studio Landscapes

Artists often prefer to make their landscape drawings in the studio instead of on location. Working indoors provides a level of comfort and control that cannot always be expected when working in the field. Free from distractions and changes to the scene, many landscape artists prefer to rely on photos and drawn references, or to create landscapes purely from imagination.

A native of Ireland, but living and working in America, Sue Bryan uses her studio in New York City to draw her small landscape drawings. Through her drawings, she strives to connect to her roots by conjuring memories from the past. Out of focus and atmospheric, Bryan's charcoal-and-carbon drawing

17.6 Joan Eardley, *Black Sky with Blue Sea, c.* 1962–63. Pastel on paper, 7⅞ × 10" (20 × 25.4 cm). National Galleries of Scotland, Edinburgh

Perhaps to some people this abstract drawing is unrecognizable as a landscape, but in fact it was made from direct observation. Eardley preferred to work outside, and her primary goal was to capture the mood and the presence of natural forms. Notice how both the ends and sides of her pastels are used to make different kinds of marks. Powerful black strokes diminishing into space contribute to a dramatic atmosphere.

17.7 Sue Bryan, *Memoryplace 4*, 2016. Charcoal and carbon on cotton paper, 6 × 6" (15.2 × 15.2 cm). Collection of the artist

Made in the artist's studio, this landscape drawing was made from memory. Measuring only 6 × 6", it has a spatial presence larger than its actual size. Its illusion of space comes from the artist's ability to create depth with atmospheric perspective. Details are pushed forward in the composition as the background becomes increasingly soft and hazy.

17.8 (below left) Shao Fan, *Landscape*, 2009. Pencil on paper, 61¾ × 64¼" (156.8 × 163.2 cm). Metropolitan Museum of Art, New York

Contemporary art often mixes traditional and modern approaches: this drawing combines traditional Chinese atmospheric effects with modern surrealistic imagery. Made in the artist's studio, the composition radiates from a central point, creating an immersive sense of balance. Massive forms move upward on the left and then spiral inward. Diagonals extend from the lower right and plunge the viewer into the deep space.

> ### TIP
> Atmospheric perspective is an excellent way to suggest space in a landscape drawing.

Memoryplace 4 is bathed with a nostalgic and reflective quality (**17.7**).

A furniture and garden designer, Shao Fan (b. 1964) also creates landscape drawings in his studio. His works are a hybrid of contemporary and traditional Chinese image-making. In *Landscape* he combines a balanced image of the natural world—a common theme in Chinese art—with a Western pencil-rendering technique to create a somewhat surreal, yet fairly classical Chinese-style image (**17.8**).

Types of Landscape Drawings

Many people tend to associate themselves with a place, and an interest in landscape drawing is a reflection of this kind of psychological bond to location. A sense of place is key to our understanding of where we stand in the world. Consider the associations you make when you think of different types of landscape. The void of a canyon might make you feel small, and in

a landscape that is similar to where you grew up you might feel secure. Artists can play with these connections to instil emotion in the viewer.

For the artist, landscape is more than a view of scenery involving trees, fields, rocks, and clouds; it is a visual experience, one in which the artist can make his or her own assessment, and incorporate his or her subjective state of mind. The type of landscape, the chosen view, and the analysis of the location are all reflections of the mind of the artist.

The genre of landscape encompasses diverse types: urban, rural, seascape, and skyscape. Each will reveal its own special and unique aesthetic to a receptive artist.

Urban

The **urban landscape** focuses on the environment of a city. These drawings confront us with man-made structures, such as architecture, roads, cars, and figures

in space. Linear perspective often has a strong presence. Some artists are attracted to the frenetic energy of the urban landscape, and others might use it to communicate a feeling of alienation.

During the latter part of his career, the French street photographer Henri Cartier-Bresson (1908–2004) stopped making photographs and returned to his first love, drawing and painting. In the same way that he made urban scenes the subject of his photographs, Cartier-Bresson now reacted to the urban landscape when drawing. Instead of capturing his subject in a fraction of a second with a camera, his drawings are built one line at a time (**17.9**).

Rural

Rural landscape drawings picture the country and country life. Rural scenes typically include trees, bushes, fields, and other terrains. They can be used to portray a sense of harmony

Urban landscape The landscape and environment of a city.
Rural landscape Scenes of the country landscape and of country life.

17.9 Henri Cartier-Bresson, *Place des Ternes*, 1981. Black chalk, 9³⁄₈ × 12½" (23.8 × 31.9 cm). Fondation Henri Cartier-Bresson, Paris, France
The urban landscape is a subject the artist explored throughout his career. Twisted and disjointed, this drawing does not rely on strict linear perspective to create buildings and rooftops. Instead, space is suggested through overlapping forms that create a strong diagonal to the upper-right of the page.

17.10 Anthony Mitri, *Corn, Effect of Snow, Bundysburg*, 2013. Charcoal and pastel on paper, 10 × 19 ³⁄₈" (25.4 × 49.2 cm). Forum Gallery, New York

A number of techniques create the illusion of space in this rural landscape: diminishment of size, diagonals, and atmospheric and linear perspective. In your opinion, which spatial device is most responsible for the suggestion of space in this drawing? Why?

and balance. Idyllic pastoral scenes, known as Arcadian landscapes, were often used in Renaissance and eighteenth-century European art. Conversely, the Romantics preferred wild rural landscapes, which they felt represented creativity.

The rural landscape challenges the draftsperson to deal with the intricacies of natural forms and textures, as seen in Nora Heysen's drawing in **17.12**, opposite. *Corn, Effect of Snow, Bundysburg*, a drawing by Anthony Mitri (b. 1951), is another good example of a rural landscape drawing, combining a detailed rendering of nature with compositional simplicity (**17.10**). Not only does Mitri record a particular location and time, but he also expresses his personal feelings about the location by manipulating the value range. Here we share his indelible memories of winter: cold, bleak, and lonely.

17.11 Winslow Homer, *Incoming Tide, Scarboro, Maine*, 1883. Watercolor on wove paper, 15 × 21⅝" (38.1 × 54.8 cm). National Gallery of Art, Washington, D.C.

Vast, picturesque, mysterious, and powerful, the awe-inspiring seascape is an enduring inspiration for artists. This artist pictures the view as horizontal bands. Compare these special divisions. Textures that are prominent in the foreground diminish into the space. Bright colors neutralize as they recede into the distance.

Seascape

Seascapes represent the expanse of the ocean. Seascapes often include the horizon line, sky, waves, and shore. The vast space of a body of water is often the particular focus of this type of drawing, and the constant motion of the sea presents an artist with intriguing technical challenges. Drawings of a stormy sea might express strong emotion, or a calm sea could represent tranquility.

Winslow Homer (1836–1910) was well known for marine themes, including ocean vistas, fishermen, boats, and weather conditions at sea. He utilized his skills as a commercial illustrator to create powerful fine artworks. *Incoming Tide* shows his mastery of watercolor technique. With broad strokes he expresses the turbulent power of the sea (**17.11**).

Seascape Scenes focusing on the sea.

Gateway to Drawing Heysen, *Gum Trees, Hahndorf*

Landscape Drawing

Nora Heysen (1911–2003) was born and raised in Hahndorf, Australia's oldest surviving German settlement, located in the southern part of the continent. Once a small-town center for farming, its charming rural setting would influence Heysen for a lifetime. She recalled bicycle trips through the countryside with her father to find places to paint, fond memories that undoubtedly inspired her later landscape works. Although it was Heysen's portraiture for which she became well known (she was the first woman to be appointed as an Australian war artist and the first to win the Archibald Prize for portraiture), it is her landscapes that seem to touch on a special sentimental aspect of her life.

Heysen drew *Gum Trees, Hahndorf* when she was eighteen years old. The complex and expansive rural subject, although so familiar to her, would have been impossible to record in every detail. Instead of concentrating on individual trees, this landscape drawing describes the deep space of the wooded scene. Only four or five trees are drawn in detail, but there appear to be many more in the composition. The largest tree is in the foreground. The rest of the trees diminish in size as they recede into the distance. In the furthest part of the woods, just beyond the viewer's focus, Heysen merely implies more trees rather than drawing them in an explicit way. Perhaps this kind of space, enchanting and free to explore, is what Heysen most appreciated about the rural setting in which she was raised.

For the other *Gum Trees, Hahndorf* boxes, see pp. 102–3 and p. 192

17.12 Nora Heysen, *Gum Trees, Hahndorf*, 1929. Carbon pencil, white chalk on green-gray paper, 16 × 13⅛" (40.6 × 33.4 cm). Art Gallery of New South Wales, Sydney, Australia

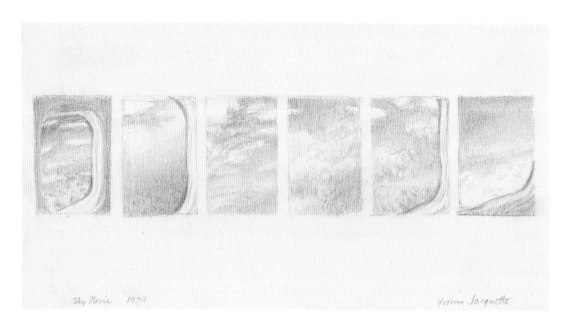

17.13 Yvonne Jaquette, *Sky Movie*, 1974. Colored pencil on wove paper, 7 × 13⅜" (17.8 × 34 cm). National Gallery of Art, Washington, D.C.
This single drawing is a collection of six smaller compositions over which a frame-by-frame progression presents an expansive skyscape. Instead of looking up at it stretching over our heads, we are in the sky. The colors and cloud forms that fascinate us conjure a place at once seemingly infinite and yet also private and isolated.

Skyscape

The sky has a tremendous impact on landscape drawings. Many landscape compositions include, or are even dominated by, sky. The way in which an artist decides to portray a sky can change a drawing's tone entirely; consider how a sunset or clouds can impact your mood. Some artists are inspired to focus solely on the depiction of the ever-changing sky, clouds, and weather, and famous masters of the genre include the British artist J. M. W. Turner (1775–1851).

After becoming interested in aerial views, Yvonne Jaquette (b. 1934) began flying in commercial airliners, and eventually chartered planes, to sketch cloud and weather formations. In order to stay close to her subject, she has also worked from the top of the Empire State Building and the World Trade Center in New York. In *Sky Movie*, Jaquette uses a sequential format to present a collection of **skyscapes** (**17.13**).

Skyscape Scenes showing the sky, clouds, and weather.

A Landscape-Drawing Demonstration

This drawing demonstration explains one approach to drawing the landscape from observation. Whether working in an urban or a rural setting, the first consideration when drawing *en plein air* is to find a good vantage point. Often, the success of a drawing is influenced by the location from which the artist chooses to draw. Try to find a comfortable place with a view with which you have a personal connection (**17.14**).

1

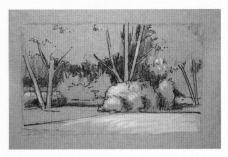

Using a viewfinder, select a portion of the landscape. Draw a number of thumbnail studies. This is important because objects in your view may move and the light may change as you work. Use only simple shapes to capture the foreground, middle ground, and background. Focus on composition, space, and light (**17.15a**, **b**, and **c**).

2

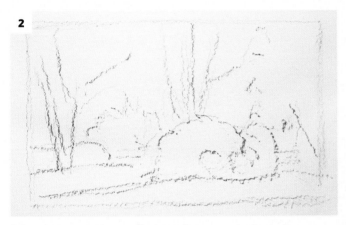

Select the composition you like best. On a separate sheet of paper, loosely draw that composition in pencil (**17.16**).

3

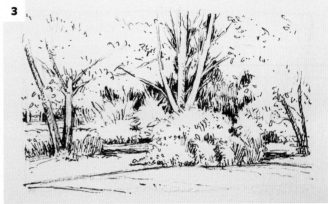

Once the composition is established, switch to a thin black waterproof pen. Restate your drawing, this time paying close attention to the particularities of your scene. Is the ground smooth or uneven? Are the trees sharp or rounded? Consider how your line work can imply the space, textures, values, and forms that you see (**17.17**).

4

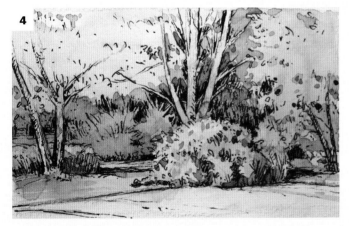

Add monochromatic watercolor to your drawing. Remember: a monochromatic color scheme utilizes only one hue and its various values (tints, tones, and shades) (see Chapter 13, p. 266). Choosing any dark color, add a series of washes to your drawing in order to emphasize light. Refer back to your thumbnail studies to make sure that you have captured the overall illumination of your scene (**17.18**).

Drawing at Work Claude

17.19 Claude Lorrain, *Trees*, c. 1655–60.
Pen, ink, and wash, 10⅞ × 8¼" (27.5 × 20.8 cm).
Musée du Louvre, Paris, France

Above all else a landscape artist, Claude Gellée became known as Claude le Lorrain (1600–1682) in Italy, where he spent much of his life; English speakers called him "Claude Lorrain" or just "Claude." Because there was no market for landscapes during the seventeenth century, most of Claude's landscapes were enhanced with depictions of mythological or biblical stories. When he sold his works he stated that he was selling only the landscape, and the figures were for free, which is a clear indication of where his passion lay.

Artists in the seventeenth century were already working in the open air, although in their minds there was a clear distinction between their outdoor research and what they considered the more significant business of studio art. It was generally thought that outdoor exercises should be practiced in moderation so that the artist was not distracted from rendering the ideal. Claude, however, drew frequently from the landscape, and also used his drawings in different ways. Sometimes they were preparation for paintings, and at other times, conversely, Claude would use ideas that had come from his paintings to create final drawings.

Trees, a pen-and-ink-wash drawing from about 1655, is a wonderful example from one of Claude's all-day countryside sessions (**17.19**). In this drawing he toils to establish a balance between lines and mass values. His lines are staccato—short, sharp, and accumulative—and it is this fast, instinctive quality that gives the impression of the texture and volume of the foliage. The brown washes, just as spontaneous, add directional light and physicality to the scene. This all serves to express the atmosphere of lights and darks that Claude observed in the landscape.

Claude's drawings remind us that all drawings, no matter how realistic they may appear, are necessarily abstractions: taking away unnecessary information, inventing ways, using the elements of art, of conveying what is seen or imagined, then organizing them into compositions with design principles.

In the Studio Projects

Fundamental Project

Find a window with a landscape or cityscape view. Tape a piece of clear acetate to the glass. With one eye closed, trace the view onto the acetate with a permanent pen. Remove the drawing from the window and tape it into your sketchbook. Next, write down your analysis of your drawing.

Observational Drawing

Create an *en plein air* landscape drawing using monochromatic color. Focus on composition, space, and light. Follow the steps described in the landscape-drawing demonstration on p. 341.

Non-Observational Drawing

Remember a landscape from your past; it could be rural or urban. Create a series of thumbnail studies that investigate different arrangements and views of the remembered landscape. Focus on compositions that imply space. Choose the thumbnail composition that you like best in order to create a larger finished drawing. Your thumbnails and larger drawing should be made entirely from your memory. Incorporate as many details as you can, including the landscape's particular type of light.

Criteria:
1. The landscape or cityscape should be traced onto acetate with accuracy.
2. The written analysis of the drawing should include:
 a. A description of the composition. Does the composition utilize the entire format in a compelling way?
 b. Does the drawing appear special? What creates the illusion of space?

Criteria:
1. The drawing should be made on location in an outdoor urban or rural setting.
2. The composition of the drawing should be well considered. Thumbnail studies should be made in preparation for the finished drawing.
3. The drawing should create an illusion of space.
4. The drawing should capture a sense of light.

Criteria:
1. The thumbnail drawings should investigate a variety of different compositions and be made entirely from memory.
2. The finished drawing should create an illusion of space.
3. The remembered landscape should include many details, including a presence of light.

Materials: Clear acetate, tape, permanent pen, sketchbook

Materials: 8 × 10" watercolor paper, pencil, waterproof pen, one color of watercolor (a dark color is recommended)

Materials: Media optional

Looking at Drawing: Critical Thinking and Critique

Here we discuss why we critique, and how we should critique. As artists, it is important to be able to analyze and talk about artistic works. This further develops our aesthetic awareness, and helps us to communicate thoughts and ideas verbally. It is helpful to have a systematic way to consider strengths and weaknesses objectively. By taking time to consider such matters, we are better prepared to make good artistic decisions during our own creative endeavors. This final chapter focuses on effective language and organized critique methods that can be used when evaluating a drawing.

Whether by a historical master, a contemporary artist, a classmate, friend, or even a work you have made, a drawing is a window into another world. By looking carefully, you can enter that world and share in the artist's exploration. The more carefully you look, the better you will become at appreciating the choices artists face, and at recognizing their consequences. In the process, you will begin to uncover who you are as a creative person, and ultimately come to understand your own artworks better.

Of course, the first requirement of learning from a drawing is to observe and contemplate the work thoughtfully. Today, we live in a fast-moving world that has trained us to expect the whole meaning of an image at first glance, but drawings offer much more than this. Just as it takes time to make them, good drawings can only be fully appreciated when we take time to study them at length.

A drawing can provide—if you are willing to spend the time—a lengthy conversation between artwork and viewer. They offer opportunities to learn and gather new ideas and impressions. The more you study drawings, the stronger and more refined your own visual literacy will become. When viewing one, ask questions about what you are seeing, such as the following.

What was the purpose of the drawing? Many reveal the point of view of the artist. What mode of drawing was used? A drawing could have been made as a part of a creative process, or as a finished work. The approach could be obsessive or sloppy, bold or gentle, confident and directed, or tentative and searching. What medium was used? The materials used in creating a drawing impact the overall look of a work profoundly. Does the drawing tell you anything about its creator? These topics are addressed fully in the chapters of this book.

Critical thinking
The methodical evaluation of a subject in order to guide decision-making.
Analysis A close examination of something, such as a drawing, forming the basis of exploration or discussion.
Interpretation
To search for and explain the apparent meaning behind a work.
Conclusion In critical analysis, one's own evaluation. A judgment based on reasoning.
Formal analysis
The scrutinizing of a work's visual appearance based on the organizing principles of design and drawing elements.
Stylistic analysis
A type of analysis that focuses on style.
Contextual analysis
A type of analysis that focuses on the context in which a work was made.

18.1 Bill Watterson, "Calvin and Hobbes" cartoon, 1995

Critical Thinking

Critical thinking is the methodical evaluation of a subject in order to guide decision-making. Although the word "critical" has some negative connotations, the act of critical thinking is a positive endeavor that seeks a better understanding by exploring merits as well as shortcomings. There are a variety of ways to organize this type of evaluation, but it generally employs a process of interpretation and analysis in order to reach practical conclusions. A good critical thinker uses accurate and in-depth analysis as evidence to support his or her conclusions, opinions, and suggestions. This is best done in an objective manner and it is important to remain open-minded and receptive to alternative ideas throughout the process. The conclusions you reach can help guide and direct your future work.

Analysis, **interpretation**, and **conclusions** are defined below. The particulars of what each investigates are described fully throughout this book.

Analysis

Analyzing a drawing involves not only the description of a first impression, but also a more in-depth exploration of how the parts of the work contribute to the entirety of the piece. Works can be scrutinized in a number of ways, often combining different types of analysis to gain a well-rounded understanding of a work. Types of analysis that work particularly well when observing drawings are formal, stylistic, and contextual analysis.

Formal Analysis

Formal analysis is the scrutinizing of a work's visual appearance based on principles and elements. Principles include unity, balance, emphasis and focal point, pattern, rhythm, variety and contrast, and scale and proportion. Elements include line, shape, value, form, space, texture, and color.

Stylistic Analysis

This type of analysis focuses on style. Style is the combination of characteristics that make a work distinctive. **Stylistic analysis** allows us to recognize the artwork made by a specific artist. Often, it is considered as a way to connect related works, especially ones of a similar period, culture, or movement.

Contextual Analysis

Contextual analysis looks at the context in which the work was made. It often considers historical and cultural circumstances and issues. These could include religious, biographical, or gender issues, to mention a few. A drawing that was made for a classroom or student project has its own set of contextual criteria, influenced by the course objectives.

Interpretation

To make an interpretation of a drawing is to search for and offer an explanation as to the apparent meaning behind the work. What is the drawing about? An interpretation may include a description of the drawing's expressive qualities. How does the work make you feel? Does it conjure thoughts of other works or ideas?

Conclusion

To offer conclusions about a drawing, one presents one's own evaluation. The evaluation may recognize successes as well as opportunities for improvement. The conclusions should be warranted and based on visual evidence. A conclusion may utilize comparisons with similar works, or could be based on the overall qualities of a single work.

Examples of Critical Reviews

What follows are two critical reviews, one of a student drawing and one of a master drawing. Each review uses a different type of structure that asks slightly different questions. Whatever type of drawing is being reviewed, and whatever questions are being answered, remember that what is most important is to provide an accurate and in-depth analysis that can be used to support conclusions.

A Critical Review of a Student Drawing

This review utilizes critical thinking, as outlined on p. 345. The worksheet affords the opportunity to analyze, interpret, and draw conclusions. The final step of this process provides a chance to offer suggestions that could strengthen the work.

Critical Review Worksheet Student Drawing

Analysis

1. **Formal analysis**

 What element(s) dominate this drawing (line, shape, value, form, space, texture, color)? Describe how they are used.

 Line, form, and color are the main elements used in this drawing (**18.2**). The collection of objects is drawn with line so that all objects are contained within the page. Every object, whether made of glass or not, is drawn as if it were transparent. This is known as "drawing through," a technique that helps to establish an illusion of form. Color pastels have been added using an analogous color scheme.

 What principle(s) are responsible for the harmony in this drawing (unity, balance, emphasis and focal point, pattern, rhythm, variety and contrast, scale and proportion)? Describe how they are used.

 The naturalistic scale and proportions of the depicted objects create a sense of belonging among them.

The analogous color scheme, green and blue, is particularly good for creating visual harmony, or unity, among the depicted objects. Objects have been drawn large, filling most of the page.

2. **Stylistic analysis**

 How would you describe the style of this drawing? From your knowledge, is it similar to other works from a certain period, culture, or movement?

 This is a realist still-life drawing done from direct observation. The gestural line quality and the sense that the artist is searching for correct proportions recalls drawings made by the modern master Alberto Giacometti.

3. **Contextual analysis**

 Why was this drawing made? What were the artist's specific objectives?

 This drawing was made for a classroom assignment. Students were asked to draw from a prepared still life. Vertical and horizontal measuring lines were to be drawn in order to guide the placement and proportions of the objects. Students were asked to draw through objects in order to give them an illusion of form. The materials required for this drawing were graphite and colored pastels.

Interpretation

What is the drawing about? How does it make you feel? Does it conjure thoughts of other works or ideas?

This collection of still-life objects appears to have been drawn by someone who made a concerted effort to create unity within the drawing. The artist created a sense of harmony through her use of proportion and color. Proportions of singular objects, as well as objects in relation to each other, were carefully examined. The artist made intelligent use of a unifying color scheme. The apparent enthusiasm for the subject helped to make this drawing something more significant than just an exercise. It is an achievement of drawing unity.

18.2 Student work. Isabella Gardner, *Bottles*. (Instructor: Steven Schetski)

Conclusion

Discuss your evaluation of the drawing. Are there particular successes? Are there opportunities for improvement?

With her own unique style, the artist highlights the importance of unity in a drawing. She shows us that the time spent considering proportion and color is worthwhile and meaningful. As there are many successes in this work, there are also opportunities for improvement. For example, the student should have made the vertical and horizontal measuring lines as straight as possible. Accidentally making crooked or curving guidelines can lead to errors. The tabletop and the background could have been considered even further. Overall, however, the believability of the drawing does not suffer due to these shortcomings.

A Critical Review of a Master Drawing

For this example of a critical review, somewhat different questions are asked and answered. This format still requires analysis, interpretation, and conclusions, but these factors are guised in the categories of artistic aims, artistic challenges, artistic method, and results. This type of review is used throughout this text in "The Work of Art" features to examine master drawings as they relate to the topics of the chapters.

Critical Review Worksheet Master Drawing

18.3 Jean-François Millet, *The Gust of Wind*, 1870–71. Charcoal on laid paper, 8½ × 11¾" (21.7 × 29.7 cm). Royal Museum of Fine Arts, Copenhagen, Denmark

Who: Jean-François Millet
Where: France
When: 1870–71
Materials: Charcoal on laid paper

Artistic Aims

Why was this drawing made? What was the artist trying to achieve, depict, or symbolize?

Jean-François Millet (1814–1875) was a leading artist in the Barbizon School, a mid-nineteenth-century group of landscape artists working in the area of the French town of Barbizon. Millet endeavored to make true representations of the rural communities in which he lived and worked. He often focused on the hardships of common agricultural laborers. In the case of the charcoal drawing *The Gust of Wind*, he worked to capture the power of the stormy country landscape (**18.3**). This was a preliminary drawing for a painting.

Artistic Challenges

What difficulties did the artist face? How did the artist overcome his or her obstacles?

Millet was working on a series of paintings that depicted the four seasons. *The Gust of Wind* is a preparatory sketch for one of these paintings, of the same title. In this series he was interested in capturing nature's great cycle of birth, growth, death, and rebirth, a challenge even for such a skillful draftsman as Millet.

Here, a key artistic challenge that faced Millet was to evoke a sense of wind, which is invisible apart from its effects. With vigorously drawn marks he seizes upon the motions of the tree and sky. The wind blows from the upper-left to lower-right portions of the composition, typical in Western art due to the cultural norm of reading in that direction.

To capture the stormy weather in his drawing, Millet tried to incorporate ideas from expressive landscape artists who came before him. He admired and was inspired by the sixteenth-century Danube school and seventeenth-century Dutch landscape artists. Additionally, Millet developed his own techniques while drawing from nature.

Artistic Method

What materials did the artist use to make the work? Which techniques or style were applied? What elements and compositional devices were used?

This sketch was made with charcoal on a paper with a ribbed texture. Millet's approach to the drawing uses a sort of shorthand, as opposed to a highly rendered technique. In some areas the landscape forms are only minimally implied. More important is the suggestion of a strong wind. He creates the impression of a gust by using long directional marks, all directed to the right in the composition, and suggests its power by leaning the tree to the right as well.

Placing the horizon line relatively high, at about the middle of the page, creates a low point of view. The resulting large area in the foreground is very faintly drawn. (This is common in many of Millet's drawings.) This compositional decision has a spatial effect. In comparison to the large foreground space, the smaller portions of the landscape recede. The darkest lines anchor the viewer in the middle ground. Finally, very small and lightly drawn, the viewer comes upon a suggestion of buildings in the far distance.

The Results

What is your evaluation of the work? How does it make you feel? Does it conjure thoughts of other works or ideas?

The wind is the dominant aspect in the drawing. It takes precedence over the details of the scene. The drawing makes me feel as though I am there, caught in a storm. Millet must have felt many aspects of this drawing worked well, as the final painting for which the drawing was made is very similar (**18.4**). Modern students can learn from this piece, as it offers effective sketching, spatial, and compositional techniques.

18.4 Jean-François Millet, *The Gust of Wind*, 1871–73. Oil on canvas, 35⅜ × 46¼" (90.5 × 117.5 cm). National Museum of Wales, Cardiff

18.5 Honoré Daumier, *The Critique*, 1862. Lithograph on wove paper,
10½ × 8⅞" (26.8 × 22.6 cm). Private collection

likes praise, it is often true that people learn the most from their mistakes. Once other opinions have been heard, the artist can decide which ideas will be most beneficial to pursue.

There are many different ways to conduct a critique, and each approach has its own areas of particular effectiveness. Artists in their studios, as well as instructors and students in their classrooms, use all types, sometimes combining them in order to gain the most feedback. No matter the type, a good critique should address the purpose and objectives of the work. When critiquing a classroom assignment, the goals and outcomes of the assignment should be clear to all. When critiquing an independent work, you can respond to the work itself, without being guided by the artist's stated intentions. It can, however, also be helpful to the reviewers if an artist describes his or her intentions at the beginning of the discussion. Whichever the approach, everyone should leave a critique feeling as though they have learned ideas that they can use to improve their own work in the future.

Critique

Drawing is done in isolation most often. Artists make decisions about their drawings independently as they strive to make their work better and better. But this method of working can become limiting. Sharing and discussing drawings with others for the purpose of exchanging opinions enhances creative vision. Others can offer insights that an artist may not have considered before. This forum of artistic dialogue, often oral but sometimes written, is called a critique. Critiques include questions and responses based on the evident intentions of an artwork. They provide an opportunity to explore a work fully, while offering guidance and interpretations from multiple points of view. Critiques also help to strengthen and develop all participants' analytical and persuasive skills. The process of critique can be one of the most stimulating and fruitful aspects of thinking about art.

When critiquing, all involved should be receptive and accepting of the opinions and ideas of others. It is helpful to consciously detach personally from the works, becoming a neutral and open-minded participant. Although everyone

Self-Critique

Artists generally engage in a sort of constant self-critique as they work (see "Working Critique," opposite), but it is also occasionally constructive to take extra time to pause and analyze one's completed works. This can be done with single pieces, or with a series or group of works. Artists need time to reflect on their purposes and progress. Done objectively, this will make you aware of your strengths and weaknesses. With disciplined thinking, you can identify problems and then find effective solutions.

Working Critique

One of the best ways to improve the possibility of producing your best drawing is to make critical reviews during the process of making a work. Pausing to discuss an incomplete drawing with others allows for trouble-shooting. A working critique might review technique, formal issues, content, or concept. For example, critiquing thumbnails before starting a final drawing can be very beneficial. When working from a study for a final drawing, reviewing whether the study has been enlarged successfully can help to ensure a similarly satisfactory composition.

If problems are identified in a working critique, they can be corrected before they become a permanent part of the work. Alternatively, successes can be acknowledged, giving artists confirmation and validation of what they are doing. A working critique can also give you ideas about how to finish your work. You will benefit most from a working critique if you remain open to considering options and new possibilities.

Written Critique

Writing is an outstanding tool for conceptualizing. Writing about art inevitably leads to deeper understanding. Written critiques offer an alternative for those who might feel uncomfortable about critiquing the artworks of others aloud by giving reviewers time to collect their thoughts and form their opinions in an organized way. Written critiques can be used alone or as a way to collect ideas and lay a groundwork for discussion before oral critiques. We have already seen two examples of written critiques in the form of critical reviews. These outlines can always be used to maintain focus on specific objectives.

One-on-One Critique

One-on-one critiques provide private and individual attention from a teacher, friend, or confidant. They allow for tailored feedback and guidance related specifically to one's work, often addressing relevant issues in greater depth. For some people, it can be more comfortable to have an individual conversation than a discussion with a large group.

Group Critique

Information can be conveyed to and from the largest number of people through a group critique. The goal is to hear alternative opinions and feedback from a variety of different people. This can be done by focusing on works one at a time, or by considering an entire collection of works and making generalized observations about them as a whole.

It is the group dynamic that makes this style of critique particularly helpful. A good group critique relies on the free flow of ideas through dialogue about one another's works. People often benefit as much from what is said about other people's work as they do from the comments made about their own. What is said to others often applies to everyone.

A group critique is most successful when everyone shares ideas and suggestions. Remember, the goal is to help others realize their visions. The focus should always be on the work, not on the individual who made it. Stay grounded in the intentions of the work. A combination of positive encouragement and constructive feedback is appreciated. Everyone should exercise common sense and courtesy when commenting. One should disregard one's own personal aesthetics and provide constructive analysis. Good remarks are useful and add to the productive nature of the discussion; poor comments do not lead to solutions.

Bad: "I don't like the drawing."

Better: "Although there is a unified sense of color in this drawing, the composition looks unbalanced. If there were another figure on the right side of the page, then the drawing would have better visual equilibrium."

Remember, despite everyone's attempts to be objective when critiquing, everyone's own aesthetic opinions and tastes will come into play. Even when looking at the same drawing, different people will often come up with very different conclusions. While this can sometimes be confusing, it is also a reminder that art is personal and subjective. In the end, it is each artist's job to decipher which viewpoints are helpful and which are not.

In the Studio Projects

Fundamental Project

Choose one of your drawings to self-critique. Be aware of both the strengths and the weaknesses that the work possesses. Create a list for both (**18.6**).

Criteria:

1. A complete list of strengths should be made.
2. A complete list of weaknesses should be made.
3. The lists should demonstrate your critical awareness of your own work.

Materials: Word-processing document

Self-critique: Strengths and Weaknesses

Name:
Title of work:

Strengths	Weaknesses

18.6 Self-Critique: Strengths and Weaknesses

Observational Drawing

This assignment is a writing opportunity. Select a student drawing that was executed from direct observation. You may choose a student drawing from a fellow student, or one that has been reproduced in this book. Use the "Critical Review Worksheet: Student Drawing" on p. 346 to write a critical review of the piece (**18.7**).

Criteria:

1. The critical review should incorporate analysis in a clear and thorough way.
2. The critical review should make interpretations in a clear and thorough way.
3. The critical review should draw justified conclusions.

Materials: Worksheet

Critical Review Worksheet: Student Drawing

Artist's name:
Title:

Analysis

1. Formal analysis
 What element(s) dominate this drawing (line, shape, value, form, space, texture, color)? Describe how they are used.

 What principle(s) are responsible for the harmony in this drawing (unity, balance, emphasis and focal point, pattern, rhythm, variety and contrast, scale and proportion)? Describe how they are used.

2. Stylistic analysis
 How would you describe the style of this drawing? From your knowledge, is it similar to other works from a certain period, culture, or movement?

3. Contextual analysis
 Why was this drawing made? What were the artist's specific objectives?

Interpretation
What is the drawing about? How does it make you feel? Does it conjure thoughts of other works or ideas?

Conclusion
Discuss your evaluation of the drawing. Are there particular successes? Are there opportunities for improvement?

18.7 Example of a Critical Review Worksheet: Student Drawing

Non-Observational Drawing

This assignment is a writing opportunity. Select a drawing that was done from a non-direct observation. It could be a masterwork, or from a professional contemporary artist. You could consider Sonia Gechtoff's work in **3.5** (p. 61), or Alain Kirili's drawing in **9.26** (p. 197). Use the "Critical Review Worksheet: Master Drawing" on p. 348 to write a critical review of the piece (**18.8**).

Criteria:

1. The critical review should incorporate analysis in a clear and thorough way.
2. The critical review should make interpretations in a clear and thorough way.
3. The critical review should draw justified conclusions.

Materials: Worksheet

Critical Review Worksheet: Master Drawing

Who:
Where:
When:
Materials:

Artistic Aims
Why was this drawing made? What was the artist trying to achieve, depict, or symbolize?

Artistic Challenges
What difficulties did the artist face? How did the artist overcome his or her obstacles?

Artistic Method
What materials did the artist use to make the work? Which techniques or style were applied? What elements and compositional devices were used?

The Results
What is your evaluation of the work? How does it make you feel? Does it conjure thoughts of other works or ideas?

18.8 Example of a Critical Review Worksheet: Master Drawing

18.9 Randall McIlwaine, *Early Art Critic*, 1999

Glossary

Acid-free Contains nothing acidic, preventing the possibility of yellowing and ageing. See p. 64

Additive An artistic process in which the work is created by adding or layering material. See p. 68

Additive color Colors produced by mixing light. See p. 258

Alignment A sighting process whereby the artist compares landmarks by extending imaginary vertical and horizontal lines. See pp. 135, 136–37

Analogous color scheme A color scheme based on a group of colors that are found side by side on the color wheel. See pp. 268, 346

Analysis A close examination of something, such as a drawing, forming the basis of exploration or discussion. See pp. 344, 345, 346

Archival Having durable qualities that prevent deterioration. See p. 65

Asymmetrical balance Compositional arrangement in which visual equilibrium is achieved by elements that contrast and complement one another without being the same on either side of a central axis. See pp. 105, 107

Atmospheric perspective Sometimes called aerial perspective, a technique that simulates the reduced visual clarity of things seen at a distance. See pp. 223–25, 232

Blind-contour line A type of contour line in which a drawing is made as the artist's eyes follow the form of the subject without looking at the paper. See p. 159

Block in or **Map out** Adding approximate values to a drawing. Often used as a first step when applying value. See pp. 140, 141, 184

Bony landmarks Parts of the skeletal system that can be seen through the skin, used by artists to assist the development of a life drawing. See pp. 304–5, 308

Box construction The construction of forms in a drawing using box-like forms. See pp. 298, 300–301

Calmes In a stained-glass window, the lead tracks that hold together individual pieces of glass in a mosaic-like fashion. See p. 28

Cartoon A full-sized drawing made as a guide for a final work. From the Italian *cartone*, meaning an artist's preliminary sketch. See pp. 144–45, 213

Cast shadow The absence of light created by an object interrupting the light source. See pp. 196, 209, 212, 215

Chiaroscuro From the Italian "light-dark," the modeling of forms using value to create the impression of volume. See pp. 208, 215

Closed composition A type of composition in which the entire subject exists within the picture plane. See pp. 96, 97

Cold-press paper Paper that generally has a slightly textured surface. See p. 65

Collage A work of art assembled by gluing materials onto a surface. From the French *coller*, "to glue." See p. 254

Color scheme Color relationships that create visual harmony. See pp. 256–73

Color wheel A diagram of color relationships. See pp. 257–58, 268

Complementary color scheme A color scheme that utilizes colors that appear opposite each other on the color wheel. See p. 268

Complementary colors Colors opposite one another on the color wheel. See p. 258

Composition The overall design or organization of a drawing. See pp. 94–115

Compositional gesture A quick, generalized drawing that is concerned with the placement of objects on the page. See pp. 133, 135–39, 147

Conclusion In critical analysis, one's own evaluation. A judgment based on reasoning. See pp. 344, 345, 347

Contextual analysis A type of analysis that focuses on the context in which a work was made. See pp. 344, 345, 346

Continuous tone A type of value application in which values are blended to create smooth and even transitions. See pp. 184, 186, 187, 192, 195, 199

Contour line Lines that delineate the edges of both interior and exterior forms to enhance the description of space. See pp. 156–57, 159–61

Contrapposto A pose in which the upper part of the body twists in one direction and the lower part in another, with most weight placed on one leg. See p. 296

Convergence lines, also known as **orthogonals** Lines that trace the receding parallel lines of an object, eventually appearing to converge. See pp. 228, 230–31, 239

Core shadow The darkest part of the shadow zone. See pp. 209, 210, 212

Critical thinking The methodical evaluation of a subject in order to guide decision-making. See pp. 344–45

Cross-contour line A type of contour line that utilizes parallel lines that move across a form to depict volume and space. See pp. 159–61

Cross-hatching The use of lines drawn at different angles to overlap and convey value. See pp. 166, 167–69

Dark half-tone The darkest of the transitional values located toward the shadow zone. See pp. 209, 210

Descriptive line A representational line. See pp. 151–52

Design drawings Drawings made by designers to explore and develop ideas and products. See p. 40

Disegno A Renaissance term that describes the process of having creative ideas and making them visible through drawing. See p. 41

Drawing As a verb, drawing refers to the action of making marks on a surface. As a noun, drawing refers to the composition resulting from this process of mark-making. See pp. 18–29

Drawing through A technique in which objects are drawn as if they are transparent. See pp. 40, 202–3

Emotional line A line that we associate with certain types of feelings, expressions, or moods. See pp. 153–54

En plein air French for "in the open air"; used to describe art produced outside. See pp. 267, 333–35, 340, 343

Envelope method The technique of establishing the outermost dimensions of a subject by using lines to encase it. See p. 205

Expression The individual spirit that results when an artist conveys ideas, feelings, and vision. See pp. 55–57

Figurative Art that is recognizably derived from the visible world, especially human or animal forms. See p. 37

Figure drawing or **life drawing** The study of the human form, usually based on observation of a live model. See pp. 290–311

Figure/ground relationship The manner in which positive and negative shapes visually interact. See pp. 154–55, 178–79, 180

Fixative A spray used to protect the surface of delicate drawings made with such media as pencil, charcoal, or pastels. See p. 68

Foreshortening The appearance of a form when depicted at a very oblique (often dramatic) angle to the viewer in order to show depth in space. See p. 220

Form (1) A type of creation (drawing as a "form" of art). (2) A three-dimensional object, or an illusion of three-dimensionality. See pp. 200–215

Form shadow The area of the form that turns away from the light source and is composed of dark values. See pp. 209, 210

Formal analysis The scrutinizing of a work's visual appearance based on the organizing principles of design and drawing elements. See pp. 344, 345, 346

Format The size and shape of a work of art. See pp. 95, 103, 112

General style A way to define works that have similar characteristics. See pp. 54–55

Geometric shapes Regular and ordered shapes that relate to geometry. See pp. 174, 175, 177–81

Gestalt A German psychological term meaning "unified whole." In art, refers to the mind's ability to assemble multiple perceptions into a whole that is more than merely the sum of its parts. See p. 104

Gesture drawing Often quickly made, these drawings intend to express a sense of movement, action, or energy. See pp. 22, 42–44

Golden Section A geometric relationship that has been employed by artists since Classical times. Its divisions, such as the Golden Rectangle and the Golden Spiral, can be used to place objects harmoniously in a drawing. See p. 100

Ground The drawing surface, paper or otherwise. See pp. 64–67

Ground plane The horizontal "floor" surface of a drawing, extending into its imaginary space. See pp. 97, 98

Half-tone The transitional value that lies halfway between the light and dark sides of a form. See pp. 209, 210, 212

Hatching The use of single-direction, parallel lines to convey value. See pp. 163, 166, 167–69

Highlight The area in which a light source is reflected most intensely. See pp. 202, 209, 210, 212

Horizon line In linear perspective, this represents the actual height of the viewer's eye level when looking at an object or scene. See pp. 228–31, 233–39

Hot-press paper Paper that generally has a smooth surface. See p. 65

Hue The general classification of a color. See pp. 258–59, 263

Implied line A line not actually drawn but suggested by elements in the work. See pp. 158, 165–67

Implied texture or **visual texture** A visual illusion expressing texture through mark-making or pattern. See pp. 74, 241–43

Interpretation To search for and explain the apparent meaning behind a work. See pp. 344, 345

Invented texture Texture conceived by the artist, i.e. not necessarily based on reality. See pp. 247–48

Irregular forms Objects the parts of which are not regular nor based on simple geometry. See pp. 279, 281, 289

Landscape drawing A genre of drawing with the central subject of location and environment. See pp. 330–43

Life drawing or **figure drawing** The study of the human form, usually based on observation of a live model. See pp. 290–311

Light half-tone The lightest of the transitional values located toward the light zone. See p. 209

Light zone The area that faces the light source and is composed of the lightest values. See pp. 141, 209, 210, 213

Line weight The quality or physical characteristic of a line, such as its width or thickness. See pp. 158, 162–65

Linear construction In a drawing, the use of lines to construct forms. See pp. 298–300

Linear modeling A technique in which line is used to create shading to suggest volume and space. See pp. 166, 167–69

Linear perspective A way of representing space based on the principle that parallel lines appear to converge as they move away from the viewer. See pp. 226–39

Local color The actual color of the surface, as it would be if it were unaffected by light or shadow. See pp. 183, 262, 264

Lost line A line that seems to disappear. See pp. 165–67

Map out or **Block in** Adding approximate values to a drawing. Often used as a first step when applying value. See pp. 140, 141, 184

Mark-making The marks made upon a surface. See pp. 43, 58–62

Mode The type of drawing and the manner of its creation. See pp. 30–44

Monochromatic color scheme A color scheme that utilizes only one hue and its various values. See pp. 79, 266

Multiple-point perspective A perspective system with many different sets of vanishing points. See p. 231

Narrative portrait A portrait that tells a story. See pp. 326–27

Negative shape The shape created through the absence of an object. See pp. 178–80

Non-objective drawing Drawings that are neither derived from, nor do they depict, a subject from reality. See pp. 52–53, 60, 154

Observational drawing Also called drawing from direct observation. Drawings made by viewing the subject directly. See pp. 45, 130–47

Occlusion The darkest part of the cast shadow. See p. 209

One-point perspective A perspective system based on one vanishing point. See pp. 231, 233, 239

Open composition A type of composition in which parts of the subject extend beyond the picture plane. See p. 97

Optical color mixing When individual color marks visually blend so that they are perceived as a new color. See p. 265

Optical mixing A type of value application in which individual marks visually blend so that they are perceived as an area of value. See pp. 184, 188, 202

Organic shapes Shapes, often found in nature, without a regular measurable structure or symmetry. See pp. 177–78

Organizing principles of design Fundamental features that guide the holistic arrangement of parts in a work of art. See pp. 101–15

Orthogonals, also known as **convergence lines** Lines that trace the receding parallel lines of an object, eventually appearing to converge. See pp. 228, 230–31, 239

Outer-contour line A type of contour line in which the exterior lines separate interior and/or exterior forms. See p. 156

Outline The outermost line of an object or figure, by which it is defined or bounded. See pp. 154–55

Overlap The effect created when one object partially covers another. See pp. 218–19, 232

Pattern A repetition of motifs within a drawing. See pp. 101, 110, 112

Pentimento (pl. **pentimenti**) Italian for "repentance," the appearance of previous marks made by the artist, often revealing the drawing process. See pp. 69, 166

Penumbra The soft outer edge of a cast shadow. See p. 209

Personal style The individual and personal influence an artist has on his or her work. See pp. 54–55

Perspective view A drawing of an object as it is seen by the eye. See p. 226

Photo transfer One of many different techniques for transferring a photo image to a drawing surface. See pp. 240, 248, 251–52, 255

Picture plane An imaginary plane corresponding to the surface of a picture; the extreme foreground of a drawing. See pp. 96–97

Planar analysis The investigation of how an object can be divided into planes. See pp. 171, 204

Plane A flat surface. Planes can be the fundamental structural unit of a drawing. See p. 97

Pointillism A late nineteenth-century style of art using short strokes of color that optically combine to form new perceived colors. See p. 265

Portraiture A specialized genre of life drawing involving the creation of a pictorial likeness, usually concentrating on the face. See pp. 312–29

Positive shape The shape created through the presence of an object. See pp. 178–80, 181

Primary colors Colors from which, in theory, all others are derived: red, yellow, and blue. See p. 258

Process drawings Drawings made for the development of a finished work of art or product. See pp. 31–44

Proportion The relationship in size between individual parts and the whole. See pp. 100, 101, 113–15

Pure color A color of clarity and purity, approximating that which is seen in the spectrum of light. See pp. 258, 271

Radial balance Compositional arrangement whereby elements emanate from a central point. See p. 109

Reflected light The part of the shadow area that receives indirect light from the environment. See pp. 196, 209

Regular forms Objects that are predictable in structure. See pp. 279–81

Rendering The execution of a drawing, especially when adding color, shading, and/or texture. See p. 58

Replicated or **simulated texture** Texture that is imitated so convincingly that it almost appears to be real. See pp. 240, 243–45

Representational drawing Drawings that record the appearance of a subject so that we recognize what is represented. See p. 53

Rhythm The regular or ordered repetition of elements in a work. See pp. 101, 103, 110–12, 145, 165

Rough paper Paper that generally has a considerably textured surface. See p. 65

Rubbings Sometimes referred to as *frottage*, a technique or process of taking an impression from an uneven surface to form a work of art. See pp. 240, 248–51, 255

Rule of Thirds A compositional scheme whereby objects are placed according to the intersections of one-third divisions of the picture plane. See p. 98

Rural landscape Scenes of the country landscape and of country life. See pp. 337–39, 342

Saturation The degree of purity and brilliance of a color, sometimes called "color intensity" or "chroma." See pp. 258, 259, 262–63, 271

Scale The size of an object or shape in relation to the viewer. See pp. 101, 113–15

Scumble To lay a color on top of an already colored surface to create uniformity and/or visual texture. See p. 74

Seascape Scenes focusing on the sea. See p. 338

Secondary colors Such colors as orange, green, and violet, obtained by mixing two primary colors. See p. 258

Self-portrait A portrait an artist makes of himself or herself. See pp. 294, 323–25, 327

Sfumato The subtle gradation of tone used to blur areas of light to dark, creating a hazy or smoky appearance. See pp. 145, 213–14, 215

Sgraffito A subtractive drawing technique in which a top layer of a medium is scratched away to reveal the layer beneath. See p. 245

Shade A color plus black. See pp. 258, 259

Shape A two-dimensional area, the boundaries of which are defined by lines or suggested by changes in color or value. See pp. 170–81

Sighting and measuring Techniques used to refine the angles and proportions of a drawing. See pp. 133, 135, 136, 140

Sighting and measuring stick A straight, thin stick used when sighting a measurement. A thin dowel or a pencil is often used. See pp. 135–38

Simulated or **replicated texture** Texture that is imitated so convincingly that it almost appears to be real. See pp. 240, 243–45

Sketch A quickly made drawing that suggests the artist's thought. See pp. 32–33

Sketchbook A book or pad used to collect drawings, observations, inventions, ideas, and notes to oneself. See pp. 116–29

Skyscape Scenes showing the sky, clouds, and weather. See p. 340

Soft line A line that is faintly drawn. See pp. 158, 165–67

Space Also known as depth. Refers to the expanse within which all parts of a drawing appear to exist. See pp. 216–39

Spherical construction The construction of forms in a drawing using rounded forms. See pp. 298, 302

Still life (1) A genre of art; (2) A scene of inanimate objects, such as fruits or flowers. See pp. 276–89

Storyboard Panels of sketches made to suggest a sequence of actions, such as a movie or animation. See p. 23

Stream-of-consciousness drawing A spontaneous approach to drawing from imagination in which the artist quickly records images and ideas as they come to mind. See p. 51

Student-grade A designation for less-expensive art supplies. See p. 64

Studio sketchbook A sketchbook utilized for creative exploration within the studio. See pp. 116, 121, 124, 125–27

Study A drawn investigation made of a subject, often in preparation for future works. Usually more detailed than a sketch. See pp. 34–36

Stumping Using a soft blending tool (a "stump") to smudge or blend media. See p. 189

Stylistic analysis A type of analysis that focuses on style. See pp. 344, 345, 346

Subtractive An artistic process in which the work is created by removing or erasing material. See pp. 68, 245

Subtractive color Colors produced by mixing pigments. See p. 258

Sumi ink A pressed block made from a mixture of carbon and glue that creates ink when water is added. See pp. 21, 154

Surface texture The physical texture on the surface of a drawing. See pp. 77, 210, 246–47, 251, 255

Symmetrical balance Compositional arrangement whereby identical elements lie on either side of a central axis. See pp. 105–6, 308–9

Temperature A description of color based on our associations with warmth or coolness. See pp. 258, 259, 260–62

Tertiary colors Colors obtained by mixing a primary and a secondary color: red-orange, yellow-orange, yellow-green, blue-green, blue-violet, and red-violet. See p. 258

Texture The tactile quality of a surface. See pp. 240–55

Three-point perspective A perspective system based on three vanishing points. Gives the illusion of looking up or down. See pp. 231, 235

Thumbnail studies Small preliminary drawings with a primary focus on composition. See pp. 37–38, 57, 134–35

Tint A color plus white. See pp. 258, 259

Tonal color scheme A color scheme that utilizes only tones, either achromatic or chromatic. See pp. 266, 268–70

Tone A color plus gray, or a color plus its complement. See pp. 258, 259

Tooth The feel, or texture, of the surface of a paper. See pp. 65, 75

Traveling sketchbook A sketchbook utilized outside of the studio for short

or extended travel. See pp. 116, 117, 121–25

Trompe l'oeil An extreme kind of illusion meant to deceive the viewer that the objects included are real. See p. 244

Two-point perspective A perspective system based on two vanishing points. See pp. 231, 234

Urban landscape The landscape and environment of a city. See pp. 337, 340

Value The relative lightness or darkness of an area or object. See pp. 182–99

Value drawing A drawing devoid of color. See pp. 182, 184, 189–90, 199, 206

Value pattern A distinct pattern or configuration that emerges from the repetition of lights and darks. See pp. 183, 185, 192

Value scale A diagram representing an incremental progression of values from black to white. See pp. 189–90

Value scheme The combinations of values within a drawing. See pp. 189–90

Value shape The shape in which a value is applied to a composition. See p. 193

Vanishing point In linear perspective, the point at which receding parallel lines appear to converge. See pp. 228, 230–31

Vanitas A genre of still-life drawing that emphasizes the brevity of life and the transient nature of beauty. See pp. 286–87

Viewfinder A small, window-like tool to assist with planning and framing a composition from observation. See pp. 133–34, 282, 283

Visual movement The graphic path taken by the eye when looking at an artwork. See p. 110

Visual texture or **implied texture** A visual illusion expressing texture through mark-making or pattern. See pp. 74, 241–43

Visual weight A measure of an object or area's ability to attract attention. See pp. 105, 107

Volumetric The impression of three-dimensionality in a drawn form. See pp. 201, 202, 209, 210, 215

Weight of paper An indication of the thickness of a type of paper. See p. 65

Glossary of Artistic Movements, Styles, and Periods

Abstract Expressionism A mid-twentieth-century artistic style in which non-representational images are used to convey intense emotions and ideas. See pp. 153, 210, 247, 287, 295

Baroque European artistic and architectural style of the late sixteenth to early eighteenth century, characterized by extravagance and emotional intensity. See pp. 210, 211, 294

Classical (1) Ancient Greek and Roman; (2) Art that conforms to Greek and Roman models, or is based on rational construction and emotional equilibrium. See pp. 52–53, 143, 295, 296, 308

Cubism A twentieth-century art movement that favored a new

perception emphasizing geometric forms. See pp. 278, 283

Expressionism (1) An artistic movement at its height in 1920s Europe, devoted to expressing emotions or ideas over objective reality. (2) An artistic style devoted to representing subjective emotions or ideas over objective reality. See pp. 110, 156

Fauvism An early twentieth-century art movement that used vibrant non-naturalistic color as a primary means of expression. From the French *fauve*, meaning "wild beast." See p. 271

Funk Art A figurative-art movement of the 1960s and 1970s, most popular in California, reacting against abstract art. See p. 246

Hyper-realism Art that imitates reality so closely that the subject

appears to be real. See pp. 48, 243, 287

Impressionism A late nineteenth-century painting style conveying the impression of the effects of light. See pp. 54–55

Minimalist An artistic style characterized by its simple and unified look, often using geometrical forms. See p. 40

Modernist A radical twentieth-century artistic movement that rejected tradition in favor of experimentation. See p. 38

Neoclassical A pure form of Classicism that emerged from around 1750. See p. 208

Pointillism A late nineteenth-century style of art using short strokes of color that optically combine to form new perceived colors. See p. 265

Pop Art A mid-twentieth-century art movement that drew inspiration from popular culture and mass media. See p. 262

Realist Artistic style that aims to depict subjects in a naturalistic way. See pp. 151, 172, 174, 177

Renaissance A period of cultural and artistic change in Europe from the fourteenth to the seventeenth century. See p. 31

Romanticism A movement in nineteenth-century European culture, concerned with the power of the imagination and greatly valuing intense feeling. See pp. 120–21, 331, 332, 338

Surrealism An artistic movement in the 1920s and later; its works were inspired by the subconscious. See pp. 181, 249, 254

Sources of Quotations

Chapter 2

p. 34: Beatrix Potter from Beatrix Potter, *The Tale of Peter Rabbit* (London: Frederick Warne, 2002), 7–8

p 34: Eli Siegel from "Romanticism Is Still With Us" (unpublished), quoted in

Marcia Rackow, "'Wonder And Matter-Of-Fact' Meet—The Imagination Of Beatrix Potter," *Journal of the Print World, Inc.*, Vol. 25 No. 4, Fall 2002, Meredith, NH

Chapter 14

p. 280: Le Corbusier in 1961, quoted by Paola Antonelli in Matilda McQuaid, ed., *Envisioning Architecture: Drawings from The Museum of Modern Art* (New York: The Museum of Modern Art, 2002), 68

p. 286: Ecclesiastes 1:2

Illustration Credits

l=left, r=right, a=above, b=below,
c=center

Where relevant, dimensions are given
in inches (centimeters)

Frontispiece Courtesy the artist
0.1 © Stephen C. P. Gardner
p. 12 Courtesy Sikkema Jenkins & Co.,
New York. Artwork © Kara Walker
p. 13 (a) Art Institute of Chicago,
Gift of David Adler, 1945.23. Photo
2018, The Art Institute of Chicago/
Art Resource, NY/Scala, Florence.
© DACS 2018
p. 13 (b) Museum of Modern Art,
New York, The Riklis Collection
of McCrory Corporation, Acc. no.
914.1983. Photo 2018, The Museum
of Modern Art, New York/Scala,
Florence. © FLC/ADAGP, Paris
and DACS, London 2018

Part 1
p. 17 Courtesy the artist

Chapter 1

1.1 Cristina DeBiase
1.2 Thomas Edison National Historical
Park, West Orange
1.3 Metropolitan Museum of Art,
New York, Rogers Fund, 1921, 21.88.18
1.4 Courtesy the Artist and Pierogi
Gallery
1.5 Barbara and Willard Morgan
photographs and papers, Library
Special Collections, Charles E. Young
Research Library, UCLA. Photo
Willard Morgan
1.6 Barbara and Willard Morgan
photographs and papers, Library
Special Collections, Charles E. Young
Research Library, UCLA
1.7 Photo CBS via Getty Images
1.8 Photo NPS.co.uk. Courtesy
Alfred Hitchcock, LLC. All Rights
Reserved
1.9 Photo Michael Ochs Archives/
Getty Images
1.10 © Miles Davis Properties, LLC.
All Rights Reserved
1.11, 1.12 Royal Library, Windsor
1.13, 1.14 Gallerie dell'Accademia,
Venice
1.15 Alexandra N. Ibarra
1.16 © April Coppini
1.17 Fondation Pierre Bergé-
Yves Saint Laurent, Paris/Guy
Marineau
1.18, 1.19 © Fondation Pierre Bergé-
Yves Saint Laurent, Paris
1.20 Photo Birmingham Museums
Trust

1.21 © Stephen C. P. Gardner
1.22 Bradford Art Galleries and
Museums, West Yorkshire/Bridgeman
Images

Chapter 2

2.1 Photo courtesy the State Museum
of Pennsylvania, Pennsylvania
Historical and Museum Commission
2.2 J. Paul Getty Museum, Los Angeles,
2001.47
2.3 Photo Victoria and Albert
Museum, London
2.4 © Stephen C. P. Gardner
2.5 Photo Musée du Louvre, Dist.
RMN-Grand Palais/Marc Jeanneteau
2.6 Christie's Images/Bridgeman
Images
2.7 © Stephen C. P. Gardner
2.8 Eliza Ivanova.
www.elizaivanova.com
2.9 J. Paul Getty Museum, Los Angeles,
91.GG.3
2.10 Metropolitan Museum of Art,
New York, Bequest of Lydia Winston
Malbin, 1989, 1990.38.18ab. Photo
2018, The Metropolitan Museum of
Art/Art Resource/Scala, Florence
2.11 Metropolitan Museum of Art,
New York, Gift of Katherine Ticknor
Heintzelman, 1966, 66.189.2
2.12 Isabella Gardner
2.13 Oscar Bluemner papers,
1886–1939, 1960. Archives of
American Art, Smithsonian
Institution, Washington, D.C.
2.14 © Stephen C. P. Gardner
2.15 Edward Hopper, *Study
for Nighthawks*, *c.* 1941–42.
Fabricated chalk on paper, $8^3/8 \times 11$
(21.4×27.8). Whitney Museum of
American Art, New York, Josephine
N. Hopper Bequest, 70.193. © Heirs of
Josephine N. Hopper, licensed by the
Whitney Museum of American Art
2.16 Edward Hopper, *Study
for Nighthawks*, *c.* 1941–42.
Fabricated chalk on paper, $8^1/2 \times 11^1/8$
(21.6×28.1). Whitney Museum of
American Art, New York, Josephine
N. Hopper Bequest, 70.195. © Heirs of
Josephine N. Hopper, licensed by the
Whitney Museum of American Art
2.17 Edward Hopper, *Study
for Nighthawks*, *c.* 1941–42.
Fabricated chalk on paper, $7^1/4 \times 4^1/2$
(18.4×11.3). Whitney Museum of
American Art, New York, Josephine
N. Hopper Bequest, 70.189. © Heirs of
Josephine N. Hopper, licensed by the
Whitney Museum of American Art
2.18 Edward Hopper, *Study
for Nighthawks*, *c.* 1941–42.
Fabricated chalk and charcoal on
paper, $8^1/8 \times 8$ (20.6×20.3). Whitney
Museum of American Art, New York,
Josephine N. Hopper Bequest, 70.253.
© Heirs of Josephine N. Hopper,
licensed by the Whitney Museum
of American Art

2.19 Edward Hopper, *Study
for Nighthawks*, *c.* 1941–42.
Fabricated chalk on paper,
$4^1/2 \times 7^1/4$ (11.3×18.3). Whitney
Museum of American Art, New York,
Josephine N. Hopper Bequest, 70.192.
© Heirs of Josephine N. Hopper,
licensed by the Whitney Museum
of American Art
2.20 Edward Hopper, *Study
for Nighthawks*, *c.* 1941–42.
Fabricated chalk and charcoal
on paper, $15^1/8 \times 11^1/8$ (38.3×28.1).
Whitney Museum of American Art,
New York, Josephine N. Hopper
Bequest, 70.256. © Heirs of Josephine
N. Hopper, licensed by the Whitney
Museum of American Art
2.21 Art Institute of Chicago, Friends
of American Art Collection, 1942.51
2.22 Scott Robertson Design
2.23 © Stephen C. P. Gardner
2.24 Courtesy the Estate of Greta
Magnusson Grossman, R & Company
Library and Archives, New York
2.25 Photo VEGAP Image Bank.
© DACS 2018
2.26 Whitney Museum of American
Art, New York, Gift of the Lenore
G. Tawney Foundation, 2014.295.
© The Lenore G. Tawney Foundation
2.27 Courtesy the artist and Sperone
Westwater, New York. © ARS, NY and
DACS, London 2018
2.28 © The Estate of Alberto
Giacometti (Fondation Annette et
Alberto Giacometti, Paris and ADAGP,
Paris), licensed in the UK by ACS and
DACS, London 2018
2.29 Photo Kunsthalle Bremen/Karen
Blindow/ARTOTHEK
2.30 Museum of Modern Art, New
York, Purchase, Acc. no. 436.1981.
Photo 2018, The Museum of Modern
Art, New York/Scala, Florence.
Courtesy Marlborough Fine Art.
© Frank Auerbach
2.31 Museum of Modern Art,
New York, Gift of the artist, Acc. no.
493.2012. Photo 2018, The Museum
of Modern Art, New York/Scala,
Florence. © DACS 2018
2.32 © Şule Yiğit
2.33 Courtesy DC Moore Gallery,
New York. © Estate of Nathan Oliveira
2.34 Courtesy the artist. © Michael
Grimaldi, 2012. All Rights Reserved
2.35 National Portrait Gallery,
Canberra, Gift of the artist 2002,
donated through the Australian
Government's Cultural Gifts
Program. Courtesy the Artist
and King Street Gallery on
William, Darlinghurst, NSW
2.36 Bibliothèque Nationale
de France, Paris
2.37 Bridgeman Images
2.38, 2.39 Artwork courtesy of and
approved by the Norman Rockwell
Family Agency
2.40 Photo Thomas Müller. Courtesy
the artist and Miguel Abreu Gallery,
New York

2.41 Museum of Modern Art,
New York, Gift of Edward R. Broida,
inv. no. 678.2005. Photo 2018, The
Museum of Modern Art, New York/
Scala, Florence. Courtesy Matthew
Marks Gallery. © Vija Celmins
2.42 Photo RMN-Grand Palais
(Musée d'Orsay)/Tony Querrec
2.43 Kim Jung Gi, 2013
2.44 Photo Claude Bornand
2.45 Metropolitan Museum,
New York, Fletcher and Van Day
Truex Funds, 2011.448
2.46 Museum of Modern Art, New
York, Gift of the Estate of Keith Haring,
Inc. Acc. no. 495.1992.a-b. Photo 2018,
The Museum of Modern Art, New
York/Scala, Florence. Keith Haring
artwork © Keith Haring Foundation
2.47 Courtesy the artist. Tel Aviv
2.48 Antonio Quattrone/Mondadori
Portfolio via Getty Images
2.49 Photo RMN-Grand Palais
(Musée du Louvre)/Thierry Le Mage
2.50 British Museum, London,
1816,0610.98
2.51 J. Paul Getty Museum,
Los Angeles, 2004.45
2.52 Sterling and Francine Clark Art
Institute, Williamstown, Massachusetts,
1996.5. Photo Art Collection/Alamy
2.53 Harvard Art Museums—Fogg
Museum, Cambridge, MA, Bequest of
Grenville L. Winthrop, 1943.393. Photo
Imaging Department. President and
Fellows of Harvard College
2.54 Museum of Fine Arts, Budapest
2.55 Smith College Museum of Art,
Gift of Mrs. John Wintersteen (Bernice
M. McIlhenny, class of 1925)
2.56 Courtesy the artist and Richard
Gray Gallery. Photo Kerry Ryan
McFate, Pace Gallery. © Jim Dine/ARS,
NY and DACS, London 2018
2.57 Courtesy Alexandre Gallery,
New York, NY. © Anne Harris
2.58 © DACS 2018

Chapter 3

3.1 © Stephen C. P. Gardner
3.2 Courtesy Yukiko Koide Presents,
Tokyo, Collection Daniel Klein.
© Kunizo Matsutomo
3.3 British Museum, London,
1968,0210.20
3.4 © Jon F. Anderson, Estate of
Paul Cadmus/VAGA, NY/DACS,
London 2018
3.5 Courtesy Foster Gwin
3.6 Photo Laura Mitchell
3.7a Art Institute of Chicago, Gift
of David Adler, 1945.23. Photo 2018,
The Art Institute of Chicago/Art
Resource, NY/Scala, Florence.
© DACS 2018
3.7b Art Institute of Chicago, Gift
of David Adler, 1945.23. Photo 2018,
The Art Institute of Chicago/Art
Resource, NY/Scala, Florence.
© DACS 2018

3.8 © Fadil Aziz/Alcibbum Photography

3.9 Rifkin, R. F., Pleistocene figurative art mobilier from Apollo 11, southern Namibia. *Expression: International Journal of Art, Archaeology and Conceptual Anthropology*, 9:97–101, 2015

3.10 Courtesy the artist

3.11 Staatliche Kunstsammlungen, Dresden, C 775

3.12–3.14 © Stephen C. P. Gardner

3.15 Amber Turner

3.16 "Draw To Perform Symposium" at Crows Nest Gallery, London (2016). Durational performance incorporating drawing, sound, body presence, and randomness—drawing out ideas of time and space. Audience and fellow artists went on a collaborative journey together over three days at "Draw To Perform Symposium"

3.17 © Studio Wim Delvoye, Belgium

3.18–3.20 © Stephen C. P. Gardner

3.21 Courtesy the artist and Marian Goodman Gallery

3.22 Museum of Modern Art, New York, Purchase. Acc. no. 79.1981. Photo 2018, The Museum of Modern Art, New York/Scala, Florence. © Succession H. Matisse/DACS 2018

3.23, 3.24 © Stephen C. P. Gardner

3.25 Courtesy the artist and Robert Fontaine Gallery

3.26 Museum of Modern Art, New York, Gift of Edgar Kaufmann, Jr. (by exchange) and Committee on Drawings Funds, Acc. no. 438.2004. Photo 2018, The Museum of Modern Art, New York/Scala, Florence. © Jasper Johns/VAGA, New York/DACS, London 2018

3.27 Metropolitan Museum of Art, New York, Rogers Fund, 1919, 19.125.2

3.28 © Stephen C. P. Gardner

3.29 J. Paul Getty Museum, Los Angeles, 2003.17

3.30 Courtesy Marlborough Fine Art. © Paula Rego

3.31 © Stephen C. P. Gardner

3.32 Metropolitan Museum of Art, New York, Purchase, Joseph Pulitzer Bequest, 1951, Acquired from The Museum of Modern Art, Lillie P. Bliss Collection, 55.21.1

3.33 © Stephen C. P. Gardner

3.34 © George Dawnay

3.35 © Stephen C. P. Gardner

3.36 © David Hockney. Photo Steve Oliver

3.37 Christie's Images/Bridgeman Images. © Wayne Thiebaud/DACS, London/VAGA, New York 2018

3.38 © Stephen C. P. Gardner

3.39 Photo © James Gurney, BDSP, 2018

3.40 Tate, London, presented by the Art Fund (Herbert Powell Bequest), 1967. Photo Tate, London 2018

3.41 Museum of Modern Art, New York, Gift of the artist. Acc. no. 2202.1967.36. Photo 2018, The Museum of Modern Art, New York/Scala, Florence. Estate of Grace Hartigan

3.42 © Stephen C. P. Gardner

3.43 Georgia Museum of Art, University of Georgia, Museum purchase with funds provided in memory of Lamar Dodd by Mr. and Mrs. Chester Roush, GMOA 1997.58. Photo Georgia Museum of Art, University of Georgia

3.44 Metropolitan Museum of Art, New York, John Stewart Kennedy Fund, 1913, 13.100.102

3.45a, 3.45b © Stephen C. P. Gardner

3.46 Metropolitan Museum of Art, New York, Rogers Fund, 1970.101.17

3.47 © Stephen C. P. Gardner

3.48 The Trustees of the British Museum, London

3.49 Tate, London, accepted by the nation as part of the Turner Bequest, 1856. Photo Tate, London 2018

3.50 © Stephen C. P. Gardner

3.51 Photo Victoria and Albert Museum, London. © Martin Longmore, MA.des.RCA. Car and motorcycle designer

3.52 Image courtesy Plancius Art Collection. © DACS 2018

3.53 Courtesy the artist and DAM Gallery, Berlin

3.54 Nathalie Savoie, *Figure 5*, 2015. Acrylic on canvas, pencil on paper, and Photoshop, 8 × 8 (20.3 × 20.3). Private collection

3.55 Solomon R. Guggenheim Museum, New York, Gift, Andrew Powie Fuller and Geraldine Spreckels Fuller Collection, 1999, 2000.46. Photo 2018, The Solomon R. Guggenheim Foundation/Art Resource, NY/Scala, Florence. © Robert Rauschenberg Foundation/DACS, London/VAGA, New York 2018

3.56 Courtesy the artist and DC Moore Gallery, New York

3.57 Photo Kerry Ryan McFate. Courtesy Pace Gallery. © Kiki Smith

3.58–3.61 © Stephen C. P. Gardner

Part 2

p. 93 Dan Muangprasert

Chapter 4

4.1 Museum of Modern Art, New York, Gift of Emily Fisher Landau. Acc. no. 64.1988. Publisher Universal Limited Art Editions, West Islip, New York, printer Universal Limited Art Editions, West Islip, New York, edition 62. Photo 2018, The Museum of Modern Art, New York/Scala, Florence. © The Murray-Holman Family Trust/Artists Rights Society (ARS), New York/DACS 2018

4.2 Photo The Print Collector/Print Collector/Getty Images

4.3–4.5 © Stephen C. P. Gardner

4.6 Christina Budres

4.7, 4.8 Metropolitan Museum of Art, New York, Van Day Truex Fund, 1981.324. Photo 2018, The Metropolitan Museum of Art/Art Resource/Scala, Florence. © Georgia O'Keeffe Museum/DACS 2018

4.9, 4.10 Kunsthalle, Bremen

4.11, 4.12 © Stephen C. P. Gardner

4.13, 4.14 Published by Crown Point Press

4.15, 4.16 Gift of the artist, 2003. Photo AGNSW 370.2003. © Lou Klepac

4.17, 4.18 The Solomon R. Guggenheim Museum, New York

4.19 Photo RMN-Grand Palais (Musée du Louvre)/Michèle Bellot

4.20, 4.21 The Trustees of the British Museum, London

4.22, 4.23 Kupfertstichkabinett, Staatliche Museen zu Berlin, Inv. no. KdZ 715. Photo Jörg P. Anders. Photo 2018, Scala, Florence/bpk, Bildagentur fuer Kunst, Kultur und Geschichte, Berlin

4.24, 4.25 Courtesy the artist and Victoria Miro, London/Venice. © Paradis/Tal R, Copenhagen

4.26 Courtesy David Zwirner, New York/London. © Estate of Ruth Asawa

4.27 Courtesy the artist

4.28, 4.29 Uffizi Gallery, Florence

4.30, 4.31 David Park papers, 19171973. Archives of American Art, Smithsonian Institution, Washington, D.C. Courtesy Hackett Mill, representative of the Estate of David Park

4.32 Courtesy Acquavella Galleries, New York

4.33 UBS Art Collection. © Helen Frankenthaler Foundation, Inc./ARS, NY and DACS, London 2018

4.34 © Dina Brodsky

4.35 Gallerie dell'Accademia, Venice

Chapter 5

5.1 Harvard Art Museums—Fogg Museum, Cambridge, MA, Gift of Elena Prentice in memory of Gweneth Knight, 2004.183.6. Photo Imaging Department. President and Fellows of Harvard College. © Elena Prentice

5.2 © Yoo Byung Hwa

5.3, 5.4 © Banco de México Diego Rivera Frida Kahlo Museums Trust, Mexico, D.F./DACS 2018

5.5 Derek Jarman Special Collection, box 49, item 1, BFI National Archive, Gaydon, England. © Derek Jarman. Reproduced by kind permission of the Derek Jarman Estate

5.6 Harvard Art Museums—Fogg Museum, Cambridge, MA, Bequest of Grenville L. Winthrop, 1943.825. Photo Imaging Department. President and Fellows of Harvard College

5.7 National Gallery of Art, Washington, D.C. The Armand Hammer Collection, 1991.217.61.b

5.8 © Stephen C. P. Gardner

5.9 Michaela Bartoňová, "My Little Eye Pet," drawing on iPad in interactive performance with visual riddles for the youngest children and families. www.tineola.cz/ www.drawinginmotion.com

5.10 Musée du Louvre, Paris

5.11 Nathalie Ramírez

5.12 The Getty Research Institute, Los Angeles

5.13 The Trustees of the British Museum, London

5.14 Fermin Uriz

5.15 Harvard Art Museums—Fogg Museum, Cambridge, MA, The Christopher Wilmarth Archive, Gift of Susan Wilmarth-Rabineau, CW2001.775.24. Photo Imaging Department. President and Fellows of Harvard College

5.16 Cooper-Hewitt, Smithsonian Design Museum, New York, Gift of Karim Rashid, 2000-50-34-4. Photo Matt Flynn. Photo 2018, Cooper-Hewitt, Smithsonian Design Museum/Art Resource, NY/Scala, Florence. Courtesy Karim Rashid

5.17 Cooper-Hewitt, Smithsonian Design Museum, New York, Museum purchase from General Acquisitions Endowment Fund, 2014-38-10-a,b. Photo Matt Flynn, 2018, Cooper-Hewitt, Smithsonian Design Museum/Art Resource, NY/Scala, Florence. Scholten & Baijings, 2009

5.18, 5.19 Photo Kurt Ohms. Courtesy The Foster Art & Wilderness Foundation

Chapter 6

6.1–6.8 © Stephen C. P. Gardner

6.9 Dan Muangprasert

6.10a–6.18 © Stephen C. P. Gardner

6.19 From Charles Bargue, *Cours de dessin*, 1866–71, Galerie Goupil & Cie, Paris

6.20 Courtesy the artist and the Dolby Chadwick Gallery, San Francisco

6.21 National Gallery, London, Purchased with a special grant and contributions from the Art Fund, The Pilgrim Trust, and through a public appeal organised by the Art Fund, 1962

6.22 Courtesy the artist

6.23 Courtesy the artist

Part 3

p. 149 Bibliothèque municipale de Lyon, 27585

Chapter 7

7.1 Collection Albright-Knox Art Gallery, Buffalo, New York, Elisabeth H. Gates Fund, 1932:130
7.2 © Filip Chaeder
7.3 © Alice Aycock
7.4 *Lo Stile: Nella Casa e nell'Arredamento*, Director Gio Ponti, Editor in Chief Carlo Pagani. © Instituto Bardi/Casa de Vidro
7.5 Photo courtesy Allan Stone Projects, New York. © The Willem de Kooning Foundation/Artists Rights Society (ARS), New York and DACS, London 2018
7.6 Photo courtesy Zaha Hadid Foundation
7.7 Museum of Modern Art, New York, Gift of the artist, Acc. no. 2202.1967.42. Photo 2018, The Museum of Modern Art, New York/Scala, Florence. Nancy Uyemura
7.8 Collection San Francisco Museum of Modern Art, Gift of John Berggruen Gallery. Photo Don Ross. © Ellsworth Kelly Foundation
7.9 Courtesy Gagosian. © Rachel Whiteread
7.10 Staatliche Graphische Sammlung, Munich.
7.11 Harvard Art Museums—Fogg Museum, Cambridge, MA, Bequest of Denman W. Ross, Class of 1875, 1936.94. Photo Imaging Department. President and Fellows of Harvard College. Hyman Bloom Estate
7.12 Alexander Hicks
7.13, 7.14 Photo Mike Bruce. Courtesy Gagosian. © Jenny Saville. All Rights Reserved, DACS 2018
7.15 Hannah Elizabeth Caney, Hastings, East Sussex, England
7.16 The Trustees of the British Museum, London
7.17 Photo Courtesy National Gallery of Art, Washington, D.C. © The Easton Foundation/VAGA, New York/DACS, London 2018
7.18 Cincinnati Art Museum, The Albert P. Strietmann Collection, 2002.23. Courtesy Matthew Marks Gallery. © Martin Puryear
7.19 Nuria Sagrera Gallardo
7.20 Courtesy Hauser & Wirth. © The Estate of Eva Hesse
7.21, 7.22 Art Institute of Chicago, Gift of David Adler, 1945.23. Photo 2018, The Art Institute of Chicago/Art Resource, NY/Scala, Florence. © DACS 2018
7.23 Photo Tim Nighswander/Imaging4Art. © The Josef and Anni Albers Foundation/VG Bild-Kunst, Bonn and DACS, London 2018

7.24 Museum of Modern Art, New York, Gift of Kleiner, Bell & Co. Acc. no. 901.1967. Publisher Tamarind Lithography Workshop, Inc., Los Angeles, printer Tamarind Lithography Workshop, Inc., Los Angeles, edition 11. Photo 2018, The Museum of Modern Art, New York/Scala, Florence. © Rico Lebrun
7.25 © Erika Radich
7.26 Photo RMN-Grand Palais (Musée d'Orsay)/Tony Querrec
7.27 Metropolitan Museum of Art, New York, The Elisha Whittelsey Collection, The Elisha Whittelsey Fund, 1959, 59.600.197
7.28 Metropolitan Museum of Art, New York, Gift of Eric Greenleaf, in honor of Ellen Wiley Todd's Scholarship on the Artist, Acc. no. 1994.525. Photo 2018, The Metropolitan Museum of Art/Art Resource/Scala, Florence. Courtesy DC Moore Gallery, New York. © Estate of Isabel Bishop
7.29 The Trustees of the British Museum, London
7.30 Courtesy the artist and Victoria Miro, London/Venice. © Celia Paul
7.31 J. Paul Getty Museum, Los Angeles, 2002.50

Chapter 8

8.1 National Museum of African Art, Smithsonian Institution, Washington, D.C. Purchased with funds provided by the Smithsonian Collections Acquisition Program 96-19-2. Osi Audu, Nigeria
8.2 Courtesy of Sikkema Jenkins & Co., New York. Artwork © Kara Walker
8.3 Photo courtesy Gemini G.E.L. LLC. © ARS, NY and DACS, London 2018
8.4 Museum of Modern Art, New York, Gift of Sarah-Ann and Werner H. Kramarsky, Acc. no. 632.2014. Photo 2018, The Museum of Modern Art, New York/Scala, Florence. © ARS, NY and DACS, London 2018
8.5 Courtesy ACA Gallery, New York
8.6 Tate, London, purchased 1992. Photo Tate, London 2018
8.7 Suzy Ehrlich fashion illustrations, KA006401_OSx1_f02_03, New School Archives & Special Collections, The New School, New York
8.8 Photo Birmingham Museums Trust
8.9 Bradford Art Galleries and Museums, West Yorkshire, UK/Bridgeman Images
8.10 Museum of Modern Art, New York, Acquired with matching funds from Charles B. Benenson and the National Endowment for the Arts, Acc. no. 290.1978. Photo 2018, The Museum of Modern Art, New York/Scala, Florence. Courtesy the artist

8.11 Courtesy Forum Gallery, New York, NY. © Wade Schuman
8.12 Paul Rodriguez
8.13 Courtesy Paul Kasmin Gallery. Photo Christopher Stach. © ARS, NY and DACS, London 2018
8.14 © 2018 The M.C. Escher Company—The Netherlands. All Rights Reserved
8.15 © DACS 2018
8.16 © Successió Miró/ADAGP, Paris and DACS London 2018

Chapter 9

9.1a–9.3b © Stephen C. P. Gardner
9.4 Courtesy Adelson Galleries, New York
9.5 Courtesy the artist
9.6 The Pierpont Morgan Library, New York, Gift of J. P. Morgan, Jr., 1924. Photo 2018, The Morgan Library & Museum/Art Resource, NY/Scala, Florence
9.7 Photo courtesy Ketterer Kunst. © Marlene Dumas
9.8 Metropolitan Museum of Art, New York, Gift of Adam Mekler, 1992.319. Photo 2018, The Metropolitan Museum of Art/Art Resource/Scala, Florence. © Martha Alf
9.9 Rijksmuseum, Amsterdam
9.10 J. Paul Getty Museum, Los Angeles, 99.GB.49
9.11 Woodmere Art Museum, Philadelphia, museum purchase, 1957. Photo Rick Echelmeyer
9.12, 9.13 © Stephen C. P. Gardner
9.14 Tate Modern, London, presented by the artist, 1974. Photo Tate, London 2018. © Estate of Paule Vézelay
9.15 Art Institute of Chicago, Helen Regenstein Collection, 1966.184. Photo 2018, The Art Institute of Chicago/Art Resource, NY/Scala, Florence
9.16 Metropolitan Museum of Art, New York, Gift of Alexander and Gregoire Tarnopol, 1976.243
9.17a, 9.17b Gift of the artist, 2003. Photo AGNSW 370.2003. © Lou Klepac
9.18 Photo courtesy The Andrew and Betsy Wyeth Collection. © Andrew Wyeth/ARS, NY and DACS, London 2018
9.19 Woodmere Art Museum, Philadelphia, Gift of Ann E. and Donald W. McPhail, 2013. Courtesy the Estate of Edna Andrade and Locks Gallery
9.20 Yang Wang
9.21a, 9.21b © Stephen C. P. Gardner
9.22 Österreichische Galerie im Belvedere, Vienna
9.23–9.25 © Stephen C. P. Gardner
9.26 Courtesy the artist
9.27 Art Institute of Chicago, signed lower left, in black chalk "Odilon Redon," David Adler Collection, 1950.1432. Photo 2018, The Art Institute of Chicago/Art Resource, NY/Scala, Florence

Chapter 10

10.1–10.4 © Stephen C. P. Gardner
10.5 Fablok/Shutterstock
10.6 Drawn for the course Vorkurs für Gestaltung und Kunst. Schule für Gestaltung Basel, Vogelsangstrasse 15, CH-40005 Basel, Switzerland
10.7 Courtesy Michael Graves Architecture & Design
10.8 © 2017 Jesse Smith. papercruiser.com
10.9 Courtesy the artist and Howard Yezerski Gallery
10.10 © Alex Beck
10.11 Courtesy Pace Gallery. Photo Bill Jacobson. © Succession Picasso/DACS, London 2018
10.12 Courtesy the artist
10.13 Madilyn Bedsole
10.14, 10.15 © Stephen C. P. Gardner
10.16 Metropolitan Museum of Art, Van Day Truex Fund, 1983.436. Photo 2018, The Metropolitan Museum of Art/Art Resource/Scala, Florence. © The Willem de Kooning Foundation/Artists Rights Society (ARS), New York and DACS, London 2018
10.17 Photo courtesy George Adams Gallery, New York. Courtesy Forum Gallery, New York, NY. © James Valerio
10.18 Morgan Library & Museum, New York, Gift of J. P. Morgan, Jr., 1924
10.19, 10.20 Courtesy of Etherton Gallery, Tucson, Arizona. © Bailey Doogan
10.21 Courtesy the artist
10.22 Hood Museum of Art, Dartmouth College, Hanover, NH, Gift of Mr. and Mrs. Thomas R. George, Class of 1940. Photo © Estate of Walter Tandy Murch

Chapter 11

11.1 Metropolitan Museum of Art, New York, Gift of Alexander Smith Cochran, 1913, 13.228.7.7
11.2 © Carl Randall. www.carlrandall.com
11.3, 11.4 © Stephen C. P. Gardner
11.5 Gabriela McDonald
11.6 Metropolitan Museum of Art, New York, Gift of Reba and Dave Williams, 1999.529.193. © John Wilson/Copyright Agency. Licensed by DACS 2018
11.7, 11.8 © Stephen C. P. Gardner
11.9 © 1988 Christo. Photo Christian Baur
11.10 © Rebecca L. Venn
11.11 © Xu Bing Studio
11.12 © Richard Diebenkorn Foundation
11.13 Metropolitan Museum of Art, New York, Morris K. Jesup Fund, 1989.287
11.14 © Hilary Brace. All Rights Reserved
11.15 Tate, London, Presented by the War Artists Advisory Committee 1946. Photo Tate, London 2018

11.16 © Stephen C. P. Gardner
11.17 Canadian Centre for Architecture, Gift of George Jacobsen and of the CCA Founders Circle in his memory, 1994, DR1994:0040. © ARS, NY and DACS, London 2018
11.18 Designed by Tony Ianiro
11.19 Bibliothèque municipale de Lyon, 27585
11.20a, **11.20b** Whitney Museum of American Art, New York, Felicia Meyer Marsh Bequest, 80.31.69. © ARS, NY and DACS, London 2018
11.21a, **11.21b** Photo 2018, Scala, Florence. Courtesy Ministero Beni e Att. Culturali e del Turismo
11.22 Photo VEGAP Image Bank. © Remedios Varo, DACS/VEGAP 2018
11.23 PUNCH Magazine Cartoon Archive. www.punch.co.uk
11.24 © Stephen C. P. Gardner
11.25 Addison Gallery of American Art, Phillips Academy, Andover, Gift of the artist (PA 1938) in memory of his parents, George Clair and Angela Montejo Roura Tooker, 1996.80.47. Photo 2018, Addison Gallery of American Art, Phillips Academy, Andover/Art Resource, NY/Scala, Florence. Courtesy DC Moore Gallery, New York. © Estate of George Tooker
11.26 Metropolitan Museum of Art, New York, George A. Hearn Fund, 1956, Acc. No. 56.78. Photo 2018, The Metropolitan Museum of Art/Art Resource/Scala, Florence. Courtesy DC Moore Gallery, New York. © Estate of George Tooker
11.27 © Stephen C. P. Gardner
11.28 Licensed by Warner Bros. Entertainment Inc. All Rights Reserved
11.29, **11.30** © Stephen C. P. Gardner
11.31 Smithsonian American Art Museum, Washington, D.C., Gift of Mr. and Mrs. Harry Baum in memory of Edith Gregor Halpert, 1971.335. Photo 2018, Smithsonian American Art Museum/Art Resource/Scala, Florence
11.32 Ronald Davis Archive, © 2008
11.33–**11.37** © Stephen C. P. Gardner
11.38 Artwork courtesy Anarchos Productions. Conceptual Artist and VFX Art Director: George Hull
11.39 Cooper Hewitt, Smithsonian Design Museum, New York, Thaw Collection, 2007-27-72

Chapter 12

12.1 Addison Jones
12.2 Courtesy the artist & Kerlin Gallery, Dublin
12.3, **12.4** Art Institute of Chicago, Gift of David Adler, 1945.23. Photo 2018, The Art Institute of Chicago/Art Resource, NY/Scala, Florence. © DACS 2018
12.5 Photo courtesy Angela Piehl. © Angela Piehl
12.6 National Museum of Natural History, Smithsonian Institution, Washington, D.C.
12.7 Photo RMN-Grand Palais (Musée du Louvre)/Gérard Blot

12.8 © Alice Leora Briggs
12.9 Courtesy George Adams Gallery, NY and Brian Gross Fine Art, SF. © Estate of Robert Arneson/DACS, London/VAGA, NY 2018
12.10 Museum of Modern Art, New York, Purchase, 309.1983. Photo 2018, The Museum of Modern Art, New York/Scala, Florence. © ARS, NY and DACS, London 2018
12.11 Courtesy the artist and Marian Goodman Gallery. © Julie Mehretu
12.12 Courtesy the artist and Victoria Miro, London/Venice. © Wangechi Mutu
12.13 © Stephen C. P. Gardner
12.14 Museum of Modern Art, New York, Gift of James Thrall Soby, Acc. no. 29.1958.30. From *Histoire Naturelle* (Natural History), introduction by Jean (Hans) Arp, 1926 (Reproduced frottages executed *c.* 1925). Publisher Galerie Jeanne Bucher, Paris, printer unknown, edition 300. Photo 2018, The Museum of Modern Art, New York/Scala, Florence. © ADAGP, Paris and DACS, London 2018
12.15 Tate, London, purchased 1987. Photo Tate, London 2018. © ADAGP, Paris and DACS, London 2018
12.16, **12.17** © Stephen C. P. Gardner
12.18 Museum of Modern Art, New York, Given anonymously. Acc. No. 346.1963.31. Photo 2018, The Museum of Modern Art, New York/Scala, Florence. © Robert Rauschenberg Foundation/DACS, London/VAGA, New York 2018
12.19 Tate, London, Bequeathed to Tate Archive by Eileen Agar, 1992. Photo Tate, London 2018. Estate of Eileen Agar/Bridgeman Images

Chapter 13

13.1 Courtesy the Warden and Scholars of New College, Oxford/Bridgeman Images
13.2 Pictures from History/Bridgeman Images
13.3–**13.9** © Stephen C. P. Gardner
13.10 Radha Howard
13.11 Christie's Images/Bridgeman Images
13.12 Museum of Modern Art, New York, Lillie P. Bliss Collection. Acc. no. 9.1934.a. Photo 2018, The Museum of Modern Art, New York/Scala, Florence
13.13 © Estate of Roy Lichtenstein/DACS 2018
13.14 © Susan Ogilvie, PSA
13.15 Museum of Modern Art, New York, Purchased with funds provided by the Edward John Noble Foundation, Frances Keech Fund, and Committee on Drawings Funds, Acc. no. 21.2010. 2018 Digital image, The Museum of Modern Art, New York/Scala, Florence. © Kanayama Akira and Tanaka Atsuko Association
13.16 Metropolitan Museum of Art, New York, Purchase, Dr. and Mrs. Robert E. Carroll Gift, 1985.78.

Photo 2018, The Metropolitan Museum of Art/Art Resource/Scala, Florence. © Estate of Mary Ann Currier
13.17 © Lorenzo Chavez
13.18 Photo RMN-Grand Palais (Musée d'Orsay)/Hervé Lewandowski
13.19 Metropolitan Museum of Art, New York, Robert Lehman Collection, 1975.1.681
13.20 Photo Galerie Bassenge, Berlin, 2014, www.bassenge.com. © Helen Frankenthaler Foundation, Inc./ARS, NY/DACS, London 2018/2RC Edizione d'Arte, Rome
13.21 Photo RMN-Grand Palais (Musée d'Orsay)/Gérard Blot
13.22 Courtesy DC Moore Gallery, New York. © Janet Fish/DACS, London/VAGA, NY 2018
13.23 Museum of Modern Art, New York, Gift of Abby Aldrich Rockefeller, Acc. no. 53.1935. Photo 2018, The Museum of Modern Art, New York/Scala, Florence
13.24 Private collection
13.25 Metropolitan Museum of Art, Gift of Stanley Posthorn, in memory of the artist, 1997.404.4. Photo 2018, The Metropolitan Museum of Art/Art Resource/Scala, Florence. © By The Estate of Joe Brainard. Used by permission of the Estate of Joe Brainard and courtesy of the Tibor de Nagy Gallery, New York
13.26 Photo Centre Pompidou, MNAM-CCI, Dist. RMN-Grand Palais/Philippe Migeat. © ADAGP, Paris and DACS, London 2018
13.27 © 2013 Monica Aissa Martinez
13.28 Museum of Modern Art, New York, Katherine S. Dreier Bequest, Acc. no. 158.1953. Photo 2018, The Museum of Modern Art, New York/Scala, Florence

Part 4

p. 275 © Jinju Lee and Arario Gallery

Chapter 14

14.1 Metropolitan Museum of Art, New York, Rogers Fund, 1920, 20.61.2(48)
14.2 Metropolitan Museum of Art, promised gift from the Leonard A. Lauder Cubist Collection, 2016.237.33. Photo 2018, The Metropolitan Museum of Art/Art Resource/Scala, Florence. © ADAGP, Paris and DACS, London 2018
14.3 Annie Williams
14.4 Courtesy the artist
14.5 Museum of Modern Art, New York, The Riklis Collection of McCrory Corporation, Acc. no. 914.1983. Photo 2018, The Museum of Modern Art, New York/Scala, Florence. © FLC/ADAGP, Paris and DACS, London 2018

14.6 Photo courtesy Galerie Hans Brockstedt OHG, Berlin. © DACS 2018
14.7 © Deborah Friedman
14.8 Kirstyn Harris. Photographed by Randy Pace
14.9 Courtesy Forum Gallery, New York, NY. © Jane Lund
14.10 Tate, London, Purchased 1982. Photo Tate, London 2018. © R. Hamilton. All Rights Reserved, DACS 2018
14.11 Courtesy Forum Gallery, New York, NY. © Estate of Susan Hauptman
14.12 Photo courtesy Hollis Taggart Galleries, New York
14.13 Metropolitan Museum of Art, New York, Purchase, Anonymous Gift, in memory of Frits Markus, and Frits and Rita Markus Fund, 2003.30
14.14 Courtesy Louis K. Meisel Gallery
14.15-**14.18** © Stephen C. P. Gardner

Chapter 15

15.1 National Galleries of Scotland, Edinburgh, purchased with the assistance of the Art Fund 1973, D 4994
15.2 Courtesy the artist and Jack Shainman Gallery, New York. © Kerry James Marshall
15.3a, **15.3b** © Kelly & Massa Photography
15.3c Courtesy Sikkema Jenkins & Co., New York. © Estate of Trisha Brown
15.4 Courtesy the artist and David Krut Projects, New York
15.5 © Jinju Lee and Arario Gallery
15.6 Private collection
15.7 Wadsworth Atheneum Museum of Art, Hartford. Charles H. Schwartz Endowment Fund, 2014.4.1.
15.8 Philadelphia Museum of Art, Gift of Mrs Thomas Eakins and Miss Mary Adeline Williams, 29.184.49
15.9 © Estate of Joan Mitchell
15.10 Courtesy the artist
15.11 Courtesy the Artist and Kedumba Gallery, Australia
15.12 Courtesy the artist
15.13 Photo Birmingham Museums Trust
15.14 Bradford Art Galleries and Museums, West Yorkshire, UK/Bridgeman Images
15.15 © Stephen C. P. Gardner
15.16 Atakan Basol
15.17 © Stephen C. P. Gardner
15.18 Photo 2018, Scala, Florence. Courtesy Ministero Beni e Att. Culturali e del Turismo
15.19 © Stephen C. P. Gardner
15.20 British Museum, London, Ff,1.36
15.21 (from l to r) © Baby Blues Partnership; Albrecht Dürer, *Saint Sebastian Bound to the Column, c.* 1499. Engraving, 4¹/₄ × 3 (10.8 × 7.5). Metropolitan Museum of Art, New York, Bequest of Grace M. Pugh, 1985, 1986.1180.85; Dan Gheno, *Gesturing Male Figure,*

Walking, 2007. Colored pencil and white chalk on toned paper, 18 × 24 (45.7 × 61). Collection of the artist; Michelangelo, *Standing Male Nude*, n.d. Pencil, 13$^{1}/_{4}$ × 6$^{5}/_{8}$ (33.5 × 16.8). Musée du Louvre, Paris. Photo RMN-Grand Palais (Musée du Louvre)/Thierry Le Mage; © CAPCOM U.S.A., INC. 2018. All Rights Reserved
15.22 Photo Sebastian Kaulitzki/ Shutterstock
15.23 © Robert Liberace
15.24 Smithsonian American Art Museum, Washington, D.C., Gift of Mr. and Mrs. Norman Robbins, 1983.95.45. Photo 2018, Smithsonian American Art Museum/ Art Resource/Scala, Florence
15.25 Ciprian Stremtan/Shutterstock
15.26 Musée du Louvre, Paris
15.27 © Alila Medical Media. www.AlilaMedicalMedia.com
15.28 Collection the artist
15.29, 15.30 © Stephen C. P. Gardner
15.31 Photo 2018, Scala, Florence. Courtesy Ministero Beni e Att. Culturali e del Turismo
15.32 Courtesy Don Gale

Chapter 16

16.1 Private collection
16.2 Stephanie Tarascio
16.3 Art Institute of Chicago, Helen Regenstein Collection, 1966.184. Photo 2018, The Art Institute of Chicago/Art Resource, NY/Scala, Florence. Courtesy The Estate of Alice Neel and David Zwirner. © The Estate of Alice Neel

16.4 © Maggi Hambling
16.5 © Romare Bearden Foundation/ DACS, London/VAGA, NY 2018
16.6 National Portrait Gallery, Smithsonian Institution, Washington, D.C., Gift of Bettina Steinke and Don Blair, NPG.93.156. Photo 2018, National Portrait Gallery, Smithsonian/ Art Resource/Scala, Florence
16.7 © The Al Hirschfeld Foundation. www.AlHirschfeldFoundation.org
16.8 Musée Unterlinden, Colmar, France
16.9 Staatliche Graphische Sammlung, Munich, Germany
16.10 Photo Jon Kopaloff/FilmMagic/ Getty Images
16.11 © Stephen C. P. Gardner
16.12a, 16.12b Courtesy the artist and Sean Kelly, New York. © Shahzia Sikander
16.13, 16.14 Metropolitan Museum of Art, New York, Robert Lehman Collection, 1975.1.869
16.15 © Stephen C. P. Gardner
16.16 The Trustees of the British Museum, London
16.17 British Museum, London, 1874, 0808.747
16.18 Harvard Art Museums—Fogg Museum, Cambridge, MA, Richard Norton Fund, S6.55.1. Photo Imaging Department. President and Fellows of Harvard College
16.19 Harvard Art Museums—Fogg Museum, Cambridge, MA, Richard Norton Fund, S6.56.4. Photo Imaging Department. President and Fellows of Harvard College
16.20 Stichting Jules De Bruycker, Ghent, Belgium
16.21 Bridgeman Images

16.22 © DACS 2018
16.23 Courtesy the Artist and the Dolby Chadwick Gallery, San Francisco
16.24 Collection of The Global Center for Latvian Art
16.25 Art Institute of Chicago, Gift of the E. Mark Adams and Beth Van Hoesen Adams Trust, 2012.383. Photo 2018, The Art Institute of Chicago/Art Resource, NY/Scala, Florence. The E. Mark Adams and Beth Van Hoesen Adams Trust
16.26-16.30 © Stephen C. P. Gardner

Chapter 17

17.1 The Trustees of the British Museum, London
17.2 Yale Center for British Art, Paul Mellon Collection
17.3 Dana Demsky
17.4 National Gallery of Art, Washington, D.C., Ailsa Mellon Bruce Collection, 1970.17.162
17.5 © Ch'ng Kiah Kiean. www.kiahkiean.com
17.6 © Estate of Joan Eardley. All Rights Reserved, DACS 2018
17.7 © Sue Bryan 2016. All Rights Reserved
17.8 Metropolitan Museum of Art, New York, Gift of Reba and Dave Williams, 1999.529.193). Photo 2018, The Metropolitan Museum of Art/Art Resource/Scala, Florence. Courtesy Galerie Urs Meile, Lucerne/Bejing. © Shao Fan
17.9 Henri Cartier-Bresson/ Magnum Photos

17.10 Courtesy Forum Gallery, New York, NY. © Anthony Mitri
17.11 National Gallery of Art, Washington, D.C., Gift of Ruth K. Henschel in memory of her husband, Charles R. Henschel, 1975.92.8
17.12 Gift of the artist, 2003. Photo AGNSW 370.2003. © Lou Klepac
17.13 National Gallery of Art, Washington, D.C., Corcoran Collection, Gift of William H. G. Fitzgerald, Desmond Fitzgerald, and B. Francis Saul II, 2015.19.2735. Courtesy the artist and DC Moore Gallery, New York
17.14-17.18 © Stephen C. P. Gardner
17.19 Photo RMN-Grand Palais (Musée du Louvre)/Thierry Le Mage

Part 5

Chapter 18

18.1 CALVIN AND HOBBES © 1995 Watterson. Reprinted with permission of Andrews McMeel Syndication. All Rights Reserved
18.2 Isabella Gardner
18.3 Artwork owned by SMK, the National Gallery of Denmark. SMK Photo/Jacob Schou-Hansen
18.4 Heritage Images/Diomedia
18.5 Private collection
18.6-18.8 © Stephen C. P. Gardner
18.9 www.CartoonStock.com

Index